DISCOVER ISLAMIC ART *in the Mediterranean*

DISCOVER ISLAMIC ART *in the Mediterranean*

A book by Museum With No Frontiers

MUSEUM
WITH NO
FRONTIERS

European Union

Euromed Heritage

We thank the Calouste Gulbenkian Foundation, Lisbon, and the Spanish Agency for International Co-operation at the Spanish Ministry of Foreign Affairs for their support.

This book has been published within the project **Discover Islamic Art** realised with the support of the European Union under the Euromed Heritage programme.

In co-operation with:

Algeria
National Museum of Antiquities and Islamic Arts, Algiers

Egypt
Museum of Islamic Art, Cairo

Germany
Museum of Islamic Art at the Pergamon Museum, State Museums, Berlin

Italy
National Museum of Oriental Art 'G. Tucci', Rome

Jordan
Jordan Archaeological Museum, Amman

Morocco
National Archaeological Museum, Rabat

Palestinian Authority
Islamic Museum and Al-Aqsa Library, al-Haram al-Sharif, Jerusalem

Portugal
Archaeological Area and Museum of Mértola, Mértola

Spain
National Archaeological Museum, Madrid

Sweden
Museum for Mediterranean and Near Eastern Antiquities, Stockholm

Syria
National Museum, Damascus

Tunisia
Museum of Islamic Art Raqqada, Kairouan

Turkey
Museum of Turkish and Islamic Arts, Istanbul

United Kingdom
The British Museum, London
Glasgow Museums, Glasgow
National Museums Scotland, Edinburgh
Victoria and Albert Museum, London

And also in co-operation with:

Algeria
Ministry of Culture

Egypt
Ministry of Culture, Supreme Council of Antiquities

Jordan
Ministry of Tourism, Department of Antiquities
Friends of Archaeology

Morocco
Ministry of Culture

Palestinian Authority
Ministry of Tourism and Antiquities

Syria
Ministry of Culture

Tunisia
Ministry of Culture, National Institute of Cultural Heritage

Turkey
Ege University, Izmir

United Kingdom
Visiting Arts

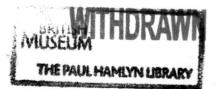

Concept and overall co-ordination
Eva Schubert, Brussels

Design
Peter Dolton, Suffolk, United Kingdom

Translations, copy-editing and indexing

Arabic edition
Manaf Al-Damad, Damascus (translations from Italian)
Fadel Jetker, Damascus (translations from English)
Hanan Kassab-Hassan, Damascus (translations from French)
Bashar Ibrahem, Damascus (copy-editing)
Verena Daiber, Damascus/Berlin (co-ordination)

English edition
Laurence Nunny, Barcelona (translations from French, Italian, Spanish)
Monica Allen, London (proofreading)
Meg Davies, Preston (index)
Mandi Gomez, London (copy-editing and co-ordination)

French edition
Jacques Bosser, Paris (translations from English)
Marguerita Pozzoli, Arles (translations from Italian)
Margot Cortez, Brussels (translations from Spanish, copy-editing and co-ordination)

German edition
Herwig Engelmann, Berlin (translations from English and French)
Ulrich Müller-Schöll, Berlin/Addis Abeba (translations from Italian)
Aimée Torre Brons, Berlin (translations from Spanish)
Claudius Prößer (proofreading)
Martin Hager, Berlin (translations from English, copy-editing and co-ordination)

Italian edition
Saverio Capozzi, Rome (translations from English, French, Spanish)
Pier Paolo Racioppi, Rome (copy-editing)

Portuguese edition
Santiago Macias, Mértola (translations from English, French, Italian, Spanish)
Paula Viana, Porto (copy-editing)

Spanish edition
Aurora Caballero García, Madrid (translations from French)
Yaiza Martínez, Córdoba (translations from French)
Sakina Missoum, Madrid (translations from French)
Lucía Rodríguez Corral, Madrid (translations from English)
Rosalía Aller, Madrid (copy-editing)
Miguel García, Madrid (translations from Italian and co-ordination)

Turkish edition
Alper Taşpınar, Istanbul (translations from English)
Saadet Özen, Istanbul (translations from French and Spanish)
Selime Pişirim, Istanbul (translations from English)
İnci Türkoğlu, Istanbul (copy-editing and co-ordination)

Pre-print production

Typesetting
Peter Dolton, Suffolk (English, French, Italian)
Christian Eckart, Vienna (German, Portuguese, Spanish)
Ahmet Boratav, Istanbul (Turkish)
Atlas Translations, London (Arabic)

Production and printing

Scanning and proofing
MRM Graphics Limited, Buckinghamshire, United Kingdom

Printing of all editions
Compass Press, London, United Kingdom

Editorial co-ordination

Brussels
Eva Schubert
Mehmet Kahyaoğlu

London
Mandi Gomez

Local co-ordination
Ghada Al-Yousef (Jordan)
Naima Elkhatib-Boujibar (Morocco)
Miguel García (Spain)
İnci Kuyulu Ersoy (Turkey)
Sa'd Nimr (Palestinian Authority)
Boussad Ouadi (Algeria)
Irene Salerno (Italy)
Enaam Selim (Egypt)
Zena Takieddine (Syria)
Saloua Zangar (Tunisia)

This book is published in cooperation with

Arabic edition
Joint edition of partner publishers in North Africa and the Middle East (see below)

English edition
Art Books International, London, United Kingdom
ISBN 978-1-874044-63-5

French edition
Editions Edisud, Aix-en-Provence, France
ISBN 978-2-7449-0682-4

German edition
Ernst Wasmuth Verlag, Tübingen, Germany
ISBN 978-3-8030-4105-0

Italian edition
De Luca Editori d'Arte, Rome, Italy
ISBN 978-88-8016-786-0

Portuguese edition
Medialivros – Actividades Editoriais, S.A., Lisbon, Portugal
ISBN 978-972-797-144-2
Depósito legal 252883/07

Spanish edition
Museum With No Frontiers, Brussels / Vienna

Turkish edition
Zero Production / Ege Yayınları, Istanbul, Turkey
ISBN 975-807-155-6

Partner publishers and distributors North Africa and Middle East

Algeria
Inas Editions, Algiers
ISBN 9961-762-17-7 (French edition)

Egypt
Al-Dar Al-Masriah Al-Lubnaniah, Cairo
ISBN 977-427-105-X (Arabic edition)
Deposit number 1754/2007
ISBN 977-427-106-8 (English edition)
Deposit number 1755/2007

Jordan
Arab Institute for Research & Publishing, Beirut, Lebanon and Al-Faris Publishing and Distribution Co., Amman, Jordan
ISBN 9953-36-958-5 (Arabic edition)
ISBN 9953-36-957-7 (English edition)

Morocco
Editions LPL, Rabat
ISBN 9981-110-13-2 (Arabic edition)
ISBN 9981-110-12-4 (French edition)

Syria
Dar Al-Fikr, Damascus
ISBN 1-59239-598-8 (Arabic edition)
Dummar Publishing, Damascus
Foreign languages

Tunisia
Maison Arabe du Livre, Tunis
ISBN 978-9973-10-240-9 (French edition)

For contact details of publishers and distributors:
www.museumwnf-books.net
books@museumwnf.net

For further information please visit the www.discoverislamicart.org Virtual Museum

The views expressed in this publication do not necessarily reflect the opinion of either the European Union or of its Member States but each article reflects exclusively the opinion of the author(s).

Table of Contents

11 **Foreword**
Eva Schubert

12 **Chronology**
Mounira Chapoutot-Remadi (Tunis)

19 **Introduction: Islamic Art in Museums – Ambassadors of a Civilisation**
Mohamed Abbas (Cairo), Mohammad Najjar (Amman) and Barry Wood (London, Istanbul)

21 **The Mediterranean Prior to the Islamic Expansion**
Aicha Benabed (Tunis)

31 **The Prophet and the Rightly Guided Caliphs**
Muhammad Al-Asad (Amman) and Claus-Peter Haase (Berlin)

37 **The Umayyads: Damascus, the First Capital**
Ghazi Bisheh (Amman)

51 Figurative Decoration
Jens Kröger (Berlin) and Mohammad Najjar (Amman)

59 **The Abbasids: the First Islamic Empire**
Noorah Al-Gailani (Glasgow) and Mounira Chapoutot-Remadi (Tunis)

79 **The Conquest of the West: Cordoba, Umayyad Capital in Al-Andalus**
Mohamed Mezzine (Fez)

87 Calligraphy: the Sublime Art of Islam
Şule Aksoy (Istanbul) and Khader Salameh (Jerusalem)

97 **Islamic and Norman Sicily**
Pier Paolo Racioppi (Rome) and Ettore Sessa (Palermo)

105 **The Fatimids: Two Centuries of Supremacy**
Ulrike Al-Khamis (Edinburgh)

119 Women and Power in the Islamic Mediterranean
Jamila Binous (Tunis)

127 **The Muslim West After the Umayyads**
Gaspar Aranda (Madrid) and Kamal Lakhdar (Rabat)

141 Islamic Geometry: the Philosophy of Space
Naima Elkhatib-Boujibar (Casablanca)

149 **The Central Maghreb: Conquest and Dissidence**
Farida Benouis and Boussad Ouadi (both Algiers)

161 'And We Made out of Water Every Living Thing': Water in Islam
Sheila Canby (London) and Zena Takieddine (Damascus)

167 **Mudéjar Art: the Islamic Heritage in Christian Portugal and Spain**
Gonzalo Borrás Gualís (Zaragoza) and Santiago Macías (Mértola)

175 **The Ayyubid Era: Conflicts and Coexistence in Medieval Syria**
Abdal-Razzaq Moaz (Damascus) and Emily Shovelton (London)

195 The *Hajj*: Pilgrimage in Islam
Nazmi Al-Jubeh (Jerusalem)

203 **The Mamluks: Cairo Becomes the New Centre of the Islamic World**
Mohamed Abbas (Cairo)

219 Science and Music
Mònica Rius (Barcelona)

227 **The Ottomans: Rulers for Six Hundred Years**
Verena Daiber (Berlin/Damascus) and İnci Kuyulu Ersoy (Izmir)

245 Reflections of Paradise: Floral Decoration in Islamic Art
A collaboration

253 **Western Influences in Ottoman Lands**
Mehmet Kahyaoğlu (Brussels) and Paola Torre (Rome)

259 **Glossary**

262 **Further reading**

264 **Index**

268 **About the Authors**

272 **About Museum With No Frontiers**

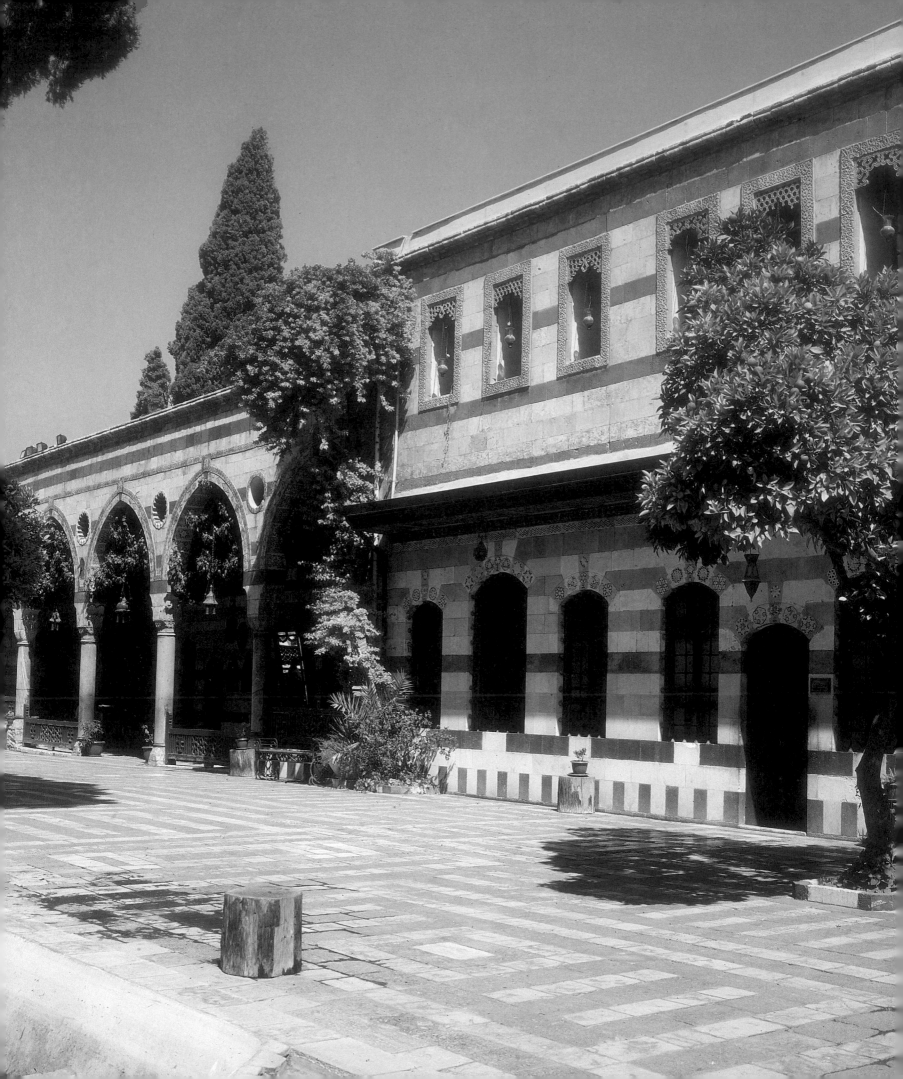

Foreword

Dear Reader,

To explain the particularity and I would even say the uniqueness of this book is not an easy task. *Discover Islamic Art in the Mediterranean* is in fact not only a book but the result and witness of a unique co-operation between persons who intend 'Art' as a sublime ambassador of different historical experiences, and who believe in the force of expression of Art to promote mutual understanding and respect.

Below I will describe briefly our exceptional experience that would have been impossible without the support of the European Union.

For almost three years 150 experts from 16 different countries, communicating in nine different languages, have been working together to create the biggest museum in the world: a new form of virtual museum combining both physical and virtual exhibition venues into an authentic museum with no frontiers where artefacts from various museums, as well as monuments and archaeological sites from various countries, are interrelated with each other. The artistic legacy of the Islamic Civilisation in the Mediterranean is the theme of the first Permanent Collection of this new museum, and this book is the first exhibition catalogue published by the www.discoverislamicart.org Virtual Museum in connection with a cycle of 18 Virtual Exhibitions inviting the visitor to Discover Islamic Art in the Mediterranean.

Thirty-nine of the scholars, museum curators and experts in cultural heritage, having participated in the experience of building the Virtual Museum, are the authors of the 22 chapters that will take the reader through 13 centuries of history, from the period of the Prophet Muhammad up until the end of the Ottoman Empire (AH 1341/AD 1922). The great Islamic Dynasties of the Mediterranean are the protagonists of this book, together with their fascinating artistic and cultural legacy. A short historical introduction at the beginning helps to contextualise the rise of Islam.

Discover Islamic Art in the Mediterranean is a collaborative work that was written for all those who share our idea that there is not only one history, but there are at least as many histories as there are peoples. The idea of this book is to contribute to a historically more accurate and thus more authentic understanding of Islam by offering different perspectives of interpreting history, art and culture.

Finally, please note that we are using a simple phonetic transliteration of the Arabic terms set in Italic characters, and that we do not provide their plural forms. For dates relating to Islamic history we provide both the *hijra* date (which according to Islamic tradition started from the migration of the Prophet from Mecca to Medina in 622) together with the commonly used Gregorian dating system.

We hope you enjoy discovering the world of Islam in the Mediterranean and very much look forward to your feedback through our Virtual Museum: www.discoverislamicart.org.

Eva Schubert
Chairperson and Chief Executive
Museum With No Frontiers

FACING PAGE
Qasr al-Azm
Ottoman, AH 1163/AD 1749-50
Damascus, Syria

Chronology

Mounira Chapoutot-Remadi

AH	AD	
	527–65	Emperor Justinian begins the reconquest of Italy and Africa.
	535	Vandal Africa reconquered by the Byzantines.
	c. 570	Year of the Elephant. King Abraha of Ethiopia attacks Mecca with an army mounted on elephant back. The Prophet Muhammad is born.
	589	Third Council of Toledo. Conversion of the Visigothic King Reccared to Roman Christianity.
	610–41	Reign of Heraclius.
	610	First revelations of the Qur'an.
01	622	Prophet Muhammad emigrates from Mecca to Medina. *Hijra* (migration), year one.
11	632	Death of the Prophet.
11–12	632–3	The wars of Apostasy (*hurub al-Ridda*) in Arabia subdued by Khalid ibn al-Walid.
11–13	632–4	Caliphate of Abu Bakr.
28 Jumada I 13	30 July 634	Victory of the Arabs over the Byzantines at al-Ajnadayn, led by General Khalid ibn al-Walid who was known as 'the Sword of Islam'; thus begins the conquest of Palestine except for Jerusalem and Caesarea.
13–21	634–44	Caliphate of 'Umar ibn al-Khattab.
Shaban 14	September–October 635	Victory of the Arabs over the Persians at Buwayb which begins the conquest of the Sassanid Empire.
Rajab 15	August 636	Battle of Yarmuk, the conquest of Syria and the occupation of Damascus.
16	637	Victory at al-Qadisiyya over the Sassanids and the fall of Ctesiphon, the ancient capital of the Sassanid Empire.
16	637	Victory of the Arabs at Jallula, which ended the conquest of Iraq. Foundation of Basra in the south of Iraq by 'Utba ibn Ghazwan.
17	638	Caliph 'Umar chooses the lunar calendar for the Muslim state and sets the start of the *Hijra* calendar at 16 July 622.
17	638	Conquest of Jerusalem (Ilya) by Abu 'Ubayda al-Jarrah.
17	638	Foundation of Kufa by Sa'd ibn Abi Waqqas, a Companion of the Prophet.
20	641	Conquest of Egyptian Babylon (current old Cairo).
23	643	Fustat, the first capital of Egypt, founded by 'Amr ibn al-'As.
26 Dhu al-Hijjah 24	3 November 644	Caliph 'Umar assassinated.
23–35	644–56	Caliphate of 'Uthman.
26	647	First Arab expedition into Ifriqiya. Battle of Sufetula (Sbeitla).

AH	AD	
18 Dhu al-Hijjah 36	17 June 656	Assassination of 'Uthman and beginning of the caliphate of 'Ali.
16 Jumada II 36	9 December 656	'Battle of the Camel'. 'Ali's adversaries 'A'isha, Muhammad and Talha defeated.
36–7	657	Revolt by Mu'awiya, governor of Syria. *Fitna*, the division of the Muslim community.
8 Safar 37	26 July 657	Battle at Siffin between Mu'awiya and 'Ali; war is prevented. Arbitration is accepted by 'Ali but the Kharijites, a supporter group, secede from 'Ali's army.
38	658	Kharijites defeated by 'Ali at Nahrawan in Iraq.
41	661	'Ali assassinated at Kufa by a Kharijite.
41–60	661–80	Mu'awiya proclaimed caliph; he founds the Umayyad Dynasty.
50	670	Foundation of Kairouan by 'Uqba ibn Nafi.
10 Muharram 61	10 October 680	*Ashura*: the date of the death of al-Husayn, son of 'Ali, at the Battle of Karbala.
62	682	'Uqba ibn Nafi defeated and killed by the Berber chieftain of the Awraba tribe, Koceila, at Téhouda near to Biskra.
65–86	685–705	'Abd al-Malik ibn Marwan Arabises the administration of the Muslim Empire and mints a gold coin.
79	698	Hasan ibn Numan ousts the Byzantines from Carthage.
83	702	Hasan defeats and kills Kahina, Queen of the Berbers.
88–96	705–15	Caliph al-Walid I erects the mosques of Damascus and al-Aqsa in Jerusalem, and rebuilds the Medina Mosque.
92	711	Beginning of the Arab-Berber conquest of al-Andalus led by Musa ibn Nusayr and his Berber lieutenant Tariq ibn Ziyad. Defeat of the Visigoths and the conquest of Córdoba.
114	732	Charles Martel, ruler of the Frankish realms, stops the Arabs at Poitiers.
132	750	Victory and accession of the Abbasids with Abu 'l-'Abbas al-Saffah.
135	752	Foundation of al-'Askar, the second palatine city located north-west of Fustat, by the Abbasid governor of Egypt.
137–71	756–88	'Abd al-Rahman I al-Dakhil founds the Umayyad Emirate of Córdoba.
145	762	Abu Jafar al-Mansur (r. 136–58/754–75) founds Baghdad, capital of the Abbasids (dynasty ends 656/1258).
160–8	777–84	Abd al-Rahman ibn Rustam founds the Kharijite Dynasty of Tahert in the Central Maghreb, which lasts until 296/909.
170–93	786–809	Caliphate of Harun al-Rashid.
181 and 191	797 and 807	Charlemagne's ambassadors arrive in Baghdad.
173	789	Idris ibn 'Abdallah flees to the Maghreb and founds the city of Fez.
184–97	800–812	Ibrahim ibn Aghlab founds the first dynasty in Ifriqiya: the Aghlabids (dynasty ends 296/909).
185	801	Foundation of al-Abbasiya near to Kairouan.
201–23	817–38	Ziyadat Allah reforms the Kairouan Mosque.
212	827	Conquest of Sicily by Asad ibn al-Furat.

AH	AD	
254–70	868–83	Ahmad ibn Tulun, governor of Egypt, founds the Tulunid Dynasty (ends 293/905) and the mosque that bears his name in the city of al-Qata'i.
263	876	Aghlabid al-Raqqada erected near to Kairouan.
296–363	909–73	The Fatimid Dynasty rules Ifriqiya.
305–8	917–21	Foundation of Mahdiya by 'Abdallah al-Mahdi (r. 297–322/ 909–34).
316	929	'Abd al-Rahman III (r. 300–50/912–61) proclaims himself Caliph of Córdoba.
334–447	945–1055	The Shi'a Dynasty of the Buyids, 'Protectors of the Abbasid Caliphate', establish themselves in Baghdad.
335–6	947	Death of Abu Yazid, leader of the last great Kharijite revolt in the Maghreb.
336	948	Foundation of Al-Mansuriya near to Kairouan.
359	969	General Jawhar al-Siqilli founds Cairo (al-Qahira) for his master al-Mu'izz li-Din Allah.
363	973	Al-Mu'izz leaves Ifriqiya to his Zirid lieutenants and founds the Fatimid Dynasty of Egypt, which lasts until 567/1171.
398	1007	Foundation of al-Qala't by the Bani Hammad, cousins of the Zirids of the Central Maghreb.
399	1009	Destruction of the Church of the Holy Sepulchre in Jerusalem, ordered by the Fatimid Caliph of Egypt al-Hakim (r. 386–411/996–1021).
422	1031	Fall of the Umayyad Caliphate of Córdoba and the birth of the *ta'ifa* kingdoms.
448	1055	Tughril Beg, founder of the Great Seljuq Dynasty, enters Baghdad, ousts the Shi'a Dynasty of the Buyids, restores Sunnism and becomes protector of the Abbasid caliph.
453	1061	Beginning of the Norman conquest of Sicily by Roger of Hauteville.
460	1067	The Bani Hammad found Béjaia (Bougie).
462	1070	Foundation of Marrakesh by the Almoravids.
463	1071	Defeat of the Byzantines at the Battle of Manzikert opens up Asia Minor to the Turks.
468–708	1075–1308	Seljuq Dynasty of Rum (Anatolia), capital Konya.
477	1085	Toledo falls to Alfonso VI of Castile.
478	1086	Victory of the Almoravid Yusuf ibn Tashufin at Zallaqa in al-Andalus. End of the first *ta'ifa* kingdoms.
489	1095	Pope Urban II appeals for a Crusade at the Council of Clermont.
492	1099	Jerusalem occupied by the Crusades. Four Crusader states are founded: the County of Edessa, the Principality of Antioch, the County of Tripoli and the Kingdom of Jerusalem.
524–48	1130–54	King Roger II of Sicily receives the great geographer al-Idrisi, who dedicates *Kitab Ruggar* (The Book of Roger) to him.
540–1	1146	Second Crusade launched following the conquest of Edessa (al-Rouha) by the Atabeg, 'Imad al-Din Zangi.
541	1147	The Almohad 'Abd al-Mu'min takes Marrakesh.
583–7	1188–92	Third Crusade.
583	1187	Saladin, victorious at the Battle of Hittin, takes back Jerusalem from the Francs.

AH	AD	
591	1195	Ya'qub al-Mansur (grandson of 'Abd al-Mu'min) claims victory in Alarcos and takes al-Andalus.
595	1199	Foundation of Ribat al-Fath (Rabat).
601	1204	The Fourth Crusade begins with the conquest of the Byzantine Empire.
612	1212	Almohads defeated at Las Navas de Tolosa (al-'Iqab).
625–47	1228–49	Abu Zakariyya' founds the Hafsid Dynasty in Tunis.
627	1229	Treaty of Jaffa resulting in the Ayyubid, al-Kamil Muhammad al-Malik, surrendering Jerusalem to the Emperor Frederick II without a fight.
629	1232	Muhammad ibn Nasr founds the Nasrid Kingdom of Granada.
642–869	1244–1465	Berber Marinid Dynasty in Morocco.
642–64	1244–65	Seville falls to the Castilians.
646–52	1248–54	Louis IX launches the Seventh Crusade and lands at Damietta. He is taken prisoner and freed for a huge ransom. He stays four more years in Acre to reorganise what is left of the Frankish States.
648	1250	Death of Emperor Frederick II of Hohenstaufen, King of Sicily and King of Jerusalem.
648–784	1250–1382	Shajar al-Durr begins the reign of the Bahri Mamluks in Egypt, Syria and Hijaz.
656	1258	Baghdad is sacked by the Mongol Hulagu Khan. Fall of the Abbasid Caliphate of Baghdad.
659	1260	The Mamluks defeat the Mongols at 'Ayn Jalut in Palestine.
659–76	1260–77	Reign of Sultan Baybars I, who ousts the Crusaders from Syria and Palestine and drives back the Mongols.
669	1270	The Eighth and final Crusade: Louis IX lands at Carthage and dies of dysentery.
679–724	1280–1324	Osman ('Uthman) rules a beylik in north-west Anatolia.
690	1291	Acre taken by the Mamluk Sultan al-Ashraf Khalil, ending the Frankish presence in Syria and Palestine.
726	1326	Bursa is conquered and becomes the Ottoman capital.
734–55	1333–54	The Nasrid Yusuf I founds the Alhambra Palace in Granada.
741	1340	Marinids defeated at Rio Salado.
749–50	1348–9	The Black Death spreads throughout the Mediterranean lands.
751–71	1350–69	Pedro 'the Cruel' crowned king of Castile and Léon.
770	1368	Edirne (ancient Adrianople), conquered in 664/1362 by the Ottomans, becomes the new Ottoman capital.
1st reign: 784–91 2nd reign: 792–801	1382–9 1390–9	Sultan Barquq founds the Circassian (Burji) Mamluk Dynasty (Mamluk Dynasty continues: 784–923/1382–1517).
798	1396	Ottoman victory over a Crusader army in Nicopolis.
804	1401	Damascus sacked by the Mongol conqueror Tamerlane.
805	1402	Battle of Ankara, Bayezid I taken prisoner by Tamerlane.
809	1406	Death of the great historian Ibn Khaldun in Cairo. He was born in Tunis in 733/1332.

AH	AD	
818	1415	The Portuguese reach Ceuta.
823	1420	The Wattasids supplant the Marinids in Morocco.
848	1444	The Ottomans defeat the Hungarians at Varna.
856	1453	Constantinople taken by the Ottoman Mehmet II *al-Fatih* (the Conqueror).
876	1471	The Portuguese reach Tangiers.
897	1492	Granada falls to the Catholic Kings. The Catholic Kings oblige Jews to convert to Christianity (thus becoming *conversos*) or force them into exile.
901	1496	Jews and Muslims expelled from Portugal.
906	1500	The Portuguese reach Agadir.
3 *Sha'ban* 907	11 February 1502	The Catholic Kings oblige Muslims to convert to Christianity (thus becoming *Moriscos*) or force them into exile.
915	1509	The Spanish take Oran.
921	1516	Victory at Marj Dabiq: the Ottomans conquer Syria.
922	1516	Algiers taken by the Ottoman privateer Aruj.
923	1517	Mamluk Egypt conquered by Sultan Selim I.
926	1520	Accession of Sülayman the Magnificent (d. 974/1566).
927	1521	The Ottomans reach Belgrade.
935	1529	First Siege of Vienna. Khayr al-Din Barbarossa, brother of Aruj, takes control of Algiers.
942	1536	The Capitulations are signed by the Turks and Francis I.
942	1536	Tunis is taken by Charles V.
956–1069	1549–1659	The Sa'did Dynasty rules Morocco.
979	1571	The Turkish navy is defeated at Lepanto by the Spanish and Venetians.
982	1574	The Turks seize Ifriqiya, permanently ousting the Hafsids and the Spanish.
986	1578	Battle of the Three Kings at Wadi Al-makhazin (Morocco). Defeat of the Portuguese.
995–6	1587	Creation of the Ottoman *beyliks* of Algiers, Tunis and Tripoli. Ifriqiya becomes the Regency of Tunis.
1018	1609	King Philipp III orders by Royal decree the expulsion of the *Moriscos* (Muslims forced to convert to Christianity) from Spanish territories.
1021–1114	1612–1702	The Muradite Bey Dynasty rules Tunis.
1068	1657	Death of Katip Çelebi (1018–68/1609–57), the great Turkish geographer.
1076	1666	Mulay al-Rashid founds the 'Alawid Dynasty (still in existence).
1078	1669	Ottoman conquest of Crete.
1117–1377/	1705–1957	The Husaynid Bey Dynasty rules Tunis.
1183	1769	The Portuguese are ousted from Mazagan (Morocco).
1212–15	1798–1801	Napoleon's expedition to Egypt.

AH	AD	
1220–65	1805–48	Muhammad 'Ali governor of Egypt.
1223–55	1808–1839	Reign of Sultan Mahmud II, start of the Ottoman reforms (Tanzimat Ferman).
1237	1821	Printing works open in Cairo.
1245	1829	Treaty of Adrianople: autonomous rule for Greece, Moldavia and Wallachia.
1246	1830	French colonisation of Algeria. Greek Independence.
1255	1839	Accession of Sultan 'Abd al-Majid (d. 1278/1861).
1257	1841	Abolition of slavery in Tunisia.
1264	1848	Surrender of 'Abd al-Kader in Algeria.
1273	1856	*Khatt-i humayun*: Declaration of Universal Civil Rights given by the Ottoman Sultan.
1274	1857	The Fundamental Pact. The reformist minister, Khayr al-Din and the reformer and historian, Ibn Abi Dhiyaf are active (Tunisia).
1286	1869	Inauguration of the Suez Canal built by Ferdinand de Lesseps.
1293	1876	Accession of Sultan 'Abd al-Hamid II (abdicated in 1327/1909).
1295	1878	The fate of a number of regions in the Ottoman Empire, including Tunisia, is determined at the Congress of Berlin.
1299	1881	French protectorate in Tunisia: Treaty of Bardo.
1325	1907	Foundation of Cairo University.
1326	1908	The Young Turks revolt and overthrow the sultan (abdicates 1327/1909).
1326	1908	Bulgarian independence.
1331	1912	French Protectorate in Morocco.
1333–7	1914–18	Assassination of Archduke Franz Ferdinand in Sarajevo. World War I starts. Egypt under British protectorate (military occupation until 1936).
1333	1914	Russia, Great Britain and France at war with the Ottoman Empire.
1335	1916	Sykes-Picot Agreement on the Near East. Arab revolt against the Ottomans led by Hussein, Sharif of Mecca.
1338	1920	Treaty of Sèvres.
4 *Sha'ban* 1338	23 April 1920	The Turkish National Assembly is established and, on 24 April, Mustafa Kemal (Atatürk) is elected as its President.
1339	1920	French mandate in Syria (–1941) and Lebanon (–1943).
1341	1922	End of the Ottoman Empire. Egyptian independence.

Introduction

Islamic Art in Museums – Ambassadors of a Civilisation

Mohamed Abbas, Mohammad Najjar, Barry Wood

From Spain to Syria, from Turkey to Tunisia, the arts of the Islamic Mediterranean exhibit a wonderful and ingenious variety. Placed in a museum setting, these works, no matter how humble, serve in a sense as ambassadors representing peoples past whose voice the museum-goer is encouraged to hear: this is how we lived; this is what we created to adorn our world. Yet taken individually, the communicative potential of each object, even on display in an exhibition, faces certain necessary limitations: the number of objects that can be shown in a given museum; the expertise of the curators; the space allotted for labels, and so forth.

Now, with the Discover Islamic Art project, an astonishing range of Islamic artworks has been brought together in an unprecedented collaboration which integrates them into a single great 'museum with no frontiers'. The Museum presents 850 artefacts from 42 museums, and 385 monuments and sites from 11 countries brought together as one interrelated corpus for the enlightenment of the interested viewer. Widely dispersed objects which were once closely related, as well as objects originally made in conjunction with a particular monument, can now be considered together, with the guidance of experts from the countries in question. This enables the objects to speak on behalf of their creators and consumers with a unified and newly powerful voice. What they have to say helps to give us a new and vital perspective on the history and culture of the Mediterranean region.

It is important to realise, for example, that the deepest roots of Islamic art lie in the art of the late Antique Mediterranean, and that such quintessentially 'Islamic' motifs as the arabesque descend ultimately from late Roman decoration. Understanding this reveals, perhaps unexpectedly, the closeness of the relation between Islamic and Western art. Yet it is also true that Islamic art was not simply a continuation of late Roman art, but a creative synthesis of selected forms put to use in new ways and for new social and ideological purposes. Over the centuries these forms evolved with the civilisations that produced them, resulting in the great spectrum of decorative ingenuity that we admire in museums today.

It is crucial, too, to emphasise the fact that 'Islamic' art is the art not of a religion, but of a culture. Islamic art from the beginning was never a religious art. Nor was it the art solely of Muslims. The term 'Islamic', in the context of art, refers not to the faith of Islam but to the culture of Islam at certain historical periods. As a cultural phenomenon it was created and developed by Muslims and non-Muslims, and its cultural products were consumed and enjoyed by communities both within and beyond the borders of the Muslim world.

Indeed, over the centuries the artistic standards and techniques developed in the art of the Islamic Mediterranean proved eminently portable across cultural boundaries. This can be seen in the enthusiasm with which Medieval and early Modern Europeans received crafts from their Muslim neighbours, both as luxury objects and as inspiration for their own designs. Fatimid rock-crystal vessels were converted into reliquaries and preserved in church treasuries; Nasrid silks were hung as backdrops for sculptures; Ottoman carpets were immortalised as a symbol of opulence in paintings by masters such as Hans Holbein. The sheer vitality of the cross-Mediterranean art trade over the centuries is a telling reminder of the close links between Europe and the Islamic Mediterranean.

The value of Islamic art as a means of understanding Mediterranean history, both Western and Islamic, is clearly profound. These works of elegance and beauty are also tangible evidence of the ties that have long bound the countries of the Euro-Mediterranean cultural sphere. They thus offer not only aesthetic enjoyment, but also a fresh appreciation of the peoples and cultures of our common region.

FACING PAGE
Mosque lamp

Ottoman, about AH 740/AD 340
Victoria and Albert Museum
London, United Kingdom

The Mediterranean Prior to the Islamic Expansion

Aicha Benabed

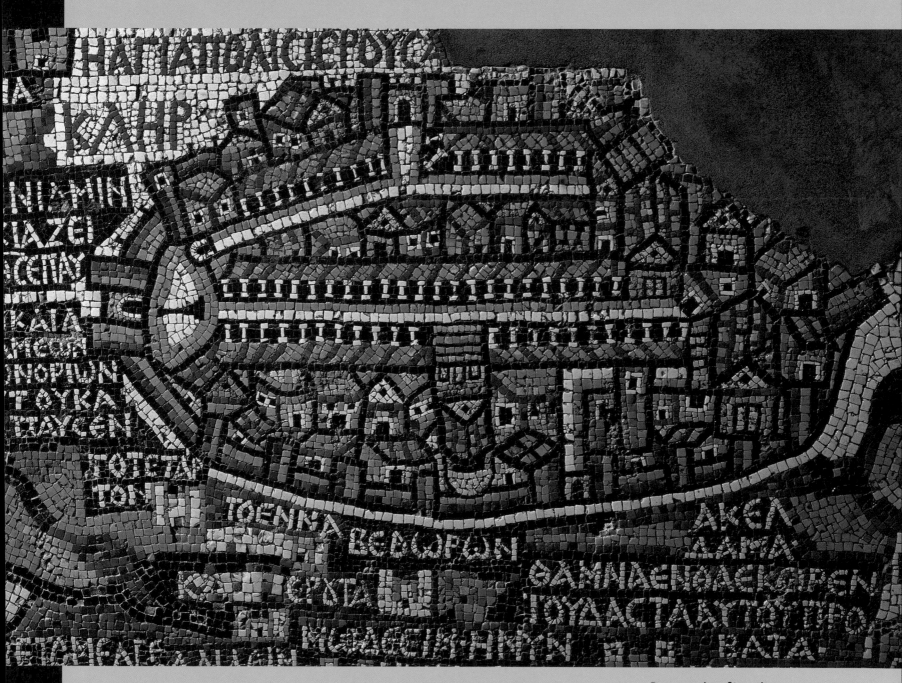

Representation of Jerusalem
Mosaic at the Church of St George

6th century AD
Madaba, Jordan

The political and military landscape of the Mediterranean basin underwent a number of profound and long-lasting changes following the great crisis suffered by the Roman Empire and its fringes in the mid-3rd century and under pressure from the Barbarian tribes. These structural changes were reinforced in 324 when Emperor Constantine renamed Byzantium Constantinople, thereby revealing his desire to balance the empire by establishing a second, Eastern, centre of gravity.

The 4th century is also seen as an age of reconstruction with a new state religion – Christianity – adopted during the reign of Constantine. He promulgated the Edict of Milan in 313, restoring previously confiscated property back to the Church and affording it absolute freedom of religion, making Christianity the religion of the Roman Empire (Edict of Thessalonica in 380). Nonetheless, the Christianisation of the entire Mediterranean basin did not bring about the end of paganism; indeed Julian the Apostate (331–63) declared that it would be tolerated, thus hoping to weaken the already Christianised ruling classes. Paganism would never be entirely eradicated, surviving for many years in cultural references, as can be seen in the

Hagia Sophia
Built by Byzantine Emperor Justinian
and later transformed into a mosque.

Byzantine, AD *537*
Istanbul, Turkey

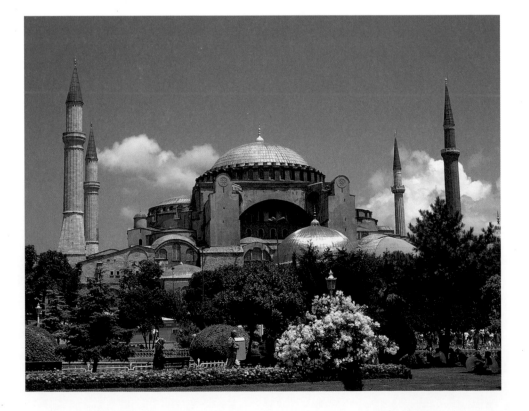

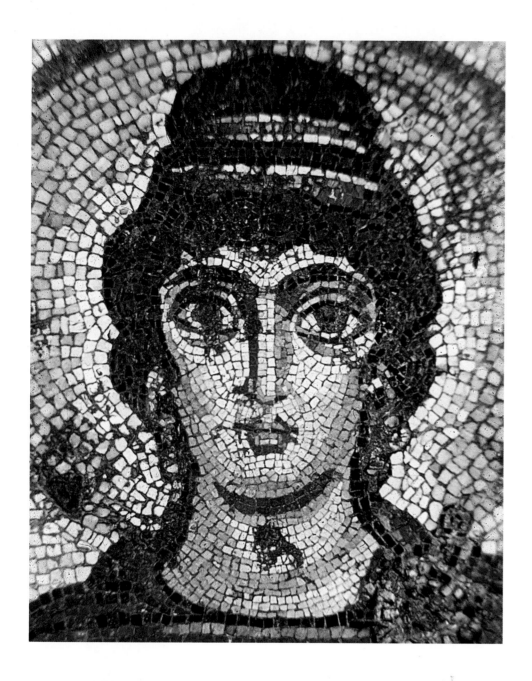

Woman from Carthage (mosaic)

6th century AD
Bardo Museum
Tunis, Tunisia

The ancient city of Carthage

6th century AD
Near Tunis, Tunisia

mythological themes of mosaics found in Syria and central Tunisia dating back to the 6th or even the 7th centuries.

Throughout the 4th century, the fathers of the Church drew up a Christian doctrine and tried to establish its rules. The challenge was a considerable one, encompassing the organisation both of the community of believers and the Church's property. In 381, the Council of Constantinople decided to make Constantinople the second Episcopal town after Rome, while Jerusalem was reduced to playing a pre-eminent spiritual role. From then on the Christian faith, based on a single God, enabled real unity in the empire, which was just what the politicians needed.

The 5th century saw the Roman Empire reorganise around two centres with Rome in the West and Constantinople in the East acting as twin capitals

Decorated pillar

Umayyads of al-Andalus,
AH *3rd–4th/*AD *9th–10th centuries*
Carmo Museum of Archaeology
Lisbon, Portugal

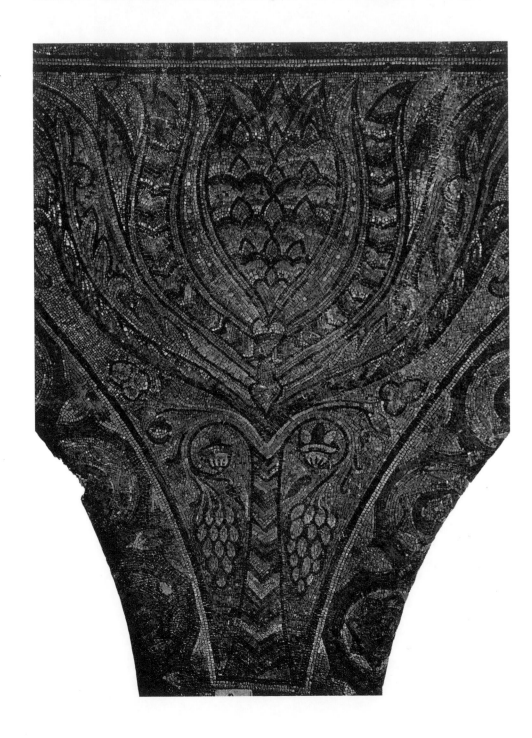

Dome of the Rock
Interior decoration (detail).

Umayyad, AH *72/*AD *691*
Jerusalem

from the reign of Theodosius's two sons, Arcadius and Honorius, in the late 4th century. The same century also saw the conquest of the great capitals by Barbarian tribes, a particularly difficult episode in the Mediterranean basin that unquestionably shaped the empire as it moved towards the Middle Ages.

The most significant event is undoubtedly the sack of Rome by Alaric the Goth in 410. For three days, Urbs, the Eternal City, was put to fire and the sword by Gothic soldiers, destroying the myth of the invincibility of Rome and marking the inexorable end of an era. The fall of Rome shook the ancient world, with Spain and then Carthage falling to the Vandals in 439. West of the Mediterranean basin was greatly weakened; the centre of the empire shifted to the East and Constantinople became the capital of the empire. This meant that the Eastern Mediterranean was ruled from Asia Minor and the Middle

The Good Shepherd
Mosaic at the Mausoleum
of Galla Placidia.

Byzantine, AD 425–30
Ravenna, Italy

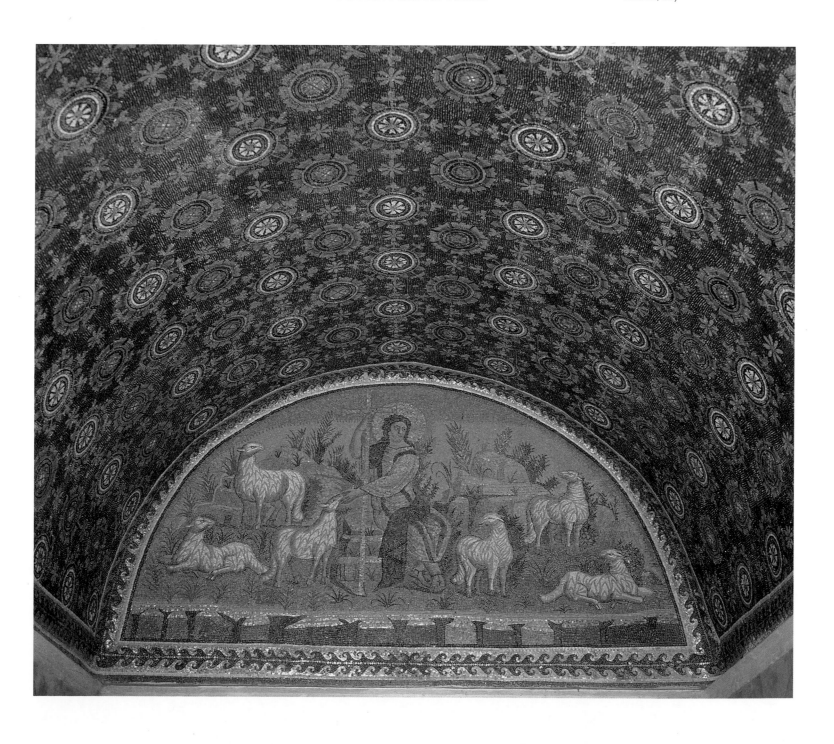

East and, while the Roman West dealt with the invaders as best it could, the Eastern Empire enjoyed a period of relative prosperity under the auspices of a strong central power.

In these contrasting geopolitical times, the triumphant Christians experienced a long period of fervent activity, both in the East and in the West. Theology became the arena in which all of the latent conflicts and trends of ancient society could be voiced and, as a result, the 5th century saw the beginning of the ruthless struggle in the East between the Monophysites, who believed in the exclusively divine nature of Christ, and the Nestorians, who also recognised Christ's human nature. Despite the efforts of the political powers to find a compromise between these two factions, both doctrines survived to well after the Arab conquest.

In North Africa, this conflict took the form of a schism, Donatism, named after the bishop Donatus Magnum. This schism, which divided the Church in North Africa for a century, was based on the rigourism of those who refused to pardon Christians who had renounced their faith under persecution. Donatism quickly took on a social dimension of significant interest to historians. With the arrival of the Vandals, Arian Christian heretics (Arianism teaches that the Son is similar but not identical in nature to the Father and the Holy Spirit, and was declared heretical by the Councils of Nicea and then Constantinople in 381), gave rise to a conflict with the Catholics, who were persecuted and had their property seized systematically after the occupation of Carthage. Although the Vandals exerted their religious differences they nonetheless adopted the lifestyle of the profoundly Romanised North African aristocrats, endeavouring to identify with their luxury and their surroundings, to the detriment of their warrior ideals.

BELOW RIGHT
Mosaic from Ma'in
Detail from a panel damaged by iconoclasts. A tail, two paws, and two horns are still discernable, while the greater part of the imagery was replaced by a bush and a jar.

Umayyad, AH 100–101/AD 719–20
Archaeological Park of Madaba
Madaba, Jordan

Floor mosaic (detail)
Depiction of Kastron Mefaa (today's Umm al-Rasas) at the Church of St Stephen.

Umayyad, Abbasid, AH 99–138/AD 718–56
Umm al-Rasas, Jordan

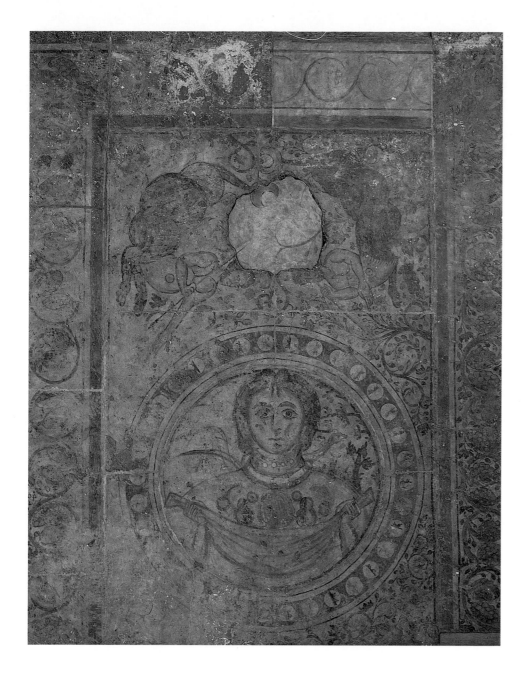

**Floor painting at Qasr
al-Hayr al-Gharbi**
The painting is thought to represent
Gaea, the mother-goddess of Roman
mythology.

Umayyad, AH 109/AD 727
National Museum
Damascus, Syria

Mosaic with Greek inscription
At the Church of the Virgin Mary.

*Byzantine, Umayyad, Abbasid,
6th–7th centuries* AD; *renovated in*
AH 149/AD 767
Madaba, Jordan

Evidence of the existence of Judaism in late Antiquity is mostly literary and archaeological. Literary proof can be found in rabbinical texts and references to Judaism in Greek, Roman and Syriac literature. Archaeological evidence consists mainly of the remains of synagogues, necropolises and catacombs, as well as inscriptions. The main Jewish communities lived in the large Eastern cities.

Throughout the 6th century, the Byzantine Empire worked tirelessly to reconquer the western part of the empire, and it is in this context that the Reconquest of Carthage in 533 by the Byzantine general, Belisarius, is seen as a great victory of historical legitimacy over the Vandal usurpers. Later, between 535 and 540, Justinian's army took back part of Italy from the Ostrogoths and even managed to reconquer part of Visigoth Spain. This Byzantine Reconquest was part of a greater project to re-establish the Roman Empire, with the Byzantine Empire aspiring to be its legitimate heir and successor.

In all the reconquered cities, the victory of 'legitimacy' and a return to origins was accompanied by an extensive drive to erect Christian cultural monuments, whose size and luxurious decoration, in particular their mosaics, contrasted with the existing monumental landscape. On a number of occasions, archaeologists have noted evidence of a marked desire to raze buildings that predated the Reconquest in order to build prestigious ecclesiastical complexes in homage to the conquerors.

This monumentality, together with the richness of the religious architecture of the 6th century, contrasts sharply with the poverty and state of abandon of ordinary homes and civic buildings, many cities in the Maghreb of the 6th and 7th centuries being extreme examples of this. Only the churches exalted the victory of the Byzantine emperors, protectors of Christianity. Public monuments such as forums and baths, when not abandoned or used as fortifications, were given over to craftsmen such as fullers and oil producers. Necropolises, which had previously been located outside city walls, were moved into the urban centres.

Visible signs of the poverty that gripped late Antique society are evidence of the profound economic and social crisis that crippled the towns. The

Umayyad Mosque
Mosaic on the façade.

Umayyad, AH 87–96/AD 706–15
Damascus, Syria

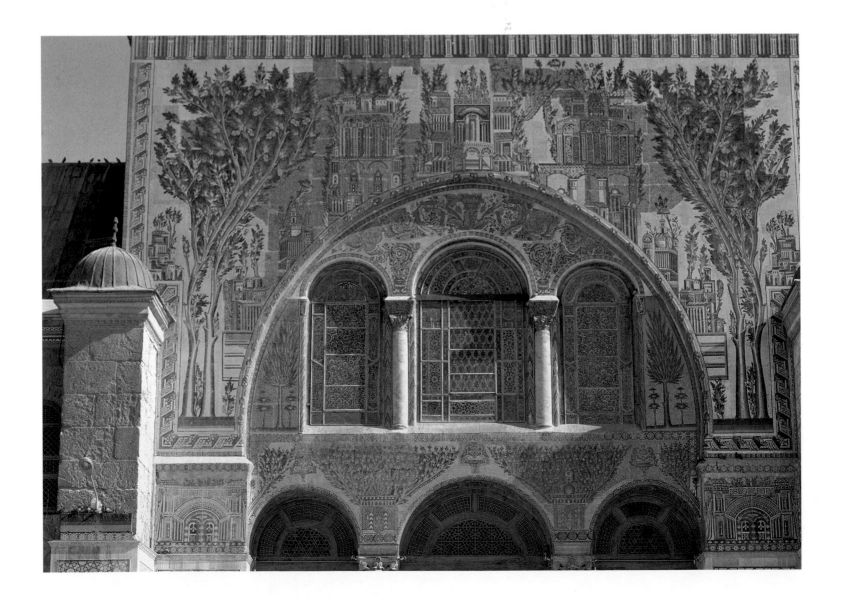

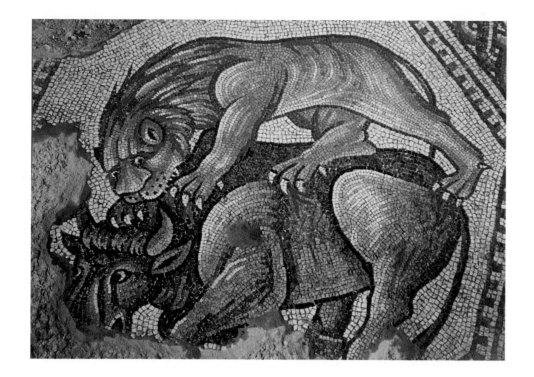

Floor mosaic (detail)
A lion attacking a bull

Umayyad, AH *2nd century/*AD *8th century*
Al-Qastal, Jordan

**Mosaic of Empress Theodora,
the wife of Justinian I**
At the Basilica of San Vitale

Byzantine, AD *527–48*
Ravenna, Italy

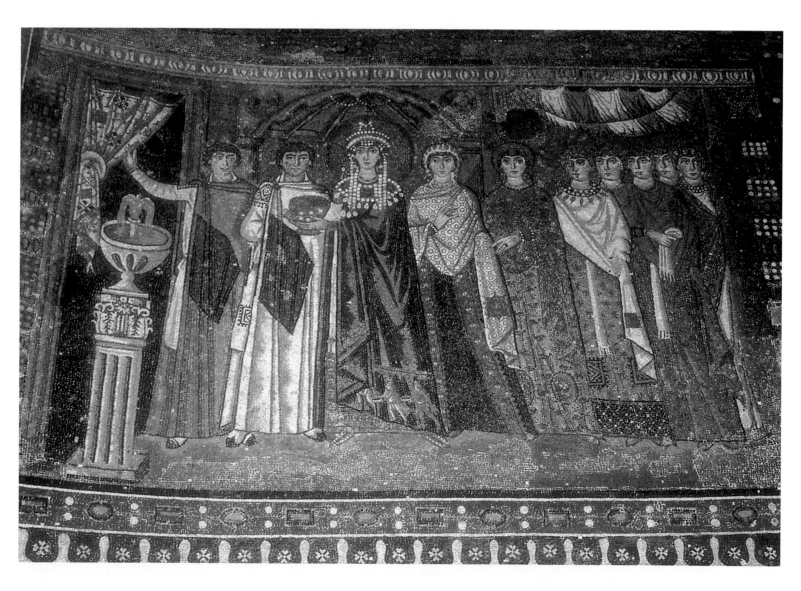

Byzantine Reconquest of the West felt like a turning of the tide, but in reality the Byzantine Empire did not have the means to realise its ambitions. Too far from these western regions, the central power in Constantinople found it increasingly difficult to quell the conflicts and revolts growing exponentially in the different provinces of the empire, and when the conquering Islamic armies arrived with their new message the people, tired of their wretched existence, rarely put up more than token resistance and allowed themselves to be won over by a new hope.

PERSONALITIES

Constantine I Roman Emperor (r. 306–37) played a determining role in the evolution of the Roman Empire in Late Antiquity. It was during his reign that Christianity was officially accepted (Edict of Milan, 313).

Julian the Apostate (Flavius Claudius Julianus) reigned over the Roman Empire from 361 to 363 and is one of the most controversial emperors ever. He is famous for his religious policies that abolished Christianity as the religion of the state and encouraged a return to paganism.

Theodosius the Great (Flavius Theodosius) was Roman Emperor from 379 to 395; under his rule Christianity became the official religion of state with the Edict of Thessalonica (380). After his death the Roman Empire was divided between his sons **Arcadius** (Eastern Empire) and **Honorius** (Western Empire).

Alaric, King of the Visigoths, at first successfully laid siege to Rome in 410; shortly after he hatched a plan to send in his men who sacked it over several days.

The Prophet and the Rightly Guided Caliphs

Muhammad al-Asad and Claus-Peter Haase

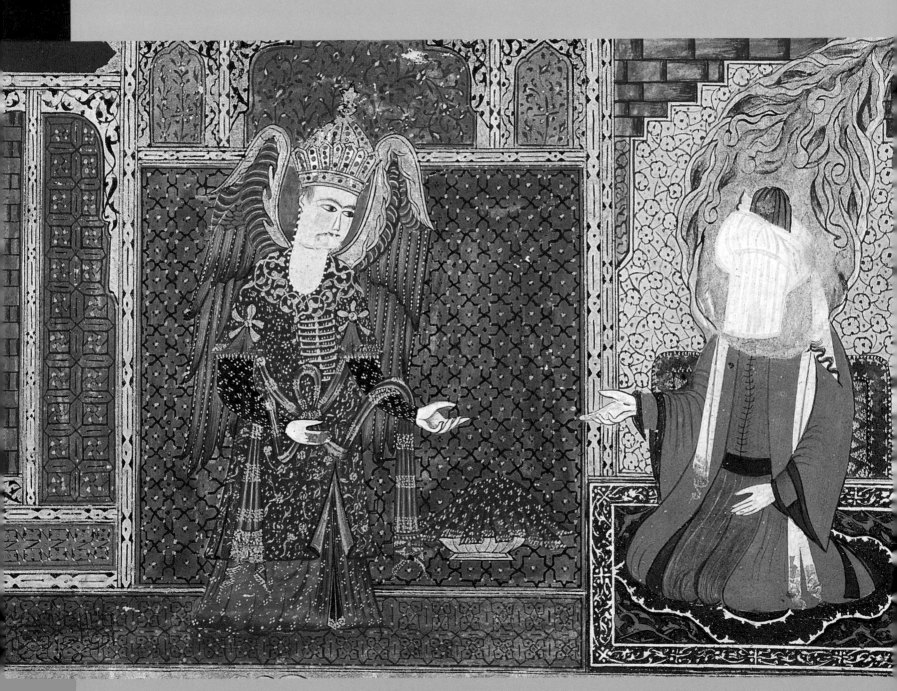

***Siyar-i Nebi* (Biography of the Prophet)**
The Prophet Muhammad talking to the
Archangel Gabriel.

Ottoman, AH mid-11th/AD mid-17th century
Museum of Turkish and Islamic Arts
Istanbul, Turkey

The religion of Islam was born in around AD 610 in Mecca, a city located in the region of the Hijaz in the western part of the Arabian Peninsula. Here, according to Islamic tradition, for a period of more than 23 years the Prophet Muhammad received the Revelation of God through the Archangel Gabriel. Initially, only a very small group followed Muhammad and the Meccans persecuted them. This was partly because they greatly benefited from the city's position as the centre of Arabian paganism, and looked at Muhammad's message of the Unity of God as a threat to their way of life and to their economic interests.

The people of Medina (Madina), located about 400 km northeast of Mecca, were the first sizable group to accept the Prophet and the religion of Islam. The city was suffering from feuds between its two main Arab tribes, the Aws and the Khazraj, and its inhabitants saw the Prophet as a man of discipline, power, integrity and spirituality who would bring unity to their city. Consequently, they

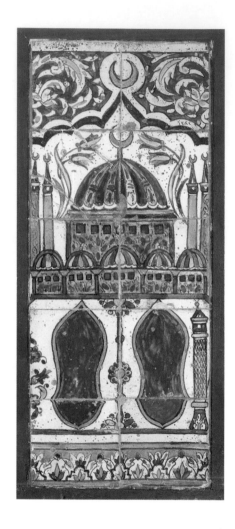

Ceramic tile panel from the Haram al-Sharif
Depiction of a mosque and the footprints of Muhammad.

Ottoman, AH 12th/AD 18th century
Museum of Islamic Art
Cairo, Egypt

Plan of the Mosque of Prophet Muhammad
Built AH 91/AD 710 on the site of the Prophet's courtyard house.

Medina (Madina), Saudi Arabia

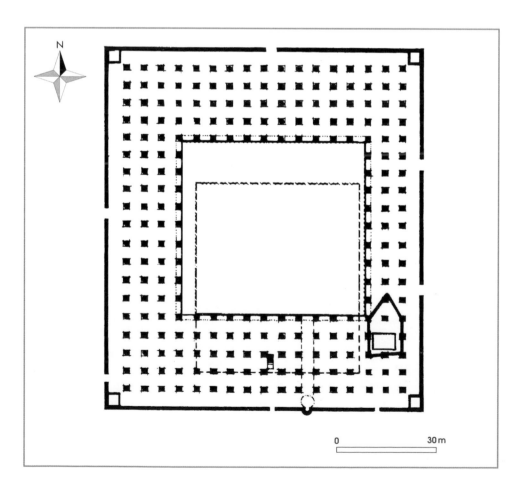

0 30 m

accepted Muhammad as their spiritual and political leader, and invited him to move there from Mecca. The move, which took place in AH 1/AD 622, is known as the *Hijra* (migration), and marks the beginning of the Muslim calendar. Little was it known that out of this small city state and under the banner of the new religion of Islam one of the greatest military, political and cultural forces of history would emerge.

From Medina, the Prophet and his followers were able to spread the word of Islam throughout the Arabian Peninsula. In 9/630, he entered his hometown of Mecca as a victorious conqueror and, by the time of his death in 11/632, the whole Arabian Peninsula had come under the rule of Islam.

Muhammad's courtyard house in Medina became the primordial praying space, indicating the direction of prayer (*qibla*) towards the *Ka'ba* in Mecca, and his pulpit (*minbar*) to its right locating the place of the Friday sermon. Between 89/706 and 92/710, during the Umayyad period (41–133/661–750), a courtyard mosque, with its roof on columns and a prayer niche was erected in its place.

Prayer book
Depictions of Mecca and Medina (Madina).

Ottoman, AH 12th/AD 18th century
Museum of Mediterranean and Near Eastern Antiquities
Stockholm, Sweden

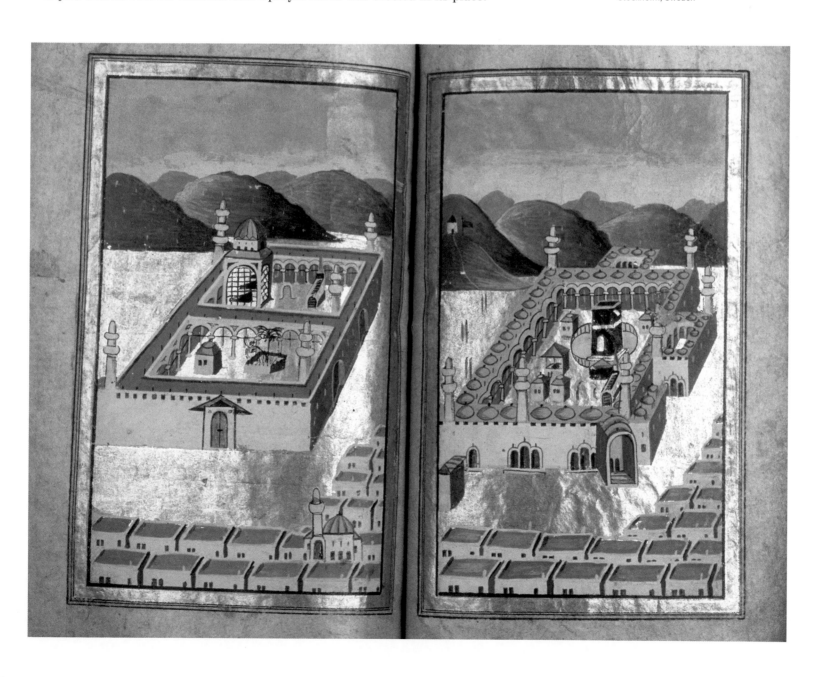

The Rightly Guided Caliphs

With the death of the Prophet, the issue of selecting a successor to lead the Muslim community needed to be resolved. A number of his companions nominated Abu Bakr, the Prophet's oldest and most trustworthy companion, as Islam's first caliph or successor. As caliph he was known both for his gentleness and modesty and proved to be a very effective leader. Some Arabian tribes had renounced their allegiance to Islam following the death of the Prophet, but Abu Bakr was able to impose authority on these tribes, thus preventing the early disintegration of the Islamic state. Moreover, during his two years in power, Muslim forces began advancing into the Syrian territories of the Byzantine Empire and the Iraqi territories of the Sassanian Empire. Before his death in 13/634, Abu Bakr nominated 'Umar ibn al-Khattab, another companion of the Prophet, to succeed him; the leaders of the Muslim community in Medina unanimously accepted 'Umar's nomination.

Islamic city of al-Ayla
City gate leading to the *suq* and the central pavilion.

Islamic, pre-Umayyad, AH *1st/* AD *mid-7th century*
Aqaba, Jordan

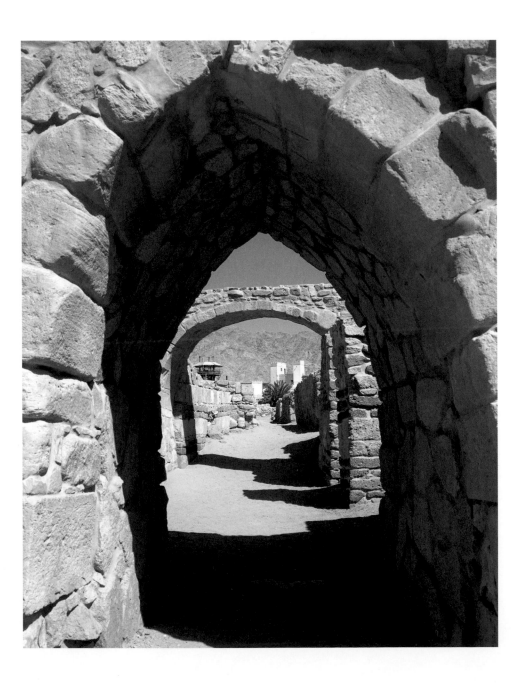

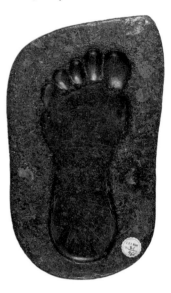

Qur'an
Caliph 'Uthman was said to have
been reading this Qur'an when he
was assassinated in AH 35/AD 656.

Topkapı Palace Museum (Pavilion of the
Holy Mantle and the Holy Relics)
Istanbul, Turkey

**Prophet Muhammad's footprint
on green porphyry**

Topkapı Palace Museum (Pavilion of the
Holy Mantle and the Holy Relics)
Istanbul, Turkey

'Umar, who proved to be a most competent ruler, was known for his piety,
simplicity and sense of justice. During his 10-year rule, the process of Muslim
expansion outside Arabia continued. The conquest of Iran was started, and,
with the loss of Syria and Egypt to the advancing Muslims, the Byzantine
Empire was greatly weakened. Moreover, 'Umar laid the foundations for an
effective administrative system that allowed the Arab Muslims to rule the
highly sophisticated societies that came under their rule. Through this
system, the Zoroastrian, Jewish and Christian members of these societies
were granted considerable freedom in running their own affairs, but were
expected to pay a yearly poll-tax to the Muslim treasury. In fact, the transfer
of authority from Byzantine and Sassanian to Muslim rule was, generally
speaking, a smooth one.

'Umar was assassinated in 24/644, and 'Uthman ibn 'Affan, a companion
and son-in-law of the Prophet, was elected caliph by a council of leaders of
the community (*shura*). During his 12-year rule, the Sassanian Empire was
wiped out, and Muslim conquests into Byzantine territories proceeded with
strength. 'Uthman was known for his mild manners and piety, but was unable
to maintain unity among the Arab-Muslim elite. Some of them accused him of

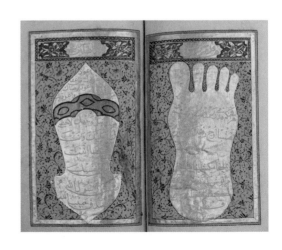

Prayer book
Depictions of a footprint and
sandal of the Prophet.

Ottoman, AH 12th/AD 18th century
Museum of Mediterranean and
Near Eastern Antiquities
Stockholm, Sweden

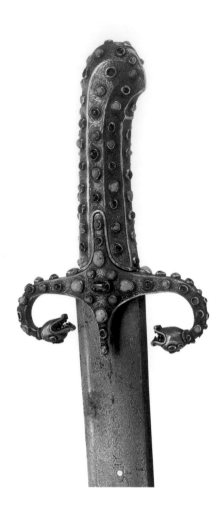

Prophet Muhammad's sword
The handle is decorated with rubies
and turquoise with gold mounts.

Topkapı Palace Museum (Pavilion of the
Holy Mantle and the Holy Relics)
Istanbul, Turkey

patronage of his kinsmen, and the tensions that arose around his rule eventually led to his murder in 36/656. His main achievement was the redaction of the authenticated text of the Qur'an, copies of which, moreover, were distributed to all the various provinces of the Muslim Empire.

'Ali ibn Abi Talib was elected to succeed 'Uthman. 'Ali was a highly esteemed, pious Muslim who was also the cousin and son-in-law of the Prophet. As such, he had been favoured as the direct successor to the Prophet by a minority of Muslims, who came to be known as the Shi'ites (Shi'at 'Ali). However, as had been the case with 'Uthman, there were tensions among the Arab-Muslim elite which continued throughout his rule. His political rivals attacked him for not punishing those responsible for the murder of 'Uthman, a number of them openly disputing his caliphate.

The most serious challenge to 'Ali's authority came from Mu'awiya ibn Abi Sufyan, the governor of Syria and a member of the Umayyad family, a rich Meccan family to which 'Uthman had once belonged. In 37/657 they met in battle at Siffin along the Euphrates, which ended in stalemate. The struggle ended only with the assassination of 'Ali in 41/661 by a member of the Kharijite movement, a puritanical and highly militant religious Muslim sect that opposed both 'Ali and Mu'awiya. 'Ali's oldest son, Hasan, half-heartedly accepted nomination as caliph, and Mu'awiya also was proclaimed caliph. Mu'awiya reached an agreement with Hasan to acquiescently surrender the title of caliph, and Mu'awiya was proclaimed sole caliph in a ceremony in Jerusalem in 41/661. Mu'awiya chose Damascus as his capital ('Ali had moved the capital of the Muslim state from Medina to Kufa in southern Iraq) and consequently, the Umayyad Dynasty was born.

Muslims regard the rules of the four Rightly Guided or Orthodox Caliphs, Abu Bakr, 'Umar, 'Uthman and 'Ali, as the Golden Age of Islam. They were all companions of the Prophet and each of them was known for his piety. Also, they were all elected to their positions by the leaders of the Muslim community. On the other hand, Mu'awiya did not convert to Islam until the conquest of Mecca in 9/630, and he reduced the electoral system established under the Orthodox Caliphs, which to a certain degree showed democratic tendencies, to one based on hereditary succession. The vast Islamic Empire and the Muslim community benefited from a new administrative organisation which brought together under one patronage the immense social, cultural, and artistic tendencies from many different traditions.

The Umayyads: Damascus, the First Capital

Ghazi Bisheh

Bathing scene
Fresco at Qusayr 'Amra.

Umayyad, AH beginning 2nd/AD second quarter 8th century
Azraq, Jordan

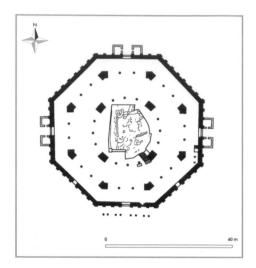

Plan of the Dome of the Rock

Umayyad, AH 72/AD 691
Jerusalem

The elective caliphate of the so-called Rightly Guided Caliphs lasted for nearly 30 years from the death of the Prophet Muhammad and the accession of Abu Bakr in AH 11/AD 632, to the murder of 'Ali ibn Abi Talib and recognition of the undisputed caliph, Mu'awiya ibn Abi Sufyan, in 41/661. Before this, however, Mu'awiya who belonged to a branch of the Quraysh – the tribe of the Prophet Muhammad in Mecca – was governor of Syria for 20 years without interruption, thus gaining the opportunity to build up his power base in the province. We are told that when the second Orthodox Caliph 'Umar ibn al-Khattab (r. 13–23/634–44) visited him in Syria, Mu'awiya received him at the head of a procession surrounded by guards; this did not please the austere caliph who rebuked Mu'awiya for behaving in the manner of Khusraw, the Sassanian emperor. Mu'awiya's answer was that the Byzantine enemy had spies in Syria and that it was important, therefore, for the Arab ruler to appear like the Byzantine emperor. The situation on Mu'awiya's accession presented many difficulties; for example, the administration of the emerging political entity was in disorder, and the question of succession had not yet

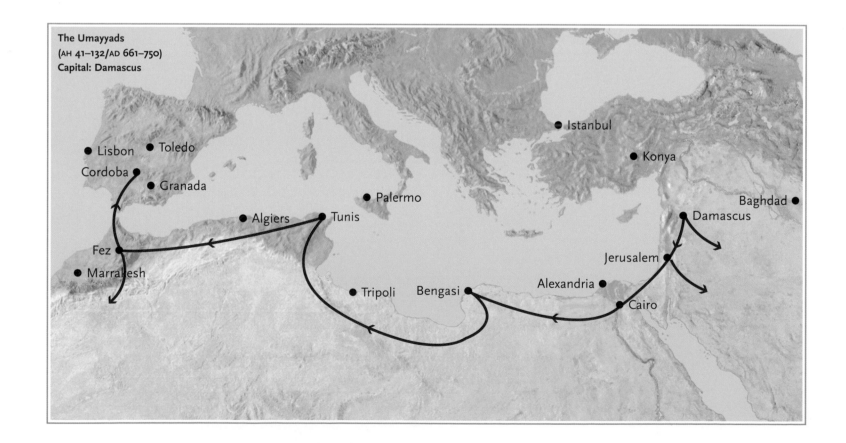

The Umayyads
(AH 41–132/AD 661–750)
Capital: Damascus

been resolved. To overcome these difficulties, Mu'awiya undertook several steps. He first transferred the seat of government to Syria, with Damascus as the capital. His second step was directed at solving the acute problem of succession; to that end he nominated his son, Yazid, as successor designate and persuaded the Arab notables to accept this decision. In this way, Mu'awiya initiated a process by which the caliphate became hereditary within a single family. Later, however, historians and chroniclers would accuse him of having transformed the caliphate into a kingship (*mulk*). The sources add that Mu'awiya used to walk with a spear in his hand and sit on a throne (*sarir*) with the people at his feet. These reports, however, are probably anachronistic, for although these elements are Umayyad innovations, they date from later periods. Other accounts indicate that Mu'awiya's rule was benign and informal, and did not have the trappings of the later Umayyad

Dome of the Rock

Umayyad, AH 72/AD 691
Jerusalem

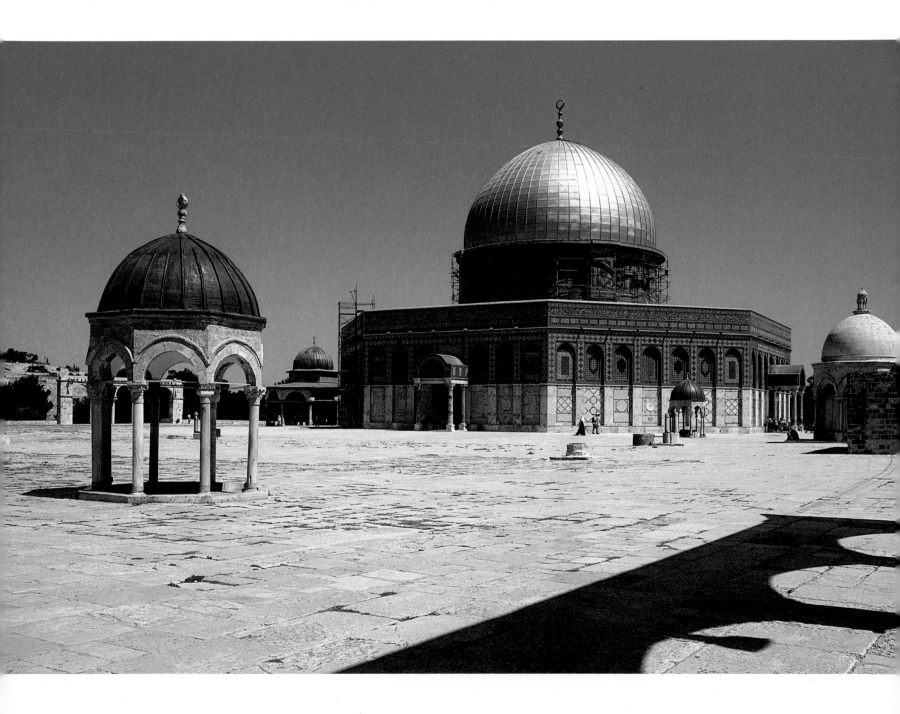

period. The decade which followed the death of Mu'awiya in 60/680 was spent in overcoming rival claimants to the caliphate and counteracting the secessionist tendencies of several provinces such as Iraq and the Hijaz.

In Syria itself, open conflict broke out between the pro-Umayyad Yemeni (South Arabian) tribes and the anti-Umayyad Qaysi (North Arabian) tribes which ended in victory for the Umayyad supporters. The elderly Marwan ibn al-Hakam (r. 64–5/684–5), a member of another branch of the Umayyad house, was now proclaimed caliph with effective control of Syria and Egypt. Before his death he succeeded in arranging the succession of his son 'Abd al-Malik ibn Marwan (r. 65–86/685–705). In the early years of his reign 'Abd al-Malik was occupied with restoring order and settling the affairs of the dynasty. These tasks were accomplished with such great success that he is justifiably regarded as the second founder of the Umayyad Dynasty.

Dome of the Rock
Interior decoration below the cupola (detail).

Umayyad, AH 72/AD 691
Jerusalem

Dome of the Rock
Interior view.

Umayyad, AH 72/AD 691
Jerusalem

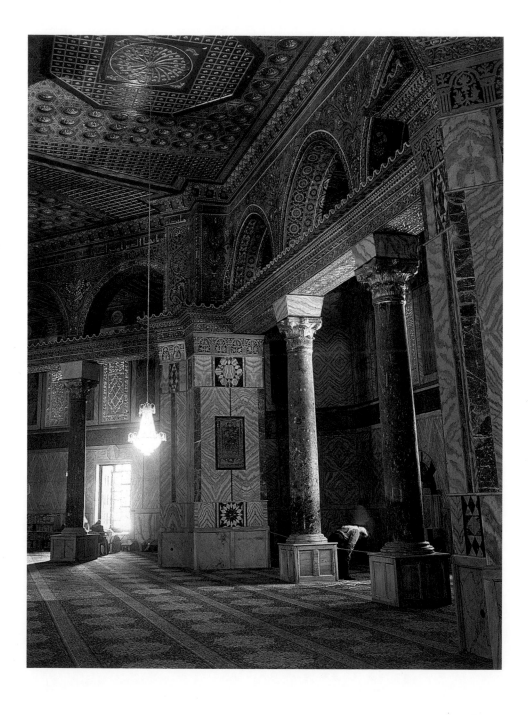

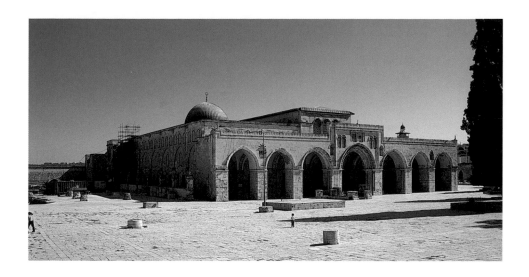

The Aqsa Mosque

Umayyad, AH 65–96/AD 685–715;
various renovations subsequently
Jerusalem

Umayyad Mosque

Umayyad, AH 87–96/AD 706–715
Damascus, Syria

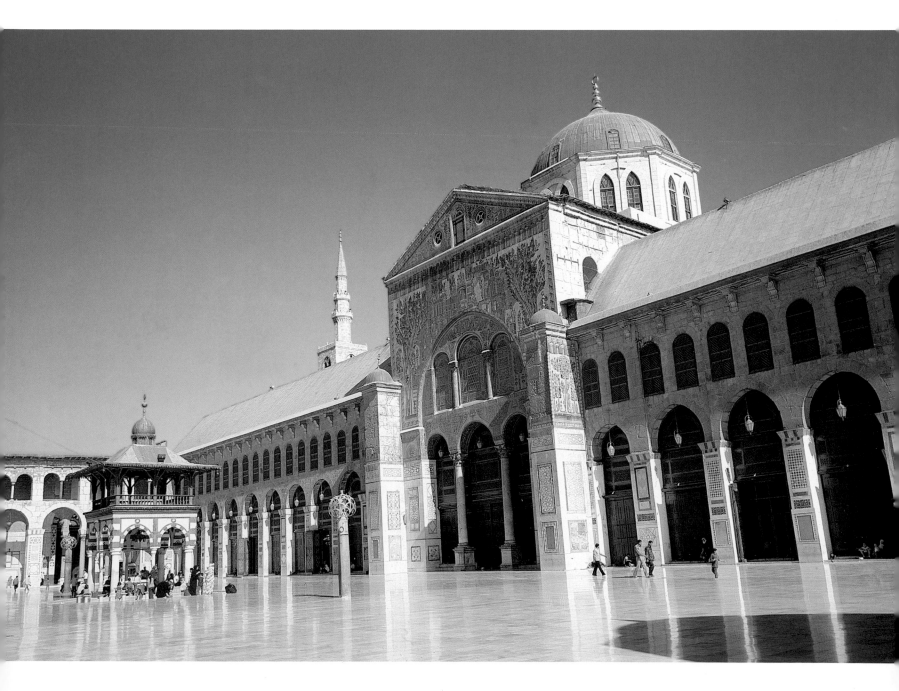

Dinar
One of the first gold coins with a calligraphic inscription stating the Islamic Profession of the Faith.

Umayyad, AH 77/AD 696–7
The British Museum
London, United Kingdom

Mosaic at Khirbat al-Mafjar
An example of the re-emergence of classical art.

*Umayyad, AH end of the 1st/
AD first half of the 8th century*
Jericho, Palestinian Authority

Now that the Umayyads were more firmly in the saddle, a sudden release of talent and creativity seems to ensue reflected in the construction of the first major Islamic monument in Jerusalem: the majestic Dome of the Rock, an octagonal structure covered by a dome whose formal origins lay in the commemorative buildings of the Byzantine period, for example the Anastasis and Ascension churches, both of which are in Jerusalem. 'Abd al-Malik also began a policy of administrative and political centralisation that culminated in the epoch-making coin reform that is marked by the mint of purely epigraphic coinage. The epigraphic-style coins replaced the Byzantine and Sassanian imitations issued up until this time and were produced as a direct response to an expanding market economy. Financial growth, in turn, came hand in hand with the Arabisation of the official administrative language, where Arabic replaced Greek and Pahlavi, the language of Sassanian Persia. The architectural programme initiated by 'Abd al-Malik was continued and expanded by his son and successor al-Walid (r. 86–96/705–15) who ordered the construction of the great mosques of Damascus, Jerusalem (al-Aqsa) and Medina; it was during al-Walid's caliphate that the mosque acquired its most

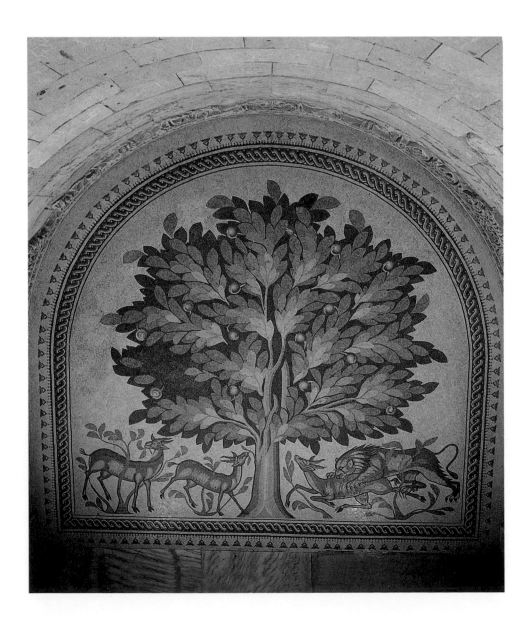

characteristic form, which became dominant for at least four centuries. This mosque type, which might appropriately be called the 'hypostyle mosque', is distinguished by its supports, which are either columns or piers. Mosques of this type were remarkably flexible and could be expanded in any direction by simply multiplying the supports. In discussing the dominant traits of the Umayyad caliphs, the Arab historian al-Tha'alibi (d. 429/1038) tells us that al-Walid had a passion for construction, the reconstruction of irrigation works and other projects, and that he enjoyed the acquisition of estates. During his reign building techniques were popularly discussed and people were urged to lay down foundations, and avidly amass estates and properties.

The mosaics both of the Dome of the Rock and the Great Mosque of Damascus, the earliest surviving Umayyad decorations, are devoid of living beings and rely instead on non-figurative motifs drawn from the Byzantine and Sassanian traditions. The walls of the Great Mosque of Damascus were decorated with glass mosaics depicting a river, trees and architectural motifs. The Jerusalemite, al-Tha'alibi, informs us that the Dome of the Rock and the Great Mosque of Damascus were built to rival the exuberant Byzantine

Floor mosaic

Umayyad, AH *2nd century/*AD *8th century*
Al-Qastal, Jordan

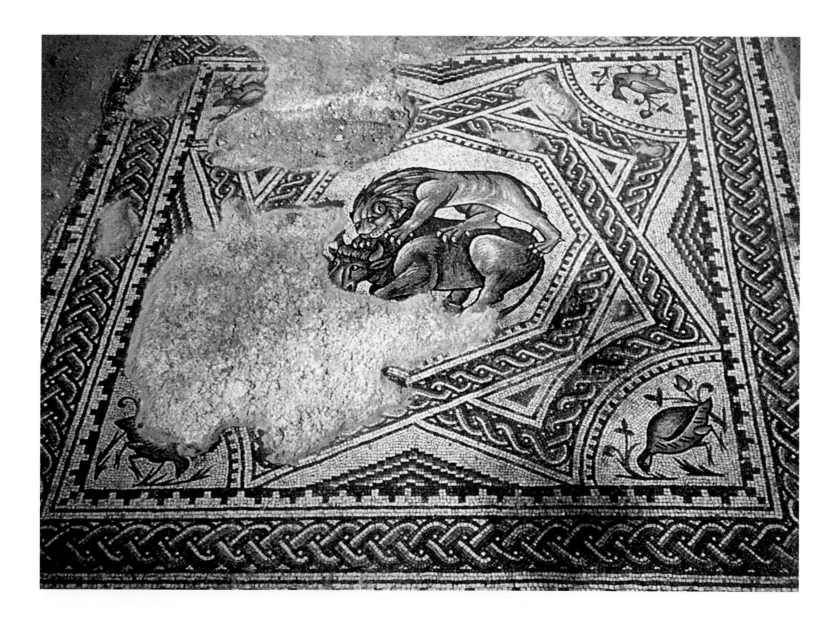

churches of Syria and Palestine, and to emulate the imperial example. Al-Walid's reign also further extended the geographical frontiers of the Umayyad Empire, which spread from the Iberian Peninsula in the West to Transoxania in the East. In the following decades the Umayyads dotted the steppes of Syria and Jordan with luxurious palatial residences, the interiors of which were decorated with coloured mosaics, fresco paintings, carved stucco and marble veneer. It is these buildings, rather than those of the major urban centres, that provide us with an idea about Islamic art in its formative stages. Generally speaking, these palaces consist of a series of separate elements which include a small mosque, a bathhouse and an audience hall, and some of them are accompanied by hydraulic installations such as cisterns, dams and aqueducts. Qasr al-Hayr al-Sharqi and Qasr al-Hayr al-Gharbi, both in Syria, and Khirbat al-Mafjar near Jericho, show evidence of large-scale

Fresco panel at Qusayr 'Amra
Personifications of Enquiry (left) and History (right).

Umayyad, after AH 92/AD 710
Azraq, Jordan

Fresco panel at Qusayr 'Amra

Umayyad, after AH 92/AD 710
Azraq, Jordan

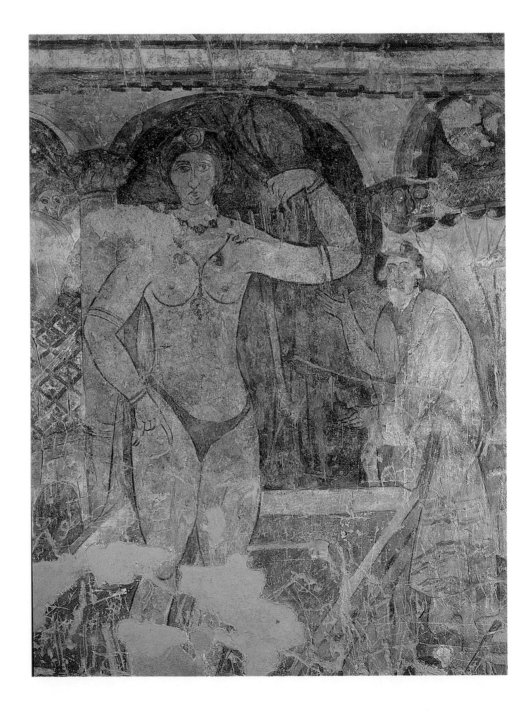

irrigation systems that were installed to serve the palace's surrounding agricultural estates – thus comparable to the Roman *villa rustica*. In the decoration of these palaces it is obvious that the aesthetic and taste which governed their creation are less obviously Islamic than those of the mosque. It may come as a surprise to see female nude or semi-nude figures, and occasionally erotic scenes, in the decoration. For example Qusayr 'Amra in Jordan, Khirbat al-Mafjar and Qasr al-Hayr al-Gharbi have extensive iconographic programmes showing musicians, dancers and female gift-bearers; themes which became an integral part of the pictorial representation of Umayyad court life, and which provide a glimpse of the ethos and *joie de vivre* of the ruling aristocrats. According to Professor Oleg Grabar, the themes of dancing females, hunting, and music were not simply the depiction of frivolous activities, but were rather reflections of royal pleasures and

Floor mosaic (detail)

Umayyad, before AH 126/AD 744
Al-Qastal, Jordan

Citadel of Amman
Plan of the Umayyad Complex.

Umayyad, around AH 110/AD 728
Amman, Jordan

0 50 m

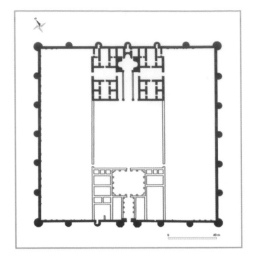

Plan of Mushatta Palace

Umayyad, probably c. AH *125–6/*AD *743–4*
Amman, Jordan

Façade of Mushatta Palace

Umayyad, probably c. AH *125–6/*AD *743–4*
Museum of Islamic Art, State Museums
Berlin, Germany

pastimes enacted in what was known as *Majlis al-Lahu* (a place for ceremonial entertainment) in which the life of the prince was expressed through his association with hunting, banqueting and dancing, all of which were amusements common in the Sassanian court and which served to glorify the prince and celebrate his greatness.

The rapid Arab-Muslim conquest of the north-east in 24/630 and 34/640 removed the barriers between Iran and Mesopotamia on the one hand and the Mediterranean world on the other, thereby producing an opportunity to mix the resources of two disparate civilisations (the Graeco-Roman and the Sassanian), and to foster a delicate symbiosis of East and West. However, the establishment of the Umayyad Dynasty in Syria – a province that had been thoroughly Hellenised over the previous millennium with its capital in Damascus – meant that the predominant artistic influences were classical or, more precisely, classical transformed under the influence of Orientalised provincial traditions, where the classical themes were given a new twist and a new meaning. For example, the rainbow mosaics, the lion devouring a gazelle at Khirbat al-Mafjar and the lion who has just sprung onto the back of a bull trying to bring him down, along with the leopard tearing the neck of a gazelle from al-Qastal, Jordan, mark a re-emergence of the classical style that can be seen also in the gay and flamboyant paintings of Qusayr 'Amra also in Jordan. Here Dionysus, Aphrodite, Nike, Grace and several *putti*, personifications of history, poetry and enquiry (labelled in Greek) are depicted on the walls of the building.

The erotic scenes within a succession of round and gabled arcades on a bronze brazier found at al-Fudayn in Jordan might be an eastern adaptation of Dionysiac themes. The arcade motif symbolises the architecture of paradise, hence its appearance on Roman sarcophagi and ossuaries. The erotic scenes on the brazier may symbolise the pious hope that participants in the mysteries of Dionysus might enjoy an afterlife of eternal pleasure and felicity, a symbolism meaningful to a pious Muslim. The arcade motif also appears in the throne-alcove in the audience hall of Qusayr 'Amra and on a spherical steatite base belonging to a lamp. Sometimes the classical model underwent a marked change and transformation, and this is quite apparent in the acanthus of the Corinthian capital which gave way to a fanciful style consisting of Arabic inscriptions, as seen on a capital from al-Muwaqqar, Jordan.

After the last unsuccessful Umayyad siege of Constantinople in 99/717, their attention was increasingly directed to the East. This shift led to a closer identification with Iran, an identification reflected in art, architecture and above all in court ceremonials, which is echoed in the plan and layout of the Mushatta Palace and the Umayyad government house (*Dar al-'Imara*) on the Citadel of Amman. Both buildings display an emphasis on the north–south central axis with a gateway on one side and an audience-hall, followed by a throne-chamber, on the other.

In the decoration of the Umayyad palatial residences, the juxtaposition of Eastern and Western motifs is notable; for example in the celebrated Mushatta façade which has a filigree delicacy in the carving of the stone

Steatite base of a lamp

Umayyad, AH *2nd/*AD *8th century*
Jordan Archaeological Museum
Amman, Jordan

Mushatta Palace
View of basilica-like hall opposite
the throne room.

Umayyad, probably C. AH *125–6/*AD *743–4*
Amman, Jordan

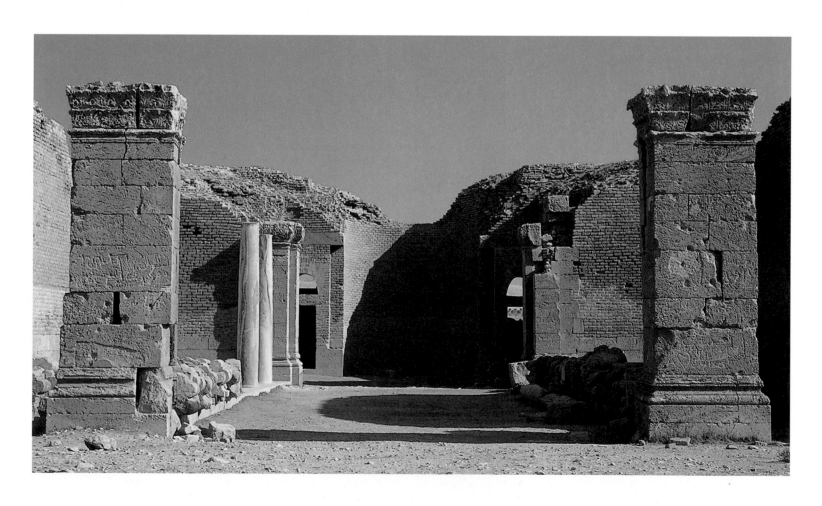

surfaces, art historians have recognised Graeco-Roman, Sassanian and Coptic influences; at Qasr al-Hayr al-Gharbi, sculptures of enthroned rulers copy Byzantine and Sassanian models. Of two large floor paintings from the same palace, one is rendered in a purely classical style (a Greek earth goddess, Gaia), while the second (a hunting scene) follows the Sassanian model. At Khirbat al-Mafjar a Central-Asian influence has been sought for semi-nude female figures holding flowers in one hand. A similar influence can be detected in an ivory panel from al-Humayma in southern Jordan which is carved with the image of a soldier wearing chain-mail and headgear. These few examples show that the cultural traditions of the conquered lands provided much of the basis for the art of the new Arab-Muslim Empire. In this formative stage one cannot speak of a full-blown Islamic art, for this eclectic art is different from that which developed 150 years later when

Ivory panel
Depiction of a soldier found in al-Humayma.

Umayyad, AH *first half of the 2nd/*
AD *first half of the 8th century*
Aqaba Archaeological Museum
Aqaba, Jordan

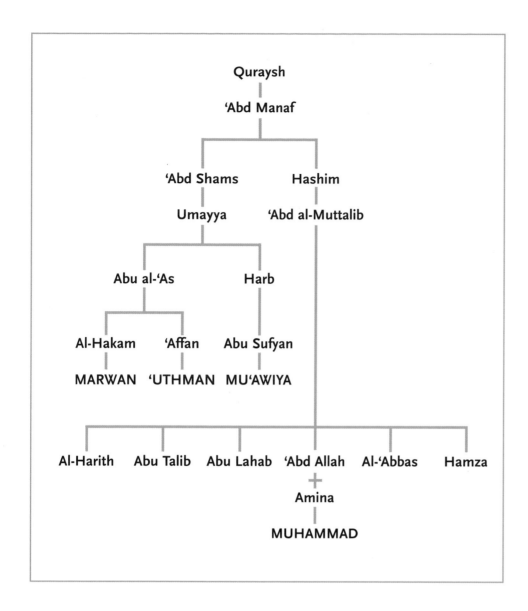

Quraysh

'Abd Manaf

'Abd Shams Hashim

Umayya 'Abd al-Muttalib

Abu al-'As Harb

Al-Hakam 'Affan Abu Sufyan

MARWAN 'UTHMAN MU'AWIYA

Al-Harith Abu Talib Abu Lahab 'Abd Allah Al-'Abbas Hamza

+
Amina

MUHAMMAD

**Genealogy of the Prophet
Muhammad and the Umayyads**

Column capital
From the water reservoir at the
Umayyad palace at al-Muwaqqar.

Umayyad, AH 101–5/AD 720–24
Jordan Archaeological Museum
Amman, Jordan

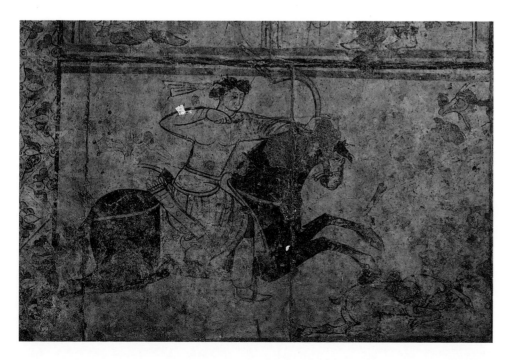

**Floor painting from Qasr al-Hayr
al-Gharbi**
A hunter dressed in Sassanian style.

Umayyad, AH 109/AD 727
National Museum
Damascus, Syria

Islamic art started to show a predilection for abstract and infinite design that became characteristic of later styles.

The death of the caliph Hisham ibn 'Abd al-Malik (105–25/724–43), marks the beginning of a turbulent period that culminated in the overthrow of the Umayyad Dynasty by the Abbasid revolutionaries in 132/750, and which saw the transfer of the seat of government to Iraq.

Brazier

Bronze braziers heated the caliph's room but were also used as incense burners in the palace.

Umayyad, AH *2nd/*AD *8th century*
Jordan Archaeological Museum
Amman, Jordan

PERSONALITIES

Mu'awiya I ibn Abu Sufyan (r. 41–60/661–80) was the founder of the Umayyad Dynasty. Before his proclamation as caliph, Mu'awiya was the governor of Syria for almost two decades. This long association allowed him to establish his power base and bring unity and cohesion among his Syrian followers. Towards the end of his life, Mu'awiya had the oath of allegiance taken to his son Yazid as his successor; thus posterity would see him as the leader who perverted the caliphate, turning it into a kingship (*mulk*). Mu'awiya is regarded as a clever ruler who got what he wanted by persuasion rather than force. He is reported to have said, 'I apply not my sword where my lash suffices, not my lash when my tongue is enough, and even if there be a hair binding me to my fellow men, I do not let it break; when they pull I loosen, and if they loosen I pull.'

'Abd al-Malik I ibn Marwan (r. 65–86/685–705) had a difficult first seven years of rule due to secessionist tendencies in Iraq and the Hijaz which needed to be overcome, while at the same time having to face up to the Byzantines who were causing a lot of trouble on the frontiers. Nevertheless, 'Abd al-Malik showed he was equal to the task and eventually succeeded in restoring the unity of the Arabs under his leadership. In 72/691 construction of the majestic Dome of the Rock in Jerusalem began under his command. Arabic was made the official language of the government, replacing Greek in Syria, Coptic in Egypt and Pahlavi in Iraq. Likewise changes occurred in the appearance of coinage, which became purely epigraphic bearing on both faces Muslim religious formulae.

Al-Walid ibn 'Abd al-Malik's (86–96/705–15) reign was the high point of Umayyad power witnessing significant territorial advances in the East (lands beyond the River Oxus in Central Asia) and West (Iberian Peninsula). He introduced a system of relief work and public charity. Al-Walid and his father, 'Abd al-Malik, were searching for an imperial style that would rival the Byzantine churches of Syria. He began building the Great Mosque in Damascus, completed the construction of the Aqsa Mosque in Jerusalem and renovated and expanded the Prophet's Mosque in Medina.

Yazid II ibn 'Abd al-Malik (101–5/720–4) seems to have spent most of his reign on his estates at al-Muwaqqar and al-Qastal in Jordan. He is portrayed in contemporary sources as a frivolous slave to passion especially to his two favourite female singers, Hababa and Sallama. He is credited (though this is doubtful) with issuing an iconoclastic edict commanding the destruction of all images of humans and animals throughout the caliphate, a step that anticipated the Byzantine emperor, Leo III's, in turbulent Iraq. Yazid II re-introduced Syrian troops and tended to rely on the Mudhar (north Arabian) tribes against the Yemenis, thus destabilising the delicate balance between the various tribal confederates.

Hisham ibn 'Abd al-Malik's (r. 105–25/724–43) reign marks the final period of prosperity of the Umayyad caliphate. He is described in the sources as a strict administrator: sober and frugal. He had Sassanian historical and administrative books translated for him. Hisham is renowned for his acquisition and development of enormous land estates from which he derived huge wealth. A series of palaces date from his reign, among which are Qasr al-Hayr al-Sharqi and Qasr al-Hayr al-Gharbi in Syria – both of which have elaborate irrigation systems – Khirbat al-Mafjar near Jericho, and the palace at Rusafa in north-east Syria.

Figurative Decoration

Jens Kröger and Mohammad Najjar

Dish

Mudéjar, AH late 9th–early 10th/
AD late 15th–early 16th centuries
The Burrell Collection, Glasgow Museums
Glasgow, United Kingdom

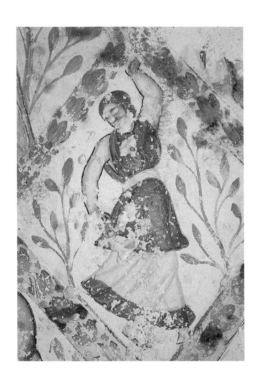

Fresco panel at Qusayr 'Amra

Umayyad, AH *first third of the 2nd/*
AD *first half of the 8th century*
Azraq, Jordan

Ivory casket (detail)

Umayyads of al-Andalus, AH *390–410/*
AD *1000–1020*
Victoria and Albert Museum
London, United Kingdom

Islamic art is a cultural phenomenon that was created by Muslims and non-Muslims for the different communities within the Islamic world. Not being a religious art like Christian art, a religious iconography did not develop; from the very beginning Islamic art developed a vocabulary as a secular art which served the needs of both royalty and ordinary people. Figurative art flourished and was accepted as a form of artistic expression in both vocabularies.

One of the misconceptions about Islamic art is that representation of the human figure was not permitted due to the deeds and sayings of the Prophet Muhammad. However, figurative imagery is not strictly banned by the Qur'an, although from the earliest beginnings it was unlawful to depict Allah and to worship images as idols. Thus within the limits of certain restrictions figurative imagery was allowed. Stricter attitudes towards the figure were developed at a later date but never completely enforced.

The first dynasty of Islamic history, the Umayyads (AH 41–133/AD 661–750), set the standard. Caliph 'Abd al-Malik's coin reform of 77/697 replaced the imagery used previously as state symbols for inscriptions and from then on, in principle, purely epigraphic coins were issued by most dynasties that

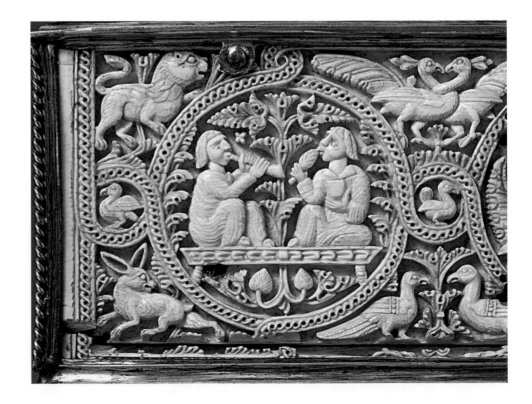

followed. From the Umayyad period on, figurative imagery was no longer found in religious architecture such as mosques, mausoleums and religious schools. Within palace architecture, however, the situation was completely different, because the Umayyad caliphs saw themselves as heirs of both the Byzantine and the Sassanian rulers. Both civilisations had formulated royal iconographies, elements of which found their place in an Umayyad iconography of the ruling power. This development led to remarkable variety in figurative imagery in Umayyad art, including sculptures in the round. Much of the royal iconography was taken over or modified by the dynasties that followed, due to the fact that numerous figurative images were symbolic

Lion from a fountain
The inscription appears to name a governor of Egypt.

Fatimid, AH 5th–6th/AD 11th–12th centuries
Museum of Islamic Art, State Museums
Berlin, Germany

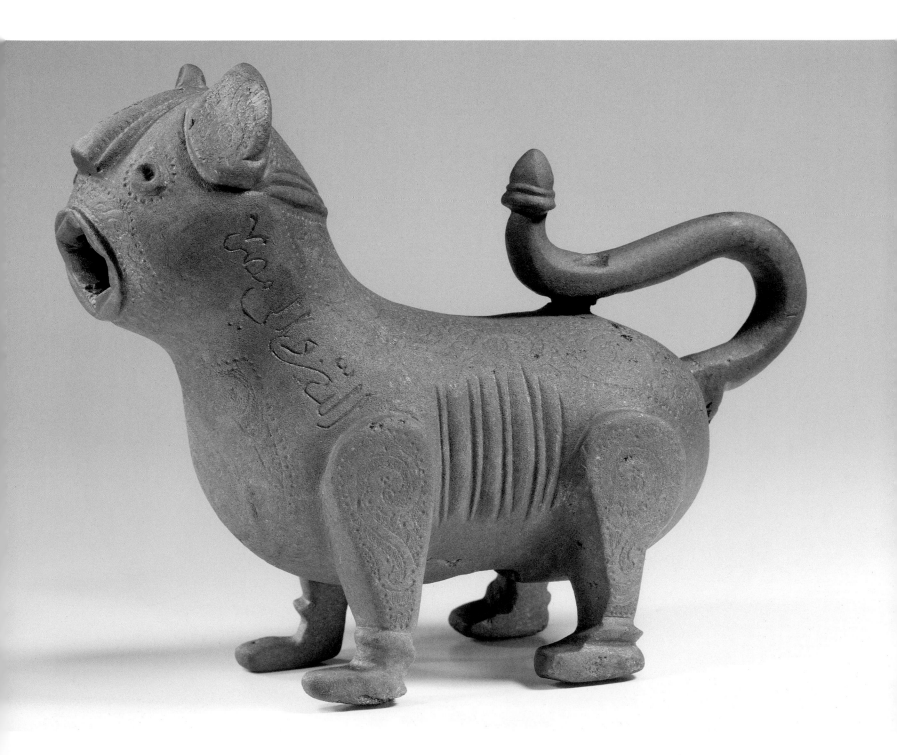

of princely power and, therefore, served the purpose of royal legitimacy. Symbolic representations of courtly life such as the hunt, or images of the enthroned ruler, emphasised the status of those in power and that of the princely entourage, and may too, in certain instances, have been seen as visions of eternal life in paradise.

The attitude developed by the Umayyads continued during the Abbasid period (132–656/750–1258). The Umayyads of al-Andalus developed a rich iconographic repertoire of figurative imagery during the mid-4th/10th–and early 5th/11th centuries that remained especially visible in works of ivory.

Dish
Depiction of a seated woman playing a stringed instrument.

Fatimid, AH 5th/AD 11th century
Museum of Islamic Art
Cairo, Egypt

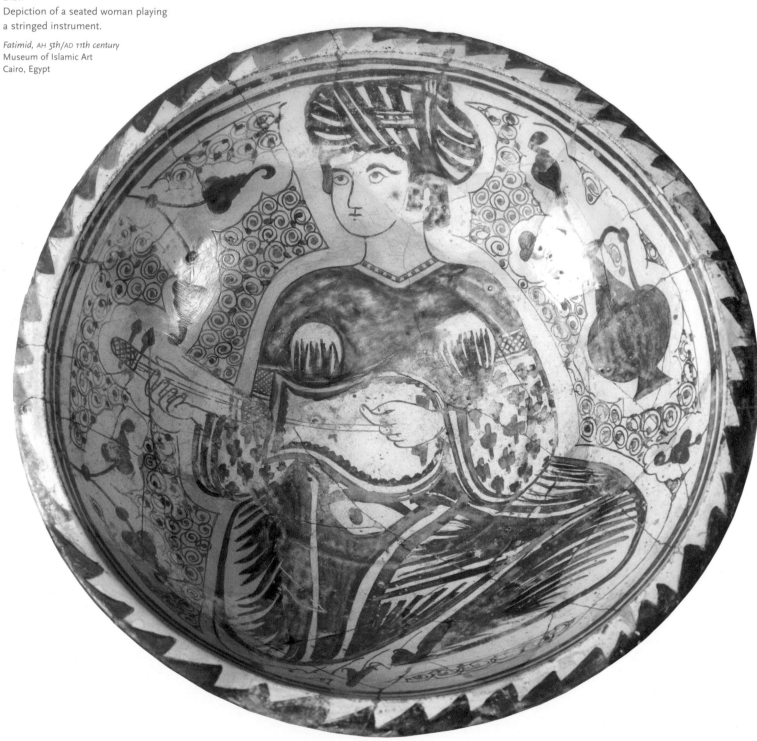

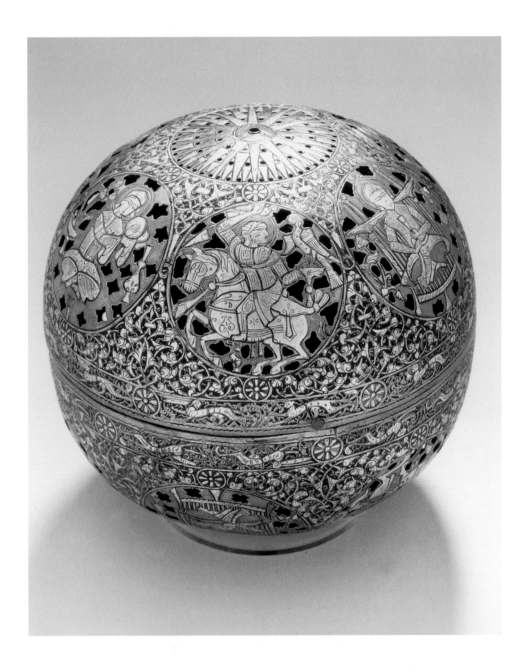

Incense burner or hand-warmer

Ayyubid, AH *third quarter of the 7th/*
AD *third quarter of the 13th century*
Museum of Islamic Art, State Museums
Berlin, Germany

Ivory panels

Fatimid, AH *5th–6th/*AD *11th–12th centuries*
Museum of Islamic Art, State Museums
Berlin, Germany

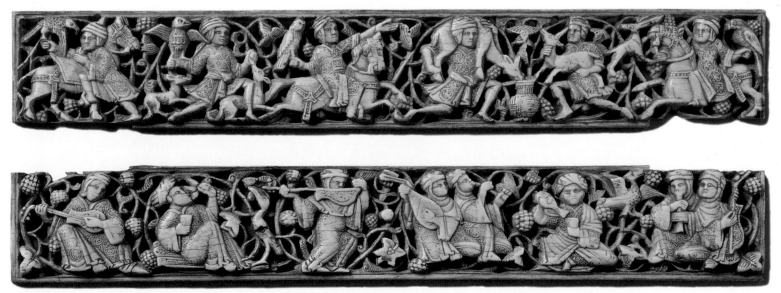

**Semi-naked female statue from
Mushatta Palace**

*Umayyad, AH first half of the 2nd/
AD first half of the 8th century*
Jordan Archaeological Museum
Amman, Jordan

Relief of a lute player

*Seljuqs of Rum (Anatolian Seljuq),
AH early 7th/AD early 13th century*
Museum of Islamic Art, State Museums
Berlin, Germany

FACING PAGE
Page of a manuscript
Depiction of Moses, Muhammad and
the Archangel Gabriel.

Ottoman, AH end 10th/AD end 16th century
Museum of Islamic Art, State Museums
Berlin, Germany

During the Fatimid period (296–566/909–1171) in Egypt, figurative representation was further developed and played an important role in court art with painted cycles that depicted hunters, musicians and dancers. These themes continued to be used by the dynasties that followed. It was during the Fatimid period that, for the first time in Islamic art, numerous depictions of scenes from daily life appeared.

During the Ayyubid period (564/1169–end 7th/13th century), an era that witnessed close contact with Europe, a new development in the depiction of

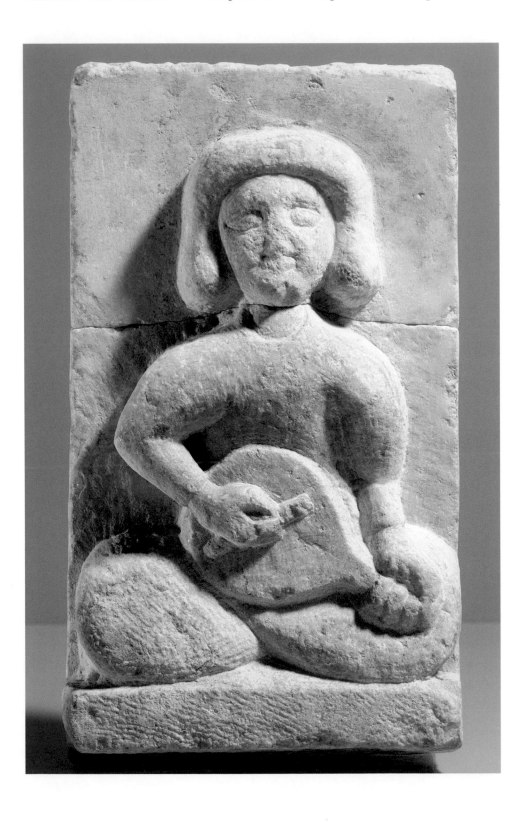

صلوة في اليوم واللّيلة وصيام ثلث شهرٍ في كلّ سنةٍ فقا

لى موسى انّ امّتك ضعيف لا يطيقون ذلك فارجع الى ربّ

انت وجبريل واسأله التخفيف لامّتك قال النبيّ عليه السّلام

فرجعتُ الى ربّي عزّ وجلّ فقلتُ يا سيّدى ومولاى انّ امّتى لا يطيقو

The 'Tavira Vase'
Probably representing the ceremonial abduction before a wedding ceremony, the animals are an allegory of good fortune.

Almoravid, AH *end 5th or beginning 6th centuries/* AD *end 11th or beginning 12th centuries*
Municipal Museum
Tavira, Portugal

knights as well as of Christians is evident. This tendency continued during the Mamluk period in which battle scenes, or depictions of leisure and recreational pastimes enjoyed by the aristocracy, played an important role. However from the beginning of the 8th/14th century a change occurred in what was acceptable in Mamluk art as the attitude toward figurative imagery became more restricted.

The Seljuqs in Anatolia (468–708/1075–1308) developed an iconography of figurative images that included both humans and animals in association with earthly kingship; some of these themes were due to their Central Asian ancestry. Close contact with both Europe in the West and Iran in the East meant that the Ottomans (699–1341/1299–1922) developed new forms of figurative art. Thus portraits of rulers in genealogies as well as European-style oil paintings serve royal legitimacy. Ottoman artists also illustrated the Life of the Prophet and his miraculous nocturnal journey to Jerusalem (*Isra'*), veiling the face of Muhammad due to his venerated sanctity.

The Abbasids: the First Islamic Empire

Noorah Al-Gailani and Mounira Chapoutot-Remadi

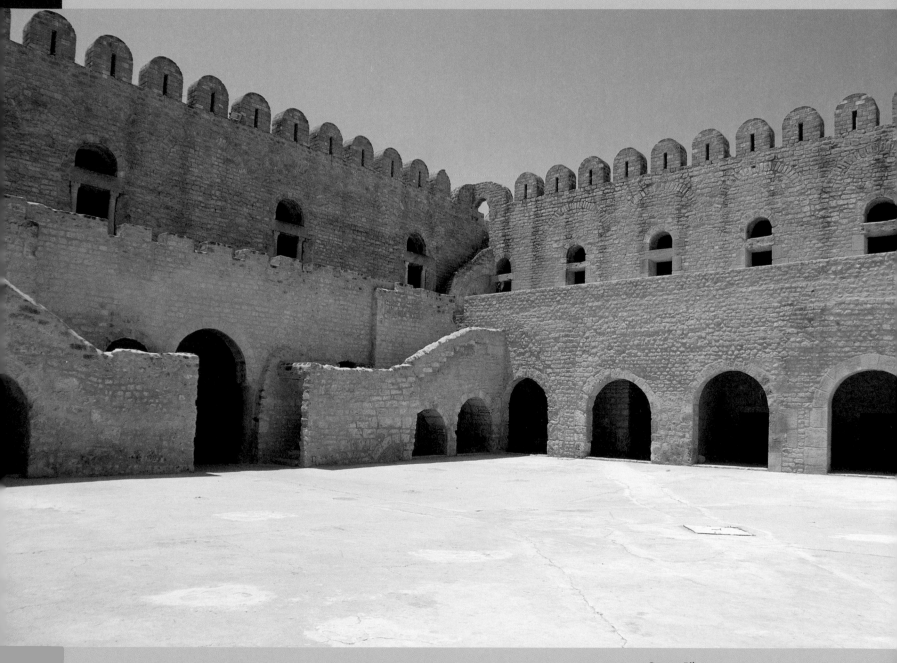

Sousse Ribat
View from the courtyard.

Aghlabid, AH 206/AD 821
Sousse, Tunisia

City Builders in the Middle East

Noorah Al-Gailani

From AH 110/AD 730 onwards a group of kinsmen belonging to the Banu
Hashim of the Quraysh tribe of Mecca (the clan of the Prophet Muhammad),
began plotting to seize power from the in-fighting Umayyad Dynasty.
Originally based just south of the Dead Sea, in a small village by the name of
al-Humayma, the Hashimids – better known as the Abbasids, were to become
the longest lasting of the Arab-Islamic dynasties, ruling from AH 132–656
(AD 750–1258). Islamic civilisation reached its zenith in the Abbasid era,
being culturally inclusive and excelling in the sciences, the arts and literature.

During the final years of their rule, the Umayyads (41–133/661–750) faced
a great deal of political pressure in the Middle East. Reluctantly, they were
drawn into the ongoing and destructive rivalries between the Yemeni (South
Arabian) and the anti-Umayyad Qaysi (North Arabian) tribes, deep-rooted

FACING PAGE
Site of the palace at al-Humayma

*Abbasid, during the Umayyad caliphate,
AH first half of the 2nd/AD first half of the
8th century*
Al-Humayma, Jordan

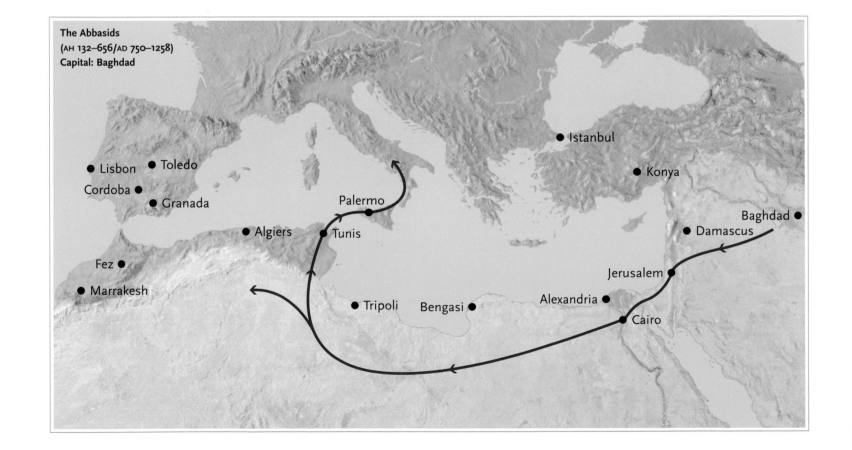

The Abbasids
(AH 132–656/AD 750–1258)
Capital: Baghdad

Istanbul
Lisbon • Toledo
Cordoba •
• Granada
Konya
Baghdad •
Palermo
Algiers • Tunis
Damascus
Fez •
Jerusalem
• Marrakesh
Alexandria
• Tripoli Bengasi •
Cairo

since pre-Islamic times. Another unsettling factor was the sectarian struggle of Imam 'Ali's Shi'a, who were demanding the restoration of the caliphate to its rightful heirs: the descendants of 'Ali, the cousin and son-in-law of the Prophet. Meanwhile, the Umayyads were sinking further into a lifestyle of decadence, with internal rivalries and court struggles recurring all over the caliphate.

With the support of the Shi'ite sect and a growing host of followers, the Abbasids continued their active struggle against the Umayyads until finally seizing power in 133/750. This revolution not only led to the take-over of a vast empire that stretched from Ifriqiya in North Africa to Central Asia, but more significantly to the transfer of power and influence from Syria, the traditional centre of power and culture in the Middle East since Hellenistic times, to Iraq and the eastern lands of the Islamic world. This move had far-reaching consequences for the ethnic make-up of the ruling elite, its administration and army. Traditionally dominated by Arabs, the Islamic caliphate in Abbasid times increasingly relied on a host of ethnically diverse officials and soldiers. Non-Arab Muslims ran the administration and held important political offices as viziers, governors and rulers, while soldiers to begin with from Khurasan then, from al-Ma'mun's reign (197–217/813–33) on, from the Caucasus and Central Asia, formed the caliphal guard. Meanwhile, the demise of Arab supremacy also led to increased Islamisation throughout the empire, as being a Muslim now became more important to an individual's standing in society than being an Arab.

Abu 'l-'Abbas al-Saffah (r. 132–6/749–53), was the first Abbasid to be proclaimed caliph at the Great Mosque of Kufa in Iraq. His inauguration marks the restoration of the Islamic caliphate as an institution that focused on both religious leadership and political governorship. Al-Saffah's four-year reign was dominated by the elimination of opposition to the Abbasids. He clamped down on the disappointed Shi'ites, who had expected the restoration of the caliphate to 'Ali's descendants rather than the Abbasids, even though these, too, based their claim to the caliphate on a lineage of descent from the Prophet's family. After a short time at Kufa, al-Saffah

Miniature painting
Baghdad in flood before the Mongol devastation.

Around AH 873/AD 1468
The British Library
London, United Kingdom

Harun al-Rashid receives the delegation of Charlemagne

By the German painter Julius Köckert (1827–1918), 1864, oil on canvas.
Maximilianeum Foundation
Munich, Germany

sought a new capital away from the Shi'ites. He moved north to al-Anbar
on the Euphrates in 134/752 and built a new city next to the existing old
town.

Al-Saffah was succeeded by his brother, Abu Ja'far al-Mansur (r. 136–58/
754–75), who was to become one of the shrewdest of the Abbasid caliphs.
He organised the state's administrative systems, clamped down on internal
revolts and attended to fighting the Rum (the Byzantine Empire). Like his
brother, al-Mansur also founded several new cities. After building al-Hashimiya
on the Euphrates in 145/762, he began searching for another location to build
a capital more suitable for the administration of the empire. Eventually he

Column capital from al-Raqqa

Abbasid, AH *3rd/*AD *9th century*
Museum of Islamic Art, State Museums
Berlin, Germany

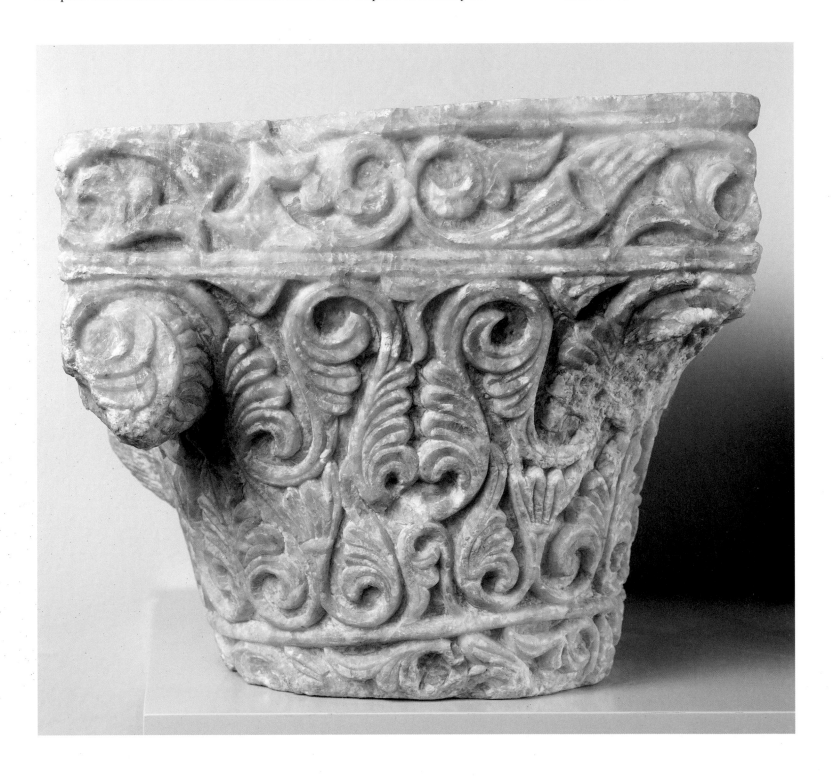

Plan of the round city of Baghdad
During the period of Caliph al-Mansur
(r. AH 137–59/AD 754–75).

 Golden Gate Palace or
Green Dome Palace

 Al-Mansur's Mosque

City walls of al-Rafiqa (al-Raqqa)

Abbasid, AH 155–8/AD 771–5; additions 180–92/
796–809; renovated during the 5th/11th century
Al-Raqqa, Syria

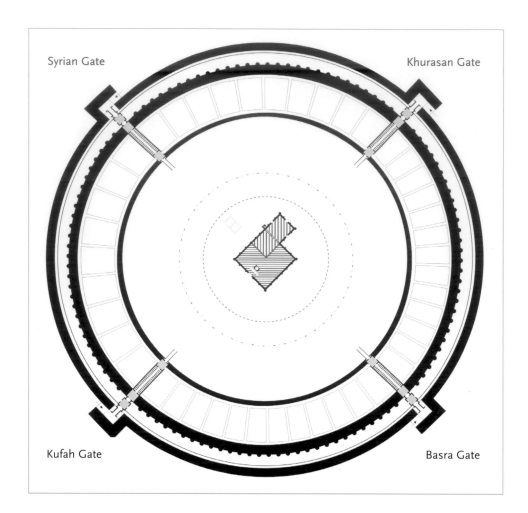

Syrian Gate

Khurasan Gate

Kufah Gate

Basra Gate

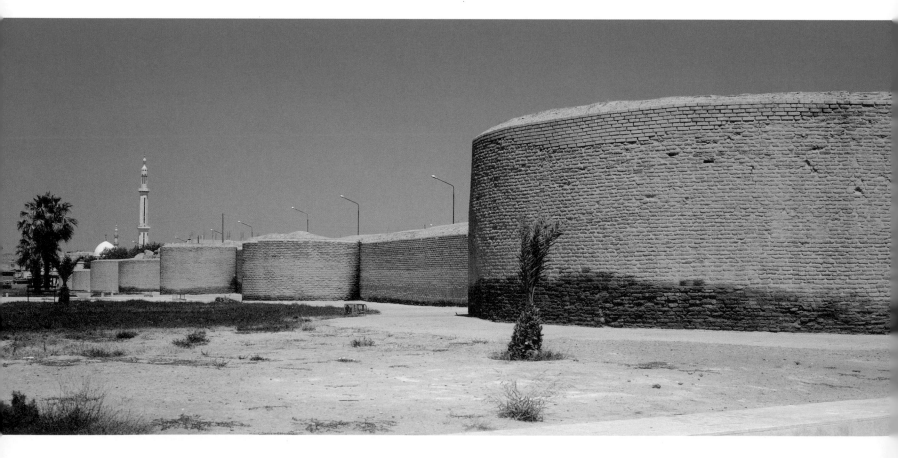

decided on the strategically advantageous location of Baghdad, an ancient town on the Tigris in central Iraq, and ordered the construction of a round city on the west bank of that river. Completed in 148/766 and named 'Madinat al-Salam' – 'City of Peace', Baghdad's round city cost nearly 500,000,000 silver *dirham*s and engaged as many as 100,000 engineers, builders and craftsmen brought from all over the Islamic world. Similar to Beijing's Forbidden City in function, the caliph's palace and mosque lay at its centre, surrounded by residences for the caliph's sons, government offices and army barracks, all encircled by fortified walls.

In 152–3/770–1, inspired by the round city, al-Mansur chose to build another royal compound adjacent to the old town of al-Raqqa on the Euphrates in Syria. The location boasted a good strategic position on the route between the Eastern and Western territories of the empire and lay close to the frontline with the Rum. Between 180 and 193 (796 and 809), as social and political unrest grew in Iraq, Harun al-Rashid founded al-Raqqa-al-Rafiqa (literally the 'female companion') as a camp for the war against Byzantium.

Some years later, during the rule of caliph al-Mu'tasim, Baghdad again witnessed serious unrest, this time due to tensions between the city's residents and the caliph's unruly Turkish army. When the situation reached crisis point, al-Mu'tasim decided to build a new capital, Samarra, further

Fragment of a pottery bowl

Abbasid, AH *136–58/*AD *754–75*
National Museum
Damascus, Syria

Fragment of a painted wooden panel

Abbasid, AH *218–27/*AD *833–42*
National Museum
Damascus, Syria

Teak panel

Abbasid, AH *3rd/*AD *9th century*
The British Museum
London, United Kingdom

north on the west bank of the Tigris. Samarra remained the Abbasid capital and royal residence under seven subsequent Abbasid caliphs between 221/836 and 270/884. Under the auspices of Caliph al-Mutawakkil (232–46/847–61), whose devotion to architecture is well known, Samarra received its Great Mosque, famous for its spectacular spiral minaret. Both the architecture and the decorative schemes that were used to enhance the city subsequently had a lasting influence on Islamic art; important Islamic cities such as al-Raqqa, Fustat and Cairo owe much of their architectural inspiration to the Samarra model.

The Golden Age of the Abbasids flourished between 158 and 232 (775 and 847). It was during this period that the legendary Harun al-Rashid (170–93/ 786–809) achieved peace with Byzantium and exchanged envoys with Charlemagne. During the rule of Harun's son, al-Ma'mun (197–217/813–33), the empire witnessed a period of keen patronage of the sciences and of the arts. Al-Ma'mun established the Bayt al-Hikma (the House of Wisdom) in Baghdad, which included a library, a centre for translation and a school. Key scientific and philosophical texts from Greece, Persia and India were translated and expounded, attracting prominent scientists and philosophers from all over the empire. Famous scholars of the time include al-Kindi who

Interior stucco decoration
From a house in Samarra.

Abbasid, AH *3rd/*AD *9th century*
Museum of Islamic Art, State Museums
Berlin, Germany

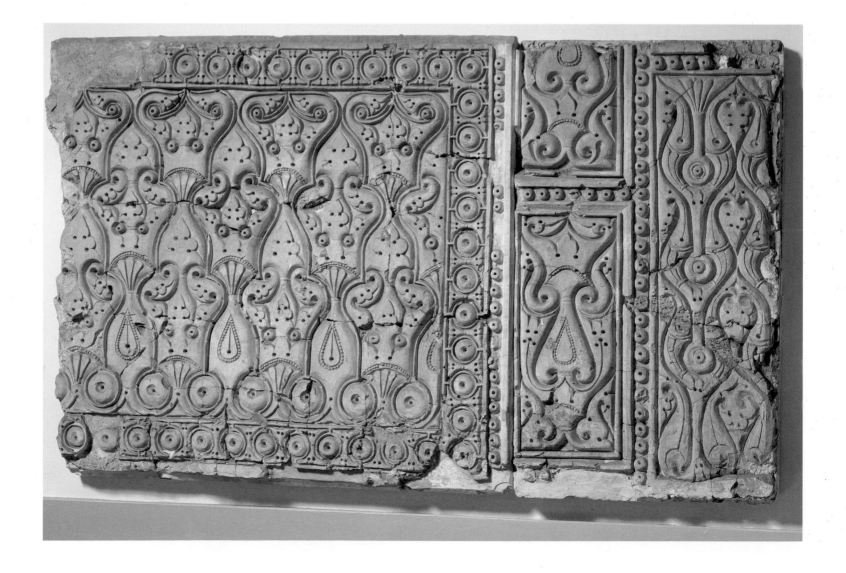

wrote about the philosophy of music, al-Farabi who established Logic as a true science, and al-Khwarizmi who revolutionised mathematics with Algebra. Meanwhile, al-Razi's and Ibn Sina's medical works were to lay the foundations for scientific medical training.

Abbasid power gradually began to decline during the 5th/11th century, with several parts of the empire becoming autonomous. In Egypt and Syria the Fatimids (r. 296–566/909–1171) had set up a rival caliphate, while in 334/945 the Shi'i Buyids took a lead as protectors of the caliphate in Bagdad. Meanwhile, in 447/1055, the Seljuq sultan, Tughril Beg, invaded Iran and eventually succeeded in placing the Abbasid seat in Baghdad under his control. Several unsuccessful attempts were made to re-establish Abbasid suzerainty until eventually the final blow came when the Mongols swept through the Middle East and conquered Baghdad in 656/1258, overthrowing the Abbasid Dynasty for ever.

Great Mosque of al-Mutawakkil Spiral Minaret
Abbasid, AH 234–238/AD 848–852
Samarra, Iraq

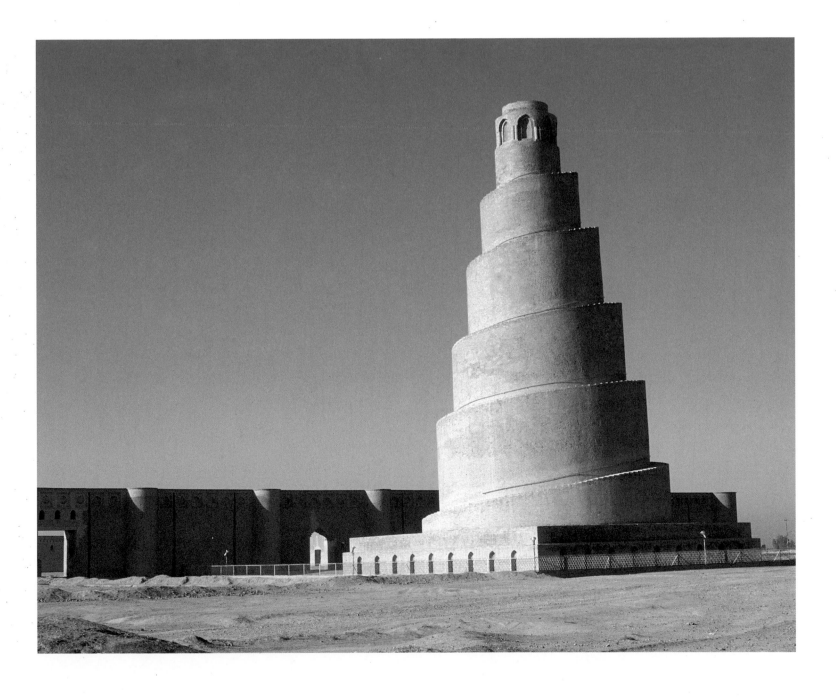

The Islamic Mediterranean in the Abbasid Era

Mounira Chapoutot-Remadi

Syria and Egypt: the Shield of the Empire

Syria and Egypt played an important strategic role throughout the Abbasid period, especially in warding off sea-borne attacks. As a result, the administration of the two countries tended to be entrusted to family members, presumptive heirs or even trusted Turkish officials. The first Abbasid representatives to rule Syria and Egypt were the Banu 'Ali, uncles of the caliphs, followed by a succession of Persian and – from the reign of the Abbasid Caliph al-Wathiq (228–33/842–7) – Turkish governors.

In Syria, the Abbasids retained the administrative districts that had formerly made up the country, with Damascus, the former Umayyad capital, now reduced to little more than a regional centre. The Abbasid Caliph, al-Ma'mun, did spend some time in Damascus and had a palace built near the town, while al-Mutawakkil even planned to move his capital to the city, but was forced to abandon the idea after a revolt by his Turkish guard forced him to return to Samarra.

Goblet from al-Raqqa
Associated with Caliph al-Mu'tasim.

Abbasid, AH 218–27/AD 833–41
National Museum
Damascus, Syria

Glass tumbler
The inscription on it reads: 'drink and be filled with delight'.

Abbasid, AH 3rd/AD 9th century
National Museum
Damascus, Syria

Wooden panel

Tulunid, AH 3rd/AD 9th century
Museum of Islamic Art
Cairo, Egypt

FACING PAGE
Bowl with radial decoration
One of the oldest examples of an imitation of the much-valued Chinese porcelain.

*Abbasid, AH second half of the 3rd/
AD second half of the 9th century*
National Museum of Oriental Art
Rome, Italy

In the East, Byzantium continued to be a formidable opponent both on land and at sea obliging the Abbasid caliphate to reinforce its frontiers with Syria. To do so, al-Mansur founded al-Rafiqa, near al-Raqqa on the Euphrates in around 154/770. The formidable Harun al-Rashid resided there from 179 to 192 (796 to 808). The caliphs frequently travelled through Syria to go on pilgrimage or to wage war against the Byzantines.

Abbasid Egypt was a wealthy province that provided the empire with important tax revenues. This explains why there was such a high turnover of governors (42 appointed between 133/750 and 194/809, as the caliphs feared that the governors were becoming too powerful. From the reign of al-Mu'tasim, the country was put into the care of Turkish officers (Afshin then Kaydar). Between 243/857 and 255/868), Egypt had four governors before the post was entrusted to Ahmad ibn Tulun, who founded a dynasty in the manner of the Aghlabids, and eventually shook off Abbasid suzerainty. His family reigned over Egypt and later Syria for 38 years, bringing peace and stability to the country. Tulun's dynasty (255–93/868–905), like that of the Ikhshidids (324–59/935–69) who succeeded it, dominated Syria and removed the Abbasids from power.

Ifriqiya and the Muslim West: a Refuge for the Enemies of the Abbasids

Throughout Ifriqiya and the western provinces separatist movements increasingly shook the empire. Al-Andalus was lost when the last surviving Umayyad, 'Abd al-Rahman al-Dakhil, arrived in the province and declared it an independent emirate in 139/756. In the Central Maghreb, the Kharijite, 'Abd al-Rahman ibn Rustam, founded a principality at Tahert in 144/761, which became independent in 161/777. Further west another fugitive, Idris

Plate with metallic glaze

Aghlabid, AH *late 3rd–early 4th/*
AD *late 9th–early 10th centuries*
Museum of Islamic Art, Raqqada
Kairouan, Tunisia

Page from a Qu'ran

Aghlabid, AH *late 2nd–early 3rd/*
AD *late 8th–early 9th centuries*
Museum of Islamic Art, Raqqada
Kairouan, Tunisia

Dinar
This Aghlabid *dinar* reflects the autonomy of the new dynasty by naming the reigning prince.

Aghlabid, AH *192/*AD *808*
Museum of Islamic Art, Raqqada
Kairouan, Tunisia

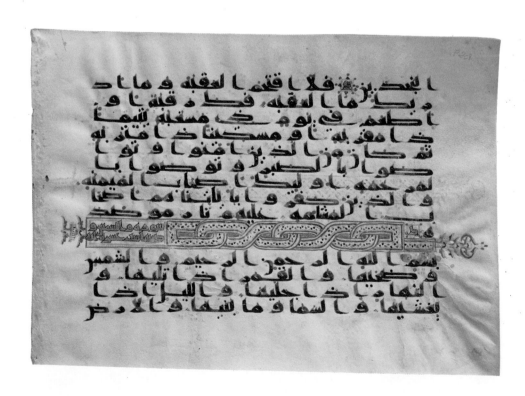

ibn 'Abdallah a descendant of the caliph 'Ali through his son Hasan, founded
the Idrisid Dynasty and chose to found his capital at Fez.

The most urgent issues to be resolved concerned Ifriqiya. Faced with the
threat of revolts, the Abbasids first dispatched the governor of Egypt to
Ifriqiya with 40,000 men to take control of the situation. Then, despite
ongoing revolts, a dynasty of governors known as the Muhallabids succeeded
for a time to hold the region for their Abbasid overlords. Eventually Harun
al-Rashid called up Ibrahim ibn al-Aghlab (r. 184–97/800–12), entrusting the
region to him as a hereditary emirate in exchange for an annual payment
of 40,000 dinars to Baghdad. Ibrahim and his successors, the Aghlabids,
remained nominally attached to Baghdad. They continued to expand their
own territories, for example with the conquest of Sicily in 212/827, while
maintaining strong economic and cultural links with the Abbasid centre.
When Charlemagne decided to send missions to Harun al-Rashid in Baghdad

Mosque of Ahmad ibn Tulun

*Tulunid, during the Abbasid caliphate,
AH 265/AD 879*
Cairo, Egypt

in 181/797 and 192/807, the Frankish ambassadors went via Kairouan, as Latin was still spoken there, and Aghlabid messengers acted as interpreters. A century later, in 294/906, Bertha of Tuscany again used an Aghlabid messenger, this time a former servant of Ziyadat Allah III (r. 291–7/903–9), to send a mission to Caliph al-Muqtafi (r. 290–6/902–8).

Continuing Abbasid interest in Ifriqiya, in return, remains tangible too as can be seen in an inscription beneath the dome of the Zaytuna Mosque in Tunis which proclaims that part of it was built in 250/864 at the behest of Caliph al-Musta'in (r. 248–52/862–6).

The Aghlabid Dynasty was the first to rule Ifriqiya independently of the Abbasid caliphate. Its end was a tragic one. After the terrible rule of the mad and bloodthirsty Ibrahim II, the last Aghlabid ruler Ziyadat Allah III fled to avoid final defeat at the hands of the Shi'ite Fatimids in 297/909. Descendants of the Prophet's daughter, Fatima, and fervent supporters of the 'Alid cause,

Carved wood fragment
From the oldest dated *minbar* in the Islamic world, originating from the Great Mosque of Kairouan.

Aghlabid, AH *242–9/*AD *856–63*
Museum of Islamic Art, Raqqada
Kairouan, Tunisia

Bowl with inscription
In the centre are four rows of *kufic* script in a brown glaze with the word *'al-mulk'* written twice.

Aghlabid, AH *late 3rd/*AD *end 9th century*
Museum of Islamic Art, Raqqada
Kairouan, Tunisia

FACING PAGE
The Great Mosque of Kairouan
View of the *mihrab*.

Umayyad, Abbasid, AH *221/*AD *836*
Kairouan, Tunisia

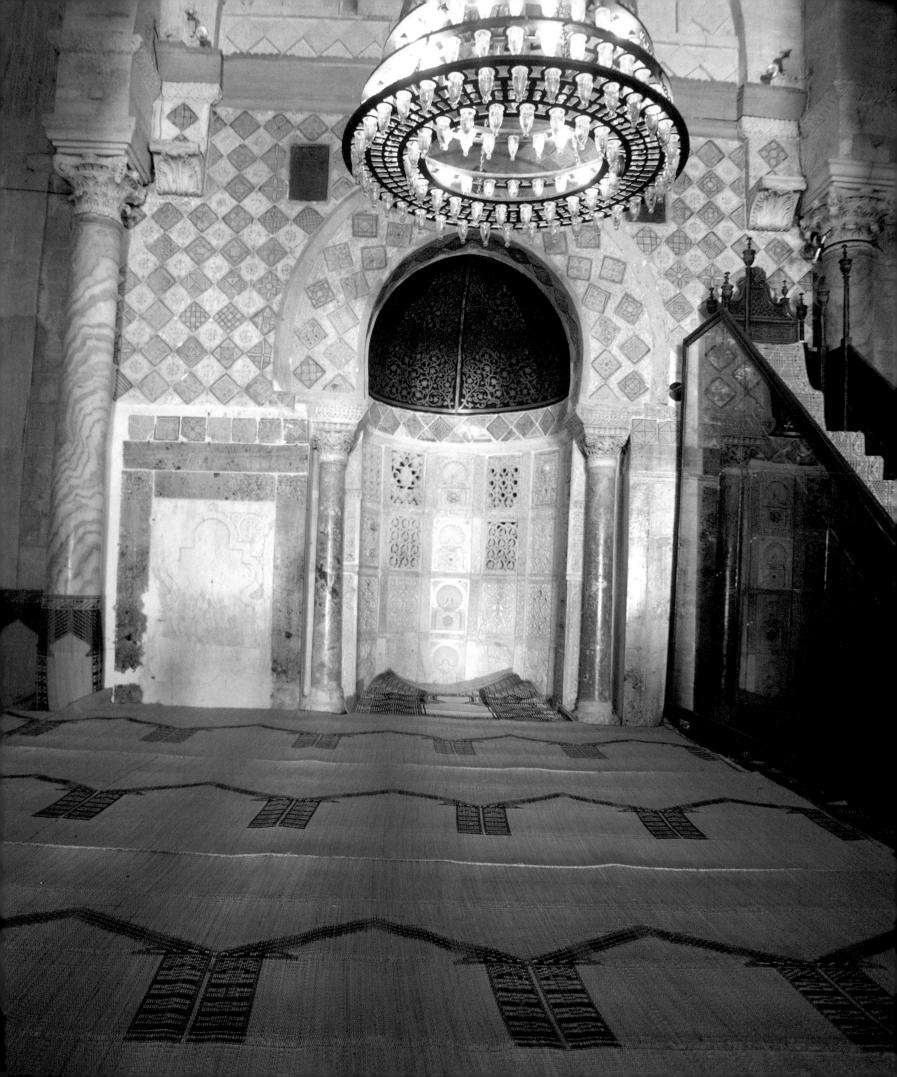

the Fatimids had started off as religious missionaries in Syria, but had been brutally persecuted by the Abbasids wherever they went. Their spiritual leader 'Abdallah (or 'Ubaydallah) was pursued from Syria and captured at Sijilmasa on the edge of the Maghreb by order of Caliph al-Mu'tadid (r. 279–90/892–902). Here, he was saved by his missionary, Abu 'Abdallah, who had converted the Kutama Berbers of Kabylie.

And so the Abbasids lost their Mediterranean provinces. Although their political domination was not always effective or stable, the Abbasids left a lasting legacy and continued to influence the Muslim world in a myriad of different ways.

The Abbasid Legacy in the Islamic Mediterranean

The first Abbasids were notable for building innovative palatine cities throughout the empire. Baghdad, Samarra and other urban developments were subsequently imitated in terms of layout and configuration by the

FACING PAGE

Textile fragment with cockerel medallions

Abbasid, AH 4th–5th/AD 11th–12th centuries
Royal Museum, National Museums Scotland
Edinburgh, United Kingdom

Sousse Ribat
Exterior view.

Aghlabid, AH 206/AD 821
Sousse, Tunisia

Abbasid governors of Egypt and Ifriqiya, the Idrisids of Fez, the Fatimids of Ifriqiya and Egypt, and even the rival Umayyad caliphs of al-Andalus.

Thus, the Aghlabids established al-Abbasiya near Kairouan in 185/801, then Raqqada in 262/876. Subsequently, the Fatimids applied the Abbasid model of city planning to the foundation of cities such as Mahdiya (305–8/917–20), Sabra al-Mansuriya (337/948) and, most importantly, Cairo (359/969). Fatimid al-Qahira, established by General Jawhar al-Siqilli, marked the third stage in the evolution of the Egyptian capital after the foundation of al-'Askar in 135/752 to the northwest of Fustat, and Ibn Tulun's urban development of al-Qata'i' further east in 257/870. Salah al-Din, the famous Saladin, added Qalaat al-Jabal (the Citadel of the Mountain), which became the residence of the sultans up until the 13th/19th century.

Figure of a dancer
Most certainly a toy.

Abbasid, AH 3rd/AD 9th century
Ribat Museum
Monastir, Tunisia

Tunic and detail of embroidery
The inscriptions in angular *kufic* lettering embroidered in silk read: 'Lasting blessings [...] sovereignty is with God'.

Abbassid, AH 3rd–4th/AD 9th–10th centuries
Bardo Museum
Tunis, Tunisia

Further west, the city of Fez evolved in a similar fashion. A first city was founded in 177/789 by Idris I, then his son Idris II added a second city, al-Alya, in 193/809. In 675/1276, the Marinids built Fas Jdid (New Fez) or al-Madina al-Bayda next to the two aforementioned cities.

In al-Andalus, the Umayyad 'Abd al-Rahman III underpinned his proclamation of a third caliphate hostile to the Abbasids and Fatimids with a new capital, Madinat al-Zahra (329–30/940–1), near Córdoba. Later that century, the excessively powerful vizier, al-Mansur ibn Abi Amir mimicked the architectural aspirations of the caliphs with the foundation of his own palatine city, al-Zahira, in 368/978.

The Abbasid legacy went well beyond urban planning, though. Architectural designs and elements first used in Baghdad and elsewhere in

Bowl
The decoration appears to be a variant on the tree-of-life consisting of wing-shaped palmettes.

Abbasid, AH second half of the 3rd/ AD second half of the 9th century
National Museum of Oriental Art
Rome, Italy

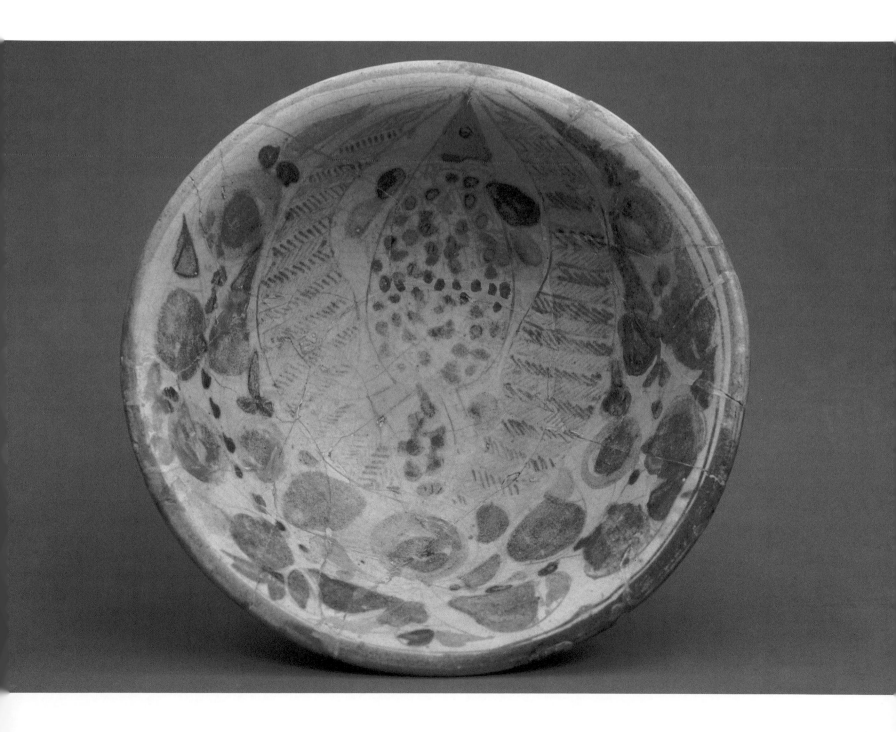

Abbasid heartlands were soon echoed further west. Thus, the dimensions of the Great Mosque of Kairouan show similarities to the layout of the mosques of Samarra and Abu Dulaf near Baghdad, while the Ibn Tulun Mosque in Cairo features a minaret clearly inspired by that in Samarra, which in turn harks back to ancient Mesopotamian tower-temples known as *ziggurats*.

Architectural decoration and furnishings, too, had strong links with Abbasid Iraq. The *mihrab* of the Great Mosque of Kairouan was rebuilt around 248/862 with imported tiles of marble and lustre-painted ceramics. Developed in Iraq, the lustre-work technique was first used in the 3rd/9th century in Raqqada and Sabra al-Mansuriya in the Muslim West, before reaching Ifriqiya and al-Andalus in the 5th/11th. Once completed, the Kairouan Mosque was furnished with a wooden *minbar*, fashioned from teak imported from Baghdad.

Thus, the Abbasids left a profound impression on Islamic civilisation at that time. The fascination that they inspired is reflected in many cultural and artistic manifestations, with all Muslim countries aspiring to emulate Baghdad.

Textile fragment
Tapestry woven in the manner used by Coptic weavers over several centuries.

Abbasid, AH 3rd/AD 9th century
Ribat Museum
Monastir, Tunisia

PERSONALITIES

Al-Mansur, 'Abdallah Abu Ja'far (101–58/718–75) was born in al-Humayma, south of the Dead Sea. He participated in the revolution against the Umayyads and became caliph in 136/754. He established the Abbasid state system, and built several cities in Iraq including Hashimiya on the Euphrates, the round city of Baghdad and al-Rusafa. Al-Rafiqa, adjacent to al-Raqqa in Syria, was also built by him. His armies fought the Byzantines reaching Baku in the Caucasus, Kandahar in Afghanistan and Kashmir in northern India.

Harun al-Rashid (145–94/763–809) was born in the city of Rayy in central Iran. Before becoming a caliph, he controlled the western half of the empire, from Western Iraq to Ifriqiya. He became caliph in 170/786. His rule coincided with the most prosperous period of the empire. He loved poetry and music, and supported the arts and architecture with his patronage. It was during his reign that the first hospital and observatory were built in Baghdad.

Al-Mu'tasim, Muhammad Abu Ishaq (177–228/793–842) was born in Baghdad and grew up in the army to become a model Arab knight. In 828 he was appointed governor of the Levant and Egypt before becoming caliph in 218/833. After only a year in Baghdad, he decided to build a new capital and barrack-city for his 4000-strong Turkish army. He built Samarra in 221/836, some 125 km north of Baghdad.

Ibn al-Aghlab, Ibrahim (r. 184–97/800–12): Caliph Harun al-Rashid gave Ifriqiya to Ibrahim ibn al-Aghlab – a Khurasanian Arab in the caliph's army – as a hereditary principality to rule. The Aghlabids became the vassals of the Abbasids in Ifriqiya between the years 184/800 and 296/909. They rebuilt several cities and constructed military fortifications along the Tunisian coast. They organised civic affairs and developed communication routes between North Africa and the Middle East.

Ibn Tulun, Ahmad (r. 254–70/868–84) was aged 33 when he was sent to Egypt as deputy governor and succeeded in stabilising the region, ensuring fiscal stability. He became governor of Egypt in 870 introducing agricultural reforms and bolstering industry. He renovated the Nilometer and built the district Qata'i', based on the Samarra model. At the centre he built a mosque in his name. He expanded his territory by conquering Syria and Palestine and struck his own coinage.

The Conquest of the West:
Córdoba, Umayyad Capital in al-Andalus

Mohamed Mezzine

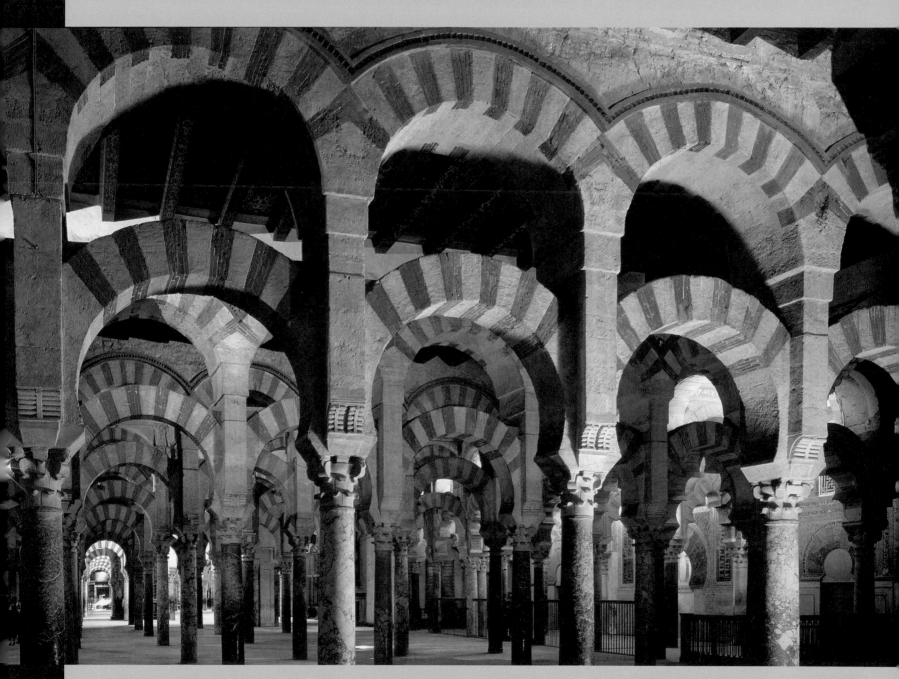

Great Mosque of Córdoba

*Umayyads of al-Andalus, Emirate and
Caliphate periods,* AH 169–377/AD 786–988
Córdoba, Spain

The Conquest of the West:
Córdoba, Umayyad Capital in al-Andalus

Please see map on page 38.

Dinar
Arabic and Latin script were used
together, so as to spread the Islamic
faith.

Umayyad, AH 98/AD 715–6
Numismatic Museum of the Al-Maghrib Bank
Rabat, Morocco

Master weight

Umayyads of the East, AH 127/AD 745
National Museum of Antiquities and
Islamic Arts
Algiers, Algeria

Great Mosque of Kairouan

Umayyad, Abbasid, AH 221/AD 836
Kairouan, Tunisia

For nearly four centuries the story of the Arab-Muslim world was one of
empire-building, from the proclamation of the Umayyad caliphate in Damascus
in AH 41/AD 661 until the fall of the caliphate in al-Andalus and its
splintering into several small kingdoms in 422/1031.

At the time of the first Umayyad caliph, Mu'awiya I, the caliphate
governed Syria and Mesopotamia as well as Egypt, which provided wealth
and prestige as well as a gateway to Africa and the Mediterranean. However,
it was necessary to take control of the regions to the West, Cyrenaica and
Tripolitania (modern-day Libya) to protect Egypt and to annex Fezzan, a
rich commercial crossroads between the Sahara on one side and the
Mediterranean and the Near East on the other, to control the caravan trade.
All of this was in preparation for the conquest of North Africa.

One of the most important actions undertaken to implement this policy was
the Umayyad expedition to Sousse, Bizerte and the island of Djerba. Four
years later, in 49/670, 'Uqba ibn Nafi incorporated this area into the Umayyad
Empire. He founded Kairouan there, creating the first Muslim province in
North Africa: Ifriqiya. Historical texts speak of the construction of the town
and of the miracles performed by 'Uqba, who after his death became Africa's
first Muslim saint. Tradition has it that the heavens showed him the direction

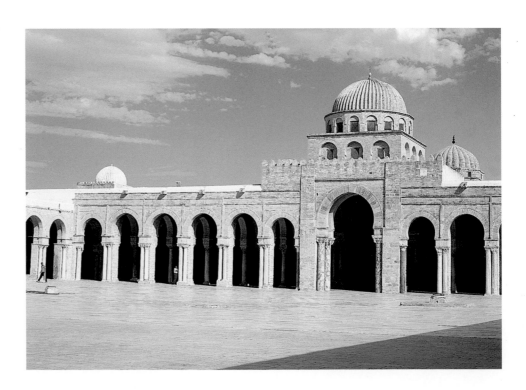

of Mecca to enable him to properly orient his mosque, and that snakes and other animals were ordered to leave the site, which they did.

At this time, the Central Maghreb was inhabited by the Berbers. Their powerful chief, Kusayla, came from the Awraba tribe, which was part of the great Berber confederation of the Sanhaja that covered the whole of the Central Maghreb.

Kusayla, a true prince whose legend passed into posterity, sided with the Umayyads along with all of the Awraba tribes in 59/678, bringing peace and re-establishing trade to the region. Kairouan's 'Uqba Mosque was restored under the auspices of Kusayla along with the rest of the town.

The pacification of Ifriqiya continued for more than 20 years and was completed in 82/701 with the foundation of the Port of Tunis. A thousand Copts, specialists in building ports, helped to draw up the plans. The port was opened in 83/702 and within some 30 years the great city of Tunis was born. Its Great Mosque (Masjid al-Jami) was expanded and became the celebrated Zaytuna Mosque, a sanctuary in the Islamic world and one of the centres of Western Arab-Muslim culture.

The westward expansion of the Umayyads continued to Tiaret, then Tlemcen, in the Central Maghreb. Mosques were built throughout, such as in Aghmat Aïlane (to the south of modern-day Marrakesh), where there has been a *minbar* since 85/704. Two individuals marked the history of this period: Musa ibn Nosayr and Tariq ibn Ziyad.

An extravagant 60-year-old, to those who knew him, Musa ibn Nosayr, protégé of the governor of Egypt, was an ambitious soldier, although he had

Decorative stone
With stylised scrollwork and pomegranates.

Umayyad, AH 86–96/AD 705–15
Museum of Islamic Art, State Museums
Berlin, Germany

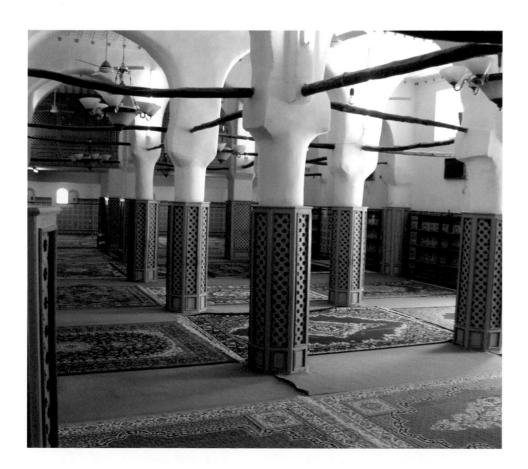

Sidi Okba ('Uqba) Mosque

Western Umayyads, AH 67/ AD 686
Biskra, Algeria

almost no opportunities to demonstrate his talent as a warrior, the exception being his support for Tariq ibn Ziyad's conquest of the Iberian Peninsula.

Tariq was the son of a Berber notable who had supported the Umayyad conquest. Governor of Tangiers, he took the initiative of leading 17,000 men across the Straits of Gibraltar in 92/711 and took the main towns in southern Spain up to Toledo. He later pushed on to the Pyrenees alongside Musa ibn Nosayr, opening up the Peninsula (Bilad al-Andalus) to a new civilisation and culture.

Ivory casket

Umayyads of al-Andalus,
probably shortly after AH 350/AD 961
Victoria and Albert Museum
London, United Kingdom

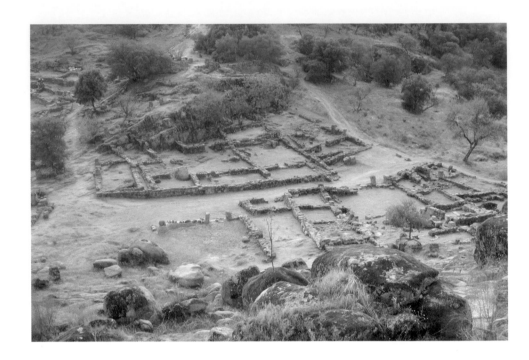

Ivory casket

Umayyads of al-Andalus,
probably shortly after AH 350/AD 961
Victoria and Albert Museum
London, United Kingdom

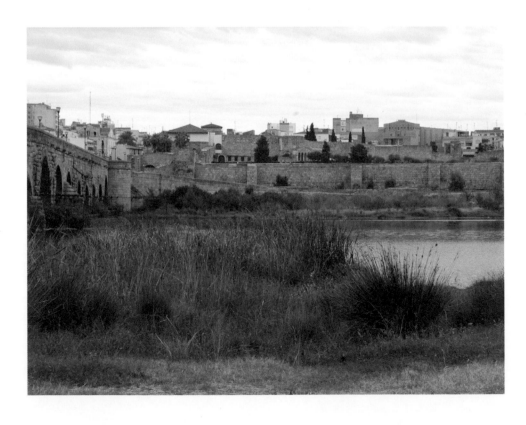

TOP RIGHT
Vestiges of the town of Vascos

Umayyads of al-Andalus, AH 318–39/AD 930–50
Toledo, Spain

Merida Citadel

Umayyads of al-Andalus, AH 220/AD 835
Badajoz, Spain

Bowl

Umayyads of al-Andalus, AH 324–66/AD 936–76
National Archaeological Museum
Madrid, Spain

Bowl

Umayyads of al-Andalus, AH 2nd–3rd/
AD 8th–9th centuries
Municipal Museum of Archaeology
Silves, Portugal

Fountain spout

Umayyads of al-Andalus, AH 339–90/
AD 950–1000
National Archaeological Museum
Madrid, Spain

Bowl

Umayyads of al-Andalus, AH 324–66/AD 936–76
National Archaeological Museum
Madrid, Spain

The arrival of the Umayyads in al-Andalus brought thousands of Berbers to the Peninsula, with many settling there, marrying Arabs or Roman-Iberians, and becoming Muslim Andalusians.

Within 40 years a local political power had grown up: the political and cultural elite, whose ties with Damascus were becoming increasingly stretched, began to prepare for the emancipation of al-Andalus, an event that was precipitated by the Abbasids taking power in Baghdad.

In 137/756 'Abd al-Rahman I, the Umayyad prince who escaped from the Abbasids, took refuge in Spain and made it into an independent emirate. He settled in Córdoba and built its famous mosque, which was expanded by his successors.

At the same time, another refugee was arriving in the Maghreb: Idris I. Fleeing the Abbasids, he founded a new dynasty, the Idrisids (172/789), which maintained relations with the Umayyads in al-Andalus for a century.

In 316/929, 'Abd al-Rahman III took the title of caliph. The caliphate lasted until 422/1031, supported by highly elaborate institutions, a centralised administration, and judicial and financial laws that contrasted with the feudal fragmentation of the Christian states and brought him economic prosperity. His navy dominated the Mediterranean, irrigation was developed, new crops such as sugarcane and mulberry were introduced, and important craft industries (silk, leather and metal) grew up.

At this time, the influence of the Umayyads in al-Andalus was also felt in Morocco, where the town of Fez was in the process of being founded.

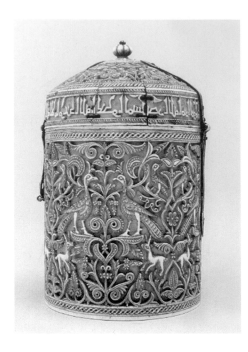

Ivory pot from Zamora

Umayyads of al-Andalus, AH 353/AD 964
National Archaeological Museum
Madrid, Spain

Madinat al-Zahra

Umayyads of al-Andalus, AH 324–65/AD 936–76
Córdoba, Spain

FACING PAGE
Astrolabe
Earliest known European-made and
dated astrolabe.

Umayyads of al-Andalus, AH 417/AD 1026–7
Royal Museum, National Museums Scotland
Edinburgh, United Kingdom

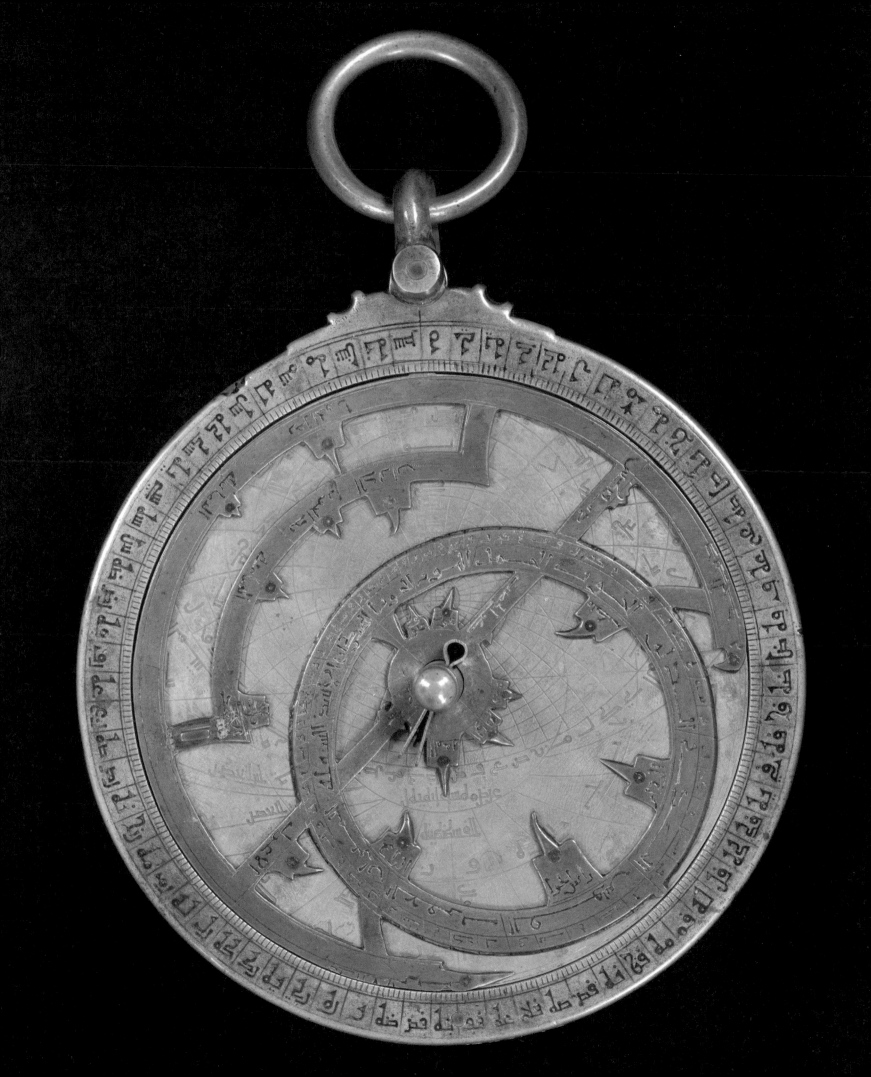

Al-Mansur basin
Ordered for the Royal Palace of
al-Zahira in Córdoba.

Umayyads of al-Andalus, AH 377/AD 988
National Archaeological Museum
Madrid, Spain

Ablutions basin
Produced at Madinat al-Zahira
workshop in Córdoba.

Umayyad Caliphate of al-Andalus,
AH 381–98/AD 991–1008
Dar Si Saïd Museum
Marrakesh, Morocco

The caliphate of Córdoba was an exceptional centre for culture and art, boasting numerous schools and a large library. The great Muslim universities there taught medicine, mathematics, philosophy and literature, with the works of Aristotle explored long before Christian Europe was to discover them. Córdoba became the centre of Arabic culture, with the scholarly achievements of Averroes and Maimonides a century later, its crowning glories. Hispano-Morisco art also reached its peak here.

In the 5th/11th century, Muslim Spain split into a multitude of independent kingdoms, the *ta'ifa* kingdoms, while on the other side of the Mediterranean a new dynasty was establishing itself in Marrakesh, the Almoravids, whose relationship with al-Andalus would not always be easy.

PERSONALITIES

Mu'awiya (r. 41–60/661–80), **Ibn Abi Sufyan**, was the first Umayyad caliph and founder of the dynasty, who emerged victorious from the 12-year struggle with the caliphs 'Uthman (r. 24–36/644–56) and 'Ali (r. 36–41/656–61). He also moved the seat of power to Damascus.

'Uqba ibn Nafi who was appointed Commander-in-Chief in 50/670, travelled across North Africa as far as Safi, bringing all of the regions he crossed into the empire. He was dismissed in 56/675 before returning to favour in 63/684. As the founder of Kairouan, 'Uqba's mausoleum (Sidi Okba), became a place of pilgrimage after his death.

Kusayla (d. 67/686) Berber chief of the Awraba tribe and the Sanhaja confederation, he successfully rallied the Berber tribes of the Central Maghreb against the Arab conquerors, although he ended up embracing Islam and the Umayyad cause in 59/678 and became governor of Kairouan in 63/683.

Musa ibn Nosayr, the Umayyad's great strategist in the Maghreb, was appointed governor of the region in 85/704. He succeeded in taking the Maghreb before overseeing the conquest of al-Andalus, and he sent Tariq ibn Ziyad to conquer the Iberian Peninsula.

Tariq ibn Ziyad (d. 101/720) was the son of Ibn 'Abdallah ibn Walghu and converted to Islam under 'Uqba ibn Nafi. Tariq, who was governor of Tangiers, directed the conquest of Spain in 92/711 and gave his name to Gibraltar (Djebel Tariq, 'Tariq's Mountain').

'Abd al-Rahman I (r. 138–72/756–88) was the son of Mu'awiya and an Umayyad *amir*; he came to power in Córdoba after Yusuf ibn 'Abd al-Rahman al-Fihri in 138/756. His reign lasted 32 years and he is considered to be the founder of the Umayyad Dynasty in al-Andalus.

Idris I (r. 172–4/788–91) was a descendant of the Prophet via 'Ali and escaped the Abbasids to Morocco, settled in Volubilis and founded the town of Fez and the Idrisid Dynasty. Today his mausoleum is a place of pilgrimage.

'Abd al-Rahman III (known as al-Nasir, 'the Victorious'; r. 316–50/929–61) was an Umayyad *amir* who proclaimed himself Prince of Believers and caliph. He freed the province of al-Andalus from the control of Baghdad and was responsible for the construction of Madinat al-Zahra.

Averroes (**Ibn Rushd**; r. 520–94/1126–98) was an Arab doctor, philosopher and mathematician who lived in Seville and Córdoba. His works were translated into Latin and Hebrew and had a great influence on Christian thought and western European philosophy.

Maimonides (**Moshe ibn Maïmun**; 529–600/1135–1204), also known as 'Rambam', this theologian, philosopher and doctor was a Spanish Jew with an Arabic upbringing who lived in Córdoba and then Fustat in Egypt. Doctor to Saladin and a jurist, he is still revered by intellectuals the world over.

Calligraphy: the Sublime Art of Islam

Şule Aksoy and Khader Salameh

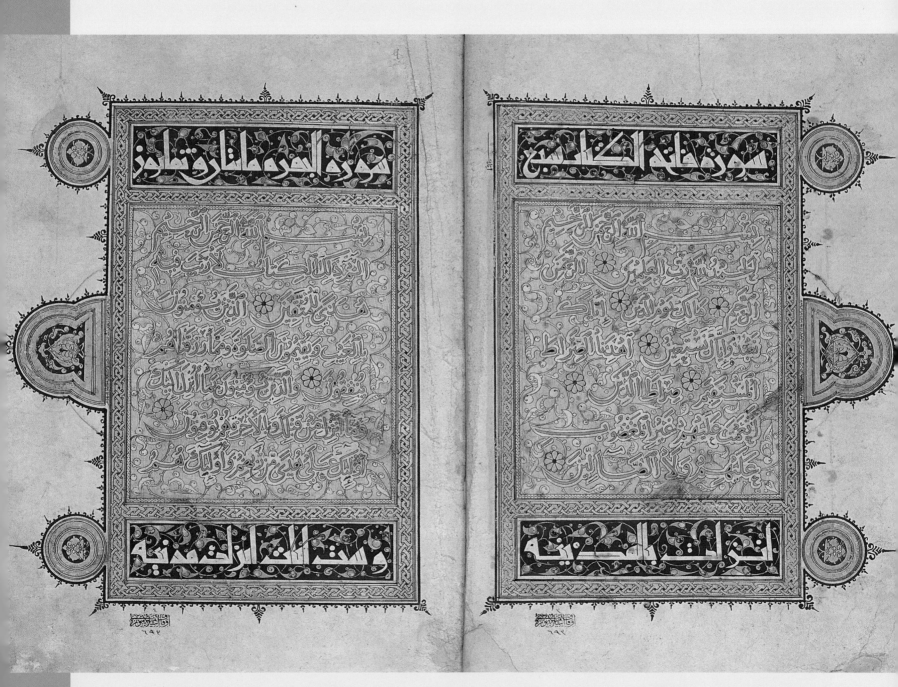

Qur'an

Mamluk, AH Ramadan 713/AD December 1313
Museum of Turkish and Islamic Arts
Istanbul, Turkey

FACING PAGE
Page from a Qur'an
Vowels are marked by red or black dots.

Abbasid, AH 3rd–4th/AD 9th–10th centuries
Museum of Turkish and Islamic Arts
Istanbul, Turkey

Qur'an
Written in *kufic* script.

Abbasid, AH 3rd/AD 9th century
Islamic Museum and Al-Aqsa Library
Jerusalem

The evolution of Islamic calligraphy over a period of 14 centuries is one of the most fascinating phenomena within Islamic civilisation. Arabs, Persians and Turks were among those who – across time and space – contributed to its development in terms of lettering and the elaboration of calligraphic styles.

A Muslim's foremost duty is to ensure the perpetuation and preservation of Allah's word, and it was out of this duty that the art of calligraphy first arose in the AH 1st/AD 7th century. Initially the Revelations received by the Prophet had simply been memorised. However, very soon the enormous responsibility of accurately preserving the Divine Word led to the first attempts at eternalising it in physical form. Very early Qur'anic fragments executed in rather ungainly, cursive Arabic styles of writing survive on materials as diverse as parchment, leather and even bone. However, by the late 1st/7th and early 2nd/8th centuries these unrefined scripts had given way to a well-proportioned and highly refined calligraphic style of dignified and superb beauty. The new script, named *kufic* after the Iraqi city of Kufa where it was developed, now became the Qur'anic script par excellence for some centuries to come, its disciplined angularity exuding a sacred aura that both reflected and visually complemented the sanctity of the text. By the 4th/10th century, however, the centrality of *kufic* script was waning in the Eastern Islamic world as new styles were coming to the fore. Only in the Muslim West and al-Andalus did the style retain its pivotal status; sublime *kufic* Qur'ans continued to be executed in Kairouan in Tunisia, the first and foremost centre of calligraphic excellence in

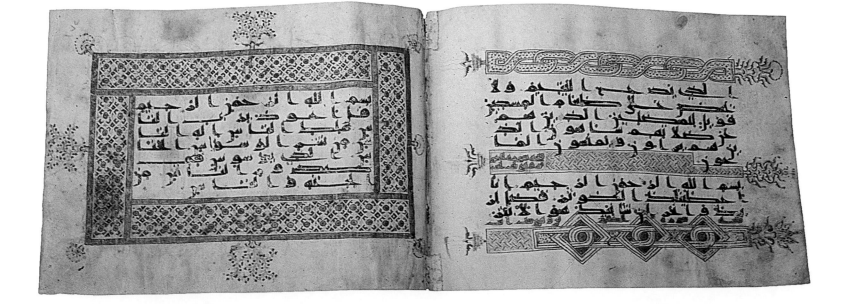

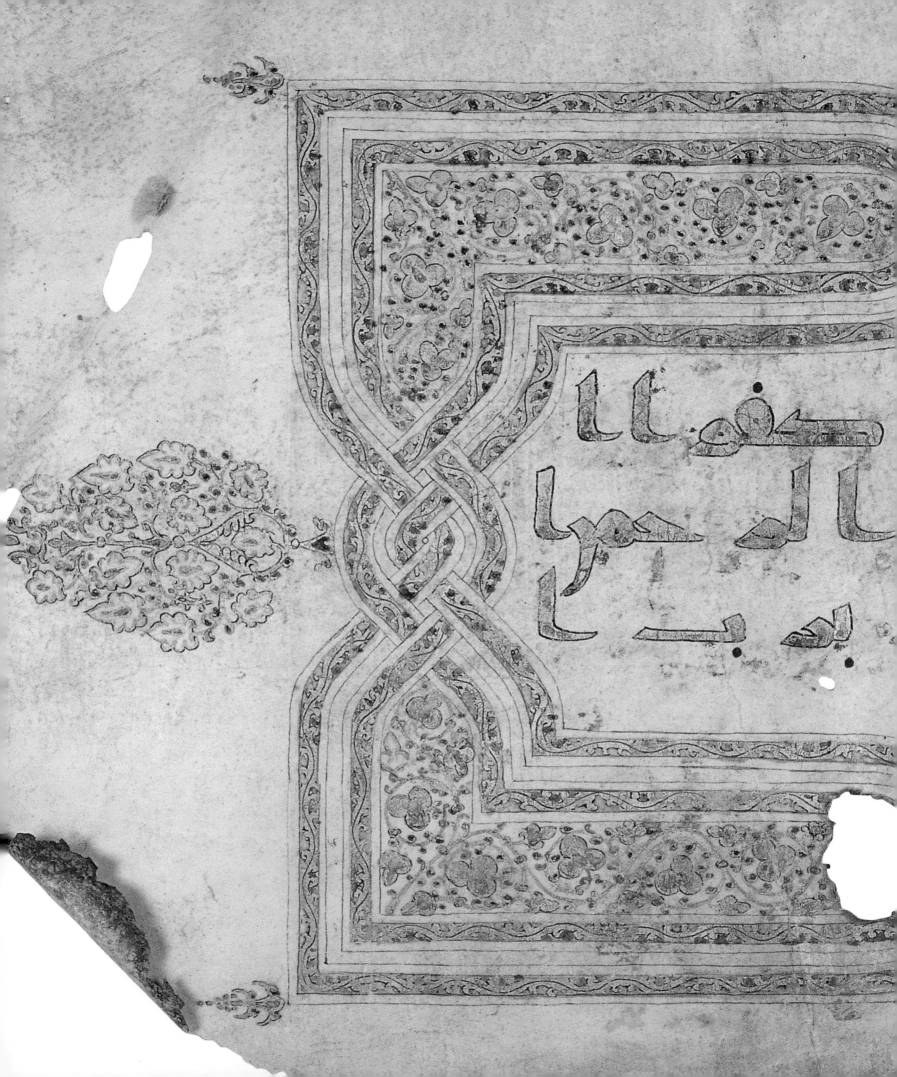

Qur'an
Written in *Maghrebi*-style script using black ink.

Marinid, AH 745/AD 1344
Islamic Museum and Al-Aqsa Library
Jerusalem

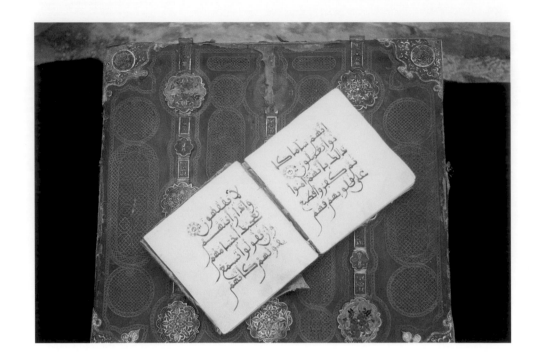

Qur'an
Written with liquid silver on green paper, in *Maghrebi*-style cursive script.

Wattasid, AH 9th/AD 15th–16th centuries
National Library
Rabat, Morocco

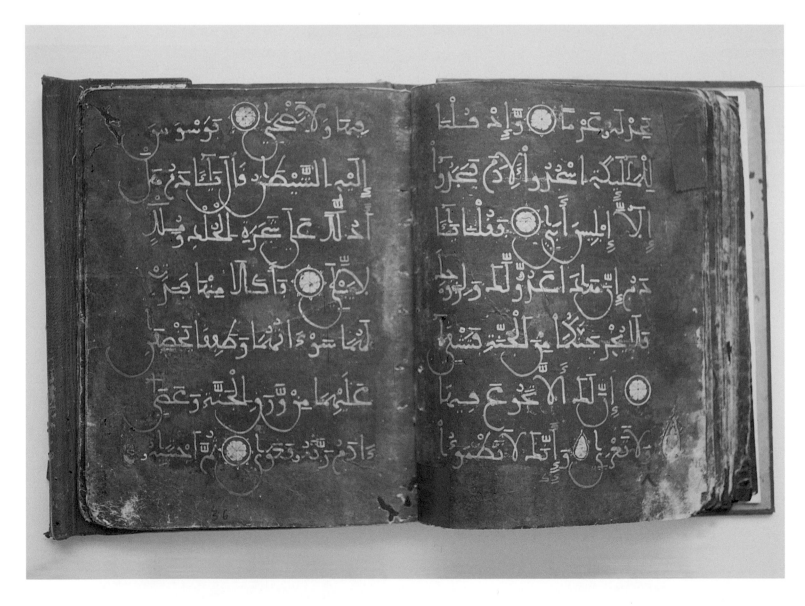

that region. From North Africa, the *kufic* style travelled to al-Andalus where
it gradually absorbed Andalusian elements and eventually evolved into the
so-called *Maghrebi* script which is still in use today.

Back at the heart of the caliphate, meanwhile, Ibn Muqla (d. 328/940) of
Baghdad initiated a set of clear rules defining the precise proportions of
every letter of the Arabic script. He is also credited with the development of
new calligraphic styles, including *naskhi*, *thuluth* and *muhaqqaq*, all of which
were to become pivotal throughout the Muslim world, not only on paper but
also, increasingly from the 4th/10th century onwards, throughout other
artistic media such as architecture and the minor arts.

In the 7th/13th century Yakut al-Mustasimi, the court calligrapher of the
last Abbasid caliph further refined existing styles. His work continues to
influence Arab, Persian and Turkish calligraphers to this day.

After the fall of the caliphate in 656/1258, Mamluk Cairo became the new
cultural centre of the Muslim world. Calligraphy received unprecedented
attention within Mamluk art. Much patronage was extended to the production
of luxurious codices of the Holy Qur'an, but soon calligraphic compositions

Qur'an
Written in *thuluth* script with black
ink.

Mamluk, before AH *771/*AD *1369*
Islamic Museum and Al-Aqsa Library
Jerusalem

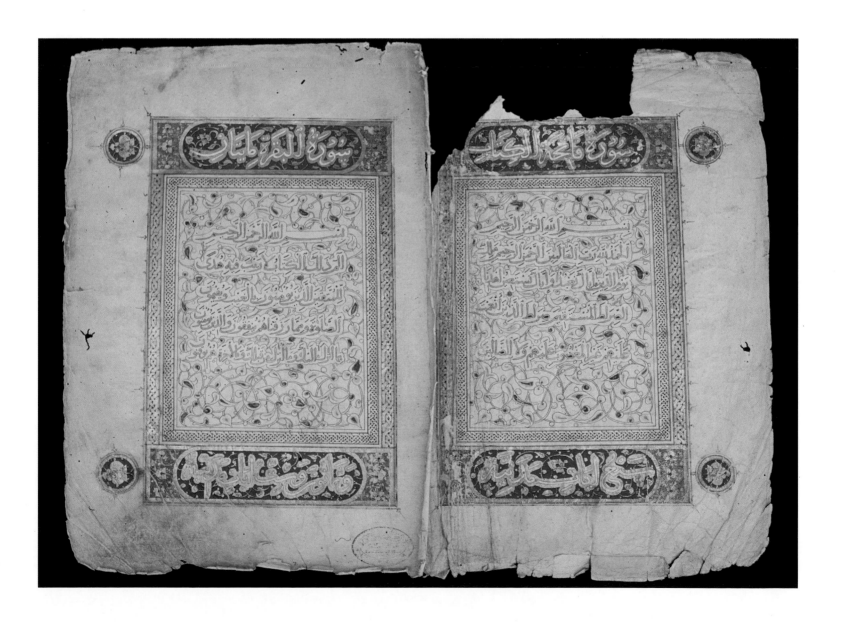

also came to predominate as the main artistic features of the minor arts, including metalwork, glassware and ivory carving.

With the advent of the Ottoman Dynasty, the calligraphic output of the empire emanated from the sultan's palace workshops in Istanbul. Calligraphy followed a particular tradition until the time of Mehmed II, after which time it gained in momentum taking on a new and creative spirit. Amasya and Edirne were two 9th-/15th-century centres where many significant calligraphers were trained, including Shaykh Hamdullah, who was considered the

Epigraphic ivory panel
Written in *naskhi* script, the panel mentions the name of Sultan Qaytbay.

Mamluk, AH 872–901/AD 1468–96
Museum of Islamic Art
Cairo, Egypt

Basin

Mamluk, AH 8th/AD 14th century
Museum of Islamic Art
Cairo, Egypt

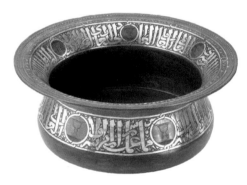

Mosque lamp
The wide band of *thuluth* script bears an excerpt from the Qur'an.

Mamluk, AH 742–54/AD 1342–54
Royal Museum, National Museums Scotland
Edinburgh, United Kingdom

FACING PAGE
Qu'ran box
In Mamluk Egypt Qur'ans were usually kept in boxes decorated with fine examples of calligraphy.

Mamluk, C. AH 730/AD 1330
Museum of Islamic Art, State Museums
Berlin, Germany

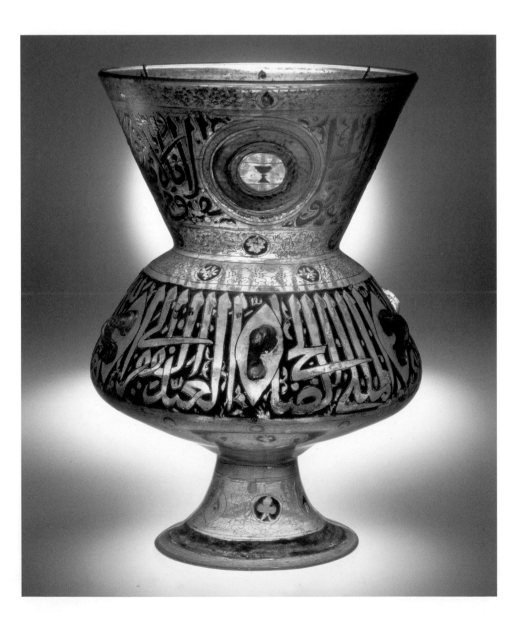

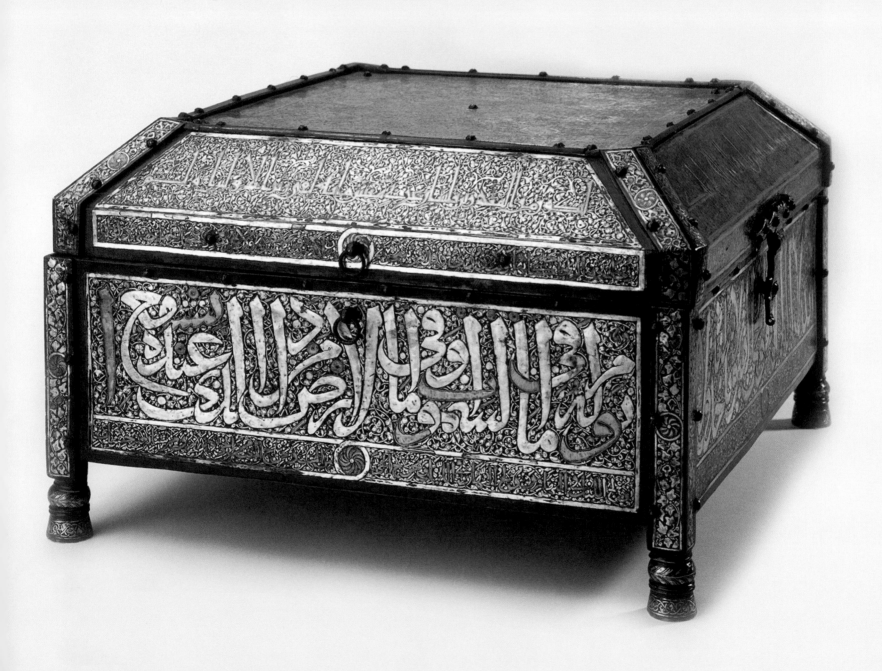

Qur'anic manuscript
Belonging to Amir Bayazid, son of
Sultan Sülayman the Magnificent.

Ottoman, AH 964/AD 1556
Islamic Museum and Al-Aqsa Library
Jerusalem

Tomb cover

Ottoman, AH 11th/AD 17th century
Royal Museum, National Museums Scotland
Edinburgh, United Kingdom

Eski Mosque
Interior view with samples of the
gigantic calligraphy on the walls.

Ottoman, AH 817/AD 1414
Edirne, Turkey

FACING PAGE
Qur'an of Shaykh Hamdullah

Ottoman, AH 899/AD 1494
Museum of Turkish and Islamic Arts
Istanbul, Turkey

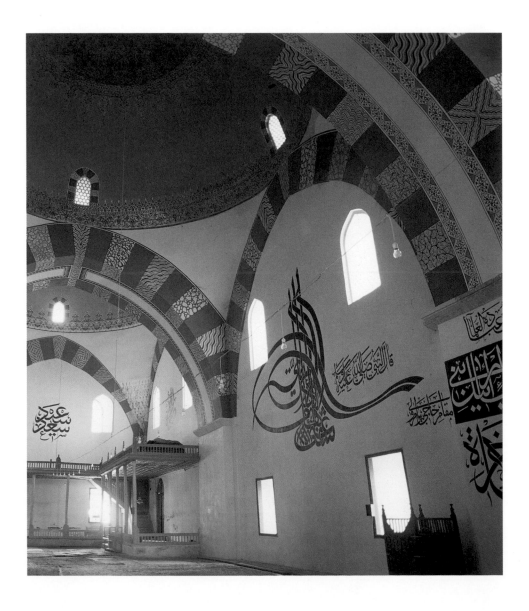

صَدَقَ اللهُ الْعَظِيمُ ۞ وَصَدَقَ رَسُولُهُ الْكَرِيمُ ۞ وَنَحْنُ

عَلَى ذَلِكَ مِنَ الشَّاهِدِينَ ۞

وَكَتَبَ الْفَقِيرُ حَمْدُ اللهِ بْنِ مُصْطَفَى دَدَه الْمَعْرُوف

بِابْنِ الشَّيْخِ حَامِدًا اللهَ عَلَى نِعَمِهِ وَمُصَلِّيًا عَلَى نَبِيِّهِ مُحَمَّدٍ

وَآلِهِ وَمُسَلِّمًا وَسَلَّمَ تَسْلِيمًا كَثِيرًا

كَثِيرًا

Album of Ahmed Karahisari
The famous artist breathed new life into 16th-century Ottoman calligraphy.

Ottoman, AH 10th/AD 16th century
Museum of Turkish and Islamic Arts
Istanbul, Turkey

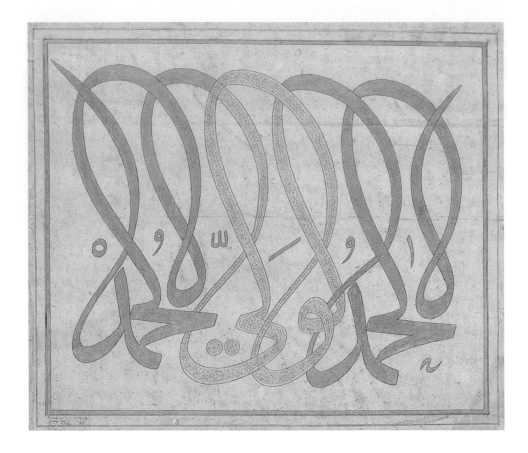

Kıbletü'l-Küttab (Master of Calligraphers) during the rule of Bayazid II (r. 830–918/1481–1512). Another genius of Turkish calligraphy in the 11th/17th century was Hafız Osman, whose reputation was due to the Qur'ans he transcribed and the copies of the *Hilye-i Sherif* (Noble Description) he produced. Editions of the *Hilye-i Sherif* were the result of the prohibition of figurative depictions in the Islamic world and were a literary device used to describe the physical appearance of holy people, enriched with verses taken from the Qur'an.

Today, the art of calligraphy, the sublime art of Islam, is in the hands of a new generation of calligraphic artists who are engaging with it as a contemporary art form that is poised to stand the tests of time.

Islamic and Norman Sicily

Pier Paolo Racioppi and Ettore Sessa

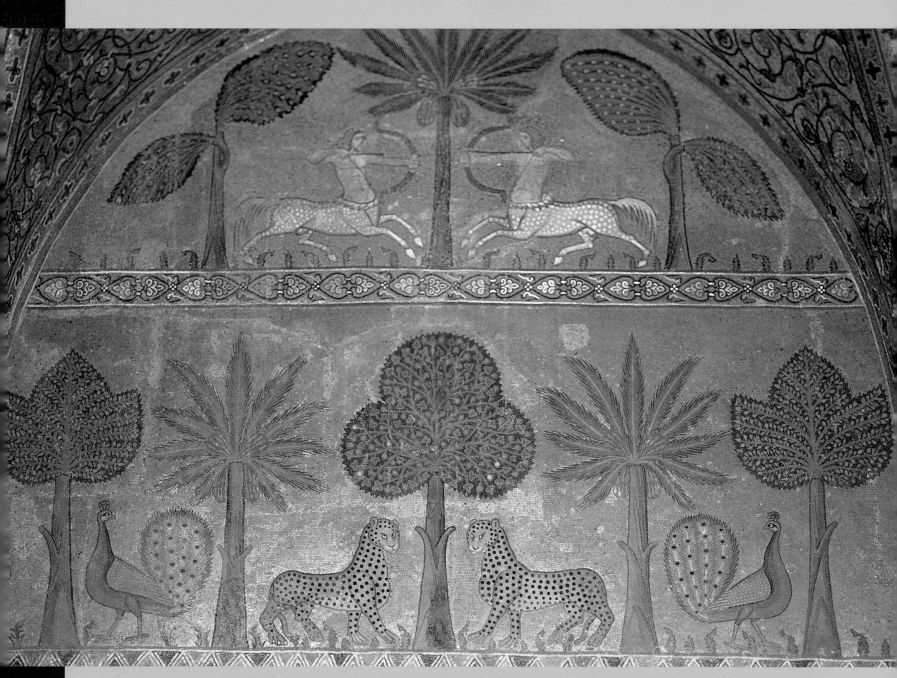

Royal Palace
Mosaic in the Ruggero Room (detail).

Norman, mosaics dating to AD 1154 *and* 1166
Palermo, Italy

Please see map on page 106.

Qanat
Underground drainage channels,
which extended over tens of
kilometres, ensured a continuous and
spontaneous supply of water.

Fatimid, Norman, AH 6th/AD 12th century
Palermo, Italy

Since the year AD 537 in the late Middle Ages, after a relatively brief period
of Barbarian invasion, Sicily had been a firmly established part of the
Byzantine Empire and remained so until AH 212/AD 827, when an Aghlabid
fleet left Sousse and landed at Mazara del Vallo (Capo Granitola), led by Asad
ibn al-Furat.

In 216/831 Palermo became the capital of the new Aghlabid Emirate,
which at that point did not yet control the entire island, and remained so until
the fall of the dynasty in 296/909 at the hands of the Fatimids. The Fatimids
set up an emirate in Sicily in 336/948, which remained faithful to them under
the rule of Hasan al-Kalbi, the founder of the Kalbid Dynasty that governed up
until the mid-5th/mid-11th century, although the final period of Kalbid reign
was characterised by in-fighting and the formation of independent fiefdoms.

Material evidence from the Aghlabid and Kalbid eras is limited to remains
of walls incorporated into later constructions, inscriptions, tombstones and
ceramic objects. Textual sources from the time are more abundant,
describing a land that saw the introduction of new farming techniques and
hydraulic engineering projects for irrigation and water supply. An example

of this is the network of canals (*qanat*) beneath Palermo, a city where the local people appear to have adapted their lifestyles and social customs to the rules of the Qur'an, and where Christians and Jews lived in a world of official tolerance and practical discrimination.

However, it was not the Aghlabids or the Kalbids who were responsible for the outstanding legacy of art, science, law and civilisation left by Islamic Sicily but, paradoxically, the new Norman Christian conquerors of the island, most obviously in their great royal commissions. In 1061 the Normans Roger and Robert Guiscard de Hauteville invaded Sicily from their strongholds in Southern Italy, taking advantage of the rivalry between the Muslim governors

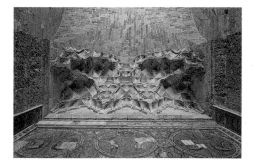

Zisa
View of *muqarnas* in a large niche (seen from below).

Norman, AD 1165–80
Palermo, Italy

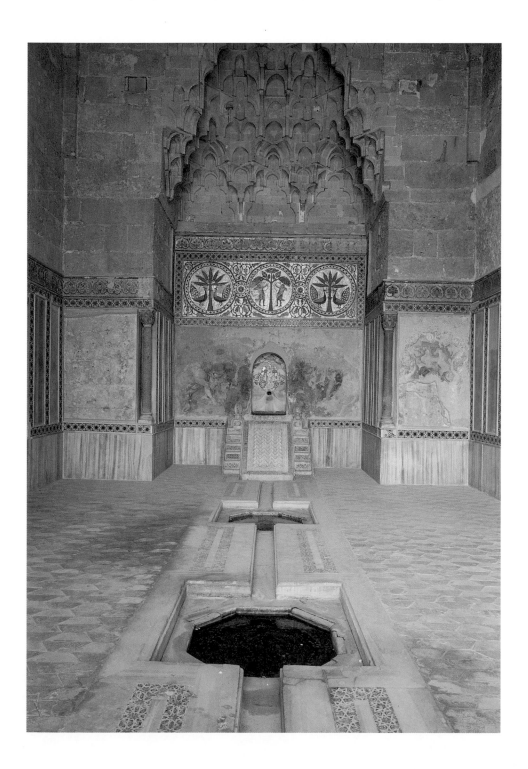

Zisa
Large niche with *muqarnas* in the fountain room.

Norman, AD 1165–80
Palermo, Italy

of Agrigento and Catania. It turned out to be a perfect moment to begin the reconquest of Sicily. In 1098 Pope Urban II made Count Roger Apostolic Legate of the Island, which gave him the right to exercise apostolic power independently, and in 524/1130 it became an independent kingdom under Roger II (r. from 506/1112 as count; as king, 524–49/1130–54). It remained so even after the succession of the Hohenstaufen Dynasty in 592/1195. Indeed, Frederick II (known as '*stupor mundi*' or 'wonder of the world'), who was first crowned King of Sicily in 595/1198 at the age of four under the regency of Pope Innocent III and then Emperor from 617/1220, made the customs of the Norman court a distinctive feature of his monarchy.

It was during the reign of Roger II that the original character of Norman art and architecture in Sicily and Southern Italy was defined. At this point foreign elements from as far afield as the Maghreb, Byzantium and Islamic Egypt are grafted onto a pre-existing Sicilian style, which in turn had arisen from the synthesis of local Byzantine elements, and architectural as well as structural forms, developed in the Islamic period. The development was facilitated by the wave of military successes delivered by the fleet of the kingdom of Sicily as it occupied the coastal regions of Tunisia and part of the Adriatic coast of the Byzantine Empire. The artistic and architectural culture promoted by the Norman kings thus looked to the mosaic art and ecclesiastical forms of Byzantium and the Romanesque buildings of France and England, as well as to Arabic culture, assimilating and reworking these influences into a highly original style of its own. No less important, possibly, within the context of the *renovatio imperii* were the references to the grandiose style of Early Christian art, with the widespread and – at that particular time – unique use of columns in church naves.

The surviving Arabic architectural legacy, such as the recreational palaces set amidst lush gardens and expanses of water (for example, Castello della Favara di Maredolce in Palermo), inspired the Norman kings to build brand-

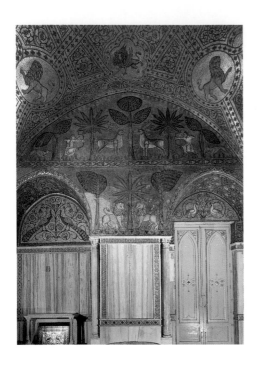

Ruggero Room at the Royal Palace

Norman, mosaics dating to AD *1154 and 1166*
Palermo, Italy

**Ruggero Room at the Royal Palace
(detail)**

Norman, mosaics dating to AD *1154 and 1166*
Palermo, Italy

FACING PAGE
Ruggero Room at the Royal Palace
The Swabian eagle, added at the time of Frederick II, and seen within an octagon at the centre of the vault, dominates the composition which is laid out on a gold background.

Norman, between AD *1131 and 1154*
Palermo, Italy

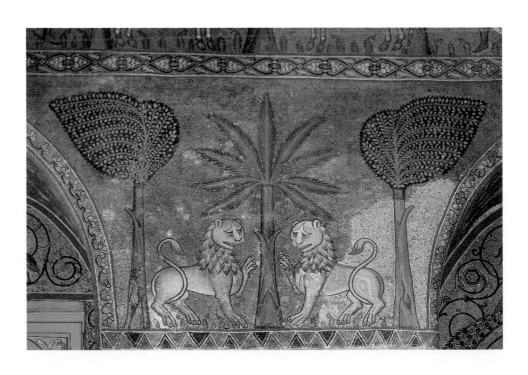

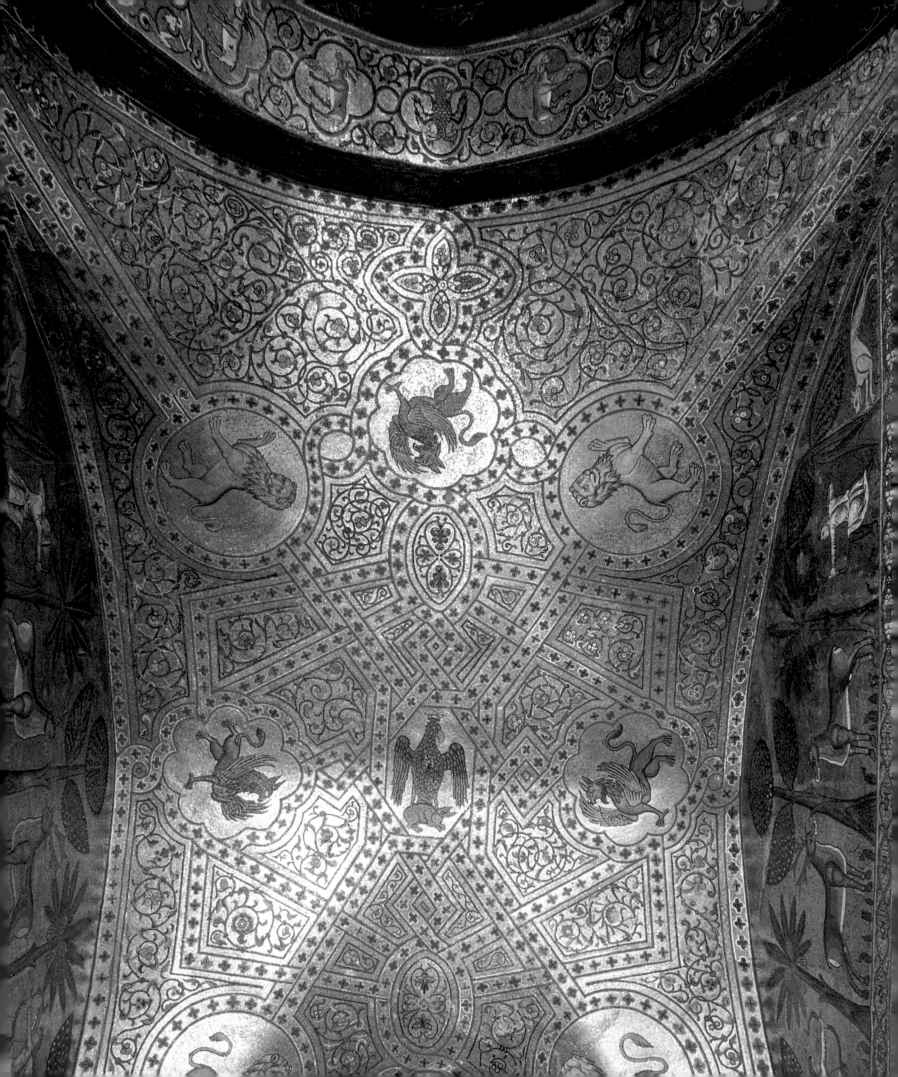

new recreational palaces such as the Zisa, the Cuba, the Uscibene (all *solatia* or pleasure gardens in the great royal Norman park, Conca d'Oro). Fresh inspiration for these exceptional buildings was even sought in contemporary Fatimid art. This probably involved bringing craftsmen directly from Egypt, with which Roger II maintained diplomatic relations, to work on particular parts of the Cappella Palatina and Cefalù Cathedral, including the painted wooden ceilings. It was also the Norman Dynasty that had a *tiraz* workshop set up in the Royal Palace in Palermo. The workshop went on to produce some of the most exquisite craftwork in the whole of Medieval Europe, including cloth embellished with gold filigree, jewellery, trimmings for clothes and ivory caskets.

The most representative buildings of the Norman period attest to the proactive syncretism of the image-based politics used by Roger II, William I, William II and other important individuals of the time, personalities such as George of Antioch and Maione of Bari, both of whom commissioned churches

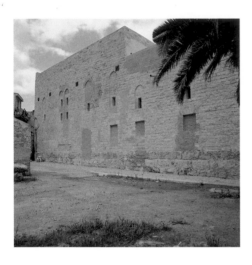

Castello della Favara di Maredolce

*Probably Fatimid, AH 388–409/AD 998–1019;
Norman, second half of the 12th century*
Palermo, Italy

Arab Baths

Fatimid, Norman, AH 6th/AD 12th century
Cefalà Diana, Italy

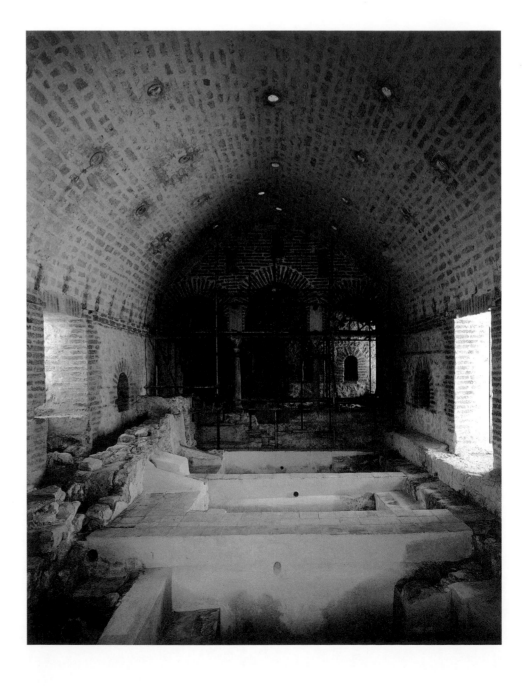

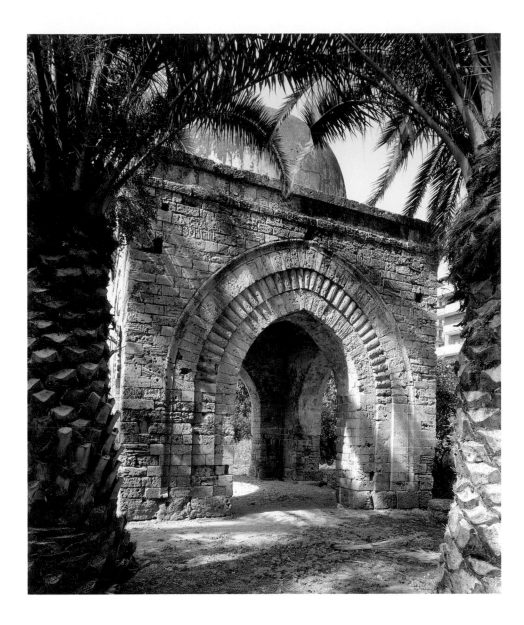

Piccola Cuba (Little Qubba)
Norman, second half of the 12th century AD
Palermo, Italy

Cuba (Qubba)

Norman, between AD *1171 and 1180*
Palermo, Italy

Cappella Palatina
Painted wooden ceiling (detail).

Norman, between AD *1131 and 1140*
Palermo, Italy

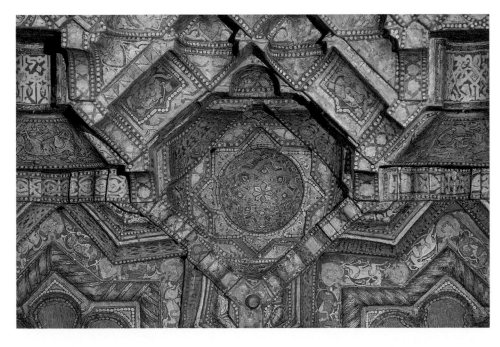

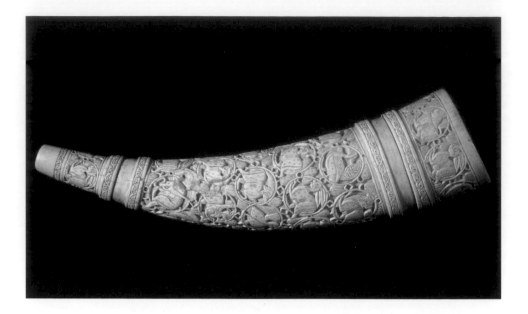

Oliphant
Carved from an ivory tusk.

Fatimid or Norman, AH *5th–6th/*
AD *11th–12th centuries*
Museum of Islamic Art, State Museums
Berlin, Germany

in a marked Byzantine style with significant Islamic features. The extensive diffusion of Siculo-Norman art throughout Sicily, subject in places to peripheral and provincial interpretations that were often nonetheless of great value, is evidence of the fruition of an original culture that represents the very essence of the Sicilian people in the early Middle Ages.

An image that sums up Sicily's capacity to assimilate Islamic cultural models, borrowing elements to define its character without compromising its own identity, can be found in the journal of the Valencian traveller, Ibn Jubayr, who was in Sicily from 579 to 581 (1183 to 1185). With reference to William II, he wrote: 'He resembles the Muslim kings in the custom of immersing himself in the delights of the princedom, as well as his legislative decrees, customs, the ranking of his optimates [the 'Best of Men' who were the aristocratic faction of the Roman Republic], the magnificence of his court and the sumptuousness of the decoration'.

PERSONALITIES

Asad ibn al-Furat (141–212/759–828) was a celebrated jurist of Persian origin, best known as the commander of the Aghlabid forces that conquered Sicily. The 212/827 expedition was ordered by the Amir of Kairouan Ziyadat Allah I to come to the aid of Eufemio, a Byzantine official who was seeking the support of the Muslims to create a Sicilian kingdom that was independent of Byzantium but allied to the Muslim world.

Hasan al-Kalbi was the founder of the Kalbid Dynasty that ruled Sicily from 337/948 until the mid-5th/11th century. He was sent to Sicily by the Fatimid Caliph al-Mansur to put down a revolt in Palermo, and he went on to found a semi-independent hereditary emirate.

Roger of Hauteville was the youngest son of Tancred of Hauteville. He arrived in southern Italy (occupied by the Normans since the early 11th century) in 1059 and was made Count of Calabria by his brother Robert Guiscard. He led the armed force that conquered Sicily between 1061 and 1091.

Robert Guiscard was made Duke of Puglia, Calabria and Sicily in 1059 by Pope Nicolas II. His conquest of

Reggio, Calabria, in 1060 was a springboard for the invasion of Sicily undertaken with his brother Roger.

Roger II was the son of Roger of Hauteville and Adelaide del Vasto. He was the first king of Sicily (r. 525–49/1130–54). He undertook military campaigns in North Africa and managed to occupy much of the coastal region of modern-day Tunisia. He also launched several successful offensives against the Byzantine Empire, forcing it to cut short its hegemonic designs on the West.

William I was King of Sicily (r. 549–62/1154–66). His power was undermined by revolts led by the Sicilian nobility, and it was during his reign that the Almohad 'Abd al-Mu'min succeeded in retaking the North African territories previously occupied by Roger II.

William II King of Sicily (r. 567–85/1171–89) undertook far-reaching administrative reforms and actively promoted art and culture. His reign was characterised by greater political stability and peaceful coexistence between different ethnic and religious groups in Sicily.

The Fatimids: Two Centuries of Supremacy

Ulrike Al-Khamis

Great Mosque of Mahdiya

Fatimid, Zirid, construction started in AH 303/AD 916
Mahdiya, Tunisia

The Fatimids: Two Centuries of Supremacy

It was the assassination of Caliph 'Ali at Kufa, and of Imam Husayn, his son, and the grandson of the Prophet Muhammad at Karbala, that gave rise to Shi'ism, a movement that claimed its right to the caliphate on the basis of their leaders' descent from the Prophet through his daughter, Fatima. Fiercely attacked by the Umayyads and Abbasids, various forms of Shi'ism nevertheless succeeded in spreading throughout the Muslim world and soon reached North Africa. It was here that a group of Shi'ite missionaries led by Abu 'Abdallah al-Shi'i was established, and they declared their aim to conquer the Islamic caliphate. The Fatimid caliphate (AH 296–566/AD 909–1171) was effectively born at Raqqada, in Ifriqiya (modern day Tunisia), where the movement first usurped the local Aghlabid Dynasty in AH 297/AD 910. The first Fatimid capital was al-Mahdiya (Mahdia), built under the direction of 'Abdallah al-Mahdi in 308/914. The town adopted an innovative plan, designed to reflect the centrality of the Shi'ite caliph according to the Fatimid world view, a style which would soon affect the appearance of all subsequent Fatimid cities: instead of the mosque the splendidly decorated, multi-storey

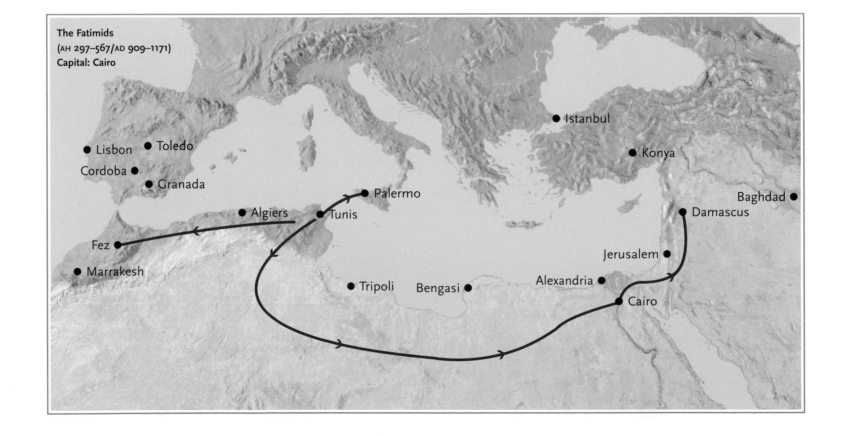

The Fatimids
(AH 297–567/AD 909–1171)
Capital: Cairo

Istanbul

Konya

Lisbon Toledo

Cordoba

Granada

Palermo

Baghdad

Algiers Tunis

Damascus

Fez

Jerusalem

Marrakesh

Tripoli Bengasi Alexandria

Cairo

palace of the caliph, who was both political leader and spiritual figurehead of the Fatimids, now occupied the very heart of the city and overlooked the main mosque near the city walls.

Some years later, under the enlightened rule of the Fatimid caliph al-Mu'izz li-Din Allah (r. 341–63/953–75), the remarkably prosperous, economic conditions of the fledgling realm provided a favourable climate in which finally to attempt the conquest of the caliphate as a whole. As part of his grandiose plan the caliph dispatched General Jawhar al-Siqilli eastwards to conquer Egypt. In 357/969, al-Mu'izz entered Egypt victorious and the foundations were laid for a new capital – al-Qahira ('The Victorious') – its remains still visible today at the heart of modern Cairo. Al-Qahira was

Great Mosque of Mahdiya
View of the colonnade surrounding the courtyard.

Fatimid, Zirid, construction started in
AH *303/*AD *916*
Mahdiya, Tunisia

TOP LEFT
Great Mosque of Mahdiya
Mihrab (detail).

Fatimid, Zirid, construction started in
AH *303/*AD *916*
Mahdiya, Tunisia

Bab al-Futuh

Fatimid, AH *480/*AD *1087*
Cairo, Egypt

Mosque of al-Azhar

Fatimid, AH 359–61/AD 970–2
Cairo, Egypt

BELOW RIGHT
Parts of a *minbar* from the Andalusian Mosque
Side panels.

Tunisian Fatimid, AH 369/AD 980
Batha Museum
Fez, Morocco

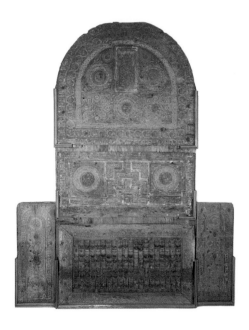

Parts of a *minbar* from the Andalusian Mosque
Back panel.

Umayyad of al-Andalus, AH 375/AD 985
Batha Museum
Fez, Morocco

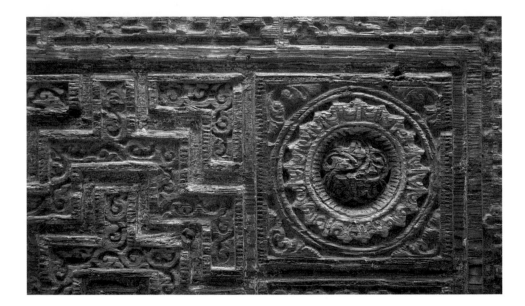

enclosed by a city wall with eight gates, one of which, Bab al-Futuh (Gate of Conquest), still stands today. The rule of North Africa was delegated to the Zirids, vassals of the Fatimids that were soon to use the opportunity to become independent and renounce Shi'ism in favour of Sunni Islam.

In Cairo, too, the enormous caliphate complex known as *al-Sharqi* or the Eastern Palace lay at the very heart of the city and covered more than nine hectares, one-fifth of the entire city. Later, the so-called Western Palace was built opposite the initial complex with a public square lying in between the two. Little remains or is known about these palaces, but historical sources mention internal burial areas reserved for Fatimid royals, a fact that would

have enhanced the air of sanctity surrounding them. As the empire expanded, concepts of Fatimid royal architecture were transmitted as far afield as Sicily and continued to inspire royal building projects there until well after the Norman Conquest.

The Fatimids also exerted much effort on the construction, furnishing and maintenance of mosques and other religious architecture to disseminate their Shi'ite beliefs. Whether at al-Mahdiya, their Ifriqiyan base, or in their splendid capital, Cairo – with imposing complexes like the Azhar and Aqmar mosques – or in regions as far away as Sicily, Fatimid mosques were designed to act as beacons of Shi'ite propaganda. Architecturally, mosques of the Fatimid period are distinctive for their protruding entrances reminiscent of Roman 'victory arches', their carved stone domes, ornate facades with *kufic* inscriptions of Shi'ite content and – most notably – the absence of a minaret. The Azhar Mosque, based on the mosque at al-Mahdiya, was the first Fatimid mosque in Cairo, built as a centre for the propagation of Fatimid Shi'ite theology. Later it was appropriated for Sunnism and became the largest Islamic university in the world.

The interiors and furnishings of Fatimid mosques and mausoleums were richly endowed and decorated with elegant religious inscriptions and intricate arabesque ornamentation. Royal patronage ensured the highest standards of

Shrine of Sayyida Ruqayya, daughter of 'Ali ibn Abi Talib

Fatimid, AH 527/AD 1133
Cairo, Egypt

Page of the Blue Qur'an

Fatimid, AH second half of the 4th/ AD 10th century
Museum of Islamic Art, Raqqada
Kairouan, Tunisia

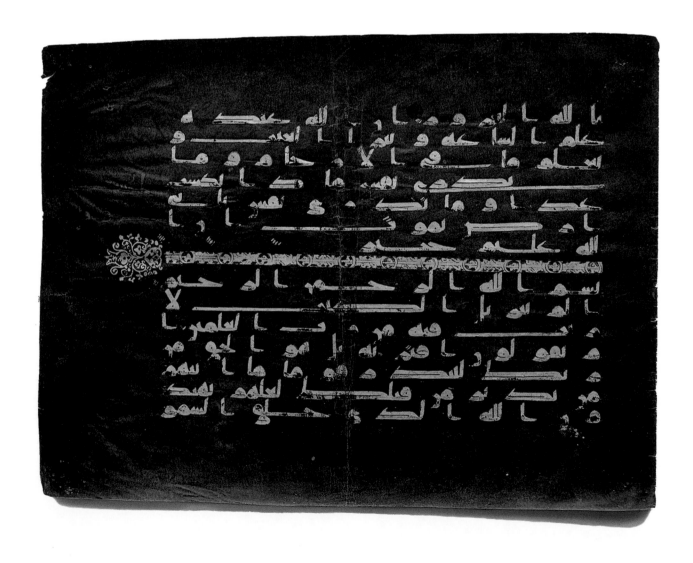

Cappella Palatina
Painted wooden ceiling (detail).

Norman, between AD 1131 *and* 1140
Palermo, Italy

Oliphant

Fatimid, AH *5th–6th/*AD *11th–12th centuries*
Museum of National Antiquities
Stockholm, Sweden

Architectural fragment from a bathhouse

Fatimid, AH *5th/*AD *11th century*
Museum of Islamic Art
Cairo, Egypt

craftsmanship, and a commitment to expressing the dynasty's religious and ideological convictions through artistic means. The Zirid Amir Buluggin I, in the service of the Fatimids, commissioned one of North Africa's oldest pulpits for the Andalusian Mosque in Fez in 369/980.

Large sums of money were invested in extravagant processions and spectacles to mark religious as well as civic festivals. These were all staged in order to show off Fatimid might and propagate their theological vision. Furthermore, lavish annual banquets and gift-presentation ceremonies were financed in order to encourage and reward the loyalty of civil servants, army generals, the judiciary and the religious establishment.

Despite their religious fervour, Fatimid court life, and that of their client rulers in North Africa and Sicily, was not short of entertainment provided by poets, singers, and dancers. In North Africa the Fatimids welcomed local

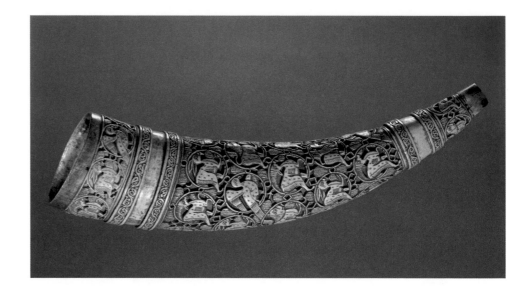

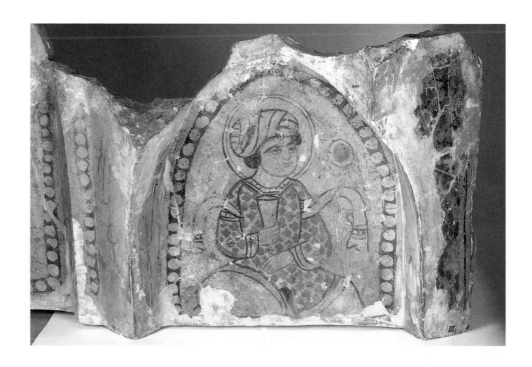

poets such as the Ifriqiyans Ibn Hani and al-Ladi. Later in Cairo, the court hosted poets from all over the Islamic world and several caliphs joined them in composing lyrical verse. The music was influenced by the traditional Eastern repertoire, as well as elements from Andalusian music, and it was performed by male and female musicians on instruments such as reed flutes, lutes and dulcimers. Singers that had mastered both an instrument and verse recited poetry that explored themes of love and chivalry. The most talented performers were handsomely rewarded for their skills.

Chess was widely played, although the rather fickle al-Hakim bi-Amrillah banned it in 402/1012. Astronomy and astrology were also popular pastimes with the caliphs, al-Mu'izz li-Din Allah and al-Hakim bi-Amrillah among the most passionate supporters.

Most of the details about Fatimid court life and entertainment have come from contemporary sources, but some are also reflected in the imagery of the surviving luxury objects used by the Fatimid court, or in the carved and painted interiors with which they surrounded themselves.

Great care was bestowed on the maintenance of gardens, orchards and menageries which housed an array of exotic animals and birds. Beyond the palace gates the Fatimid elite engaged in hunting and horsemanship; a subject often echoed on elaborately carved hunting horns. The hunt, using birds of prey, dogs and horses, included the pursuit of birds, hares, and gazelles. Based on an ever-expanding empire, the Fatimids engendered a brilliant civilisation rivalling that of the Abbasid caliphs in Baghdad and the Umayyads in Spain. Urbanism, the sciences, the arts and literature reached new heights due to extensive royal patronage, not only by male members of the dynasty, but notably by women, too.

In reverence to their descent from Fatima, the Prophet's daughter and wife of Imam 'Ali, the Fatimids accorded their princesses not only a luxurious lifestyle but also an important role in public life, an attitude that positively

Ivory panels

Fatimid, AH *5th–6th/*AD *11th–12th centuries*
Museum of Islamic Art, State Museums
Berlin, Germany

Rectangular piece of wood
Probably once part of a high frieze.

Fatimid, AH *5th/*AD *11th century*
Museum of Islamic Art
Cairo, Egypt

influenced contemporary society's treatment of women generally. Many women of the court held important political posts and Sitt al-Mulk, the sister of Caliph al-Hakim bi-Amrillah, even governed Egypt for four years in place of her infant brother.

Many Fatimid women of rank managed their own wealth and were active in trade, even owning commercial ships that transported goods far and wide. Lavish lifestyles attested to their personal wealth with one princess by the name of 'Abda leaving on her death so many chests filled with gems,

Earring

Fatimid, c. AH 5th–6th /AD 11th–12th centuries
National Museum
Damascus, Syria

Wooden *mihrab*
Built for the tomb of Sayyida Ruqayya.

Fatimid, AH 6th/AD 12th century
Museum of Islamic Art
Cairo, Egypt

jewellery and treasures that 14 kilograms of wax were needed to seal them and 30 reams of paper to list their contents.

Many Fatimid princesses endowed palaces and religious institutions. We know that a hall in the Western Palace in Cairo was designated to Sitt al-Mulk and that it was lined with carved-wood panelling depicting scenes of court life and hunting. Also in Cairo, the wife of the Caliph al-Amir bi-Ahkam Allah commissioned an ornamental shrine for Sayyida Ruqayya, upon which *kufic* calligraphy commemorated her patronage. The shrine was furnished with, among other things, a magnificent wooden prayer niche (*mihrab*).

Beyond the patronage of richly embellished religious architecture, the Fatimids had one other major preoccupation – textiles. Throughout the Fatimid era, Egypt was famous for its outstanding luxury textiles, particularly those produced at the so-called *dar al-tiraz* textile workshops in cities such as Damietta, Dabiq, Tanis, Alexandria and Shata. The Persian word *tiraz* denotes an embroidered decorative band, attached near the edge of a piece

Handkerchief

Fatimid, AH 365–86/AD 975–96
Museum of Islamic Art
Cairo, Egypt

of fabric or on the facings or sleeves of garments. The *tiraz* included blessings and invariably held the name of the ruling caliph or high-ranking patron for whom it was made. On special occasions the Fatimid caliphs would choose the most ornate *tiraz* textiles or robes of honour to reward dignitaries and courtiers, such as, for instance, the grand vizier who received 30 complete outfits which he in turn was free to distribute among his staff. Others were given to high-ranking guests of the court or – at celebrations or anniversaries – even to members of the public. *Tiraz* costumes varied in type and style depending on the rank of their recipients. Gilded silks were for princely dignitaries, and a variety of other silks were available for governmental staff.

Within the palace at Cairo, the caliph's private wardrobe including his personal *tiraz* garments, was managed by a female manager and 30 bondwomen; a garden nearby provided scented flowers to perfume his

Fragment of woven linen and silk

Fatimid, AH 570–96/AD *end of the 12th century*
Royal Museum, National Museums Scotland
Edinburgh, United Kingdom

garments. A second palatial wardrobe for general courtly use was maintained by a senior official, a chief tailor and his assistants. Complete Fatimid *tiraz* garments are rare, but extant fragments bear out the descriptions of them found in contemporary sources. Many were made in an array of colours from linen or silk and were embroidered with silk. The sources repeatedly mention textiles with figurative images on them, but most of the extant fragments show epigraphic or abstract-patterned *tiraz* bands which are sometimes enlivened by small animal motifs. There are few remains of the Fatimids' legendary luxury objects celebrated in contemporary accounts. It is certain, however, that the minor arts reached new heights in both quality and quantity. Highly skilled artisans produced sophisticated artefacts in various media to the specifications of a diverse clientele both at court and in the cities.

The most exquisite objects were reserved for the Fatimid court. Thus, princes and courtiers vied to possess vessels carved from highly prized, imported rock-crystal. Glass, too, was widely used and Fatimid patronage enabled the glass industry in Fustat to apply the highest technological

Fragment of woven linen
The inscription reads: 'Victory comes from God'.

Fatimid, AH *late 5th–early 6th/*AD *12th century*
Royal Museum, National Museums Scotland
Edinburgh, United Kingdom

standards in blowing, moulding, cutting and embossing. A particular speciality was the application of lustre. Lustre decoration on glass had been known in Egypt since antiquity and was later transferred to ceramics. Indeed, lustre pottery – due to Fatimid patronage of migrant potters – soon marked the high point of Fatimid ceramics production, which also included other types of glazed pottery. Another flourishing industry was devoted to metalwork. Artisans specialised in the production of three-dimensional animals and birds, cast and beaten vessels, scientific instruments such as astrolabes, and surgical tools.

Fatimid woodcarving is characterised by its intricate high-relief technique executed in a variety of indigenous and imported woods. Occasionally the final panels were painted, varnished and treated so that they were fire retardant. Ivories and other types of bone were similarly carved and used as inlays on a range of products.

The material wealth of the Fatimid Dynasty is also apparent in the coinage. Fatimid gold *dinar*s, silver *dirham*s and copper *filse*s were widely traded.

Bowl

Fatimid, AH 5th–6th/AD 11th–12th centuries
The British Museum
London, United Kingdom

Jar

Inscribed with repetitions of the word *barakah* (blessings, bounty).

*Fatimid, AH late 4th–early 5th/
AD late 10th– early 11th centuries*
The Burrell Collection, Glasgow Museums
Glasgow, United Kingdom

FACING PAGE
Ewer
Carved from a single piece of
rock-crystal.

Fatimid, AH 391–452/AD 1000–1060
Victoria and Albert Museum
London, United Kingdom

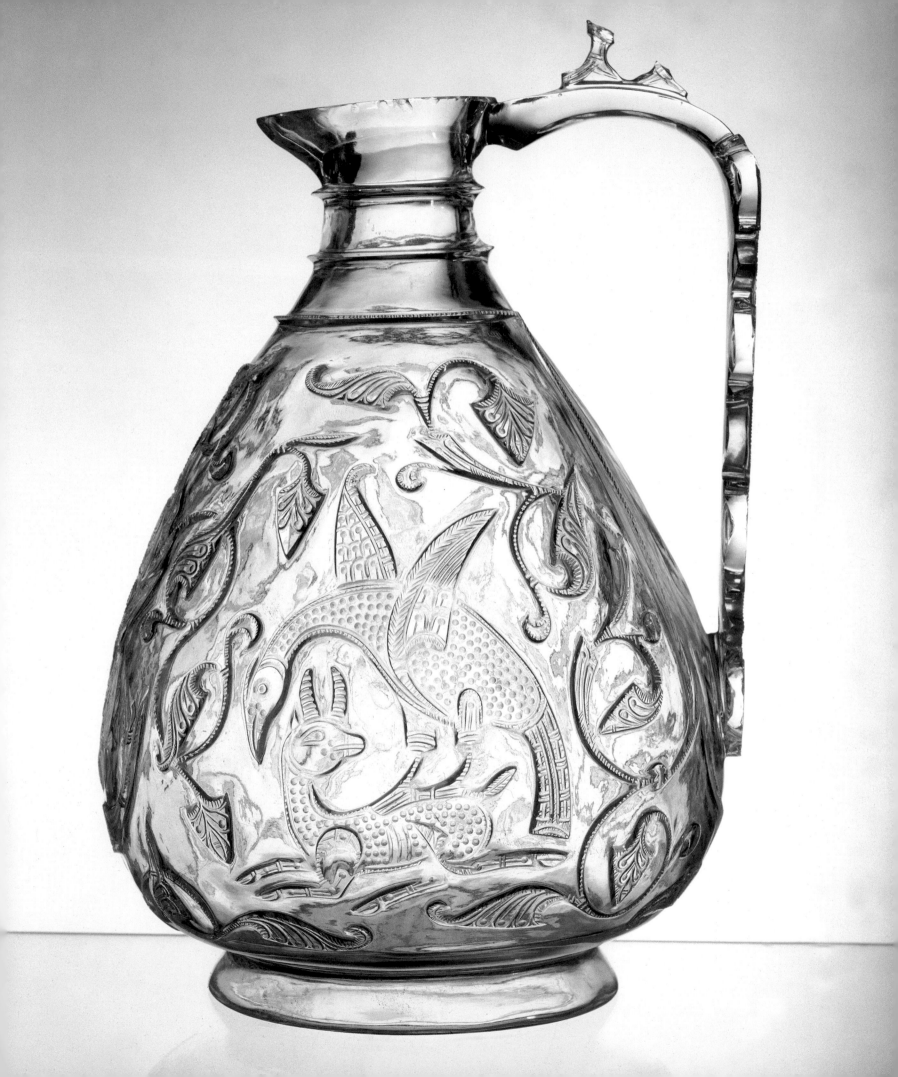

Ivory casket

Fatimid, AH 4th–5th/AD 11th–12th centuries
Museum of Islamic Art, State Museums
Berlin, Germany

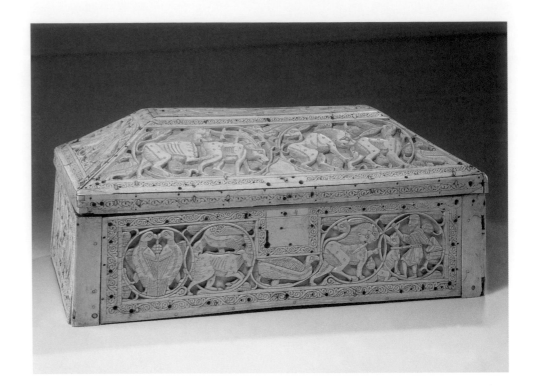

Dinar
Struck at al-Mahdiya during the reign
of the fifth Fatimid Caliph al-Aziz.

Fatimid, AH 380/AD 990
Archaeological Museum
Aqaba, Jordan

An accurate commercial weight was achieved, made possible for the first time
by specially executed glass weights, which were stamped with the relevant
denomination and the name of the ruler. The glory of the Fatimids spanned
nearly two centuries but their supremacy did not last: the arrival of the
Crusaders in the 5th/11th century, economic decline, misrule and major
epidemics all contributed to the ultimate downfall of this brilliant dynasty,
which was eventually extinguished at the hands of Salah al-Din Ayyub (Saladin)
in 566/1171.

Women and Power in the Islamic Mediterranean

Jamila Binous

Fragment of a mural painting
Possibly a songstress brought from
the Hijaz to sing in the Umayyad
palaces of the Syrian Desert.

Umayyad, AH 109/AD 727
National Museum
Damascus, Syria

Women and Power in the Islamic Mediterranean

The exclusion of women from public life, and even more so from political life, is an idea that predates Islam. In his philosophical work on the idea of the 'City', Aristotle developed a system in which women would disappear entirely from public life to be confined to domesticity. He even states in *Politics* that 'nature created a strong sex and a weak sex'.

Islam has promoted this idea of inferiority only as much, if not less than, other monotheist religions.

The exclusion of women is an historical reality, but only one of several such realities. It is promoted by the misogynistic tendencies of Islam, which

Silk garment
Belonging to the wife of the Ottoman governor of Jerusalem.

Ottoman, AH 1245/AD 1830
Islamic Museum and Al-Aqsa Library
Jerusalem

entirely eclipse another historical fact: that some women did force their way into political power. Who were these women, completely ignored by the official histories, and how did they manage to get into power?

The development of the role of women and the perception of them in society over time differed depending on which part of the Islamic world is being considered, their position being subject to regional differences arising from the interaction of Islam with existing cultures.

No female heads of state ever dared to proclaim that they were caliph or *imam*, titles that can only be used in the masculine. The caliph, as representative of the Prophet, has a spiritual mission linked to Divine Law. The *imamat* was forbidden to women by agreement between the religious authorities. On the other hand, sultans and *maliks*, who manage the interests of their earthly citizens, have the female equivalents of sultana and *malika*; besides, there are other titles for women who exercise power: *hurra*, *sayyida*, *sitt* and *khatun*.

On the Trail of 'A'isha, Wife of the Prophet

Throughout the history of Islamic civilisation some extraordinary Muslim women have aspired to both emulate the Prophet's wives and make their mark on history.

'A'isha, the favourite wife of the Prophet, was the first Muslim woman to claim and assume a political and indeed military career, even leading several thousand men into battle.

Both tribal chiefs and queens were common among the Berbers, possibly because their customary laws allowed women access to political power. Thus, Ibn Khaldun, for example, left us a eulogy of Dihya, Queen of the Aurès, known as Kahina, calling her 'the most redoubtable prince of the Berbers'. She continued to oppose invading Arab troops until her death in AH 69/AD 688.

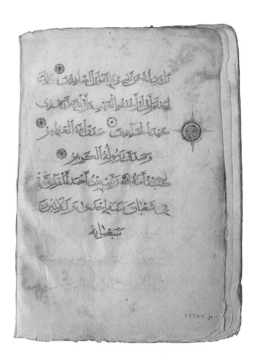

Section from a Qu'ran
Written by the female calligrapher Zaynab bint Ahmad al-Maqdisiyya.

Mamluk, AH 731/AD 1330
Museum of Islamic Art
Cairo, Egypt

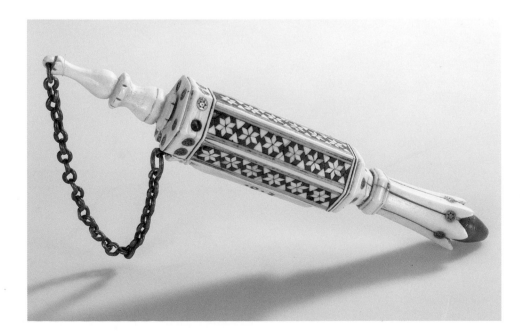

Kohl container
Kohl was used in the eyes in order to beautify them as well as to treat them medically.

Mamluk, AH 8th–9th/AD 14th–15th centuries
Museum of Islamic Art
Cairo, Egypt

Ribat and Mosque of Sayeda
Mihrab (detail)

Aghlabid, Zirid, AH mid-3rd/AD 9th century
Monastir, Tunisia

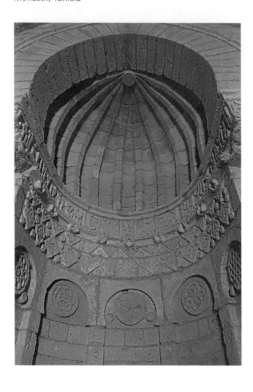

Ribat and Mosque of Sayeda
View of the prayer hall and *mihrab*,
with cruciform pillars supporting
groined vaults.

Aghlabid, Zirid, AH mid-3rd/AD 9th century
Monastir, Tunisia

FACING PAGE

Page from a Qur'an
Belonging to Fatima al-Hadinah,
governess to the Zirid prince Badis.

Fatimid, Zirid, AH 410/AD 1020
Museum of Islamic Art, Raqqada
Kairouan, Tunisia

The Fatimid era produced two women of note: Sayyida al-Sanhajiya, who reigned over Ifriqiya and whose tribe swore an oath of allegiance to her on 23 Thw al-Hijjah 406 (2 June 1016), and Sitt al-Mulk, born in 359/980, who succeeded her brother al-Hakim bi-Amrillah, the sixth caliph of the Fatimid Dynasty in Egypt.

The most famous queen of the Islamic Mediterranean was Shajar al-Durr, wife of the seventh sovereign of the Ayyubid Dynasty of Egypt, who died in 647/1249. She rose to power as a result of her strategic sense and carried off a resounding victory over the Crusaders at Damietta, taking King Louis IX of France prisoner. Is her epithet 'Queen of the Muslims' not essentially the same as caliph?

In Iran, Türkan Khatun, the wife of the Great Seljuq Sultan Malik Shah, succeeded her husband and ruled for 20 years from 465/1072 to 485/1092, taking control of an area stretching from China to Syria. To defend herself against pretenders to her power, she sought the help of the Abbasid Caliph, al-Muqtadi. He agreed to her taking control of the land (*mulk*), but refused her the Friday sermon (*khutba*), which had to be spoken in the name of Khatun's son, despite the fact that he was only four years old.

In Almoravid Morocco, Zaynab al-Nafzawiya shared power with her husband, Yusuf ibn Tashufin, while in 7th-/13th-century Algeria, Sitt al-Nisa, the mother of the sultan of Tlemcen, was in a position to negotiate a peace treaty with the Hafsid sultan of Tunis.

At the time of the fall of al-Andalus in the 9th/15th century, 'A'isha al-Hurra, known to the Spanish as the 'sultana mother' of Boabdil (Abu 'Abdallah) the last Nasrid ruler, won the respect of her Christian enemies by resisting them until the fall of Granada.

Finally, to give one more example, a Moroccan woman of Andalusian origin, Sayyida al-Hurra became a pirate and was known as '*Hakimat Tetouan*' ('she who governs Tetouan'). She eventually took the King of Morocco, Ahmad al-Wattasi, as her second husband.

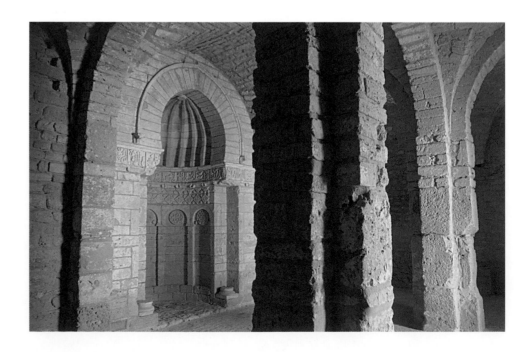

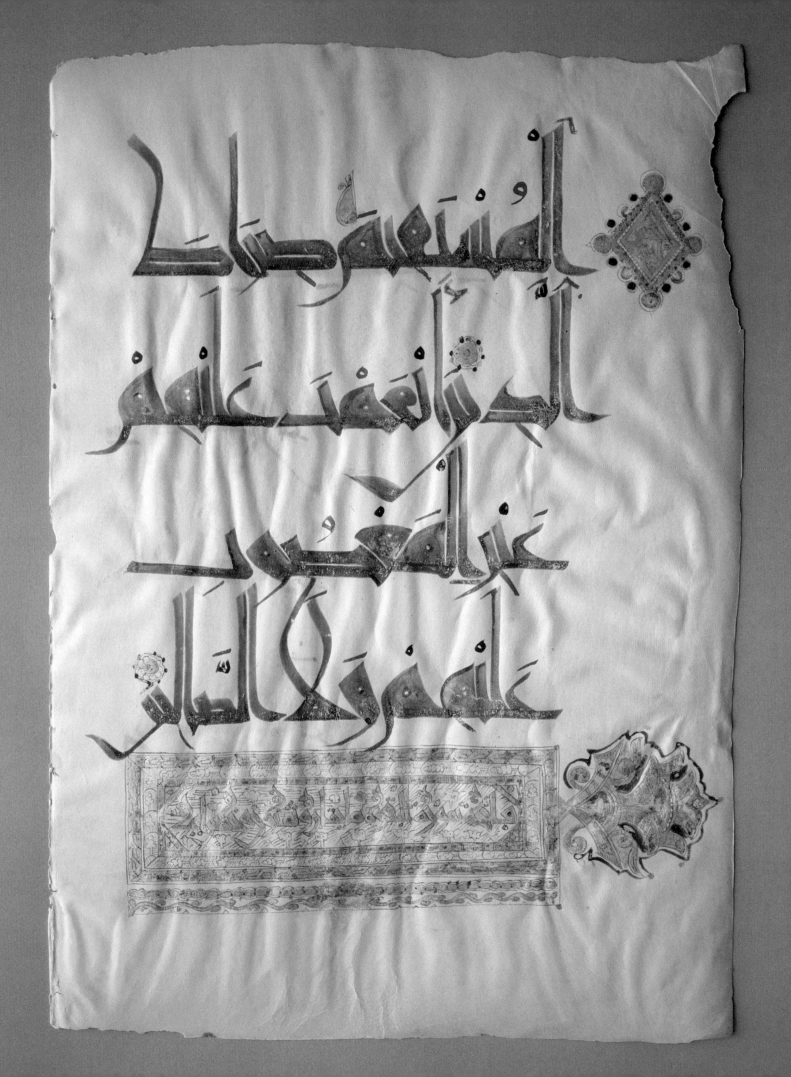

There are many more examples, and they all have a common factor: each time a woman rises to power, it is seen as aggression and a transgression of the limits (*hudud*). These limits are presented as arising from spiritual and Shari'a law, but are in fact a human construction and an interpretation of the texts that can differ depending on the time and place, as has been shown throughout history.

Women and Power – Three Case Studies

'A'isha, the First Muslim Woman in Politics

'A'isha, wife of the Prophet, is portrayed as 'the wisest of women in the matter of religious sciences'. She led an insurrection against the fourth orthodox caliph, 'Ali ibn Abi Talib, in 36/658. To prepare for the conflict, she visited mosques and harangued the crowds, encouraging them to take up

Gold necklace

Ayyubid, AH *mid-7th/*AD *13th century*
Museum of Islamic Art
Cairo, Egypt

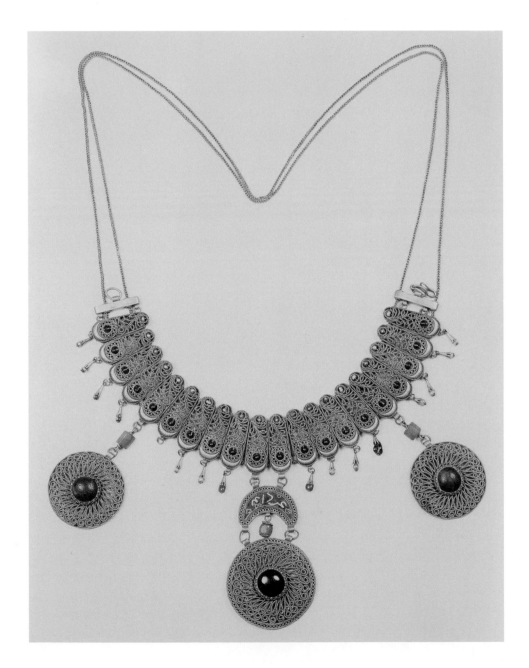

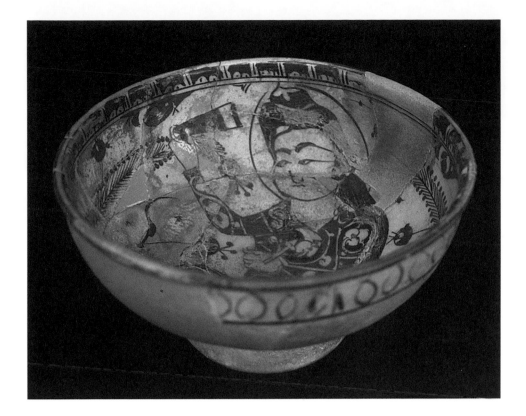

Bowl

Ayyubid, AH *6th–7th/*AD *12th–13th centuries*
National Museum
Damascus, Syria

arms against 'Ali. She also went on a campaign to win the support of
provincial governors who were the disciples of the Prophet. She succeeded in
assembling several thousand men and took the battle to 'Ali. The only woman
on the battlefield, she directed operations on camelback, which resulted in
the conflict being known as the 'Battle of the Camel'. Seven thousand Muslims
fell in just a few hours of the first civil war that would establish the scission
between Shi'ite and Sunni Muslims.

Shajar al-Durr, the Love of Power
Shajar al-Durr was a slave of Turkish origin freed by the Ayyubid Sultan
al-Malik al-Salih. She was his favourite before becoming his wife, and they
had a son who was just four years-old when his father died in 648/1250. At
the time, the Ayyubids ruled Egypt and Syria and depended on the Abbasid
caliphate of Baghdad.

Shajar al-Durr was no stranger to power, having taken an interest in
politics – in particular the army – while her husband was still alive. The first
decision she made was to conceal the death of the sultan and organise an
offensive against the Crusaders who were laying siege to Egypt under King
Louis IX of France (Saint Louis). Following a strategically astute victory at
Damietta, she demanded recognition from the Caliph al-Mustasim, who
refused. Shajar al-Durr carried on regardless and took the title *Malikat al-
Muslimin* (Queen of the Muslims), but the attitude of the caliph undermined
her authority. The governors of Syria refused to recognise her and the army
was divided. A general was chosen as a rival candidate for the throne and
presented to the caliph. Shajar al-Durr quickly married him and demanded
that all of Cairo's mosques say the *khutba* in the name of both sovereigns.

Topkapı Palace
View from the hall of Valide Sultan
(mother of the Sultan) in the *harem*.

Ottoman, construction began in AH *9th/*
AD *15th century; final additions in the*
AH *13th/* AD *19th century*
Istanbul, Turkey

Ayyubid, 12th–13th centuries
National Museum of Damascus,
Damascus, Syria

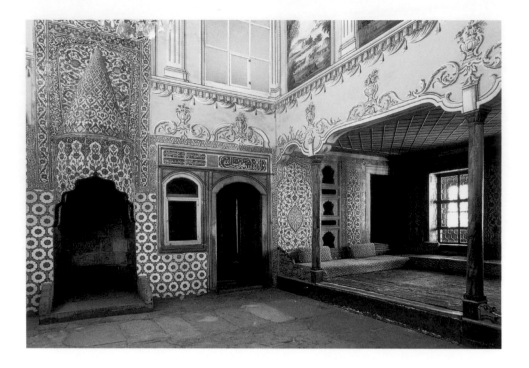

She also ensured that the coins minted included her name alongside her
husband's and that no official document left the palace without both
signatures.

'A'isha al-Hurra and the Fall of Granada

'A'isha al-Hurra, the 'sultana-mother' of Boabdil, was the wife of Sultan 'Ali
Abu al-Hasan, King of Granada in 866/1461. She had two sons, Muhammad
Abu Abdallah (Boabdil) and Yusuf. She lived in the wing of the Alhambra that
contained the famous Courtyard of the Lions.

Disenchantment with her marriage pushed her into politics when her
husband fell in love with a beautiful Spanish slave named Isabel, who
converted to Islam under the name of Suraya. The sultan freed and married
her, and she bore him children, which put her in a strong position to win
favour and advantage for her family.

The Granada elite mobilised around 'A'isha, who decided to depose her
husband and replace him with her son, Abu 'Abdallah, in 887/1482.
Throughout the 10 years that her son ruled, it was 'A'isha who organised
both his defensive and offensive campaigns.

127

The Muslim West After the Umayyads

Gaspar Aranda and Kamal Lakhdar

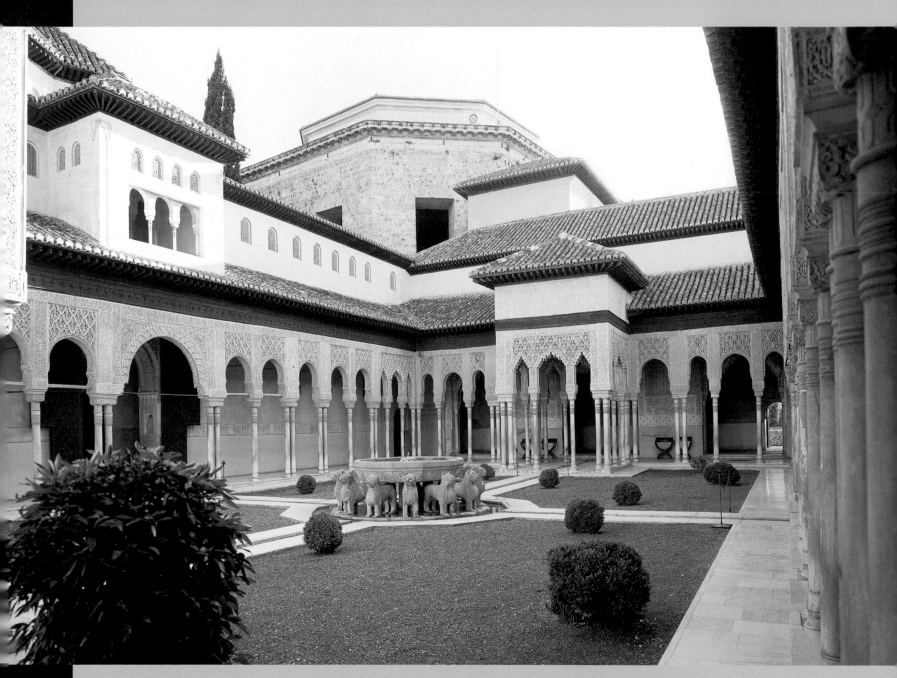

Alhambra
Patio of the lions.

Nasrid, from AH 636/AD 1238 *to the reign of*
*Muhammad V (*AH 754–94/AD 1354–91)
Granada, Spain

The Muslim West After the Umayyads

From the fall of the Umayyad Dynasty of al-Andalus in AH 422/AD 1031, to the colonisation of Morocco in 1330/1912, the Muslim West experienced nine centuries of turbulent history, covering the *ta'ifa* kingdoms of al-Andalus, the rise of the Almoravids in the Maghreb, and the 'Alawid Dynasty's 300-year reign in Morocco.

Sometimes unified and sometimes fragmented, the Muslim West witnessed a succession of dynasties on either side of the Straits of Gibraltar: the Almoravids put an end to the mosaic of kingdoms that had fragmented the Iberian Peninsula after the fall of the caliphate of Córdoba; the Almohads established a true empire in the 6th/12th century; the Nasrids and Marinids established parallel and closely linked dynasties, leaving the Sa'dids and 'Alawids to become the keepers and successors of the culture of the Muslim West after the fall of Granada in 897/1492.

In the Iberian Peninsula, the *ta'ifa* kingdoms attempted to reproduce, on a small scale, the political and administrative structures of the Umayyad caliphate, destroyed in 339/1009 by civil war. These small local 'states' (the

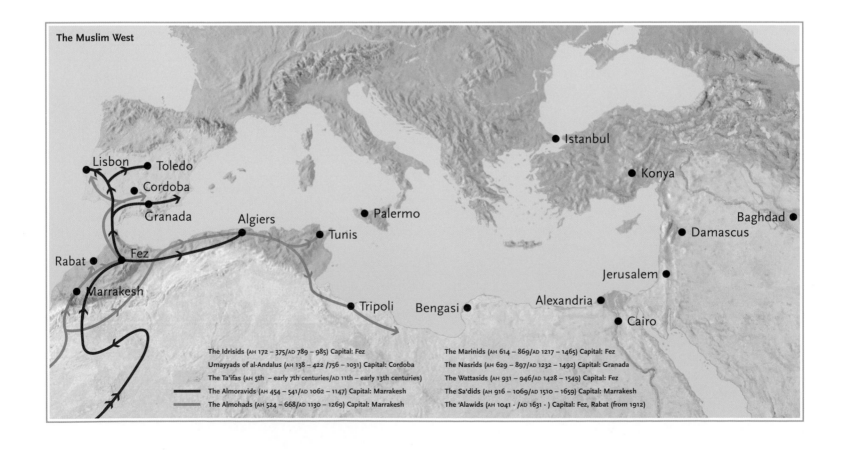

The Muslim West

The Idrisids (AH 172 – 375/AD 789 – 985) Capital: Fez
Umayyads of al-Andalus (AH 138 – 422 /756 – 1031) Capital: Cordoba
The Ta'ifas (AH 5th – early 7th centuries/AD 11th – early 13th centuries)
The Almoravids (AH 454 – 541/AD 1062 – 1147) Capital: Marrakesh
The Almohads (AH 524 – 668/AD 1130 – 1269) Capital: Marrakesh

The Marinids (AH 614 – 869/AD 1217 – 1465) Capital: Fez
The Nasrids (AH 629 – 897/AD 1232 – 1492) Capital: Granada
The Wattasids (AH 931 – 946/AD 1428 – 1549) Capital: Fez
The Sa'dids (AH 916 – 1069/AD 1510 – 1659) Capital: Marrakesh
The 'Alawids (AH 1041 - /AD 1631 -) Capital: Fez, Rabat (from 1912)

ta'ifa kingdoms of Valencia, Denia, Murcia, Seville, Malaga, Algeciras, Zaragoza, Granada, Toledo, Badajoz, Mértola and Silves, to name a few) governed by petty kings of Andalusian, Berber or Slavic origin, did not have the unalienable power of the caliphs due to their lack of religious legitimacy. They were also bound to pay costly tributes or *parias* to the Christians.

Keen to conserve what little power they had with a show of grandeur, they transformed their capitals into genuine centres of art and culture. In Zaragoza, al-Muqtadir of the Hudid Dynasty realised his dreams of glory in the Aljafería Palace, the best architectural example from the period. The poet-king al-Mutamid of the great Abbadid *ta'ifa* of Seville attracted writers, artists and scholars to his court, ushering in Andalusia's most brilliant period of learning, seen in particular in the fields of mathematics and astronomy. The Berber Zirid Dynasty made Granada a great city by building walls, gateways, bridges, baths, mosques and a *kasbah*. The Zirids also took the great *ta'ifa* of Malaga from the Hammadids and rebuilt its *kasbah*.

Toledo of the Dhu 'l-Nunids, one of the most politically important *ta'ifa* kingdoms, fell into the hands of Alfonso VI of Castile in 477/1085, forcing al-Andalus to shift its focus to the Maghreb.

Courtyard of Aljafería Palace
North portico.

Ta'ifa *kingdom of Banu Hud*, AH 437–73/
AD 1046–81
Zaragoza, Spain

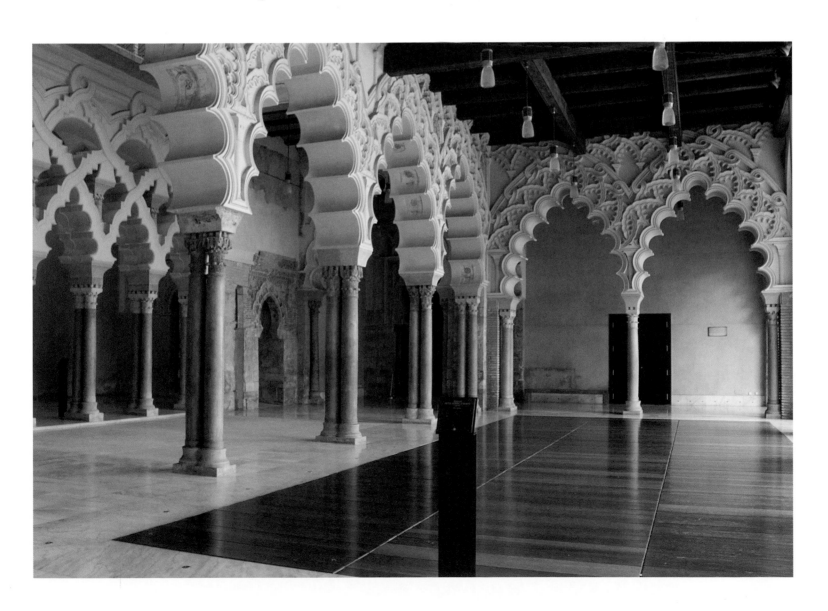

Astrolabe

Ta'ifa kingdom of Banu Dhu 'L-Nun (Toledo),
AH 459/AD 1067
National Archaeological Museum
Madrid, Spain

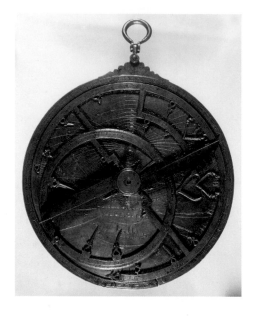

Minbar from Kutubiya Mosque

Almoravid, AH 532/AD 1137
Badi Palace
Marrakesh, Morocco

Almoravid Koubba

Almoravid, AH 532/AD 1137
Marrakesh, Morocco

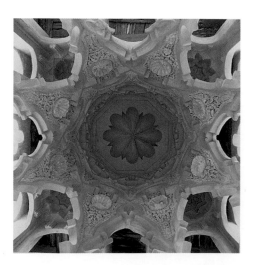

During this time, the weakening of the Idrisid Dynasty in the Maghreb had encouraged foreign incursions, and the control of Fez switched between the Fatimids of Tunisia and the Umayyads of al-Andalus. The fragmentation of the Idrisid kingdom resulted in more than half a century of unrest and confusion, without actually threatening the country's economic prosperity.

It was at this time that the Almoravids arrived; they were known as *al-Murabitun*, the 'People of the Fort'. Members of a Berber tribe from the Western Sahara, these warrior-nomads were driven to conquer new lands by their religious reformist zeal and their need for fertile land. Returning from their oases to the plains in 445/1053, they took Sijilmasa, a crossroads on the caravan routes, and entered the Atlas Mountains to conquer the Western Maghreb.

A military leader named Yusuf ibn Tashufin I took power in 453/1061. The collapse of the Umayyad caliphate of Córdoba and of the established power in the Central Maghreb, allowed him to become the master of the Muslim West, from Granada to Algiers, creating the first Berber Dynasty in Morocco with a new capital, Marrakesh, which he founded in 462/1070 before annexing the Saharan lands up to the Senegal River. His intervention in Spain checked the progress of the Christian *Reconquista* with a victory at Zallaca, near to Badajoz, in 478/1086.

Initially resistant to Andalusian civilisation, the Almoravids ended up abandoning their puritan traditions and immersing themselves in their predecessors' culture of refinement and splendour.

The Andalusian influence was at first intellectual (poetry and science), and later Almoravid buildings began to be influenced by the architecture of Córdoba and Seville. In this field, the Almoravids managed harmoniously to combine the Eastern and Andalusian elements to create an original and innovative style that enjoyed its heyday under 'Ali ibn Yusuf.

Most of the Almoravid monuments in Morocco were destroyed by their successors, the Almohads (524–668/1130–1269), but the Koubba in Marrakesh, the extensions to the Qarawiyin Mosque in Fez, the Great Mosques of Algiers, Tlemcen and Nedroma in Algeria, and the monuments and remains that have survived in Portugal, are evidence of the wealth and brilliance of this artistic era.

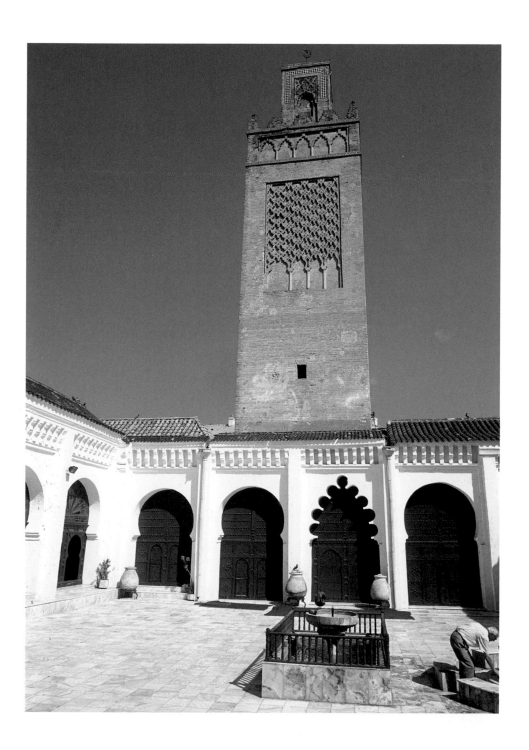

Great Mosque of Tlemcen

Almoravid, AH 590/AD 1136
Tlemcen, Algeria

The decline and disintegration of the Almoravid Empire was essentially caused by popular uprisings against the ostentatious luxury and corruption of the ruling class. It was in this context that a Berber from the Anti-Atlas, Ibn Tumart, who had studied theology in Córdoba and Baghdad, returned to Morocco and began advocating a reformist doctrine based on Islamic rigourism. Having taken refuge in Tinmel to the south of Marrakesh in 518/1125, he set up an embryonic hierarchical state and conducted the first raids against the Almoravids. By doing so, Ibn Tumart created the Almohad movement (al-Muwahhidun, 'the Unitarists'). After his death, 'Abd al-Mu'min took over power and continued the struggle.

The true founder of the Almohad Dynasty, 'Abd al-Mu'min, extended his influence to the Central Maghreb, took Marrakesh in 541/1147 and occupied Cádiz, Badajoz, Córdoba, Granada and Almeria in Andalusia. He also lent his support when Ifriqiya (Tunisia) was invaded by the Normans and took Tunis, Sfax and Tripoli.

'Abd al-Mu'min's grandson, Ya'qub al-Mansur, officially annexed al-Andalus and some of Portugal to his empire following his victory over the Spanish and the Portuguese at Alarcos in 591/1195. An enthusiastic builder and patron, he led his empire to its political, economic, intellectual and artistic apogee. Like the Idrisids in Fez and the Almoravids in Marrakesh, he wanted to endow his empire with a new capital, but his death in 595/1199 put an end to the

Glazed bowl

Almohad, AH *second half of the 6th/*
AD *second half of the 12th century*
Museum of Mértola
Mértola, Portugal

Kutubiya Mosque
View of the cupola decorated with
muqarnas.

Almohad, AH *6th/*AD *12th century*
Marrakesh, Morocco

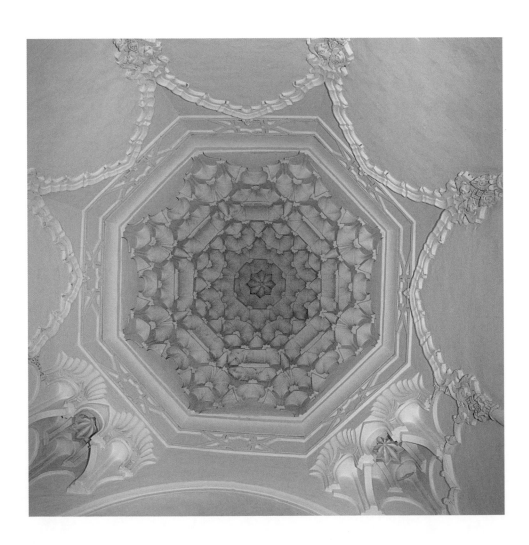

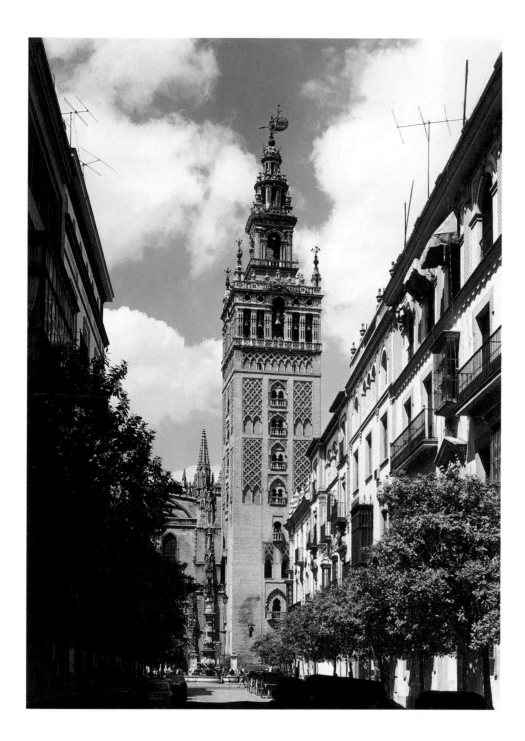

Giralda
Most important of the Iberian
Peninsula's surviving religious
buildings from the Almohad era.

Almohad, AH 580–94/AD 1184–98
Seville, Spain

Manuscript
Transcript from one of the 30 volumes
of the medical treatise, *al-Tasrif*.

Almohad, AH 610–9/AD 1213–23
National Library
Rabat, Morocco

grandiose Ribat al-Fath project, of which only the perimeter walls and part
of a mosque, the Hassan Mosque, were built.

Before their own decline, marked by their defeat at the hands of the
Christians at Las Navas de Tolosa (612/1212), the Almohads enhanced
Western Islamic civilisation with many architectural projects which reveal
a universal tendency towards grandeur and sobriety with their gigantic
ramparts, monumental gateways, majestic minarets and refined decoration.
In this regard, although they destroyed many of the monuments left by the
Almoravids, the Almohads were nonetheless the heirs to their predecessors
and, like them, used Andalusian architects and decorators extensively,
without ever losing touch with their Eastern heritage.

After a century of expansion, the Almohads' power was weakened by in-fighting and disappeared with the loss of control of the Saharan routes, the conquest of the Central Maghreb by the Hafsids of Tunis and the advance of the *Reconquista* in Spain. It was at this time that Fez was taken by the Marinids, the Banu Marin, a tribe of Berber nomads from Eastern Morocco. They attempted to re-unite the Maghreb, taking Tlemcen in 737/1337 and Tunis in 748/1347, and made several incursions into al-Andalus, hindering the progress of the Christians and helping to protect Granada.

For 150 years, Morocco experienced a period of brilliance that was marked by the establishment of a new capital, Fez al-Jadid. Here numerous mosques and *madrasa*s were constructed, the arts were developed, and there was an intensification of cultural activity which was enriched by the Andalusian intellectuals who flocked to Fez to take refuge from a faltering Muslim Spain. The Marinids erected buildings on a smaller scale than the Almohads had, but decorated them more extensively and densely, sometimes covering entire interior surfaces from floor to ceiling. The most characteristic examples include the Chellah Necropolis at Rabat, the internal structures of which were seriously damaged by an earthquake in the 12th/18th century, the 'Attarine

Chandelier

Marinid, AH 690/AD 1291
Batha Museum
Fez, Morocco

Al-'Attarine Madrasa

Marinid, AH 8th/AD 14th century
Fez, Morocco

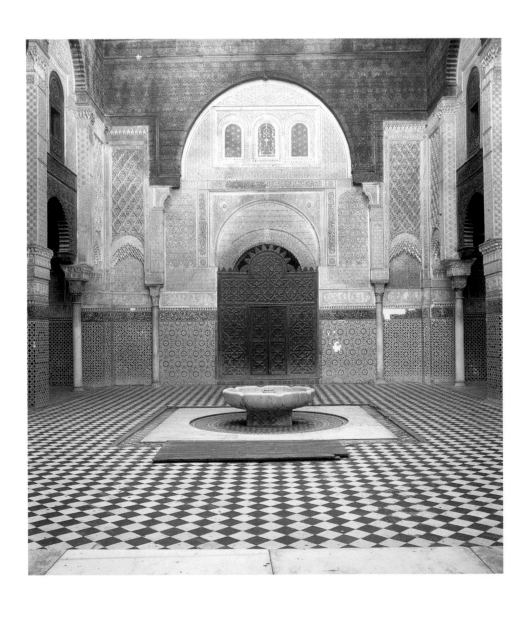

and Buinaniya *madrasa*s in Fez, with their earthenware-tiled walls, wooden *muqarnas* domes, marble-paved courtyards and bronze-clad doors.

After this period of Marinid brilliance, whose figurehead was Sultan Abu al-Hasan, the Black Death epidemic of 748–50/1348–50 together with the rebellions of Tlemcen and Tunis, marked the decline of the dynasty, which also suffered a heavy defeat by the Spanish and Portuguese at Rio Salado in 741/1340.

The Nasrid kingdom of Granada was the last Muslim state in the Iberian Peninsula. It developed as one of the *ta'ifa* kingdoms that sprung up around al-Andalus with the decline of the Almohad Empire, and was the only one to survive the Christian *Reconquista* of the 7th/13th century. It covered the modern-day provinces of Granada, Malaga and Almeria. Its founder, Muhammad ibn Yusuf ibn Nasr, proclaimed *amir* at Arjona (Jaén) in 629/1232, built the Alhambra (*al-Hamra*, the 'Red Castle'), which served as the residence of the Nasrid sultans for 250 years, until Granada was taken by the Catholic Kings in 897/1492.

The period during which the sultanate was established was followed by dynastic crises and political and economic decline, interspersed with periods of great splendour. In the 8th/14th century under sultans Yusuf I and his son Muhammad V, the kingdom reached its political, economic, cultural and artistic apogee. Thanks to a skilful use of diplomacy, peace was established and the Nasrids re-organised the civilian and military life of their kingdom.

Measuring instrument

Marinid, AH 731–49/AD 1331–48
National Museum of Antiquities and Islamic Arts
Algiers, Algeria

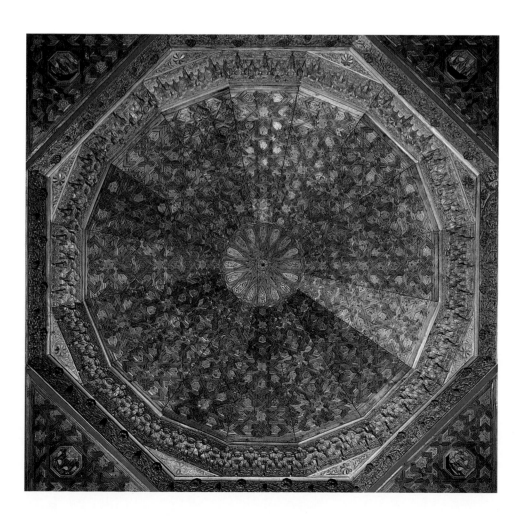

Alhambra
Domed cupola.

Nasrid, c. AH 719/AD 1320
Museum of Islamic Art, State Museums
Berlin, Germany

Sa'did Tombs

Sa'did, AH 10th/AD 16th century
Marrakesh, Morocco

Dinar

Sa'did, AH 1020/AD 1612
Numismatic Museum of the Al-Maghrib Bank
Rabat, Morocco

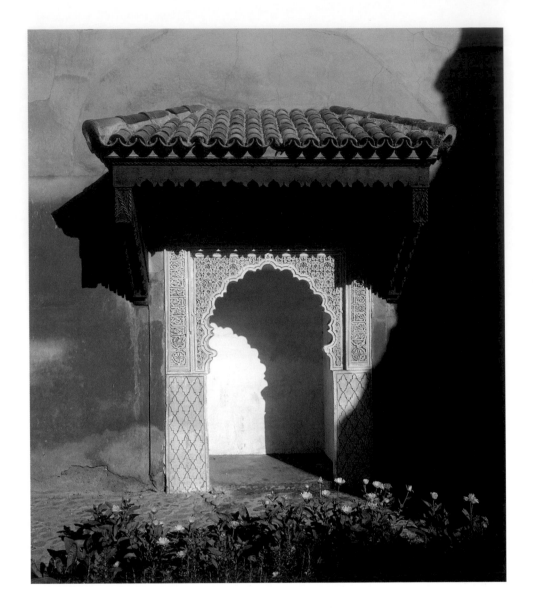

New buildings at the Alhambra (monumental gateways, the Comares Palace, the Riyad Palace, also known as the Palace of the Lions, and the Calahorra Tower built by Yusuf I) and Granada (*madrasa* and *maristan*) provide evidence of this prosperity. There were noteworthy viziers and writers too, in particular Ibn al-Khatib, who described in detail the luxurious palace parties at that time.

Despite some brief periods of recovery, the socio-political situation deteriorated during the 9th/15th century. Internal conflict was exacerbated by economic problems, caused mainly by Granada's increasing isolation from the rest of the Muslim world – in particular from the Maghreb since the fall of the Marinids – with whom the Nasrids had maintained close relations that represented the peak of cultural unity between al-Andalus and the Maghreb, established initially by the Almoravids and the Almohads.

The fall of the Marinids was confirmed when the Wattasids (Banu Wattas), a family of Marinid ministers, made themselves regents and then usurped the throne in the 9th/15th century. The country fell into a grave economic crisis with the fall of Granada, the last Muslim kingdom in Spain, and the flood of

deportees from al-Andalus only served to heighten popular frustration and religious disputes.

In the early 10th/16th century, Morocco descended into anarchy and impotence, with the Portuguese taking Tangiers, Safi, Azemmour, Mazagan and Agadir, and the Spanish enclave, Melilla. Incapable of containing the religious disputes or opposing external aggressions, the Wattasids attempted to cling on to power by allying themselves with the Ottoman Turks, the rulers of the Central Maghreb and Ifriqiya. The tribes of the south and their religious brotherhoods then called upon the Sa'dids who had come from Arabia in the 8th/14th century declaring themselves descendants of the Prophet. They led the struggle and took power of the south of the country, retaking Agadir and becoming rulers of the country with the conquest of Fez in 965/1554.

The fourth Sa'did king, Muhammad al-Mutawakkil was driven from power after only two years as king by his uncle, 'Abd al-Malik. He sought the help of Portugal whose young king, Sebastian I, saw an opportunity and unadvisedly set out to conquer Morocco for himself. The inevitable confrontation took place on 30 Jumada al-awal 986 (4 August 1578) at Oued al-Makhazine in the north of Morocco and resulted in the defeat of the Portuguese.

Known as the 'Battle of the Three Kings' because Sebastian I, al-Mutawakkil and 'Abd al-Malik all died there, the consequences of the battle were far-

Ibn Yusuf Madrasa
View of the prayer hall.

Sa'did, AH 972/AD 1565
Marrakesh, Morocco

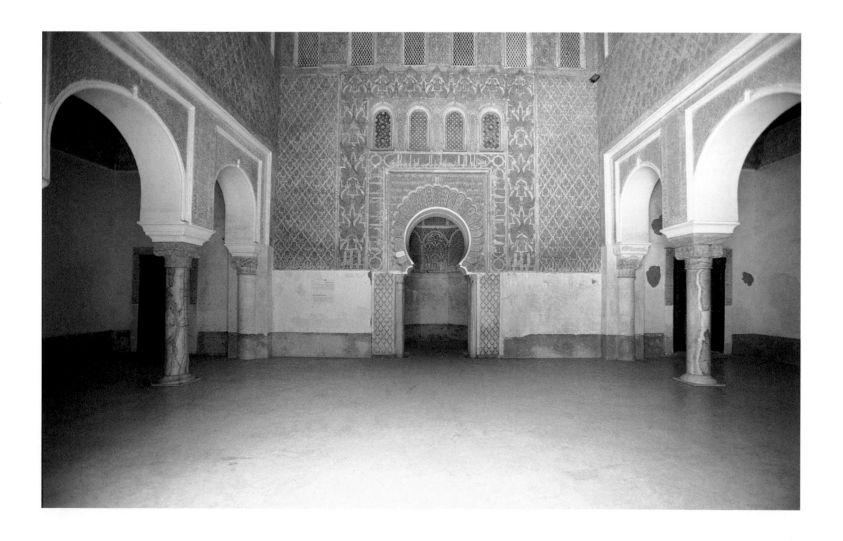

FACING PAGE
Mulay Isma'il Mausoleum

'Alawid, AH 11th–12th/AD 17th–18th centuries
Meknès, Morocco

reaching: it conferred immense national and international prestige on Ahmad al-Mansur, the brother of 'Abd al-Malik, who was proclaimed king on the battlefield; it brought great riches to Morocco by means of the ransoms paid for captured Christian knights; and it resulted in Spain annexing Portugal, as Sebastian had left no direct heir.

Morocco was now in a position to oppose the Turks in Algeria and Tunisia, and it retook control of Saharan trade, reorganised its army and administration, and developed agriculture, craft and trade with Europe. Architecturally, with the exception of the development of the Qarawiyin in Fez, it was in Marrakesh that the Sa'dids left their mark. Although the Badi Palace (the 'Incomparable') was destroyed by Mulay Isma'il in the late 11th/17th century, the Sa'did tombs, Ibn Yusuf Madrasa and a number of other buildings in the *kasbah* survived, all showing the heritage of previous dynasties and differing degrees of Ottoman influence.

But the grandeur of the Sa'dids was too dependent on exceptionally favourable circumstances and the personalities of its two sovereigns: 'Abd al-Malik and Ahmad al-Mansur. When the latter died in 1012/1603, the political and economic difficulties returned, along with unrest among the brotherhoods and the privateering that confirmed the break with Europe.

The 'Alawid sharifs, who exercised a modest amount of power in Tafilalet to the south of the mid-Atlas mountains, used their religious aura and skills

Bab Mansur

'Alawid, AH 11th–12th/AD 17th–18th centuries
Meknès, Morocco

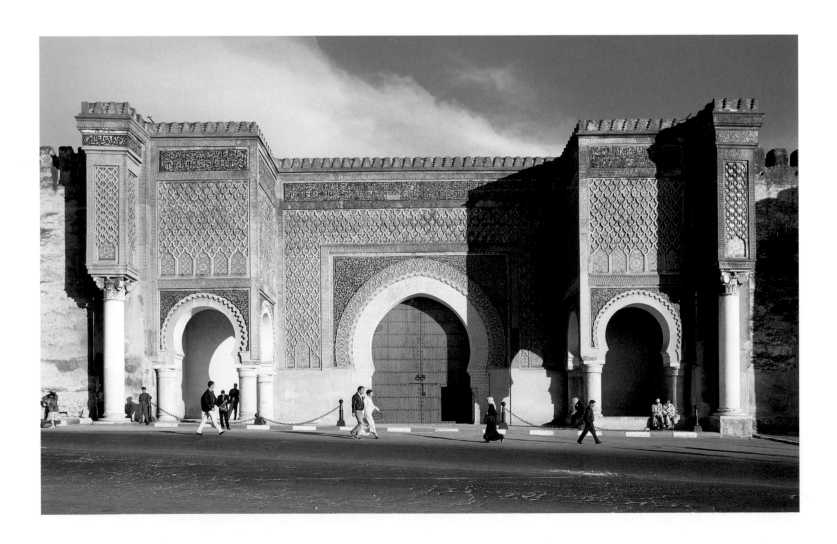

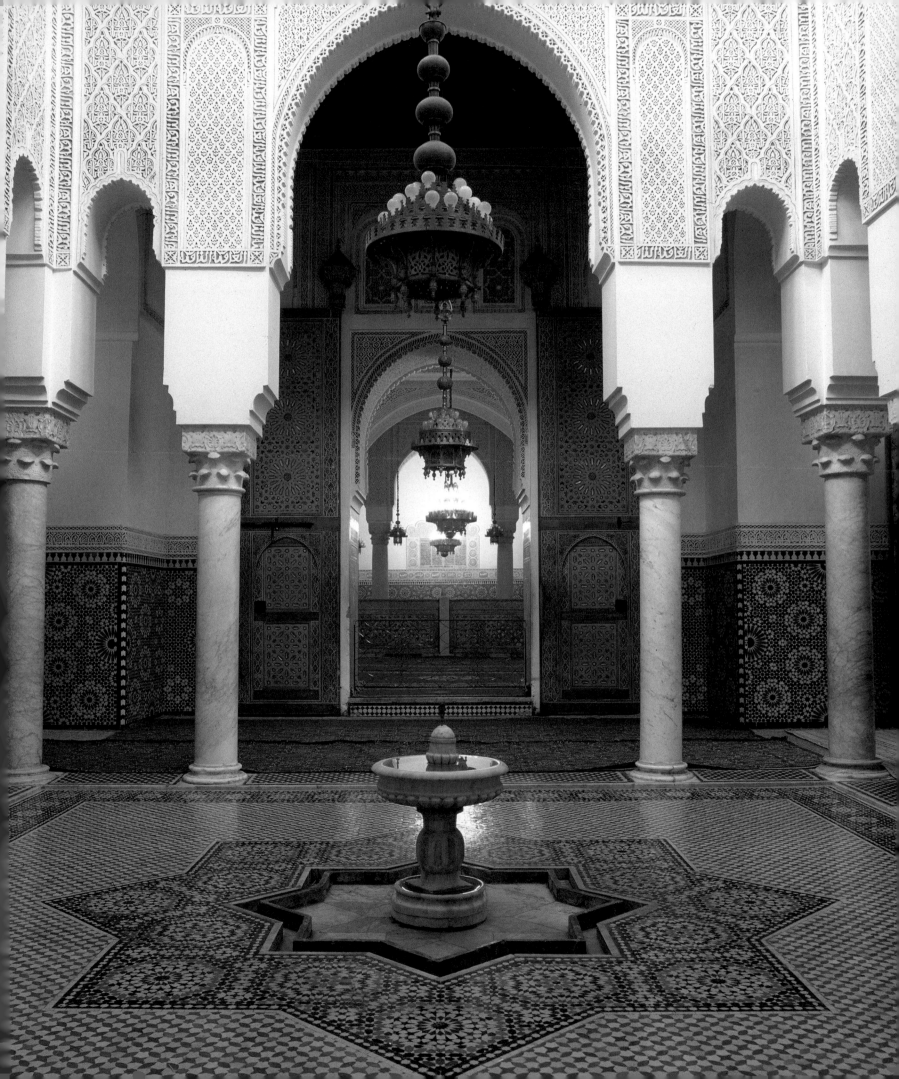

as warriors and organisers to take control of Eastern Morocco, Fez (1049/ 1666) and Marrakesh (1052/1669).

The legendary Sultan Mulay Ism'ail (1055–1139/1672–1727), consolidated the work of the founders of the dynasty and ushered in a new period of brilliance in Moroccan civilisation. A great builder, he endowed his capital, Meknès, with palaces, gardens, mosques, shops, *hara*s (stud-farms) and hydraulic engineering works, all within a powerful perimeter wall whose main gateway, Bab Mansur, epitomises the way the sultan ruled, with power, magnificence and pragmatism.

In the political arena, he opposed the Turks and reconquered the places still occupied by the Europeans on the Atlantic. But this military power proved to be too costly and, with the death of Mulay Ism'ail, Morocco entered a grave political and economic crisis that was accentuated by the loss of the revenue from privateering.

After 30 years of chaos, Morocco experienced a spectacular recovery in the second half of the 18th century: reining in the army and tribal governments, opening up the country to the Atlantic, and reinforcing diplomatic and commercial links with Europe and America. But these advances were checked by a plague epidemic and a great famine that reduced the population from five million to three million. The country became introverted and its weaknesses left it wide open to the vast European colonial movement.

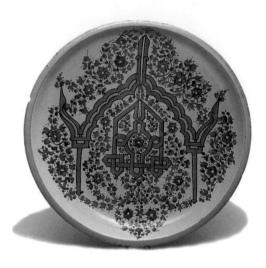

Dish with inscription

'Alawid, AH 13th/AD *first half of the 19th century*
Batha Museum
Fez, Morocco

PERSONALITIES

Yusuf ibn Tashufin (r. 453–500/1061–1106) was an Almoravid king who reinforced the power of the dynasty by conquering Western Maghreb (Morocco), the Central Maghreb (Algeria) and al-Andalus, where he had been summoned to help the *ta'ifa* kings. He founded Marrakesh.

Al-Mutamid (r. 461–83/1069–91) was known as the poet-king and was the third sovereign of the Abbadid Dynasty of the *ta'ifa* kingdom of Seville until he was dethroned by the Almoravids in 483/1091. He created a brilliant literary and artistic court.

Ibn Tumart (484–524/1091–1130) was a theologian educated in the East. He set up a reformist movement in the Atlas Mountains that gave rise to the Almohad Dynasty and initiated the armed struggle against the reigning Almoravid Dynasty.

Ya'qub al-Mansur (r. 580–95/1184–99) was an Almohad king whose empire encompassed the entire Muslim West from the Atlantic to Tunis, Gibraltar to Toledo. An enthusiastic patron of architecture, he was responsible for a number of important monuments, such as the ramparts and the Hassan Mosque in Rabat, the Kutubiya in Marrakesh and the Giralda in Seville.

Muhammad ibn Yusuf ibn Nasr (r. 629–71/1232–73) was the founder and first sultan of the Nasrid kingdom of Granada. He resided in the Alhambra, the seat of power for subsequent sovereigns. He forged alliances with Castile and with the Marinids, extending his kingdom around Malaga and Almeria and outlining the territorial map of the sultanate for several decades.

Ibn al-Khatib (713–75/1313–75) was Secretary to Yusuf I, and vizier to Muhammad V, and was actively involved in the politics of the Nasrid kingdom of Granada. As a historian and writer, he recounted in detail the daily life of Granada and its people in his main work, *Ihata*.

Abu al-Hasan (r. 731–52/1331–51) was a Marinid sovereign who tried to re-establish the Almohad Empire in the Maghreb and al-Andalus. He devoted himself to domestic politics, art and culture and to the construction of mosques and *madrasas*. Pursued by his son Abu Inan who rebelled against him, he died in the High Atlas Mountains and is buried in the Chellah Necropolis in Rabat

Yusuf I (r. 733–54/1333–54), a Nasrid king under whom the kingdom of Granada grew politically, economically and culturally, before reaching its peak during the reign of his son, Muhammad V. He signed truces with Castile and the Marinids of the Maghreb, establishing a peace that he used to reorganise the civilian and military life of the kingdom.

Ahmad al-Mansur (r. 986–1011/1578–1603) was a Sa'did sovereign; proclaimed king on the battlefield with the death of his brother, 'Abd al-Malik. He conquered the Sudan, from where he exported large quantities of gold and developed the sugar and arms industries. He was responsible for introducing Turkish influences into military, sartorial and architectural spheres.

Mulay Ism'ail (r. 1083–1140/1672–1727) is known as the great 'Alawid king remembered sometimes as a bloodthirsty despot and sometimes as the 'sun king'. During his long reign, he pacified Morocco, liberated Tangiers and Larache, developed relations with Europe and endowed his capital, Meknès, with monuments, fortifications and new infrastructure.

Islamic Geometry: the Philosophy of Space

Naima Elkhatib-Boujibar

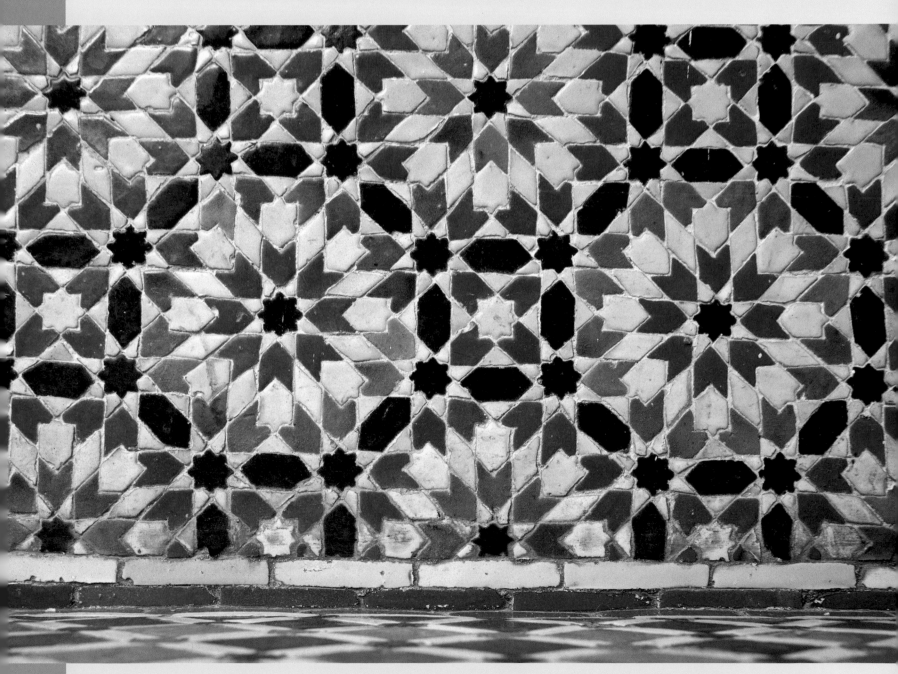

Detail from a tile panel (*zellij*) from Lebbadi Palace

'Alawid, AH 13th–14th centuries/AD 19th centuries
Tétouan, Morocco

In the different countries where Islam took root as of the AH 1st/AD 7th century geometric motifs were already being used in decorative compositions, for example: a number of Roman mosaics in Syria, Berber architecture in Africa and Coptic furniture from Egypt. However, no artistic style employed this form of decoration as widely as Islamic art, where it was used to such an extent that it became the hallmark of the style and a common aesthetic link between different artistic disciplines and geographical areas. This trend towards geometric decoration did not appear immediately with the arrival of Islam in these countries, however, but emerged gradually during the Umayyad era. It was first found on the latticed windows of certain buildings, and later on the frames of floral panels from Samarra and on a number of

The Aqmar Mosque
Main entrance (detail).

Fatimid, AH 519/AD 1125
Cairo, Egypt

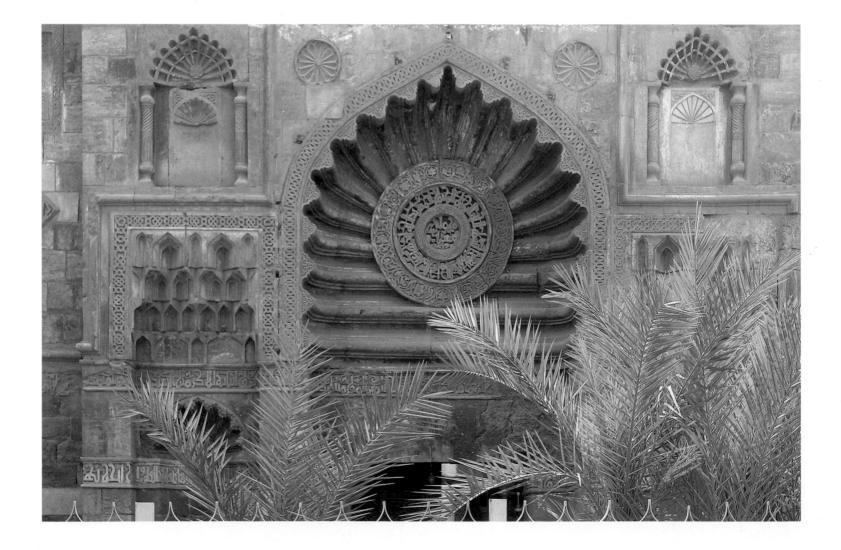

Panel of mosaic tiles (*zellij*)
Covering the entrance wall of the
Buinaniya Madrasa.

Marinid, AH 751–7/AD 1351–6
Batha Museum
Fez, Morocco

Kaftan fragment
The design is composed of eight-
pointed stars with a central motif
consisting of eight tulip-heads issuing
from a central rosette.

Ottoman, AH *late 10th–early 11th/*
AD *late 16th–early 17th centuries*
Royal Museum, National Museums Scotland
Edinburgh, United Kingdom

Silk textile with a geometric pattern

Nasrid, AH 8th–9th/AD 14th–15th centuries
Victoria and Albert Museum
London, United Kingdom

Qur'an

Geometrically laid out, in the centre is
an eight-pointed star containing
surah 41, verse 42 from the Qur'an.

Mamluk, AH 713/AD 1313
Museum of Turkish and Islamic Arts
Istanbul, Turkey

Tulunid works from Cairo. It was not until the 5th/11th century that it began
to appear on the walls of Fatimid buildings in Egypt, reaching its apogee in
the 8th/14th and 9th/15th centuries in the East under the Mamluks and in
the West under the Nasrids and the Marinids.

Geometric decoration originally appeared in the form of plaits, knots and
interlacing. Interlacing or braiding could enliven the façades of minarets, or
trace lozenge-patterns in earthenware tiles on walls on their own, but they
were most notably used to produce skilful compositions that required prior
study, a very good knowledge of geometry and a high level of technical
expertise. This is seen in the perfectly proportioned star shapes which
develop from a circle and divide into regular polygons and which, in turn,
divide in perfect symmetry to produce a repetitive design that appears to
spread into infinity. The endless variations on this theme create an
inescapable feeling of depth and space. Prolific artists and master craftsmen,
eager to diversify their decorative repertoires were not content with the
existing flat figures. Taking advantage of the architectural procedure that
turned square-plan vaults into octagons, they invented a three-dimensional
decorative form known as *muqarnas*, consisting of seven prismatic parts

joined together and which became a distinctive feature of Islamic art from the 5th/11th century. Made of stone, brick, wood or stucco, *muqarnas* was used to embellish arches, ceilings and minarets, seen by some as directing meditation towards the heavens through its verticality and elevation.

The reason behind this fascination for geometric decoration shown by Muslim artists is an enduring question for art historians and a number of theories have been advanced. Some believe that the weight of religious taboo on figurative representation directed creative thought towards geometric expressions while others feel that the importance Muslims placed on mathematics and the science of numbers led artists to use geometry to compose their skilful decoration. The answer may lay in the appearance of the treatise *Kitab al-Jabr* (Book of Algebra) by the mathematician al-Khwarizmi, which appeared in the 3rd/9th century, at the same time as the first Islamic geometric decorative designs.

***Minbar* from Kutubiya Mosque**
Side panel (detail).

Almoravid, AH 532/AD 1137
Badi Palace
Marrakesh, Morocco

Giralda
Detail of decoration of the minaret.

Almohad, AH 580–94/AD 1184–98
Seville, Spain

FACING PAGE
Madrasa al-Jaqmaqiyya
Elaborate *muqarnas* niche with polychrome stone ornamentation decorating the eastern facade of the mausoleum.

Mamluk, AH 762–822/AD 1361–1421/2
Damascus, Syria

Panel of mosaic tiles (zellij)
From the walls of the Badi Palace,
Marrakesh.

Sa'did, AH 986–1002/AD 1578–93
Batha Museum
Fez, Morocco

Column capital with muqarnas rows

Mamluk, AH 8th–9th/AD 14th–15th centuries
Islamic Museum and Al-Aqsa Library
Jerusalem

For those who support the idea that religious and mystical thought had an influence on the craftsmen, the never-ending designs represent a belief in the indivisibility of God, while those who uphold the theory of symbolism and esotericism see a meaning in each geometric figure, with brotherhoods of initiated craftsmen keeping secret codes and meanings for the symbols.

There are no aesthetic treatises by Muslim scholars extant from this time, and both of these theories appear plausible.

PERSONALITIES

Al-Khwarizmi (d. 241/856) was a mathematician from the Khawarizm region, east of the Caspian Sea. He was summoned to Baghdad by the Abbasid prince al-Ma'mun, where he published a book on Indian numerals and another entitled *Kitab al-Jabr* (Book of Algebra), for which he is considered to be the 'Father of Algebra'.

The Central Maghreb: Conquest and Dissidence

Farida Benouis and Boussad Ouadi

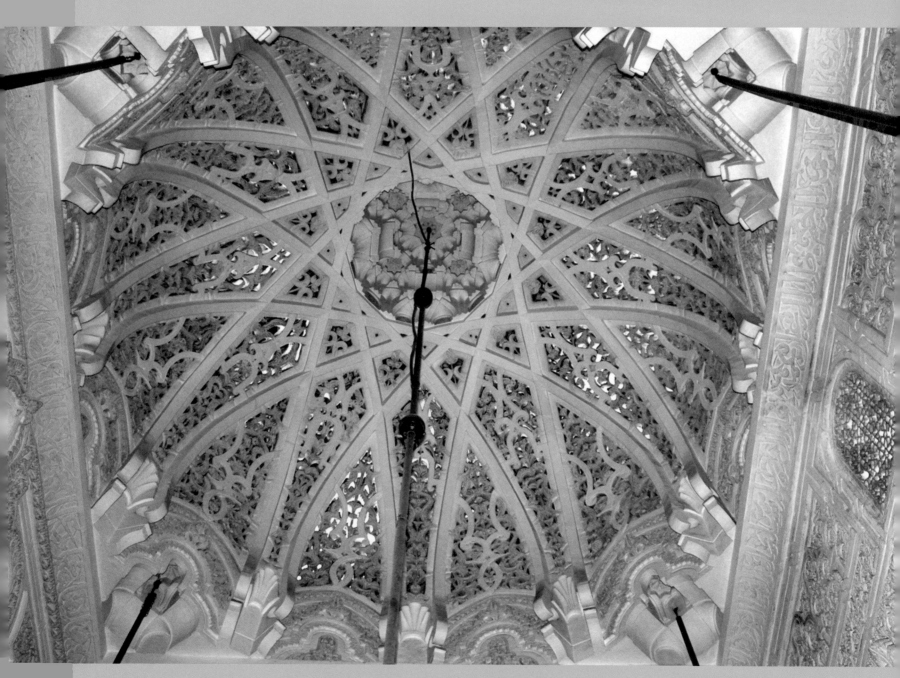

Great Mosque of Tlemcen
Cupola (detail): the interlacing fillets
give the artwork a translucent quality.

Almoravid, AH 530/AD 1136
Tlemcen, Algeria

Fragment of a frieze

Rustamids of Sedrata, AH 296–467/AD 909–1074
National Museum of Antiquities and
Islamic Arts
Algiers, Algeria

If their conquest of the Middle East created few difficulties, the Arab armies came up against much sterner resistance in the Maghreb in the form of Berbers from the Aurès Mountains in Algeria.

The conquering Arab ʻUqba ibn Nafi died in Algeria in AH 64/AD 683 and his mausoleum, erected that year in the small oasis near to the town of Biskra that bears his name, was the first Islamic building in Central Maghreb. Its door, from the Zirid era (4th/10th century) is a masterpiece in carved wood.

The Maghreb was definitively subjugated in 91/709 with the Berbers converting en masse and joining in with the Arab conquest. Nonetheless, their independent spirit remained and found its expression through Kharijism, a revolutionary schism that originated in a disagreement over the succession of the caliphate. The movement developed in the Maghreb where Kharijite rebels had taken refuge to form a number of dissident kingdoms.

In 144/761, ʻAbd al-Rahman ibn Rustam founded the independent Kharijite state of Tahert, near modern-day Tiaret. At the same time, Abu Qurra was also creating a Kharijite kingdom near to Tlemcen. In 155/771, these two kingdoms controlled Central Maghreb and Ifriqiya (modern-day Tunisia).

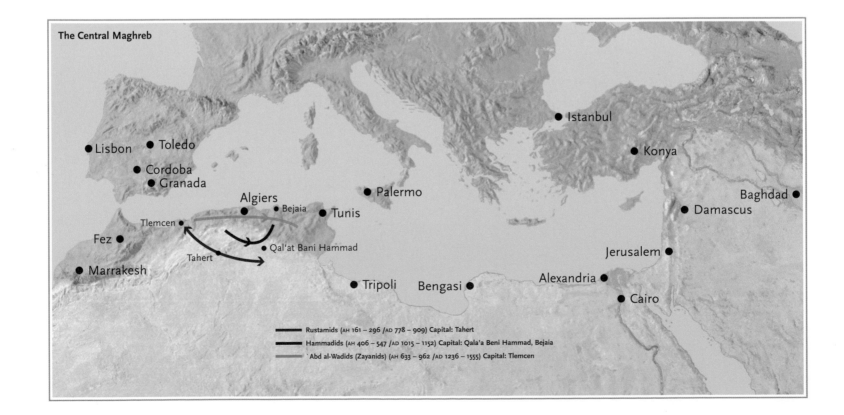

The Central Maghreb

Rustamids (AH 161 – 296 /AD 778 – 909) Capital: Tahert
Hammadids (AH 406 – 547 /AD 1015 – 1152) Capital: Qala'a Beni Hammad, Bejaia
ʻAbd al-Wadids (Zayanids) (AH 633 – 962 /AD 1236 – 1555) Capital: Tlemcen

Not long afterwards, an 'Alid (descendent of 'Ali, son-in-law of the Prophet) named Idris, set up a dissident emirate in Fez and later Tlemcen.

A century later in 296/909, the Rustamids, fleeing their first capital, founded Sedrata near to modern-day Ouargla, where the remains of a mosque have been found along with a palace containing sculpted plasterwork (*timchent*), one of the most interesting artistic finds from the period.

Driven out of Sedrata with the succession of the Fatimids, the Rustamids set up five towns in the Mzab Valley, 600 km south of Algiers, where their descendants still live today, testament to their ingenious adaptation to a hostile environment and desire to perpetuate the doctrine.

The Fatimid Dynasty grew out of Shi'ism, a legitimist schism like Kharijism, which it opposes due to its strict allegiance to the descendants of 'Ali, to the exclusion of all other potential caliphs.

Once they had taken the town of Sijilmasa in 298/910, where the *mahdi* 'Ubaydallah was held, the Fatimids became the masters of the Maghreb. They went on to annex Egypt and left the Maghreb to their allies, the Zirids. Thanks to the Fatimids of Egypt, these Berbers from Central Maghreb became the new rulers of the Maghreb.

Sidi Okba ('Uqba) Mosque

Zirid (416/1025), built around the tomb of 'Uqba ibn Nafi dating back to the West Umayyads AH *67/*AD *686)*
Biskra, Algeria

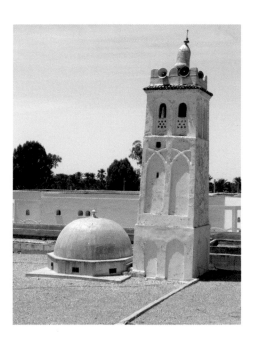

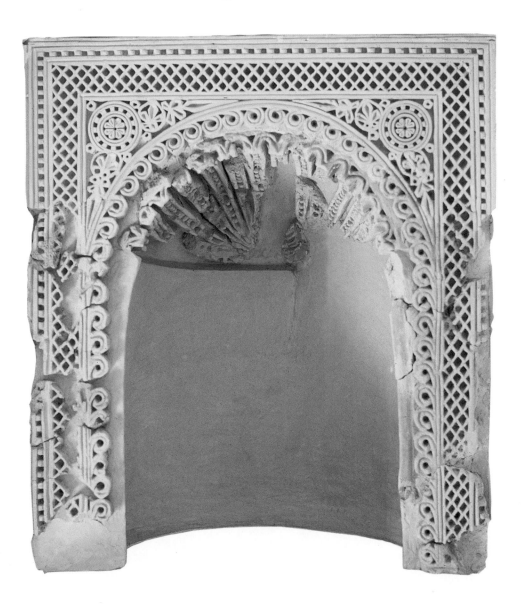

Niche
Corner of a room in a palace in Sedrata.

Rustamids of Sedrata, AH *296–467/*AD *909–1074*
National Museum of Antiquities and Islamic Arts
Algiers, Algeria

Bird figure
Probably used as a handle.

Hammadid, AH 406–547/AD 1015–1152
National Museum of Cirta
Constantine, Algeria

Plate

Zirid, AH 361–543/AD 972–1148
National Museum of Antiquities
and Islamic Arts
Algiers, Algeria

RIGHT
Fragment of a plate

Hammadid, AH 406–547/AD 1015–1152
National Museum
Setif, Algeria

When they came to Ifriqiya, the Zirids left their town, Achir, to their cousins the Bani Hammad, who signalled their desire for independence by establishing the citadel of Qal'at Bani Hammad in the Hodna Mountains in southeast Algeria in 398–9/1007–8. The town's mosque has retained its minaret, one of the most beautiful towers in Algeria whose decoration, harmoniously divided into three sections, was later copied in the Giralda in Seville and the Cuba Palace in Palermo.

The war between the Zirids of Ifriqiya and their Hammadid cousins in the Maghreb lasted until 434/1042 when their heirs managed to negotiate the peaceful cohabitation of the Central Maghreb and Ifriqiya. This period is unanimously recognised by contemporary historians and geographers as one of great economic prosperity. The towns of Achir, al-Qal'at Bani Hammad and then Béjaia, all helped to develop the region, as well as establishing some local architectural features that much later were to influence prestigious towns such as Tlemcen and al-Jaza'ir (the city of Algiers). In 440/1048 the Zirids ended their vassalage to the Fatimids of Cairo, and the Maghreb achieved its independence. In retaliation, the Fatimid caliph decided to send the great nomadic Arabic tribes of Bani Hilali and Bani Sulaym. The Hilali invasion caused widespread disorder, with newly established structures and nascent, prosperous towns annihilated. The besieged Zirids had not been up to the task of resistance.

Having paid a costly tribute to the nomads established near to al-Qal'at, the

Site of Qal'at Bani Hammad

Hammadid, AH 397–8/AD 1007–8
M'sila, Algeria

Earrings

Almohad, AH 7th/AD 13th century
National Museum
Setif, Algeria

Fountain mouth

Hammadid, AH 406–547/AD 1015–1152
National Museum
Setif, Algeria

Hammadids resigned themselves to leaving the town for Béjaia, their second capital, established in 460/1067 by al-Nasir Alannas (r. 454–81/1062–88) on the site of ancient Saldae.

The second half of the 5th/11th century saw the re-establishment of religious orthodoxy in the Maghreb with the arrival of new conquerors, the Almoravids, originally from the Moroccan Sahara. In 463/1070, having taken control of the caravan cities of Sijilmasa and Audaghost, they founded their capital, Marrakesh, the base from which they launched their conquest of the northern towns: both Oran and Algiers were taken in 475/1082.

The cultural contribution of the Almoravids is marked by a combination of influences from the Sahara, whence they came, Maghreb and al-Andalus.

Bab al-Bunud (Gate of Standards)

Hammadid, AH 5th/AD 11th century
Béjaia, Algeria

Capital

Hammadid, AH 406–547/AD 1015–1152
Museum of M'sila (National Agency
of Archaeology)
M'sila, Algeria

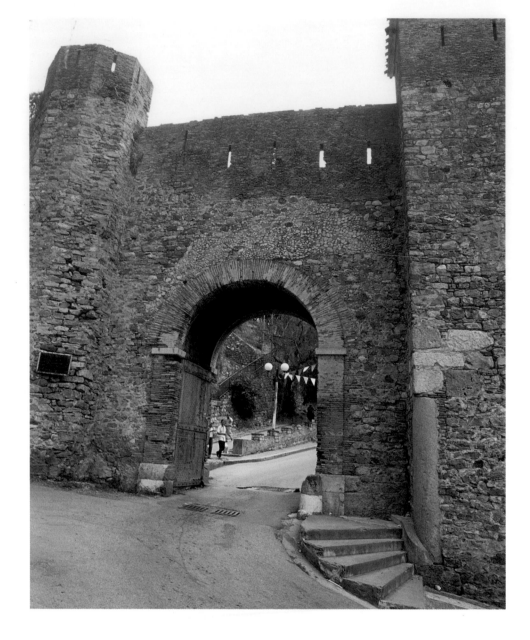

Sitting lion

Hammadid, AH 406–547/AD 1015–1152
National Museum of Antiquities and
Islamic Arts
Algiers, Algeria

They built the Great Mosques of Tlemcen, Nedroma and Algiers, and left consoles and *minbar*s (such as the *minbar* in the Great Mosque of Algiers) that represent some of the greatest examples of Islamic woodcarving.

The Almohads, their successors, represented the triumph of mountainous and sedentary Berber tribes of the High Atlas Mountains in Morocco. 'Abd al-Mu'min took the title of caliph in the name of the founder of the Almohad Dynasty, Masmuda Berber ibn Tumart (Tumartism), and became the political leader of Almohad expansion. The Almohads conquered the towns of northern Morocco, then Oran in Ifriqiya in 540/1145, the Almoravid capital Marrakesh in 541/1146, and finally al-Andalus.

In time, Ifriqiya was conquered and the event took on an even greater significance as it was the first time that all of North Africa had experienced political unity.

It is noteworthy that each of these different political movements was first a movement for religious reform (Kharijism, Shi'ism, Malikism and Tumartism) that found support among rebelling Kharijite tribes, the Kutama Fatimids of Kabylie and the Berber tribes of Southern Morocco, respectively. In each case, the founders of the movement took control of the caravan routes and cities, such as Sijilmasa.

However, once the Almohad Empire began to show signs of weakness, palace revolutions put a stop to their unity. Hafsid, 'Abd al-Wadids and Marinid tribes in turn declared their independence and the Almohad lands were split into three.

Dinar
The existence of coin-making workshops in towns beyond the capital, Marrakesh, testifies to the power, expansion and wealth of the Almoravids.

Almoravid, AH 537/AD 1142
National Museum of Antiquities
and Islamic Arts
Algiers, Algeria

Cornerstone of an arch

Hammadid, AH 6th/AD 12th century
National Museum of Antiquities
and Islamic Arts
Algiers, Algeria

Great Mosque of Tlemcen
Interior view.

Almoravid, AH 530/AD 1136
Tlemcen, Algeria

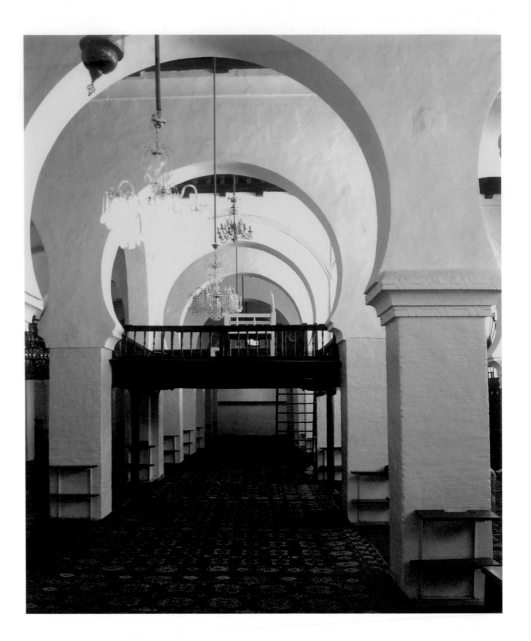

Minbar **from Great Mosque of Algiers**

Almoravid, AH 490/AD 1097
National Museum of Antiquities
and Islamic Arts
Algiers, Algeria

Great Mosque of Algiers

Almoravid, AH 490/AD 1097
Algiers, Algeria

The Christian Threat and the Ottoman Counter-Attack

Several attempts were made to construct a state around these three groups, but the weakness of the central powers meant that the Central Maghreb would never be unified again.

Economically, the opening of the Atlantic routes deprived the region of its income from caravan trade. Christian merchants had trading posts at Maghrebian ports, accentuating the region's dependence on European capital.

BELOW LEFT
Cubit measure
Used commercially at the *suq*.

Ziyanid, AH 728/AD 1328
Museum of Tlemcen (National Agency
of Archaeology)
Tlemcen, Algeria

**The Mahala al-Mansura
(the Victorious Camp)**
Military base.

Marinid, AH 698/AD 1299
Tlemcen, Algeria

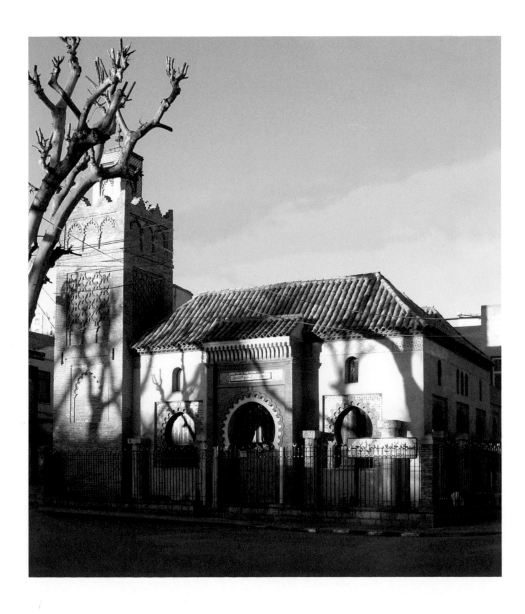

Sidi Bel Hassan Mosque

'Abd al-Wadid, AH 696/AD 1296
Tlemcen, Algeria

Medallion

The inscription reads: '*Al mulk lillah wahdahu*' (sovereignty belongs to God alone).

Almohad or Hafsid, AH *524–668/* AD *1130–1269 or 627–982/1229–1574*
National Museum of Cirta
Constantine, Algeria

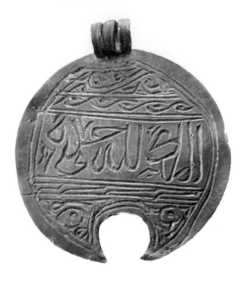

Large tray
Placed on a small painted wooden table and used for serving meals.

Ottoman, AH *1156/* AD *1743*
National Museum of Antiquities
and Islamic Arts
Algiers, Algeria

FACING PAGE
Dar 'Aziza Bint al-Bay (Palace of the Princess)

Ottoman, AH *10th/* AD *16th century*
Algiers, Algeria

The town of Tlemcen, as a Saharan port, remained prosperous and became the capital of the 'Abd al-Wadid kingdom. It filled with monuments typical of Islamic art of that time. The *mihrab* of the Sidi Bel Hassan Mosque is an exquisite example of chisel work. The Marinid kings, who lived in the town for a time, glorified their saints by building the mausoleums of Sidi Boumediene and Sidi el-Halloui.

In the late 9th/15th century, the threat of Spanish incursions into Maghrebian ports was added to the woes of economic decline. The Africans called upon the Ottoman Turks in the name of Islam, and they came to try and re-unify the scattered parts of the Muslim world.

It was as champions of Islam that the Ottomans responded to the calls from al-Jaza'ir to release it from Spanish hold. It became the first vassal-town of the Ottoman Empire in North-West Africa. By allying itself in this way, the Maghreb found the necessary strength to drive back the Christian menace. The country was divided into three provinces or *beylik*s, each ruled by a *bey* who was appointed by the *dey*, himself appointed from Istanbul.

Privateering – an essentially Mediterranean business activity – provided a good income for the regency for 200 years. Mosques betraying a marked Ottoman influence sprang up around the town: basilical layouts and domes

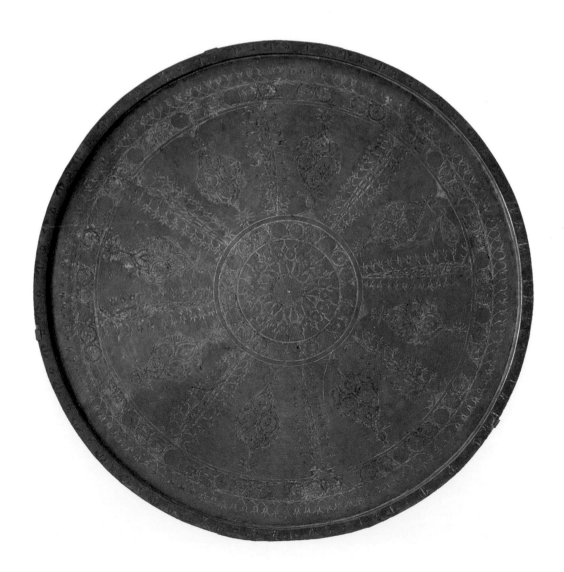

(Jami' al-Jadid in Algiers, for example), while palaces and residences reflected more local influences inherited from towns such as Achir and al-Qal'at.

However, privateering declined as the Europeans gained control over the Mediterranean and ended up being the death throes of a moribund Maghrebian maritime force. The changing times were epitomised by Algiers which, having been home to 100,000 people a century before, had a population of just 30,000 when France's colonial occupation of Algeria began in 1245/1830.

Funerary stele

Ottoman, AH 925–1245/AD 1519–1830
National Museum of Antiquities and
Islamic Arts
Algiers, Algeria

PERSONALITIES

'Uqba ibn Nafi Qays Qurayshi was born in the final years of the Prophet's life, this maternal nephew of Amr ibn al-'As was given control of Ifriqiya in 49/670 and founded the city of Kairouan. He was dismissed in 55/675, but returned in 63/684 as governor of Ifriqiya. He led a reconquest as far as Gibraltar, before he was murdered by the Berber chieftain, Koceila, at Téhouda near to Biskra, where he was buried. His own and his companions' tombs are still a few kilometres outside Biskra at a place called Sidi Okba.

'Abd al-Rahman ibn Rustam (r. 161–71/756–88) was of Persian origin, born in Iraq, and was leader of the Ibadite doctrine. His father, Rustam, died on a pilgrimage to Mecca. As his mother married a Maghrebian pilgrim, he grew up in Kairouan and became one of the five missionaries to spread the Ibadite doctrine, the surviving branch of Kharijism. He founded the town of Tahert in the Maghreb, which developed between 143 and 296 (761 and 908).

Hammad ibn Buluggin I (r. 405–19/1015–28) was the son of the Zirid prince, Yusuf Buluggin I, who ruled the Maghreb for the Fatimids from 361/972 when they conquered Egypt and moved there. When Buluggin died in 374/984, Hammad founded al-Qal'at and declared its independence.

'Abd al-Mu'min ibn 'Ali (r. 524–58/1130–63) was the founder of the Almohad Dynasty in late 524/1130. He completed his Qur'an studies in the town of Tlemcen. He became a disciple of Ibn Tumart in 516/1123 and received the title Amir al-Mu'min, making him the *mahdi*. He became the undisputed leader of the Almohads and established his authority throughout the Maghreb and Spain. During his long reign, he founded and restored many towns.

'And We Made Out of Water Every Living Thing': Water in Islam

Sheila Canby and Zena Takieddine

Aghlabid reservoirs
View of the buttresses of one of the reservoirs.

Abbasid, AH 248/AD 862
Kairouan, Tunisia

'And We Made Out of Water Every Living Thing': Water in Islam

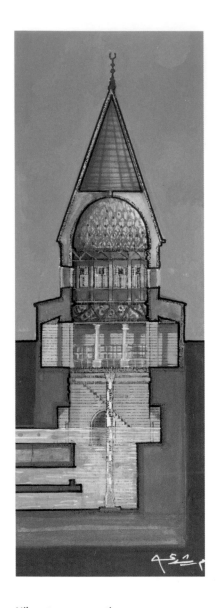

Nilometer, cross section

Abbasid, AH 247/AD 861
Roda Island in the River Nile
Cairo, Egypt

Traditionally mankind has developed various ways to maintain a regular and sufficient water supply for personal, ritual and agricultural use. In Islamic society water was especially sacred for, as the Qur'an indicates, it is the secret to life: '… and We made out of water every living thing' (*surah* 21, verse 30). Because much of the Islamic world is arid, water management and distribution methods were elaborate and varied including subterranean canals, regular canals, aqueducts, cisterns, dams, rain reservoirs and waterwheels.

Massive expansion and population growth took place under the Islamic dynasties, stretching from Spain to Central Asia. In addition to pre-Islamic water-distribution methods inherited from the Nabataeans, Romans and Byzantines, innovations in water management were introduced. Regional governors were responsible for ensuring urban and rural water-supply. Only the most qualified engineers skilled in mathematics, physics, geometry, astronomy (weather forecasting and time keeping) and landscaping, would have been hired to maintain reliable and just water-distribution systems.

Canals carved through the desert irrigated the land and riverside mechanical constructions, such as the Nilometer of Egypt and the *nawa'ir* of Hama, controlled flooding and supply. The upkeep of cisterns in remote

Solomon's Pools

First and second pool: Roman, 1st century BC;
third pool: Mamluk, AH 865–72/AD 1461–7
Bethlehem, Palestinian Authority

*caravanserai*s was essential for both travellers and pilgrims. Wells and basins also supplied water to the public. Endowment documents show that some were meant for humans while others, equally monumental, were intended for animals, such as cattle or caravan camels.

Supplying free water for the thirsty is the duty of every Muslim. During the Ayyubid and Mamluk periods (AH 6th–10th/AD 12th–16th centuries), a distinctive monument known as the *sabil* grew out of this concept, particularly in Cairo, Jerusalem and Damascus. This consisted of an underground cistern, a chamber with window grilles onto the street through which an attendant distributed water in cups, and a loggia on the first floor which served as a boys' school. Just as thirsty passers-by drank the free water of the *sabil*, poor boys were given a free education; both charitable deeds spread communal good and endowed the patron with spiritual blessings.

In the Muslim West, especially in Morocco, these public fountains were called *sikaya*. They were often designed as an arch, set in the wall with water issuing from spigots into a basin. Both *sabil*s and *sikaya*s are found in

Noria (pl. *nawa'ir*) of Hama

Atabeg, Ayyubid, Mamluk, and Ottoman,
AH *6th–10th/*AD *12th–16th centuries*
Hama (River Orontes), Syria

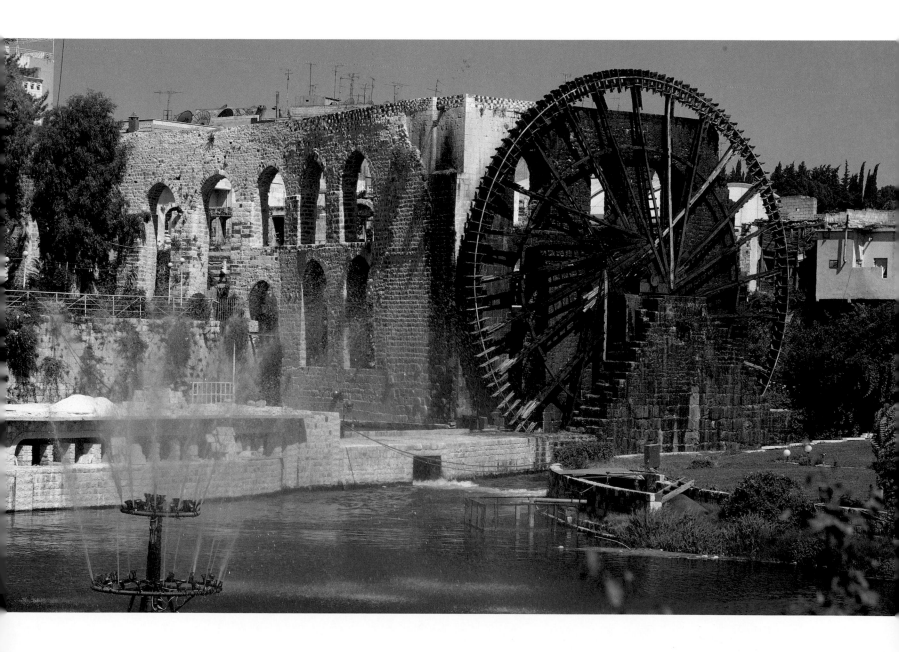

Water jar

*Almohad, AH second half of the 6th or early
7th/AD second half of the 12th or early 13th
centuries*
Museum of Mértola
Mértola, Portugal

**Fountain of Nejjarin Funduq
(caravanserai)**

Alawid, AH 1123/AD 1711 (for the funduq).
In the centre of Fez Old Town,
Place Nejjarine
Fez, Morocco

FACING PAGE
Ewer

Mamluk, AH 872–901/AD 1468–96
Victoria and Albert Museum
London, United Kingdom

Ottoman Istanbul. In palatial settings, such as the Umayyad desert palaces of
Jordan and Syria or the Alhambra in Spain, decorative fountains and canals
nourished lush garden enclosures.

The need to wash regularly and the Qur'anic emphasis on personal
hygiene led to the development of public baths (*hammam*s). These included
a changing room, an unheated room, a warm room and a steam room. While
a trip to the bath may be a weekly or, for poorer families, a bi-monthly event,
ritual ablutions occur five times a day, as cleanliness is obligatory before
prayer. Mosques and religious schools (*madrasa*s) provide basins for this
purpose.

The precious nature of water in desert lands led to the ornamentation of
implements used for drinking and washing. Pitchers, cups and bowls appear
in all contexts and media: glass, ceramic, stone and metal. They combine the
function of holding water with the aesthetic properties of luxury articles. In
wealthy households, servants poured water over diners' hands from inlaid
metal ewers into basins for washing before meals. Such basins were often

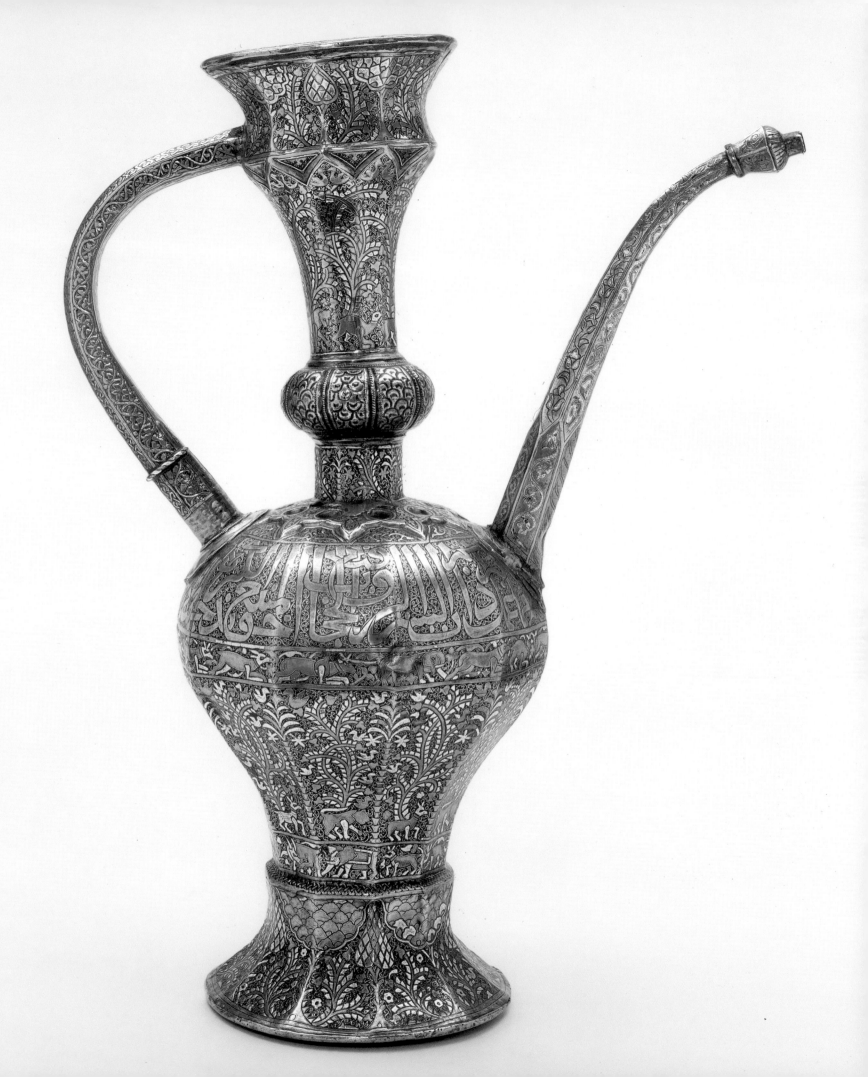

Wash basin and jug

Post-Zangid, AH *second half of the 8th/
AD third quarter of the 13th century*
Museum of Islamic Art, State Museums
Berlin, Germany

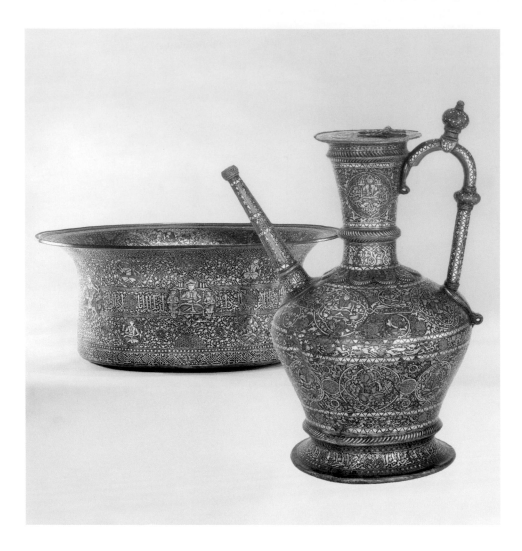

Filter for a water jar

Fatimid, AH *4th–5th/*AD *10th–11th centuries*
Kelvingrove Art Gallery and Museum,
Glasgow Museums
Glasgow, United Kingdom

decorated inside with a central whorl of fish that appeared to swim when the basin was filled with water.

Large three-footed metal cauldrons or smaller containers were used for boiling water. Glass goblets were used for drinking-water, while unglazed pottery jugs with openwork filters kept water cool and clean as insects could not penetrate the filters and the porous clay allowed the water to breathe.

Mudéjar Art: the Islamic Heritage in Christian Portugal and Spain

Gonzalo Borrás Gualis and Santiago Macías

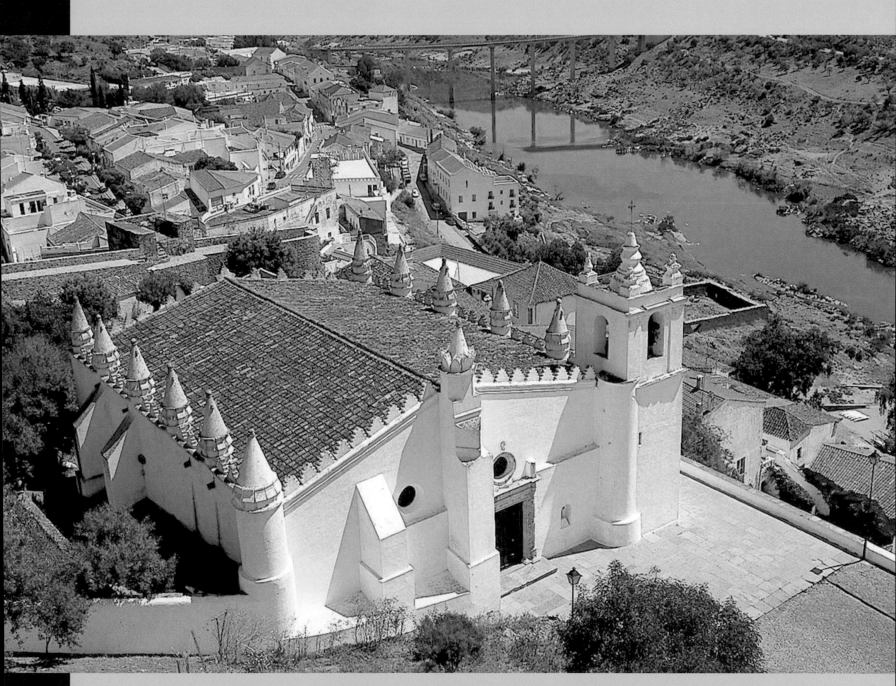

Mértola Mosque
Converted into a church after the
Reconquista. Rebuilt in the 16th century AD.

Almohads, AH *second half of the 6th/*
AD *12th century*
Mértola, Portugal

Mudéjar Art: the Islamic Heritage in Christian Portugal and Spain

The term *Mudéjar* is derived from the Arabic *Mudayyan*, referring to those Muslims that stayed behind after the *Reconquista* of the Iberian Peninsula and who were tolerated by the Christian conquerors. Muslim architects, artists and craftsmen, whose families had been living there for several centuries, continued working under Christian rule. Between the AH 7th and 9th (AD 13th and 15th) centuries numerous cathedrals, churches, monasteries and palaces were built all over what is today Spain and Portugal to celebrate the 'new religion'. Both the exteriors and interiors were designed by the Mudéjar, who followed their own religious and philosophic understanding of space, form and decoration, based on the crucial importance of geometry and the use of bricks and coloured tiles as the most used material. The style they created is therefore called Mudéjar.

In European Medieval art, the Mudéjar style is an artistic manifestation unique to Christian Spain. Romanesque and Gothic forms from France dominated Christian architecture in Spain between the 5th/11th and 7th/13th centuries, evident in the Cathedrals of Santiago de Compostela and Burgos, but social and economic factors made Mudéjar art, of Andalusian origin, an alternative to European art forms, reaching its apogee in the 8th/14th century and lasting until the modern era (in the Canary Islands and Latin America). Mudéjar art is a complete system and not just a collection of isolated features that provides its own solutions to all structural requirements. It should not be understood as Romanic or Gothic architecture in brick as, although they are clearly Christian, these religious buildings are entirely different from their Romanic or Gothic counterparts. Although brick is the building material par excellence of Mudéjar architecture in certain regional centres such as Aragon, it is not

Bowl

Mudéjar, AD 14th century
The Burrell Collection, Glasgow Museums
Glasgow, United Kingdom

Cupola from Torrijos

Mudéjar, late AD 15th century
National Archaeological Museum
Madrid, Spain

Cathedral of Santa Maria

*Mudéjar, second-half of the
13th century* AD *to 1538*
Teruel, Spain

Albarello **(pharmaceutical jar)**

Mudéjar, AD *15th century*
National Archaeological Museum
Madrid, Spain

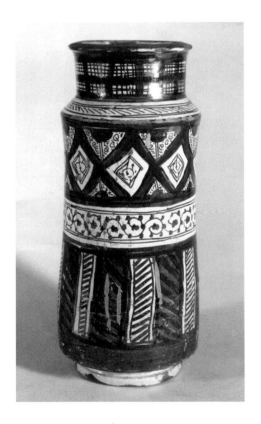

the only material used, and in some cases is not even the most prevalent.
Furthermore, some constructions are of Islamic and not Christian origin, for
instance the bell towers constructed on the bases of minarets, or the rich
variety of wooden ceilings constructed using various techniques emblematic
of the Mudéjar style. Nonetheless, the essence of the Mudéjar style does not
lie in the structure but the decoration, which combines Christian forms with
compositional rhythms and aesthetics from the Islamic tradition.

Mudéjar art is not limited to civic and religious architecture, with equally
magnificent examples of decorative art found elsewhere, particularly in
decorated ceramics. The potteries of Valencia (Paterna and Manises), Aragon
(Teruel and Muel) and Catalonia (Manresa) were all important manufacturing
centres, producing wares inspired by the tradition of al-Andalus, including
pieces decorated in green and manganese and lustre-decorated ceramics.
Decorative ceramics take on a new function when applied to the outside of

buildings; making them lighter and less tangible, as can be seen in the towers of Teruel (Santa María, San Pedro, San Martín and Salvador).

The rich and varied forms of Spanish Mudéjar art can be found in hundreds of monuments in the regional centres of Léon and Old Castile, Toledo, Extremadura, Seville, Granada and Aragon, commissioned both by courtiers and aristocrats (such as the often-imitated Palace of Pedro I 'the Cruel' of Castile, which was added to the Royal Alcázars of Seville between 1364 and 1366). In the popular tradition, the parish churches in Toledo (San Román and Santiago del Arrabal), Seville (San Marcos and Santa Marina), Lebrija (Santa María del Castillo and Santa María de la Oliva), Granada (Santa Ana and San Juan de los Reyes) and Zaragoza (San Pablo, Santa María Magdalena and San Miguel) are good examples. The typological bell towers, fused onto existing minarets with a bell-housing on top, tended to be square-plan, although there are some noteworthy octagonal examples in Aragon (San Pablo de Zaragoza). Some Mudéjar houses (in Carmona and the cloisters of Toledo) and Moorish houses (such as the ones found in the Albaicín district of Granada) have also survived.

The end of the Christian conquest of the west of the peninsula in the mid-7th/13th century all but permanently established the Portuguese border, creating a new historical framework.

Part of the Muslim elite from Gharb al-Andalus departed for the Kingdom of Granada, leaving their land to the new Christian lords. The impoverishment

Seville Citadel
Patio de las Doncellas (the Maidens) (detail).

Mudéjar, AD 13th–15th centuries
Seville, Spain

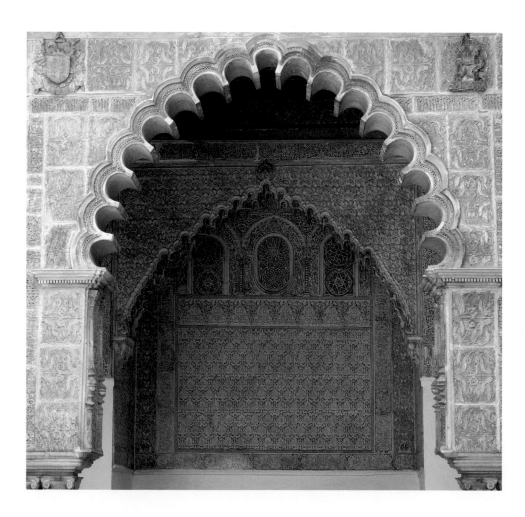

of the Mudéjar community; the conditions endured by the Muslims in the far
west – which were immediately worsened by the presence of a large Christian
community – together with the slow obliteration of a popular memory of the
old way of life between the 2nd/8th and 7th/13th centuries, all contributed
to the decline of the Islamic presence in Portugal between the 7th/13th and
10th/16th centuries. Surviving remains are few: the mosques and *madrasa*s
disappeared long ago; new buildings were erected where simple houses
once stood, and furniture was lost to the ravages of time and pillagers. The
expulsion of the Jews and Muslims in 901/1496 all but silenced the remaining
voices from this time.

Archaeology has gone some way to reviving this memory, with finds in
Portugal including two Islamic tombstones dating to some time after 647/
1250; two capitals with religious inscriptions that would have belonged to the
Islamic community; a font from the Mouraria Mosque in Lisbon and a
processional cross whose Islamic decorative motifs reveal the origin of its

Church of Santiago del Arrabal

Mudéjar, AD 1245–7
Toledo, Spain

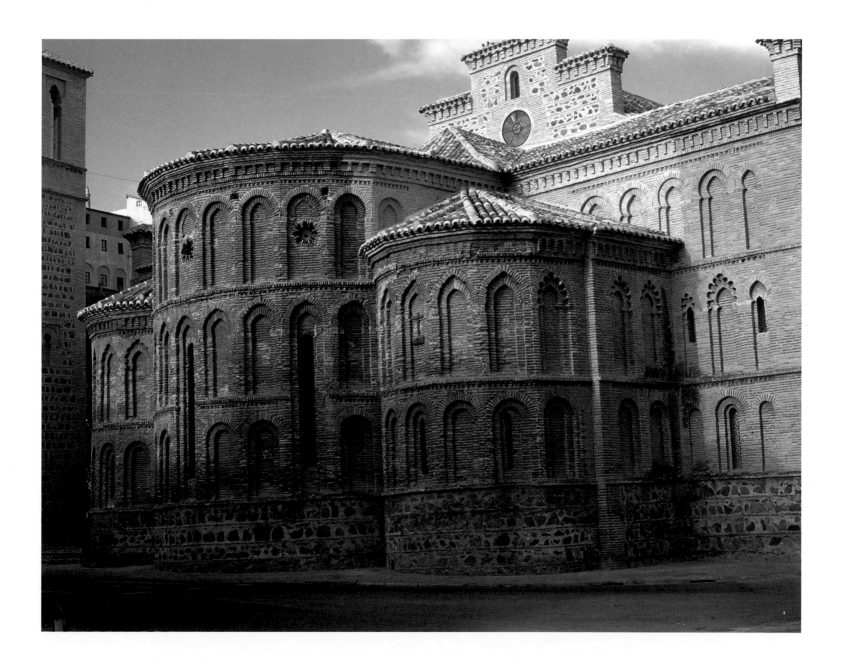

Processional cross

Mudéjar, 14th century AD
National Museum of Ancient Art
Lisbon, Portugal

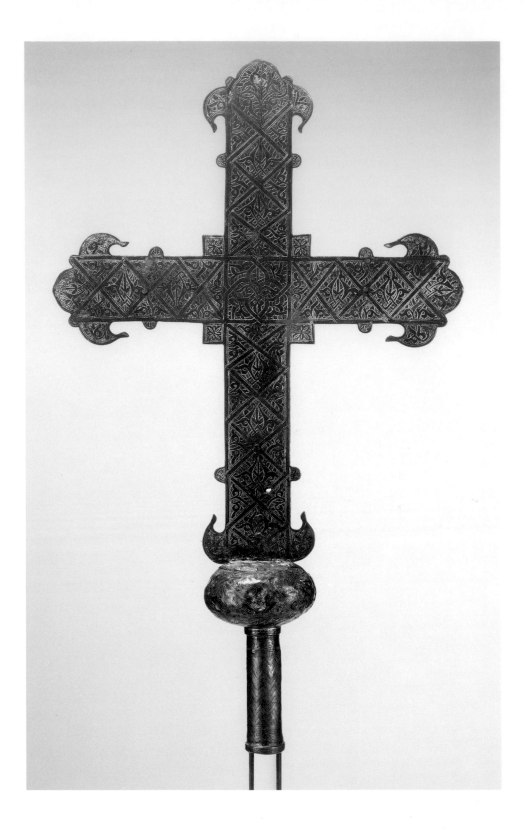

maker and provide proof of contact between the Christian and Muslim communities.

Despite the limited number of examples, there is more than just archival evidence of the presence of Muslim craftsmen in Portugal: an *alarife* (literally 'bald Moor') built Alandroal Castle (Alentejo) in the late 7th/13th century, while another left his lament inscribed in the walls of Coimbra Cathedral some time in around the second half of the 6th/12th century.

Mértola Mosque (detail)
Converted into a church in the 16th century, taking in features of Islamic art.

Almohads, AH *second half of 6th/* AD *12th century*
Mértola, Portugal

Cordovil Palace

Mudéjar, end of the 15th–beginning of the 16th century AD
Évora, Portugal

Évora City Walls
View of the Palace of the Counts of Basto which was built on top of the imposing city walls.

Umayyads of al-Andalus, AH *301–2/*AD *913–14*
Évora, Portugal

Wall tile

Mudéjar, 15th century AD
Kelvingrove Art Gallery and Museum
Glasgow Museums
Glasgow, United Kingdom

The final years of the 9th/15th century and the first of the 10th/16th saw a significant boost to Mudéjar art in Portugal. Art historian Pedro Dias has identified four main centres: Coimbra, Beira Alta and Beira Baixa; the Sintra area; Alentejo; and Madeira. In Beira and even further north, the Mudéjar influence was due to the area's proximity to the Kingdoms of Castile and Léon, an indirect route influenced by Christian art. Further south, the influence was due to contact with the Kingdom of Granada and to a large extent the long journey made by Manuel I to Spain in 903/1498.

There was later a marked trend towards the artistic models of al-Andalus, a style reflected in the aesthetic taste of the Portuguese court in the early 10th/16th century. Seville tiles covered the walls of churches and palaces, luxurious halls were covered with *alfarje* ceilings and the horseshoe arch reappeared in the urban landscape.

This phenomenon, more decorative than structural, was short-lived and was soon replaced with models from the Italian Renaissance, but its remains illustrate well the continued importance of the region's Islamic past at that time, and the fascination it still inspired.

PERSONALITIES

Pedro I 'the Cruel' (r. 750–70/1350–69) was King of Castile and Léon. His reign was a turbulent one due to conflicts with factions of the aristocracy. He was one of the great patrons of Mudéjar art, responsible for the construction of a number of palaces.

Manuel I (r. 900–27/1495–1521) was King of Portugal. An outstanding ruler, he modernised the state and expanded Portuguese possessions overseas. Patron both of the arts and letters, he gave his name to the Portuguese style of the period: the Manueline.

The Ayyubid Era: Conflicts and Coexistence in Medieval Syria

Abdal-Razzaq Moaz and Emily Shovelton

Crac des Chevaliers

Kilabid, Seljuq; Counts of Tripoli;
Knights Hospitallers and Mamluk,
AH 5th–10th/AD 11th–16th centuries
Homs region, Syria

The Crusaders

Many crises befell the Muslim World at the close of the AH 5th/AD 11th century: political fragmentation, two different caliphates competing for supreme Islamic rule and a number of emirates striving for independence. The situation was further compounded when in less than two years, from 484/1092, all four main Muslim political leaders died: first the Seljuq vizier and sultan, then the Fatimid Caliph, and finally the Abbasid Caliph. It was at this chaotic moment that Pope Urban II (1088–99) launched the First Crusade under a religious pretext, but motivated also by political, economic and social factors.

Between 488 and 669 (1095 and 1270), 14 Crusader campaigns took place: nine crusades to the Holy Land, two to Byzantium, two to Egypt, and one to Ifriqiya (Tunisia). Baldwin of Boulogne conquered Edessa, establishing the first Crusader state in al-Raha in 491/1098. The Kingdom of Jerusalem, the third and largest state, was established in 492/1099 after a series of gruelling battles.

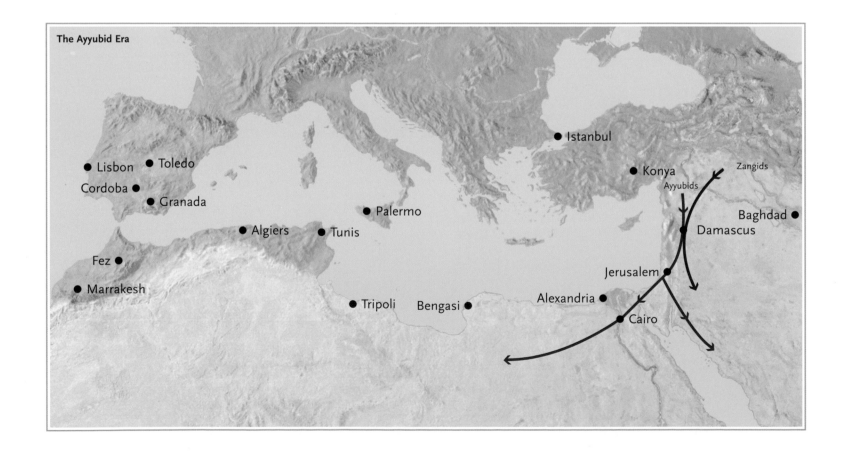

The Ayyubid Era

Tombstone of Sharwa al-Hakkari
A member of a large Kurdish family
who fought against the Crusaders
with Saladin.

Ayyubid, AH 587/AD 1191
Islamic Museum and Al-Aqsa Library
Jerusalem

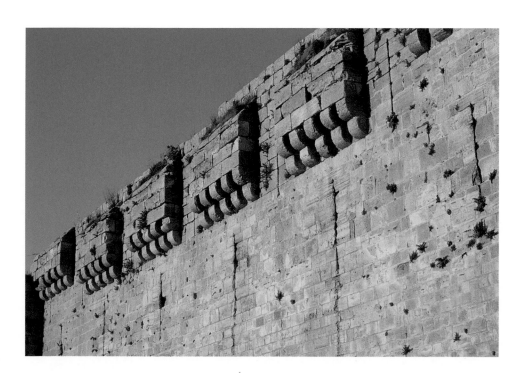

Sword

Crusader, AH 6th/AD 12th century
The Burrell Collection, Glasgow Museums
Glasgow, United Kingdom

CENTRE LEFT
Frankish Letter
Sent to the Templar Brotherhood
in Jerusalem.

Crusader, AH 575–79/AD 1180–8
Islamic Museum and al-Aqsa Library
Jerusalem

Crac des Chevaliers
South-western part of the outer
fortification (detail).

*Kilabid, Seljuq; Counts of Tripoli;
Knights Hospitallers and Mamluk,
AH 5th–10th/AD 11th–16th centuries*
Homs region, Syria

The first king was Godfrey of Bouillon, who titled himself 'Defender of the Holy Sepulchre'. Over the next 200 years, many Crusader-states were won and lost until the final expulsion of the Franks in 690/1291 by the Mamluks at Acre.

The Arabs gave the invading Crusaders the epithet '*al-Franj*' – the Franks – whose sudden onslaught caused major changes in Muslim civilian life. Communities throughout the region became focused on *jihad*, or holy war. Many refugees from the Holy Land, al-Maqdis, sought refuge in Damascus, especially the district of al-Salihiyya. A spirit of militarisation thus marked the 6th/12th century, reflected in the social life, literature and architecture of the period.

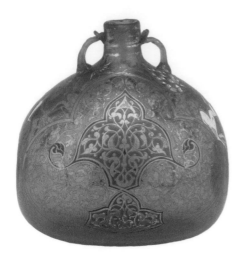

Pilgrim bottle

Mamluk, AH end 7th/AD end 13th century
The British Museum
London, United Kingdom

Citadel of Aleppo

*Zangid, Ayyubid and Mamluk, AH 6th–7th/
AD 12th–13th centuries*
Aleppo, Syria

Ajlun Castle

Ayyubid, Mamluk, AH 579–658/AD 1184–1260
Ajlun, Jordan

Warrior relief

Anatolian Seljuq, AH *6th/*AD *12th century*
Museum of Turkish and Islamic Arts
Istanbul, Turkey

Despite the massacres and intermittent warfare, Franks and Muslims learned to coexist largely through commerce. The Franks brought with them their building techniques and architectural styles for the construction of castles. Once installed in the region, they developed a taste for the 'exotic' art of the Muslims, taking back with them to Europe luxurious works of ceramics, metal, crystal, glass and textiles.

The Atabegs and Ayyubids

Other invaders who would have a great impact in the Muslim World at this time were the Central Asian nomadic tribes: the Seljuqs. These Sunni warriors took control of Baghdad and became self-styled protectors of the weakened Abbasid caliphate. They ruled over a vast area by appointing *atabegs* – governors employed to guide princes in the arts of military leadership – who grew in power, often becoming independent rulers. The Seljuqs re-united the regions of Iran, Iraq and Syria under the banner of Sunni Islam, and even penetrated Asia Minor at the decisive Battle of Manzikert in 463/1071, taking the Byzantine Emperor hostage, which raised the alarm in Latin Europe.

Throughout the Crusader period, the strategic cities of Aleppo and Damascus in Syria remained under Muslim Atabeg control, becoming strongholds of Islamic unity and anti-Crusader propaganda. One such

Atabeg was 'Imad al-Din Zangi who was based in Aleppo and who succeeded in expelling the Crusaders from Edessa in 539/1144. His son and successor Nur al-Din Mahmud ibn Zangi (d. 569/1174) took over Damascus in 549/1154 and united Syria. Under his rule, Damascus witnessed a political, economic and religious renaissance, becoming the cultural magnet of the Muslim World.

The famous Saladin, or Salah al-Din ayyub, was of Kurdish origin and one of Nur al-Din's most brilliant lieutenants. He rose to prominence during his successful campaigns in Egypt where he defeated the Fatimids in 567/1171.

Karak Castle
Crusader, Ayyubid and Mamluk, AH *6th–8th/*
AD *12th–14th centuries*
Karak, Jordan

Painting of a battle scene

Ayyubid, AH *7th/*AD *13th century*
The British Museum
London, United Kingdom

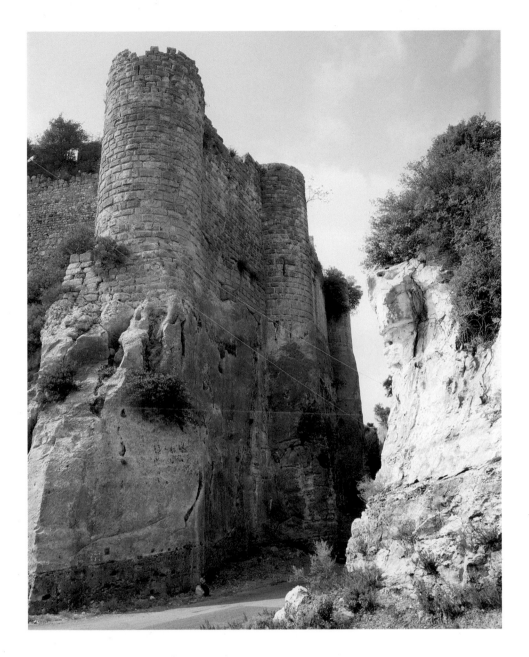

Saladin's Castle

Hamdanid; Byzantine; Seljuq; Crusader;
Ayyubid and Mamluk, AH 4th–7th/
AD 10th–16th centuries
Latakia region, Syria

Equestrian figurine
Known as the 'Horseman of al-Raqqa'.

Ayyubid, AH 6th/AD 12th century
National Museum
Damascus, Syria

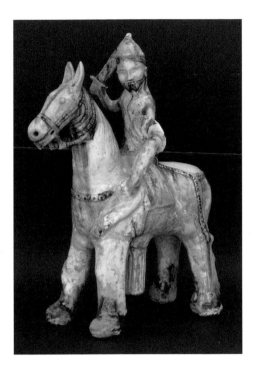

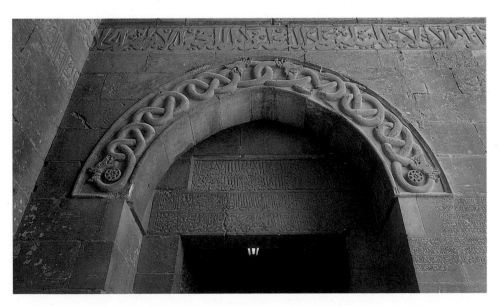

Citadel of Aleppo, Serpent Gate
Serpents and dragons decorating
gateways symbolised the power of the
sovereign and the security of the land
under his domain.

Zangid, Ayyubid and Mamluk, AH 6th–7th/
AD 12th–13th centuries
Aleppo, Syria

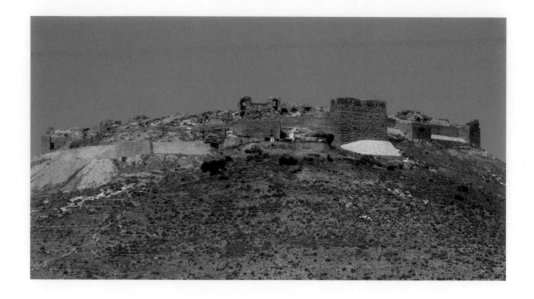

Shawbak Castle

Crusader, Ayyubid and Mamluk, AH 6th–7th/
AD 12th–13th centuries
Shawbak, Jordan

Saladin succeeded Nur al-Din, founding the Ayyubid Dynasty. After his death, his realm was shared among members of the dynasty who were more inclined to establish peace treaties with neighbouring Frankish states than wage war. Consequently, trade between Europe and the Levant continued to thrive from the 1180s to the 1250s.

Saladin and Crusader Castles

Saladin, the most famous Muslim hero of the Crusades, heralded one of the brightest periods in Arab history. After Nur al-Din's death in 569/1174, he spent ten years fighting fellow Muslims and consolidating his army before turning his attention to the Franks. His unification of Egypt and Syria (and even Yemen) resulted in the formation of a large military force. His major victory was at the Battle of Hittin in 583/1187 after which he captured Jerusalem. When Saladin died in 589/1193, his sons built him a mausoleum next to the Great Umayyad Mosque of Damascus.

Shmemis Castle

Atabeg and Ayyubid with some Mamluk
restoration, refortified and enlarged to current
dimensions in AH 628/AD 1230
Salamiyya region, Syria

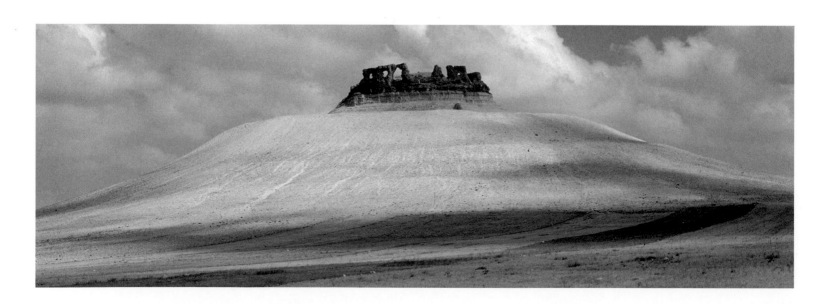

Church of the Holy Sepulchre
The church dates back to the Byzantine period but several renovations were implemented in subsequent periods.

Initial construction AD *326–35; present construction:* AH *543/*AD *1149*
Jerusalem

Turkish horsemen, from Central Asia and Iran, played a crucial role in the success of both Nur al-Din and Saladin's armies. These fierce warriors employed archery when at a distance from the enemy, and the lance or sword when fighting at close range. Speed and agility on horseback gave them a huge advantage against the Franks. The development of weapons, such as the catapult (*manjaniq*), as well as Saladin's strong military organisation, also strengthened the Ayyubid army.

The Levant, especially Syria, formed the main battleground of the Crusades. As a result this region was dotted with Muslim and Frankish castles and citadels. These fortifications repeatedly changed hands between the Crusaders and Muslims. Saladin's successful campaigns saw the conquest of some 50 Crusader positions, including Chateau de Saone, which he besieged in 584/1188. Now known as Saladin's Castle (Qal'at Salah al-Din), this is one of the finest 6th-/12th-century examples extant.

Military fortifications were expanded and restored by the Ayyubids and Crusaders and were then further embellished under the Mamluks in the latter half of the 7th/13th century. The Franks brought to the Levant new techniques both in art and architecture, and the Franks in turn returned home with techniques learned from Islamic builders and artists. That both Frankish and Muslim craftsmen contributed to fortifications is evidenced by the different styles of masonry and architectural features.

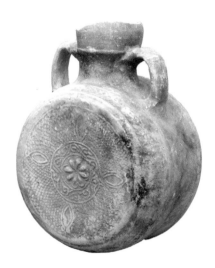

Pilgrim bottle

Ayyubid, early Mamluk, AH *7th/*AD *13th century*
Museum of Mediterranean and Near Eastern Antiquities
Stockholm, Sweden

Pilgrimage and Travel

Trade and pilgrim routes between the Mediterranean, Central Asia and Arabia were perilous even in times of peace, and were particularly dangerous during the Crusader period. Despite the hazards of travel, Muslims and Franks frequently crossed each other's territories. Ibn Jubayr, a Valencian

pilgrim from Muslim Spain who was heading from Damascus to Acre with a caravan of merchants in September 580/1184, writes: 'One of the strangest things in the world is that Muslim caravans go forth to Frankish lands, at the same time as Frankish prisoners of war enter Muslim lands'.

Thus even in times of war both sides sought to ensure safe routes for trade and travel. Castles and citadels were built at strategic points to protect the roads, such as Karak and Shawbak castles. Pilgrims, soldiers, scholars, traders and craftsmen from all over the Mediterranean region, and further east, were attracted to Syria and Palestine, making the region a vibrant meeting ground for diverse ethnic groups.

For Christian pilgrims, the Holy Land was the end goal, with Jerusalem, Bethlehem and Hebron as the most important destinations. Every year Muslim pilgrims would travel to Mecca for their foremost pilgrimage (*hajj*). There were two main Caravan routes for the *hajj*: the Egyptian, which

Khan al-'Arus
Commissioned by Salah al-Din Ayyub (Saladin) to provide shelter for travellers.

Ayyubid, AH 577/AD 1181–2
On the Damascus to Homs Road, Syria

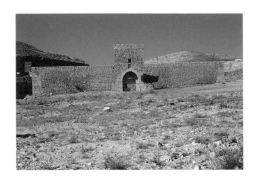

The Haram al-Sharif
The 'Noble Sanctuary', where the Dome of the Rock and al-Aqsa Mosque are located.

Building began in AH 15/AD 637 *and continued until* AH 1336/AD 1917
Jerusalem

Madrasat al-Firdaws
One of the greatest religious
complexes to be erected during the
Ayyubid period by a powerful woman,
Dayfah Khatun.

Ayyubid, begun before AH 633/AD 1235–6 *and*
completed before AH 642/AD 1240
Aleppo, Syria

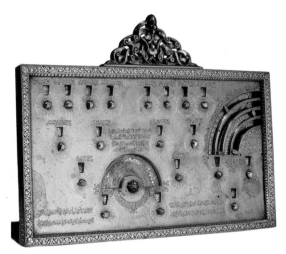

Geomantic instrument

Ayyubid, AH 639/AD 1241–2
The British Museum
London, United Kingdom

included Muslims from African Countries, and the Syrian, which brought
those from the Eastern Provinces. Muslim pilgrims often journeyed through
Jerusalem where they would visit the Dome of the Rock and the Aqsa mosque
in the Haram al-Sharif, the third most sacred site after Mecca and Medina.

Merchants often travelled in the same caravans as pilgrims. They would
put up for the night at hostelries, *caravanserais* or *khans*, built on the roads
outside cities and within main cities, which provided shelter, food and water.
Once the merchants reached a city, they would find markets, *suqs*, selling an
impressive range of goods: silk, perfume, jewellery, gold, spices, glassware,
metalwork and ceramic vessels.

Manuscript on geography

Mamluk, AH 741/AD 1340
National Museum
Damascus, Syria

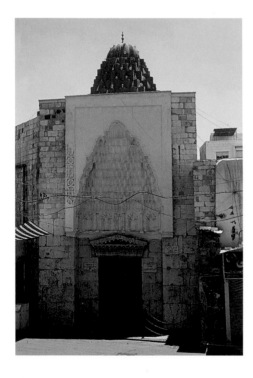

Bimaristan Nur al-Din

Atabeg, AH 549/AD 1154
Damascus, Syria

FACING PAGE
Astrolabe

Ayyubid, AH 683/AD 1240–1
The British Museum
London, United Kingdom

Madrasas and the Transmission of Knowledge

The earliest *madrasa*s – colleges for religious education in the Sunni doctrine – were built by the Seljuqs in the 5th/11th century. There was a significant surge in their construction under the Atabegs, Zangids and Ayyubids. This was part of a wider Sunni revival following the demise of the Shi'ite Fatimids. Across Syria, Palestine and Egypt hundreds of religious institutions, including *madrasa*s, were sponsored by Nur al-Din, Saladin and their successors. Nur al-Din clearly stated his intention behind his patronage of *madrasa*s as: '… the transmission of knowledge, the ousting of heresies and the revival of religion'.

Numerous Muslims seeking religious enlightenment and scientific instruction were attracted to Syria. Scholars from Iraq, Iran, Central Asia, al-Andalus, the Maghreb and Egypt poured into Syrian *madrasa*s both as students and teachers. Many were fleeing the Mongol invasions in the East, the Crusaders in the Levant and the *Reconquista* in the West. Under Nur al-Din's keen patronage, Damascus was transformed into one of the foremost intellectual and political hubs of the Muslim World. *Madrasa*s were usually run with the aid of endowments (*waqf*) which facilitated grants, salaries, and places to live for the scholars (*ulama*). Both male and female members of the Turkish and Kurdish ruling elite taught at and sponsored these institutions.

Sciences were taught alongside religious studies. Astrolabes and celestial globes were designed for accurate readings of the constellations, while geomantic instruments were designed to attempt predictions for the future. Besides *madrasa*s, hospitals (*bimaristan*s) were important centres for medical and pharmaceutical training. During this period the famed illustrated manuscript on mechanical and hydraulic engineering was written by Abu al-'Izz Ismail al-Jazari, of the Artuqid court. Geographic almanacs were also produced, such as that by the Ayyubid Abu al-Fida in Hama.

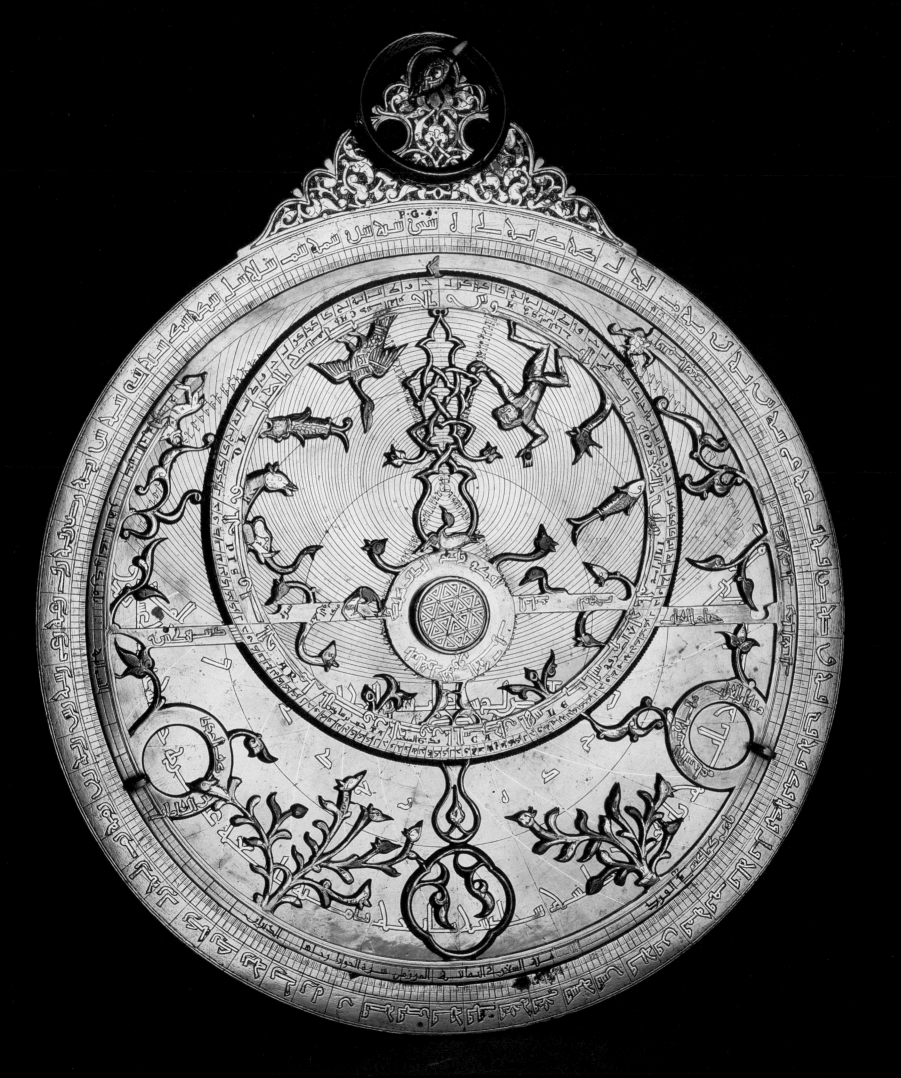

Atabeg and Ayyubid rulers were dedicated builders. They commissioned new mosques, mausoleums, *hammams* (bathhouses), *suqs*, *madrasas*, *khanqahs* and *khans* (hostels). Contemporary historians record the construction of 242 mosques, as well as 100 new *madrasas*, built in Damascus alone. New architectural forms were introduced and adapted to suit the new Syrian environment, such as the *madrasa* and the *bimaristan* inspired by Iranian Seljuq models. Artistic innovations were also achieved in metalwork from Mosul, pottery in al-Raqqa, and carved woodwork from Damascus and Aleppo.

The Umayyad Mosque in Damascus was restored by Nur al-Din and Saladin after suffering a series of catastrophic fires. The citadels and city walls of Damascus, Aleppo, Cairo and various other cities were also thoroughly

Pitcher

Atabeg, AH *late 6th/*AD *12th century*
National Museum
Damascus, Syria

ABOVE RIGHT
Damascus Citadel

Ayyubid, AH *599–610/*AD *1202–14*
Damascus, Syria

Diyar Bakr Citadel

*Built during the reign of the Roman Emperor
Constantine in* AD *349; additions and repairs
made in the Byzantine and Islamic periods*
Diyar Bakr, Turkey

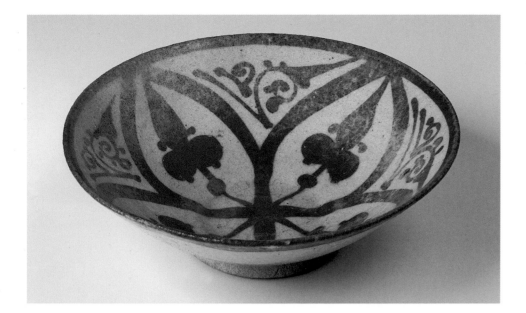

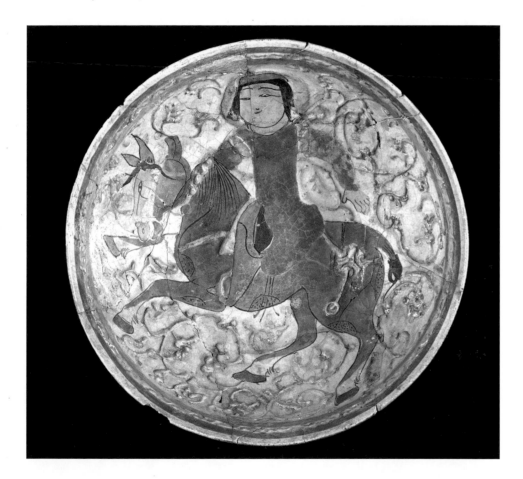

Lustre bowl from al-Raqqa

Ayyubid, AH *late 6th–early 7th/*
late 12th–early 13th centuries AD
Museum of Islamic Art, State Museums
Berlin, Germany

Fragments of a flask

Atabeg, Zangid, AH *521–41/*AD *1127–46*
The British Museum
London, United Kingdom

Bowl with horseman

Seljuq, AH *6th–7th/*AD *12th–13th centuries*
National Museum of Oriental Art
Rome, Italy

Brass box

Atabeg, Ayyubid, AH *631–57/*AD *1233–59*
The British Museum
London, United Kingdom

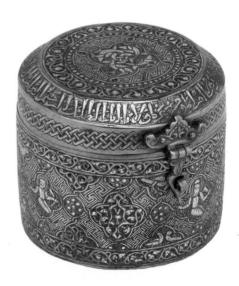

refortified. Palaces were built within citadels to protect them from the
constant threat of the Crusaders; the best surviving example of which is
within the Citadel of Aleppo. The palaces would have been filled with
sumptuous carpets, fine metalwork and glass vessels.

Many of these items would have been gifts from other rulers or nobles.
The exchange of gifts helped to strengthen relations between neighbouring

Fragment of a fresco panel

Ayyubid, AH *6th–7th/*AD *12th–13th centuries*
National Museum
Damascus, Syria

Metal grille or enclosure

Crusader, AH *6th/*AD *12th century*
Islamic Museum and Al-Aqsa Library
Jerusalem

Dome of the Rock

Umayyad, AH 72/AD 691
Jerusalem

territories and rival rulers. The Artuqids – Turkmens from Anatolia who established themselves in Diyar Bakr in the late 5th/11th century – forged ties with nearby rulers by sending them gifts.

The use of luxury objects to oil diplomatic relations also occurred at the court of Badr al-Din Lu'lu'. An Armenian convert to Islam, Lu'lu' was a Zangid vizier before becoming an independent ruler of Mosul in northern Iraq from 615 to 657 (1218 to 1259). He took a great interest in metalwork inlaid with gold and silver. The number of inlaid brass vessels bearing his name is testimony to their ambassadorial function.

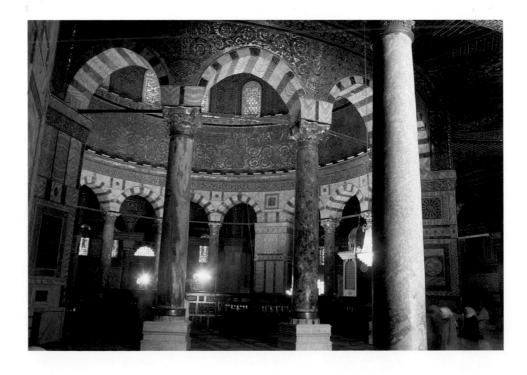

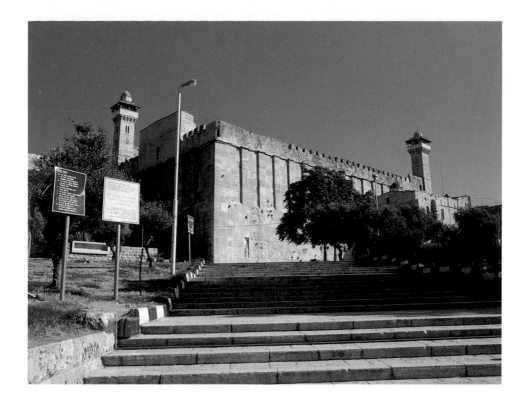

Sanctuary of Abraham (Ibrahimi Mosque)
One of most important religious sites in Islam.

The foundation goes back to Roman times and construction continued until the end of Ottoman period.
Hebron (al-Khalil), Palestinian Authority

Incense burner

Ayyubid, AH 596–647/AD 1200–50
The British Museum
London, United Kingdom

LEFT
Marble balustrade

Crusader, AH 6th/AD 12th century
Islamic Museum and Al-Aqsa Library
Jerusalem

Christians as Patrons of the Arts during the Crusader Period

At the same time as the fervent reinvigoration of Islamic institutions, Christian churches and monasteries experienced a renaissance of their own. New cycles of wall-paintings, were commissioned, the like of which had not been witnessed in Syria since the frescoes of the Umayyad period. The Church of the Monastery of Mar Ya'qub (St Jacob), in Jerusalem, and the Monastery of Musa al-Habashi (St Moses the Ethiopian) in Syria, are both excellent examples of the burgeoning medieval Christian art seen in the East. Many of the churches and Christian institutions created at this time were converted from Islamic buildings, and Crusader buildings were likewise converted to Islamic use. It is, therefore, often difficult to establish the exact origin of each stylistic element.

In Jerusalem both the Dome of the Rock and the Aqsa Mosque were converted into churches, with the latter also accommodating Crusader knights. The writer, diplomat and politician, Usama (487–583/1095–1188) who lived at Shayzar Castle, was personally acquainted with Nur al-Din and Saladin, as well as their Frankish opponents. He describes going to pray near the Aqsa mosque, which was otherwise occupied by the Templars. Thus certain members of the military elite, both Arab and Frank, would have shared a common code of chivalry. As part of their diplomatic discourse and day-to-day interaction, they would have been on cordial terms in times of peace.

Cultural exchange between the new Frankish inhabitants of the region and certain Muslim communities occurred, despite the on-going warfare. The main contribution of the Franks to this region was in the field of architecture. Craft workshops were set up by Crusaders, and European artefacts were

Candlestick of Qalawun

Mamluk, AH 693–741/AD 1294–1340
Islamic Museum and Al-Aqsa Library
Jerusalem

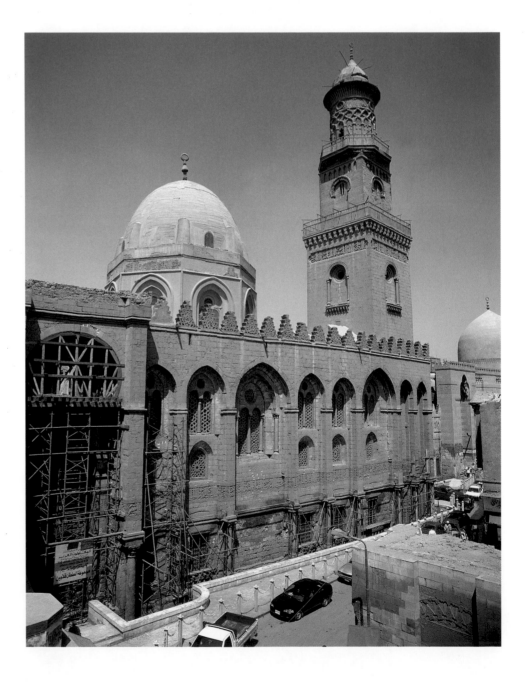

The Complex of Sultan al-Mansur Qalawun

Mausoleum, *madrasa* and hospital.

Mamluk, AH 684/AD 1285
Cairo, Egypt

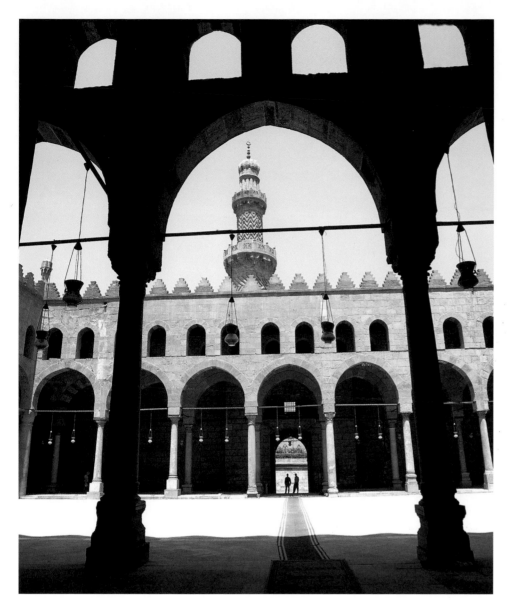

Mosque of Sultan al-Nasir Muhammad ibn Qalawun

Mamluk, built in AH *718/*AD *1318; enlarged extensively in 735/1335*
Cairo, Egypt

imported into the Levant. However, the Franks soon began to acquire a taste for local craftsmanship. Prized objects, such as under-glaze painted ceramics, enamel-painted glass and inlaid metalwork, were taken back to Europe by traders and pilgrims. A particularly interesting group of inlaid metal objects survives from this period featuring Christian imagery. Although produced by local craftsmen these were presumably made specifically for the Crusaders.

Mamluk Sultans and an End to the Crusades

By the 1250s, Frankish states and Muslim principalities were all jostling for power. Although the Ayyubid Dynasty had managed to a large extent to drive the Frankish crusaders from the Levant, they had not been entirely successful. The arrival of the Mamluks reinvigorated the counter-Crusade movement. After a further 50 years of struggle, the Mamluks achieved the ultimate goal of driving the Franks from the Holy Land and the Syrian coast once and for all.

Incense burner

Mamluk, AH *675–7/*AD *1277–9*
The British Museum
London, United Kingdom

Tower of al-Zahir Baybars
Carving of a lion (detail).

Mamluk, AH 658–76/AD 1260–77
Cairo, Egypt

Incense burner

Ayyubid, AH mid–late 7th/AD 13th century
Royal Museum, National Museums Scotland
Edinburgh, United Kingdom

The Mamluk sultan who led the greatest number of victorious campaigns against the Crusaders was al-Zahir Baybars. Like Saladin, he is remembered as a great Muslim hero and he was also buried in a mausoleum close to the Great Umayyad Mosque in Damascus. His successor al-Mansur Qalawun (r. 678–89/1279–90) also won many battles. Finally al-Ashraf Khalil (r. 689–92/1290–3) led the victorious campaign at Acre in 690/1291, which signalled the end of the Crusader states. Khalil symbolically took the stone-portal of Acre Cathedral to be used in the gate of his *madrasa* in Cairo.

Baybars commissioned both luxury objects and architecture, not only in his capital, Cairo, but also in Syria and the Holy Land. While military architecture was a major preoccupation, he also built a large congregational mosque in Cairo – the earliest surviving royal Mamluk mosque in the city. Qalawun was an even more prolific patron of architectural projects throughout the region. His most impressive construction is an imposing complex in Cairo, which includes a *madrasa*, mausoleum and a hospital. This complex was inspired by Qalawun's experience at the Bimaristan Nur al-Din in Damascus where he was cured of a life-threatening illness. Following the tradition of providing charitable care for the ill and homeless, this hospital was dedicated to Muslims of both sexes and from any social position.

The cross-cultural exchange that occurred intermittently during the Atabeg and Ayyubid periods continued with the Mamluks, even after the Crusader defeat. This can be seen in the buildings constructed under the auspices of Qalawun's son, al-Nasir Muhammad: the façade of Sultan al-Nasir's *madrasa* in Cairo displays Gothic and Romanesque features, inspired by Latin architecture.

The *Hajj*: Pilgrimage in Islam

Nazmi Al-Jubeh

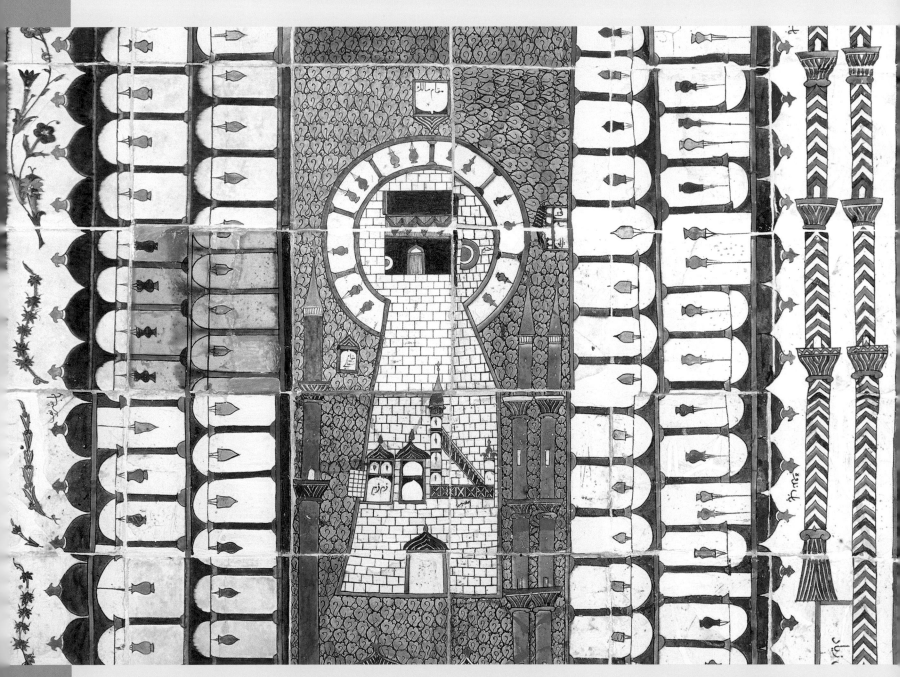

Ceramic tile panel (detail)
Depicting the *Ka'ba* in Mecca.

Ottoman, AH 1087/AD 1676
Museum of Islamic Art
Cairo, Egypt

The *Hajj* (Pilgrimage) in Islam

The *hajj* or pilgrimage is one of the five fundamental duties or 'pillars' of Islam and one of the shortest paths to God.

It is not known entirely when the *hajj* to Mecca began, but its origins certainly go back to a time well before the advent of Islam and thus date to what the Muslims call the period of ignorance or *Jahiliyya*.

Mecca, one of the few small towns of the Hijaz before Islam, claimed its centrality by controlling the main trade routes that connected the different markets of Africa, India, the Middle East and the Western Mediterranean. Merchants from Mecca travelled in two main caravans; the first took place in the summer towards the north, the second in the winter to the south. In turn, merchants from all over the Arab peninsula and beyond converged on Mecca, particularly in the annual pilgrimage season when homage was paid to an array of local idols housed in the *Ka'ba*.

The *Ka'ba*, according to Muslim belief, had originally been built by Allah's prophet Abraham upon the same site that Adam had once built the 'first house' used for the worship of Allah. Abraham had exiled his wife Haggar and her son Ismail (Ishmael) to the 'valley where nothing grows' in Mecca. Haggar ran between al-Safaa and al-Marwah looking for water for her son.

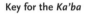

Key for the *Ka'ba*

Mamluk, AH 765/AD 1363
Museum of Islamic Art
Cairo, Egypt

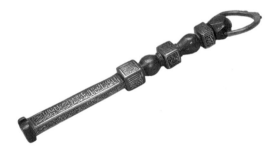

Topographical view of Mecca
Used by pilgrims for orientation
during the *hajj*.

Ottoman, AH *early 12th/*AD *early 18th century*
Uppsala University Library
Uppsala, Sweden

Qibla directional plate
Used to pinpoint the direction of
the *Ka'ba*.

Ottoman, AH 918–26/AD 1512–20
National Museum
Damascus, Syria

The Haram al-Sharif
The 'Noble Sanctuary', where the
Dome of the Rock and the Aqsa
Mosque are located. It was blessed
by God in the Holy Qur'an and was
made the first *qibla* for Muslims.

Building began in AH 15/AD 637 *and
continued until* AH 1336/AD 1917.
Jerusalem

Pilgrim flask

Mamluk, AH 742–6/AD 1341–5
National Museum
Damascus, Syria

Suddenly, the holy water of Zamzam came gushing forth between the feet of her baby boy. As thanksgiving to God, Abraham built the *Ka'ba*, dedicated it to Him and offered sacrifices in it. God then commanded him to walk around the *Ka'ba* seven times to pay homage and worship.

By the *Jahiliyya* period the *Ka'ba* had long become a focus of idol worship. At that time the shrine and much of Mecca's trading activity was controlled by the powerful tribe of Quraysh.

It was into an impoverished branch of this tribe that Muhammad, the prophet of Islam was born in AD 570. He, too, grew up a merchant but soon grew weary of the material greed and polytheistic excesses of his contemporaries. According to Islamic tradition Muhammad was chosen by Allah as the last messenger of the true faith and he set about bringing His will to the people and teaching them to live according to His laws. The annual pilgrimage was one of the traditional customs that were now transformed according to the will of Allah.

Indeed, Islam and the directives within the Holy Qur'an as revealed to the Prophet transformed the *hajj* into a duty incumbent upon every Muslim once in a lifetime if physically and financially able. Mecca and its *Ka'ba* shed their pagan significance and became the global focus for a growing Muslim community in two important respects. Firstly, Allah instructed the Prophet to have all Muslims pray towards Mecca and the *Ka'ba* after having originally directed their prayer towards Jerusalem. Secondly, Mecca and the *Ka'ba* became the centre for the Muslim *hajj*, undertaken once a year in the Islamic month of Dhu al-Hijjah.

Piece of the *kiswa* (cover) of the *Ka'ba*
Renewed every year before the *hajj* season.

Ottoman, AH 13th/AD 19th century
Islamic Museum and Al-Aqsa Library
Jerusalem

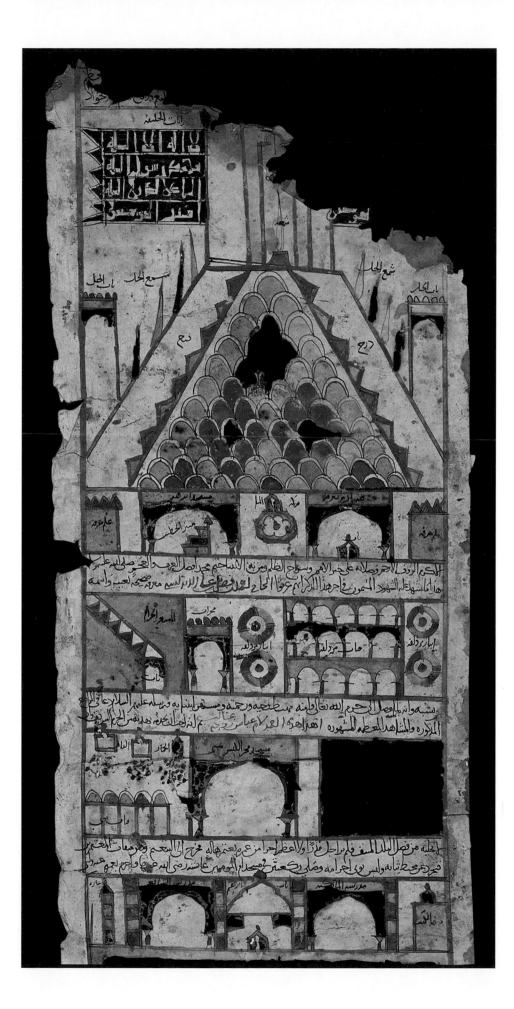

Pilgrimage proxy scroll
People who sent a proxy on their own behalf received a certificate like this one to prove that all the requirements of the pilgrimage had been fulfilled.

Ayyubid, AH 602/AD 1206
Museum of Turkish and Islamic Arts
Istanbul, Turkey

Milestone
Erected to indicate the distance between two stations along a pilgrimage or trade route.

Umayyad, AH 66–86/AD 685–705
Museum of Turkish and Islamic Arts
Istanbul, Turkey

In terms of ritual, the Prophet adopted many pre-Islamic customs associated with the performance of the pilgrimage, but He abandoned the practice of naked circumambulation of the *Ka'ba*. Instead he now ordered that pilgrims wear light, white clothing. An unsewn white garment (known as an *ihram*) is worn by all male pilgrims, who commence the pilgrimage rituals by calling on God to accept their repentance, and supplicate him: 'Here I am at Your service O Allah, I am present, there is no partner with You.'

A complex set of rituals is associated with the *hajj* which culminates in a stay on Mount Arafat (*Waquf*) and is concluded with an offering of sacrifice to God Almighty. This marks the beginning of *'Eid al-Adha* (The Feast of Sacrifice), the most important of Islamic festivals. As an extension to the *hajj* duties, Muslim pilgrims also visit the grave of the Prophet, his mosque at Medina and other shrines and sites, the most important of which is the Holy City of Jerusalem.

In recent decades the *'Umra*, an undertaking of the *hajj* rituals possible at any point during the year, has gained importance in Muslim practice due to the fact that the *hajj* season can no longer accommodate the enormous numbers of Muslims who want to take part. In modern times the Saudi government has restricted the numbers of pilgrims that are allowed to undertake the *hajj* during Dhu al-Hijjah every year and, thus, the *'Umra* remains an alternative for those who aspire to visit Mecca.

In their care of the Holy Cities and commitment to organising the Islamic pilgrimage, the Saudi Government continues a time-honoured tradition according to which Muslim rulers prided themselves not only in their ability to facilitate the annual rituals in Mecca itself, but also to organise the journey of Muslim pilgrims from the far-flung regions of the Muslim world. Of course, the provision of these services was not just a political and administrative duty but was also a source of political legitimacy and – most importantly – a request for recompense and blessings from Allah. Special interconnecting roads for *hajj* caravans (*darb al-hajj*) were built from all parts of the Muslim world and were equipped by the authorities with all the necessary facilities needed for the pilgrims' comfort. A sophisticated system of inns and resting places lined the route to cater for the ever-increasing caravans that included not only pilgrims but also merchants, support personnel and – if caliphs or sultans were present – an extensive official entourage, military units and musicians.

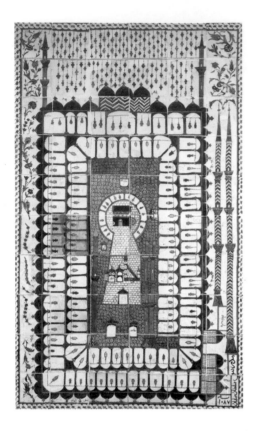

Ceramic tile panel

Ottoman, AH 1087/AD 1676
Museum of Islamic Art
Cairo, Egypt

FACING PAGE
Tomb cover

Ottoman, AH 11th/AD 17th century
Royal Museum, National Museums Scotland
Edinburgh, United Kingdom

Terms relating to the Hajj

Hajj: The fifth pillar of Islam. It is the duty of every Muslim to fulfil *hajj* at least once in a lifetime providing he or she is able to do so in terms of health and resources.

Ka'ba of Mecca or *Ka'ba* of Quraysh: There were many Arab tribes before Islam who had *Ka'bas*. With the advent of Islam, these became nullified and the singularity of the *Ka'ba* was emphasised with the one *Ka'ba* at Mecca. *Ka'ba* means literally 'cube'. It appears as a cube in shape and is considered the most holy site for Muslims, being the direction towards which they pray. Pilgrims circle the *Ka'ba* seven times when they first arrive in Mecca in the *tawaf al-Qudum* (the circuit of arrival). Likewise, they circle the *Ka'ba* before they leave Mecca, this is called *tawaf al-Wada'* (circuit of farewell).

'Wadi ghair dhi zara: ('Valley where nothing grows'): the Qur'anic term to express the arid valley of Mecca.

Al-Safaa and al-Marwah: The two points in Mecca between which Haggar ran desperately searching for water for her son who was suffering from great thirst due to the extreme heat.

'*Eid al-Adha*: A festival on the tenth day of Dhu al-Hijja, called variously, the Day of Immolation, the Great *Eid*, Festival of *Eid* or the Feast of Sacrifice. The legacy of this sacrifice goes back to the Prophet Abraham and is considered the most important festival for Muslims, marking the end of the *hajj* rituals.

Rituals of the Hajj

The Intention: A Muslim first makes known his or her intention of performing the religious duty of the *hajj*, and at his or her departure, heads towards Mecca.

Al-Ihram: This is a concept with physical and spiritual aspects. Firstly it comprises a body of specific rules regarding the physical appearance of the pilgrim. All sewn clothing is discarded and replaced by a piece of white cloth wrapped around the body. Hair on the head is either shaved or shortened. On a spiritual level these rules imply that the pilgrim is prepared to abstain from any behaviour that would nullify the benefits of the *hajj* such as killing or hunting.

Al-Tawaf: Circumambulation of the *Ka'ba* seven times at the time of arrival and departure.

Al-Sa'y: The ritual walk between al-Safaa and al-Marwah.

Waquf (Halt) at Mount Arafat: All pilgrims meet at the wide elevation in Mecca which is called Mount Arafat.

Stone throwing: This is the pelting of the symbols of evil (the devil) with small pebbles, the aim of which is to distance oneself from evil.

Zamzam: This is the well of Mecca, and the one continuous and permanent source of water. According to the Islamic tradition, the spring came forth by the power of Allah when the suckling thirsty infant, Ismail, struck the earth with his feet while his mother was looking for water. The water is considered holy and blessed by the pilgrims who carry quantities of it back home to give to family and friends.

Leave-taking of the Pilgrims: This is part of folk heritage which has been transformed into a national day. Special songs are sung on this day, which differ from country to country. It is usual for official representatives of the administration to take part in the departure of the *hajj* caravan, resembling the reception of the pilgrims when they return. In the past, the *hajj* caravan was received at the frontiers of provinces.

Hajj Route or Road (*darb al-hajj*): This was a specific route that has changed at times and was taken by pilgrims from every corner of the Islamic world who were heading to Mecca. Usually all the necessary services were provided, especially security, by the administration. Caravans would come together at specified times in designated places, for example the Turkish caravan would meet with the caravan from al-Sham and they would travel together to join up later with the Jordanian and Palestinian caravans.

Visit to Jerusalem: It was common in early Islam to consider a visit to Jerusalem (al-Quds) as the pilgrimage of the less able, those who were not physically or financially equipped to make the journey to Mecca. Jerusalem is the first of the two *qibla*s and the third Holy City and is thus included in the holy triangle. Usually a visit to Jerusalem was included in the return trip, a trend that was widespread especially among people from Spain and North Africa (the Western Islamic World).

'*Umra*: '*Umra* is almost the same as the rituals of the *hajj* but takes place outside the *hajj* season. It includes a visit to all the holy places and is undertaken for all the religious shrines with the exception of Mount Arafat.

Black Stone: The black stone or rock that is considered to be the foundation stone of the *Ka'ba*. It is surrounded by a silver frame to protect it and many pilgrims go there to kiss it, imitating the action of the Prophet Muhammad.

Printing block
Listing the holy places in the region of Palestine.

Ottoman, AH *13th/*AD *19th century*
Islamic Museum and Al-Aqsa Library
Jerusalem

The Mamluks: Cairo Becomes the New Centre of the Islamic World

Mohamed Abbas M. Selim

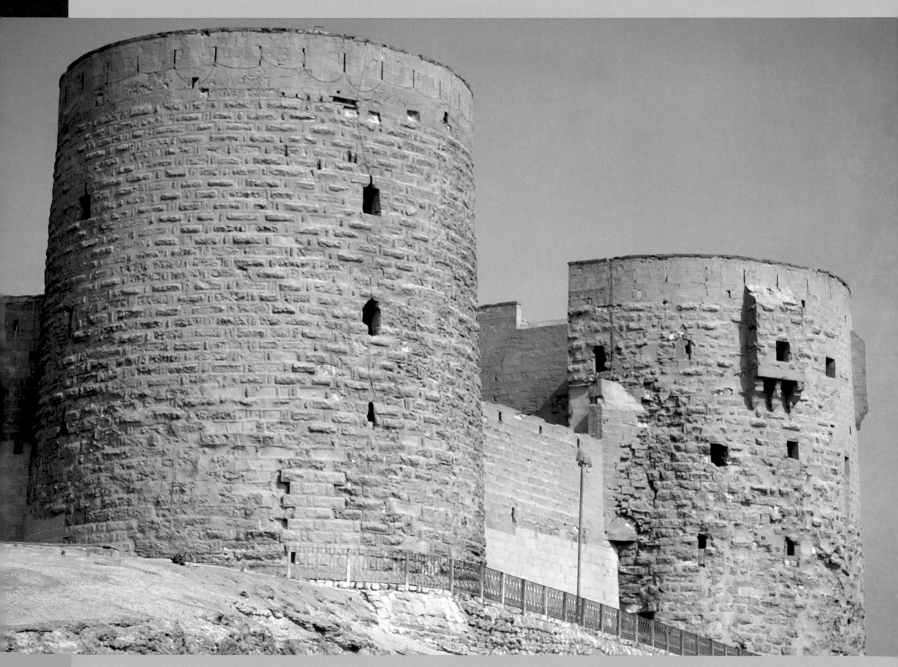

Towers (*Burg*) of the Citadel of Saladin
Burg al-Ramla and Burg al-Haddad, which were used as lodgings for soldiers from the reign of the Mamluk Sultan Qalawun.

Ayyubid, AH 579/AD 1184
Cairo, Egypt

The Mamluks: Cairo Becomes the New Centre of the Islamic World

Coat of armour

Mamluk, AH 7th–8th/AD 13th–14th centuries
National Museum
Damascus, Syria

The Mamluks (r. AH 648–923/AD 1250–1517) ruled Egypt and Bilad al-Sham (the Levant, including Syria and Palestine) as one of the most powerful Muslim kingdoms of the Middle Ages for nearly 300 years. Famed for expelling both Crusader and Mongol invaders from the Near East they further secured their place in history by reinstalling and protecting the Islamic Caliphate in Cairo after the Mongol devastation of its original seat, Baghdad, in 656/1258.

The Arabic term '*mamluk*' means 'owned' and originally, the Mamluks were slaves obtained as captives of war, through purchase or as gifts to provide elite troops and body guards for the Abbasid caliphs. Many came from far afield and included Africans, Circassians, Greeks, Kurds, Sicilians and Turks.

When fresh Mamluk recruits arrived at the barracks of their new master, they had to go through a rigorous regime to prepare them for service. First of all they underwent a medical check-up to ensure fitness for service. Once their physical health had been ascertained, they were allocated to military units that reflected their ethnic background. Here, Muslim tutors (*faqih*)

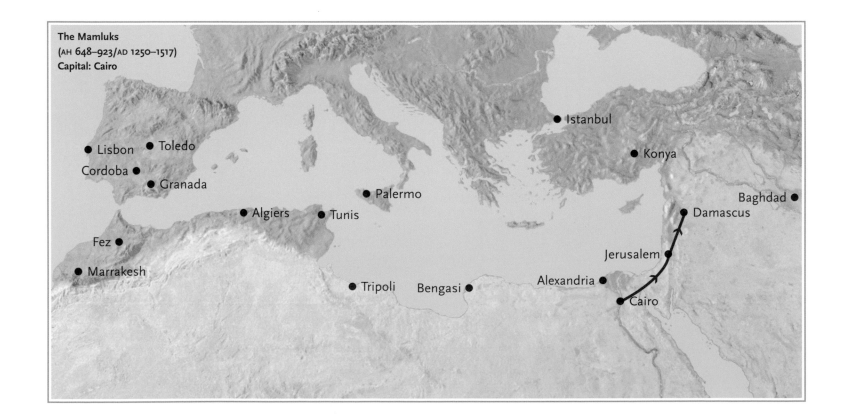

The Mamluks
(AH 648–923/AD 1250–1517)
Capital: Cairo

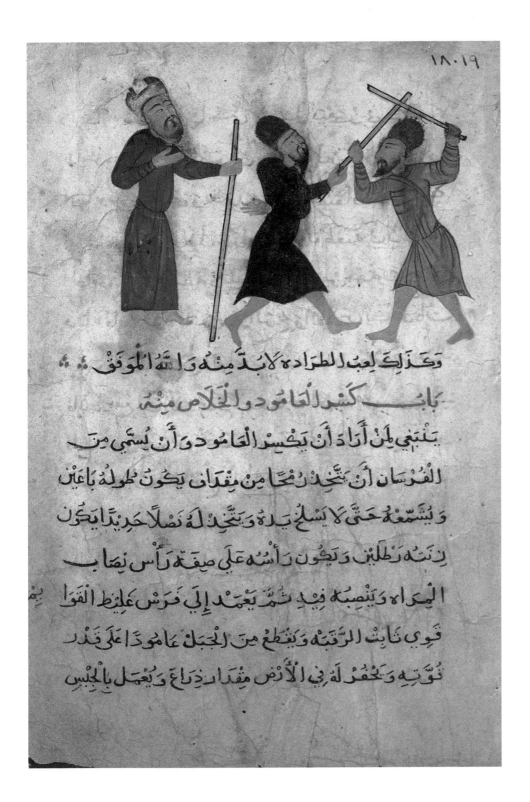

١٨٠١٩

وَكَذَلِكَ لِعَبِ الطِّرَادَةِ لَابُدَّ مِنْهُ وَاللّهُ الْمُوَفِّقُ

بَابُ كَسْرِ الْعَامُودِ وَالْخَلَاصِ مِنْهُ

يَنْبَغِي لِمَنْ أَرَادَ أَنْ يَكْسِرَ الْعَامُودَ وَأَنْ يُسَمَّى مِنَ

الْفُرْسَانِ أَنْ يَتَّخِذَ رُمْحًا مِنْ مِقْدَارٍ يَكُونُ طُولُهُ بَاعَيْنِ

وَيُشَمِّعُهُ حَتَّى لَا يَسْلَخَ يَدَهُ وَيَتَّخِذَ لَهُ نَصْلًا حَدِيدًا يَكُونُ

رَأْسُهُ وَطَلَبَيْنِ وَيَكُونُ رَأْسُهُ عَلَى صِفَةِ رَأْسِ نِصَابِ

الْبِحَرَاةِ وَيَنْصِبُهُ فِيهِ ثُمَّ يَعْمِدُ إِلَى فَرَسٍ عَلِيطِ الْقُوَّ

قَوِيُّ ثَابِتُ الرَّقَبَةِ وَيَقْطَعُ مِنَ الْجَبَلِ عَامُودًا عَلَى قَدْرِ

قُوَّتِهِ وَيُحْفَرُ لَهُ فِي الْأَرْضِ مِقْدَارُ ذِرَاعٍ وَيَعْمَلُ بِالْجِبْسِ

Page from a manuscript on horsemanship
Containing a number of sections on the arts of war and horsemanship.

Mamluk, AH 9th/AD 15th century
Museum of Islamic Art
Cairo, Egypt

Scaled armour and sword

Mamluk, AH 7th/AD 13th century
Jordan Archaeological Museum
Amman, Jordan

provided instruction in the fundamentals of Islam and in basic Arabic. The new Mamluk recruits received extensive training in the art of warfare and all the military skills required from a member of the ruler's elite force. On completion of their training, a public procession was led by the ruler through the streets of Cairo which marked the Mamluks' acceptance into official service. On this occasion they had to swear an oath of allegiance to their master and were given the title *faris* (plural *fursan*, meaning something similar to 'knight').

The Ayyubid Sultan al-Salih Najm al-Din Ayyub (r. 637–47/1239–49) was the first Muslim ruler to acquire a very large number of Mamluks. Stationed in specially designated barracks on Roda Island in the middle of the River (Arabic *bahr*) Nile near the capital Cairo, they soon became known as the Bahri Mamluks. Their influence and power grew to such an extent that they were able to seize power after the death of Najm al-Din Ayyub and, following the premature death of his son and heir, Turan Shah, it was Mamluk commanders who proclaimed his wife, Shajar al-Durr, Sultana of the realm. This measure was strongly opposed by the Abbasid caliph and, in order to avoid a major political éclat, a marriage of convenience was arranged between the sultana and a senior Mamluk *amir* by the name of 'Izz al-Din Aybak. In 648/1250 Shajar al-Durr abdicated in favour of her new husband and thus paved the way for the establishment of a Mamluk state in Egypt, ruled by senior figures of the Bahri Mamluk contingent.

A period of internal political wrangling and external threats marked the next few years. In 658/1259 the son of Sultan 'Izz al-Din Aybak was overthrown by another Mamluk, Sayf al-Din Qutuz (r. 658–9/1259–60), who

Qur'an
Commissioned for Sultan Jaqmaq.

Mamluk, AH 842–57/AD 1438–53
Museum of Islamic Art
Cairo, Egypt

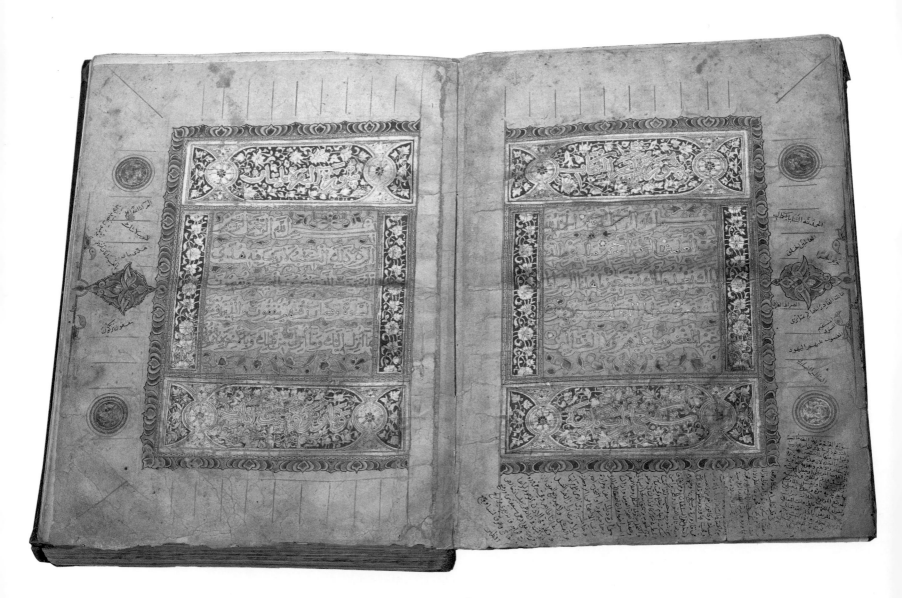

Madrasa al-Zahiriyya
Glass mosaic panel (detail) of a
landscape with floral and architectural
elements.

Mamluk, AH 676/AD 1277
Damascus, Syria

declared himself sultan and vowed to avert the Crusader and Mongol threat
to Mamluk lands. In 659/1260 he succeeded in defeating the Mongols in a
decisive battle at 'Ayn Jalut in Palestine, halting their seemingly unstoppable
progress and thus saving the Islamic world and Europe from catastrophic
devastation. The whole of Syria (except for the principality of al-Karak) and
Palestine now fell under the sovereignty of the Mamluk sultanate. However,
Qutuz received little thanks for his efforts. On his return to Egypt, the sultan
was assassinated in a conspiracy orchestrated by his friend, Baybars al-
Bunduqdari, who now took over the reins of power. Despite his violent ascent,
Sultan Baybars proved a wise and successful leader of his country and much
progress and reform are ascribed to his rule.

Another great leader during the period of Bahri Mamluk rule was Sultan
al-Mansur Qalawun, who gained power in 678/1279. Crucially he introduced
hereditary rule to the Mamluk Empire, where before succession had been
decided either by a council of senior Mamluks or, more pragmatically,
through court intrigue, manipulation and violence. The dynastic line
established by Sultan Qalawun remained in power until the end of the Bahri
Mamluk state in 784/1382 and contributed much both to the evolution of the
Mamluk Empire and Islamic civilisation in general.

In 784/1382 another powerful contingent of Mamluks managed to ursurp
power from the Bahri Mamluk court. These Mamluks, mainly of Circassian
(Jarkasi) origin, were stationed and trained in the towers (*burj*) of the Cairo
citadel and were therefore known as the Burji Mamluks. Led by their new
Sultan al-Zahir Barquq, the Burji Mamluks now laid the foundations for the
second phase of Mamluk rule, which was to last until the early 10th/16th
century. Initially marked by renewed efforts against enemies pushing
westwards in the wake of Timur's assaults throughout Asia, Burji rule soon
managed to concentrate on consolidating the political, economic and artistic

Ajlun Castle
Unlike other castles in the region, this
one was entirely built by Muslim
forces.

Ayyubid, Mamluk, AH 579–658/AD 1184–1260
Ajlun, Jordan

Tray

Mamluk, c. AH 800/AD 1400
The British Museum
London, United Kingdom

Bottle with polo-playing riders
Polo was much-loved by the Mamluk
rulers as it united both military
exercise and recreational sport.

Mamluk, AH 700/AD 1300
Museum of Islamic Art, State Museums
Berlin, Germany

Lunch box

Mamluk, AH 9th/AD 15th century
The British Museum
London, United Kingdom

achievements of the empire. By the time of Sultan al-Ashraf Barsbay
(r. 825–42/1421–38) Mamluk sovereignty extended throughout much of the
Middle East, the Mediterranean and the Red Sea ports. The Port of Alexandria
gained the monopoly over domestic and foreign trade and subsequently
became the main base for a host of foreign commercial representatives and
trade counsellors.

Barsbay's successor, Sultan al-Zahir Jaqmaq (r. 842–57/1438–53) further
secured the empire's prowess as a trading nation by land and by sea, not
least by quelling the persistent menace of pirates in Mamluk-controlled
waters. With Sultan Qaytbay taking power in 874/1468, Egypt completed its
ascent as one of the most powerful and respected empires in the Muslim
world, not only due to its internal stability and economic affluence, but also
due to its political standing and religious authority, all reflected to this day in

Pen box

Mamluk, AH mid-8th/AD mid-14th century
The British Museum
London, United Kingdom

Madrasa and Mosque of Sultan Hassan

Mamluk, AH 764/AD 1362
Cairo, Egypt

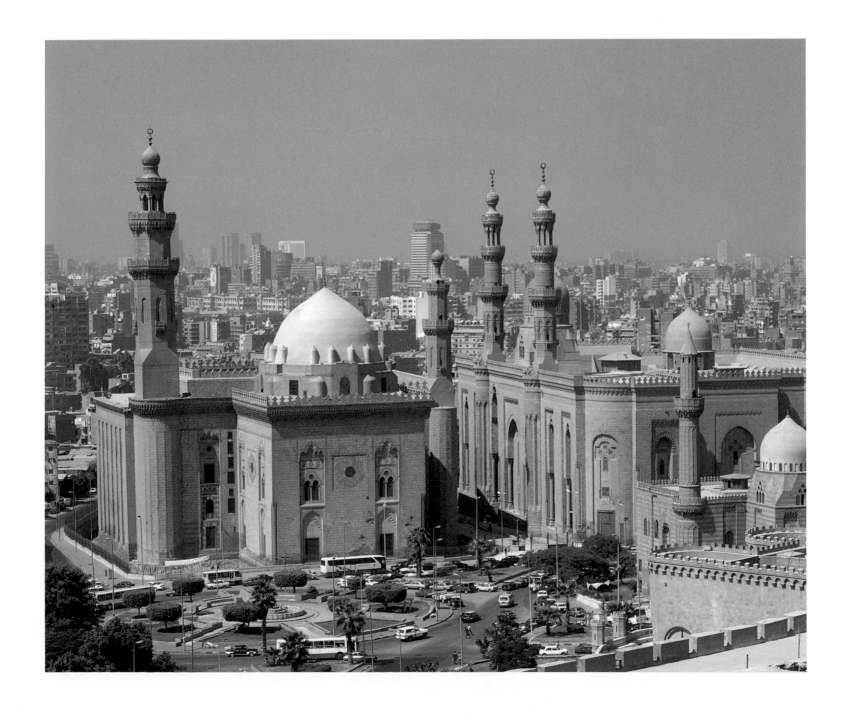

the architectural edifices and facilities built throughout the Mamluk territories in Egypt, Syria and Palestine.

The era of Mamluk supremacy and magnificence persisted until the beginning of the 10th/16th century, and even the very last Mamluk Sultan al-Ashraf Qansuh al-Ghuri (r. 906–21/1501–16), continued to consolidate the presence of Mamluk civilisation in sponsoring military installations, such as the fortifications on the coasts of Alexandria and Rashid (Rosetta), and magnificent architectural edifices that still grace al-Mu'izz li-Din Allah Street in Cairo. However, 300 years of Mamluk rule were soon to come to a sudden end. For some time, Egypt's political and economic status had been eroded as a result of the discovery of the Cape of Good Hope, which resulted in the bulk

Candlestick

Mamluk, AH 8th/AD 14th century
Royal Museum, National Museums Scotland
Edinburgh, United Kingdom

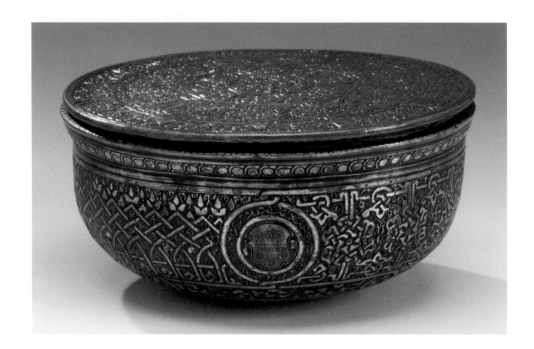

ABOVE RIGHT
Spice box

Mamluk, AH 9th/AD 15th century
Royal Museum, National Museums Scotland
Edinburgh, United Kingdom

Weighing-scales pan

Mamluk, AH 9th/AD 15th century
Royal Museum, National Museums Scotland
Edinburgh, United Kingdom

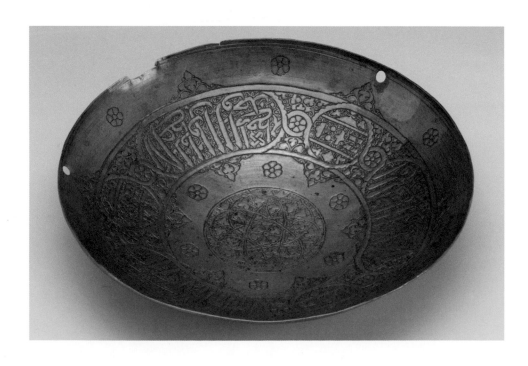

of trade that had formerly passed through Mamluk territories being diverted through the Atlantic Ocean and the shores of West Africa. Furthermore, the ambitions of the Ottoman Dynasty to ever expand their empire from Anatolia and the Bosphorus became ever more pressing. Eventually, Sultan al-Ghuri was killed in a decisive battle with the Ottomans at Marj Dabiq near Aleppo in 921/1516 and the once glorious Mamluk Empire was now absorbed into Ottoman territory.

The Mamluk hierarchy was a complex structure with the sultan at the helm. He was the supreme commander of the state as well as the protector of orthodox Islam and the Islamic caliphate. His official base and court were at the citadel, the main façade of his palace overlooking a square studded with

Two ivory plaques
Bearing representations of Christian men.

Mamluk, AH 8th/AD 14th century
The British Museum
London, United Kingdom

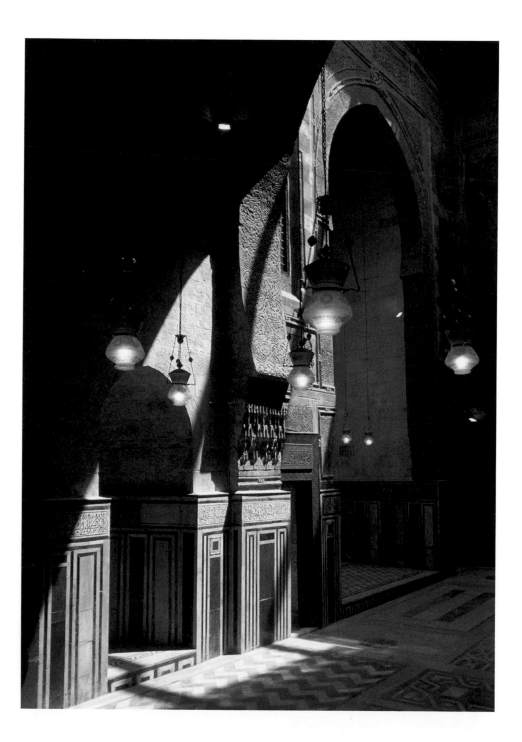

Madrasa and Mosque of Sultan Qaytbay
Interior view.

Mamluk, AH 877/AD 1472
Cairo, Egypt

magnificent palaces. The sultan surrounded himself with an immediate entourage of loyal senior *amir*s, each of whom held one of the high offices of state in the sultan's service. Each of these posts was symbolised by an emblem, known as a blazon: a sword designated the *amir* responsible for the state's weaponry, the polo-stick the *amir* responsible for sport, and so forth.

The Mamluk elite lived their lives completely isolated from the rest of contemporary society, which consisted of many different ethnic and religious groups, including Egyptians, Arabs, Armenians and Greeks. The majority of the population adhered to Islam, but there were also extensive Coptic, Catholic and Orthodox Christian as well as Jewish communities. Protected by Islam, these groups played an important economic role in Mamluk society; the Copts in particular made a great contribution to Mamluk culture and art, specialising in the textile, mosaic and woodworking industries.

To their subjects, the political, religious and economic prowess of the Mamluk state and its rulers was best demonstrated during extravagant processions staged on important occasions. One of the most lavish processions was held to mark the inauguration of a new sultan. Descending from behind the citadel, the sultan would walk northwards until he entered Cairo through the gate, Bab al-Nasr, and then continue southwards along al-Mu'izz Street, passing through Bab Zuwayla, until he reached the citadel once again. The streets of Cairo would be extravagantly decorated; the walkways covered with

Incense burner

Mamluk, AD 9th–10th/AD 15th–16th centuries
Kelvingrove Art Gallery and Museum,
Glasgow Museums
Glasgow, United Kingdom

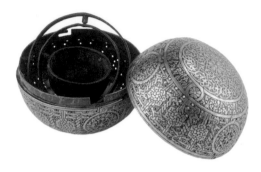

Madrasa and Mosque of Sultan Hasan
View of the *mihrab*.

Mamluk, AH 764/AD 1362
Cairo, Egypt

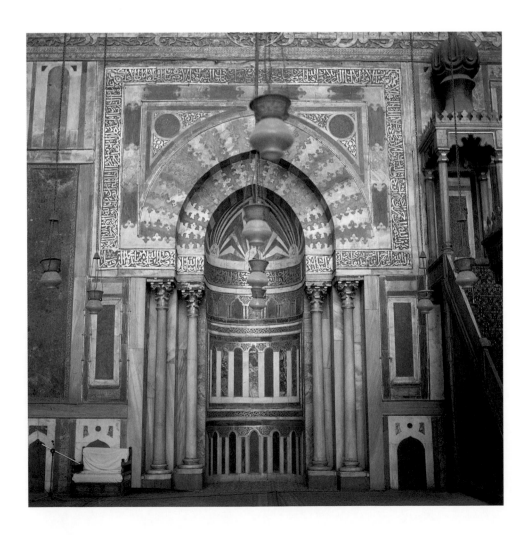

silk for the Mamluk ruler to walk on. Annual religious occasions were celebrated with public processions, too. Every year, the pilgrimage (*hajj*) procession, known as *mahmal*, carried the new, richly embroidered heavy silk coverings (*kiswa*) for the *Ka'ba* at Mecca. The procession followed the route mentioned above until it reached the citadel square where the sultan was waiting; he would typically have been finely dressed and seated on his horse on a specially erected dais surrounded by his *amir*s and Mamluks.

Notable public celebrations were also held on sight of the new moon at the beginning of the Islamic month of Ramadan, and the *'Eid al-Fitr* (End of Fasting) at the end of the month, during which the sultan distributed new

Minbar
Probably from Cairo.

Mamluk, AH 872–901/AD 1468–96
Victoria and Albert Museum
London, United Kingdom

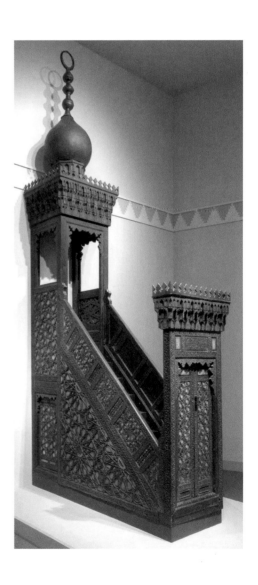

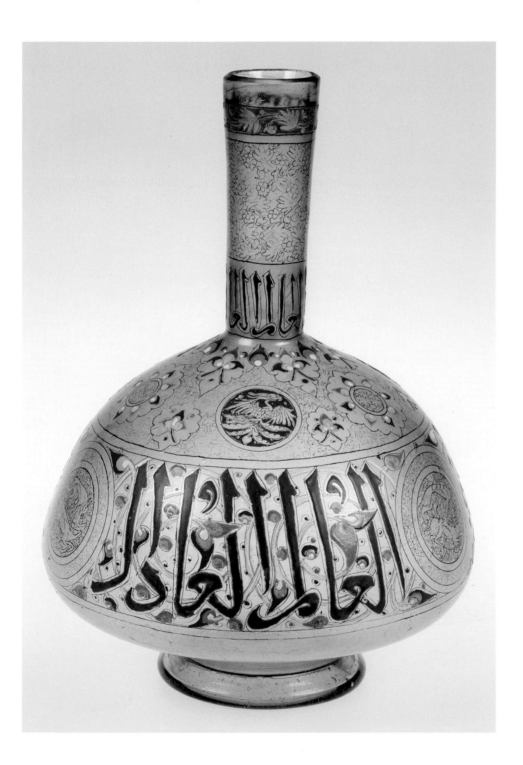

Bottle

Mamluk, AH mid-8th/AD mid-14th century
Calouste Gulbenkian Museum
Lisbon, Portugal

Sprinkler

Mamluk, AH 694/AD 1295–6
Victoria and Albert Museum
London, United Kingdom

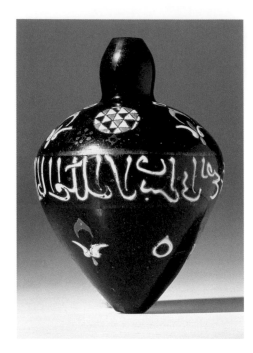

The Complex of Sultan al-Mansur Qalawun
Interior view of the mausoleum.

Mamluk, AH 684/AD 1285
Cairo, Egypt

clothes, gifts and money. The Rising of the Nile was also marked annually, and the celebrations on that occasion included tournaments, particularly contests in horsemanship and hunting.

Despite such confident displays of power, the Mamluk system was volatile internally, and high office or safe income could not be assumed for life. The Mamluks developed an ingenious method to protect their property from confiscation and secure a steady income. Known as *waqf* this involved the establishment of religious endowments which provided the necessary financial resources for public utilities and services like fresh-water supply and education while also giving the Mamluk donor and his family financial security. In addition to their military, religious and social responsibilities, the sultan and his court engaged extensively in international diplomacy. Close political ties were forged both with Europe and the East, and exquisite diplomatic gifts made in Mamluk workshops were sent to underpin important diplomatic relationships.

In the wake of a stable, well-respected state, there came important and lucrative trade relations, particularly with Europe, India and China. Markets

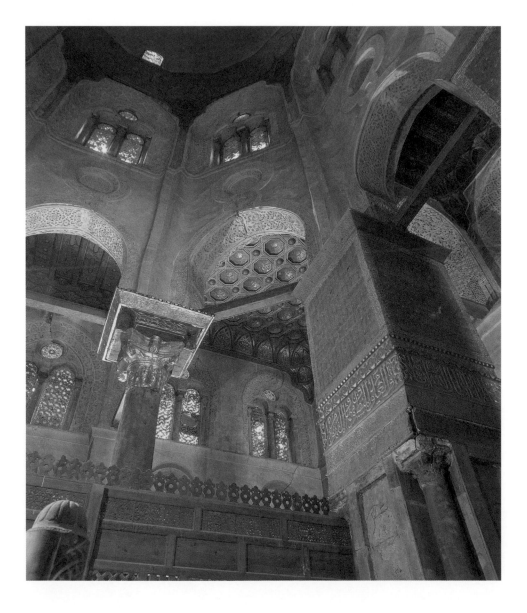

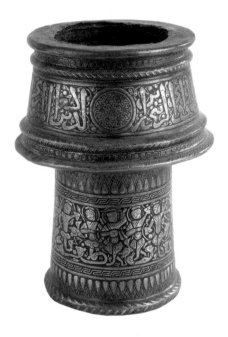

Medical prescription
Describing a treatment for coeliac disease (a disorder of the intestines).

Mamluk, AH 9th/AD 15th century
Museum of Islamic Art
Cairo, Egypt

Candlestick socket

Mamluk, AH 694/AD 1294
Museum of Islamic Art
Cairo, Egypt

(*suq*s, *khan*s) sprang up all over the empire, particularly in Damascus and Cairo. Many of these sophisticated structures have survived to the present. Purpose-built inns (*caravanserai*, *khan*s, *wikala*s) provided merchants with a base for storage of their goods, lodgings and commercial transactions. Merchants from Genoa and Venice brought wood, glue, iron and copper from Italy, spices, silk and linen textiles from India, Yemen and Somalia. Mamluk sultans monopolised the revenue from all these trade activities and used it to run the state. Economic, scientific and artistic activity flourished. Cairo, Damascus and Jerusalem were the most important urban centres. Cairo, the Mamluk capital, was by far the richest city in the Near East and became known as the metropolis of the world. Scientists, scholars, traders and artists

from all over the world converged on the city to exchange ideas and commodities.

A large portion of the state revenue was spent on the patronage of art and architecture which reached new heights during the Mamluk era. Many innovative elements were introduced into the building and embellishment of both religious and civil edifices. The new influences often reflected the Mamluks' heterogeneous ethnic origins: from many different ethnic backgrounds, they brought with them their own artistic traditions and customs. The Mamluks introduced new architectural elements such as the *madrasa* (school) complex which was common in the Eastern Islamic world, particularly in Iran. They also introduced new stylistic elements from Syria as can be seen in the domes on the tomb of Qalawun and in the Qalawun hospital (*bimaristan*), which was based on the Nuri Bimaristan in Damascus. Decorative elements borrowed from Morocco were used in architecture seen, for example, in the horseshoe arch and the square-based minaret of the Qalawun Madrasa, and in the *madrasa* and mausoleums of Salar and Singar al-Gawli. Mamluk architectural innovation is also evident in the multi-purpose

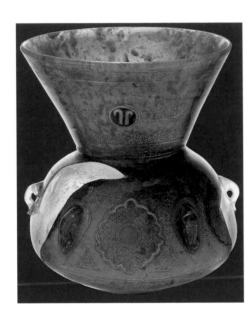

Mosque lamp

*Mamluk, ᴀʜ first half of the 8th/
ᴀᴅ 14th century*
Museum of Turkish and Islamic Arts
Istanbul, Turkey

**Sabil and Kuttab (Qur'anic School) of
Sultan Qaytbay**

Mamluk, ᴀʜ 884/ᴀᴅ 1479
Cairo, Egypt

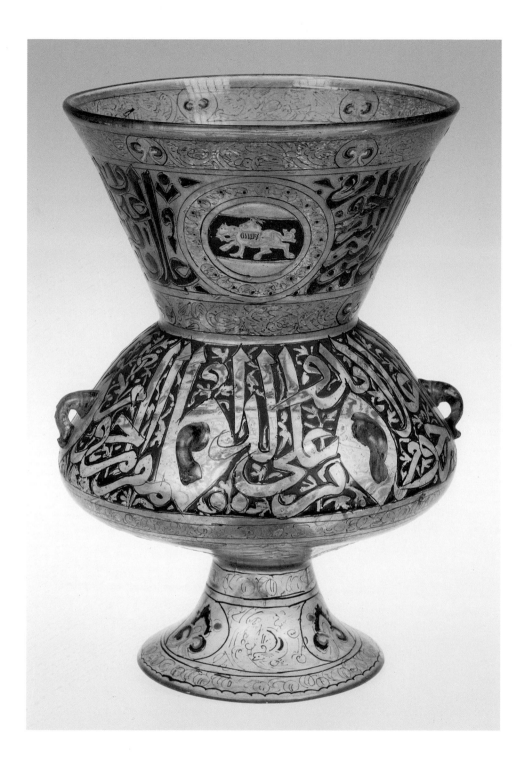

Mosque lamp

Mamluk, later than AH 721/AD 1321
Calouste Gulbenkian Museum
Lisbon, Portugal

complexes that combine religious, educational and charitable purposes, as well as the addition of *sabils* (a water fountain for the distribution of free drinking water) to mosques and *madrasa*s. Minarets became more elaborate in both structure and decoration: domes were made larger, and portals were embellished with stalactite-like *muqarnas* squinches.

Mamluk patronage of the arts led to the establishment of the famed specialist workshops that produced artefacts for both the home market and foreign clients. Mamluk glass, gold and silver-inlaid metalwork, ceramics, carpets and textiles were in great demand both in the Muslim world and in Europe, where over time they greatly influenced European taste. Cities like

Manuscript on surgery

'The arrangement [of knowledge] for one who is unable to compile [it himself]' by the al-Andalus physician Abu al-Qasim (d. after 400/1009).

Mamluk, AH 8th–9th/AD14th–15th centuries
National Museum
Damascus, Syria

Venice developed a metalwork industry to imitate inlaid Mamluk metalwork and Arabic inscriptions in *thuluth* script, so popular in Mamluk art, appeared in European art. Even architecture was affected. Thus, the bell towers of the late Renaissance churches for example were influenced by the shape of Islamic minarets.

In executing their wares Mamluk craftsmen did not use only Islamic elements such as epigraphic inscriptions in *naskhi* and *thuluth* scripts, or the arabesque, they also took inspiration from an array of readily available, foreign elements. Chinese decorative elements like the phoenix, the dragon and the peony to decorate ceramics, textile or wooden objects joined others brought from Iran or the West.

The Mamluk period is of profound significance in the history of Islamic civilisation. Its religious, cultural and artistic legacy can still be felt today.

PERSONALITIES

Al-Zahir Baybars al-Bunduqdari (r. 659–76/1260–77) was the real founder of the Mamluk state; his reign is characterised by military victories against the Mongols and the Crusaders. In addition, he crushed internal revolts, reduced taxes, repaired roads and reformed the naval fleet, amongst other changes; he also achieved political and economic stability. Perhaps the greatest achievement of his era was the revival of the Abbasid caliphate in Egypt, while his greatest architectural achievement was the mosque which still stands in the Zahir quarter in Cairo.

Al-Mansur Sayf al-Din Qalawun (r. 678–89/1279–90) was the second father of the Mamluk state. He, and his children after him, ruled for 100 years. One of his most important architectural achievements is his complex in al-Mu'izz li-Din Allah Street which consists of a tomb, a *bimaristan* and a *madrasa*. This complex marked the beginning of a new architectural style: the multi-purpose building complex. He died during the siege of Acre. The reign of the Qalawun family was one of the brightest in the history of art in the Mamluk era.

Al-Zahir Sayf al-Din Barquq (r. 784–802/1382–99) was the first sultan of the Jarkasi (Burji) Mamluks based in the citadel. His most important architectural achievement is a *khanqah* and a *madrasa*, located near Sultan Qalawun Madrasa in al-Mu'izz Street, which was the first to be built under the Jarkasi Mamluks.

Al-Ashraf Abu al-Nasir Qaytbay (r. 873–902/1468–96) was born in 827/1423 and was promoted up the ranks until he became sultan. He ruled for 29 years, longer than any other Mamluk sultan. His rule was characterised by stunning military victories. He built a number of buildings in Cairo and in other Egyptian cities, as well as Syria and the Hijaz. His most important architectural achievements are the Mosque and Madrasa of Sultan Qaytbay which still stand intact in the Mamluk Cemetery in Cairo, in addition to the fortresses bearing his name in Alexandria and Rashid (Rosetta).

Science and Music

Mònica Rius

Manuscript on geography
Thought to be based on Arabic translations
and modifications of Ptolemy.

Mamluk, AH 741/AD 1340
National Museum
Damascus, Syria

Science and music

Although the role played by Arab-Islamic civilisation in bringing the scientific knowledge of the Orient and of Antiquity to Europe is well attested, the creative and original influence of Islam on the scientific development of humanity has passed largely unnoticed. With his Bayt al-Hikma (House of Wisdom), the Abbasid caliph, al-Ma'mun (r. AH 197–217/AD 813–33), without doubt did much for the cause of science. This centre of learning saw the translation of works of previous traditions (in Greek and Sanskrit), opening up the knowledge of algebra, trigonometry, logic, astronomy and medicine developed by that time. The original work done there was also fundamental, for example the development of new astronomical tables and the ability to measure a degree of the terrestrial meridian. One of the most celebrated scholars of the time was Khwarizmi (fl. *c.* 215/830).

Glass vessel
Possibly used for chemistry.

Abbasid, AH *3rd–4th/*AD *9th–10th centuries*
National Museum
Damascus, Syria

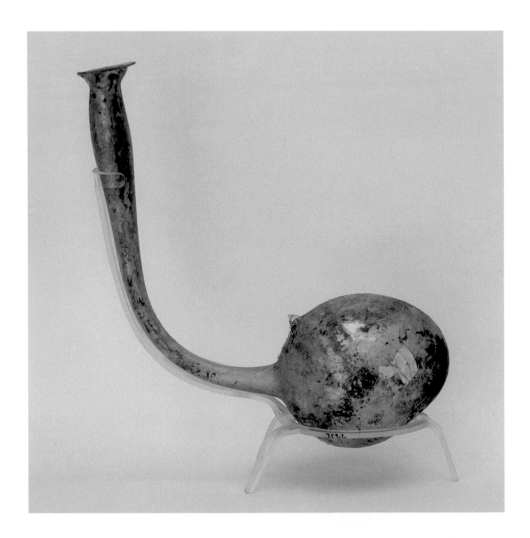

Astronomy was among the disciplines that saw the greatest development, with its success linked in part to its practical applications: in Islamic worship (e.g. orientation of mosques and establishing prayer times) and in preparing horoscopes. The astrolabe proved extremely useful for this, as it significantly reduced the time needed by the astronomer to make his calculations. One of the most important astronomers of the time was al-Biruni (363–439/973–1048) who was also a skilled mathematician and philosopher.

In medicine, the fusion of the Greek and the Iranian traditions was personified by al-Razi (Rhazes, *c.* 251–312/865–925), who having been a musician in his youth, went on to run the 'Adudi hospital in Baghdad. Specifically, Islam gave rise to two institutions subsequently exported to the West: mental asylums and examinations to obtain permits to practise medicine. The *bimaristan* (hospital) usually had some land where medicinal

Manuscript
Page from a medical treatise.

Almohad, AH 610–9/AD 1213–23
National Library
Rabat, Morocco

Surgical scalpel

Abbasid, AH 3rd/AD 9th century
Museum of Islamic Art
Cairo, Egypt

Fragment of a medical prescription
Mentioning the benefits of *aloe vera* for
the treatment of certain ailments.

Abbasid, AH beginning of the 2nd/AD 8th century
Museum of Islamic Art
Cairo, Egypt

plants could be grown, as well as its own school. Some employed up to 80 doctors of different specialisations (e.g. ophthalmologists, surgeons and traumatologists) who also worked as lecturers. Pharmaceutical and botanical studies were the object of particular interest, with attempts made to establish taxonomic classifications of plants. Medical and pharmaceutical implements that have survived demonstrate how pharmacists and alchemists carried out laboratory experiments that had an influence in apparently unrelated areas, such as the work of craftsmen (dyers and perfumers).

Abbasid Baghdad under Caliph Harun al-Rashid (146–94/763–809) also offered one of the most original contributions to music through the master composers Ishaq ibn Ibrahim al-Mawsili (150–236/767–850) and his disciple Ziryad. The latter, forced to flee al-Andalus, founded a singing school in Córdoba and made a significant contribution to the technique of lute playing.

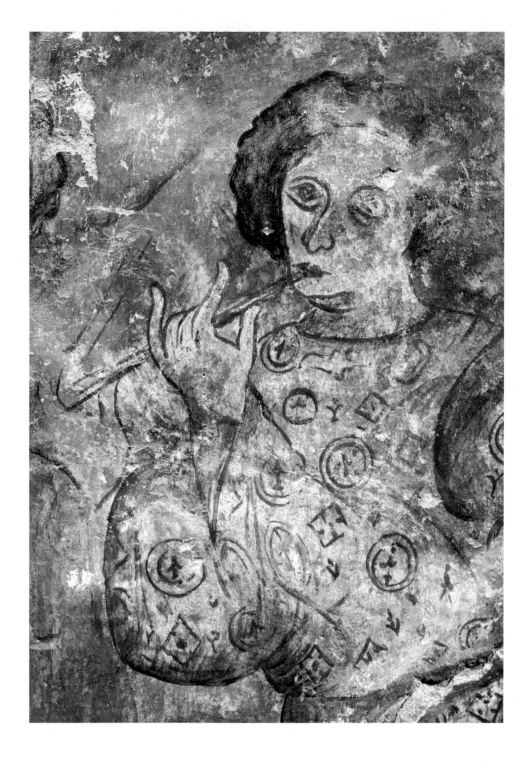

Fresco panel at Qusayr 'Amra
Depiction of a flutist.

Umayyad, AH *2nd/*AD *8th century*
Azraq, Jordan

Cup with *rubab* player
Abbasid, AH *4th/*AD *10th century*
National Museum of Oriental Art
Rome, Italy

Other institutions dedicated to higher learning, the *madrasa*s, were built both in the Muslim East and West.

In al-Andalus, the most original scientific advances were made by the surgeon Abu al-Qasim al-Zahrawi (Abulcasis, c. 325–404/936–1013) and the Toledan astronomer Ibn al-Zarqalluh (Azarquiel, d. 494/1100).

Technological development was driven primarily by practical need, as in the case of new glass-cutting and ceramic-glazing techniques, although genuine works of art and ingenuity, such as automatons, were produced. Significant advances were also made to the machines of war, but it was hydraulic engineering (water channelling and irrigation systems such as *noria*

Buinaniya Madrasa

Marinid, AH 751–6/AD 1351–6
Fez, Morocco

(pl. *nawa'ir*) and *qanat* that had the most significant influence, helping to improve agricultural yields.

The Age of Discovery in the 9th/15th century owes much to the work of Muslim geographers and navigators, who boasted extensive theoretical and practical experience. Muslim sailors were excellent navigators of the Indian Ocean (as is evident in the tale of the Seven Voyages of Sinbad the Sailor in *One Thousand and One Nights*), the Mediterranean and part of the Atlantic, and they drew up nautical charts that would later be used by European

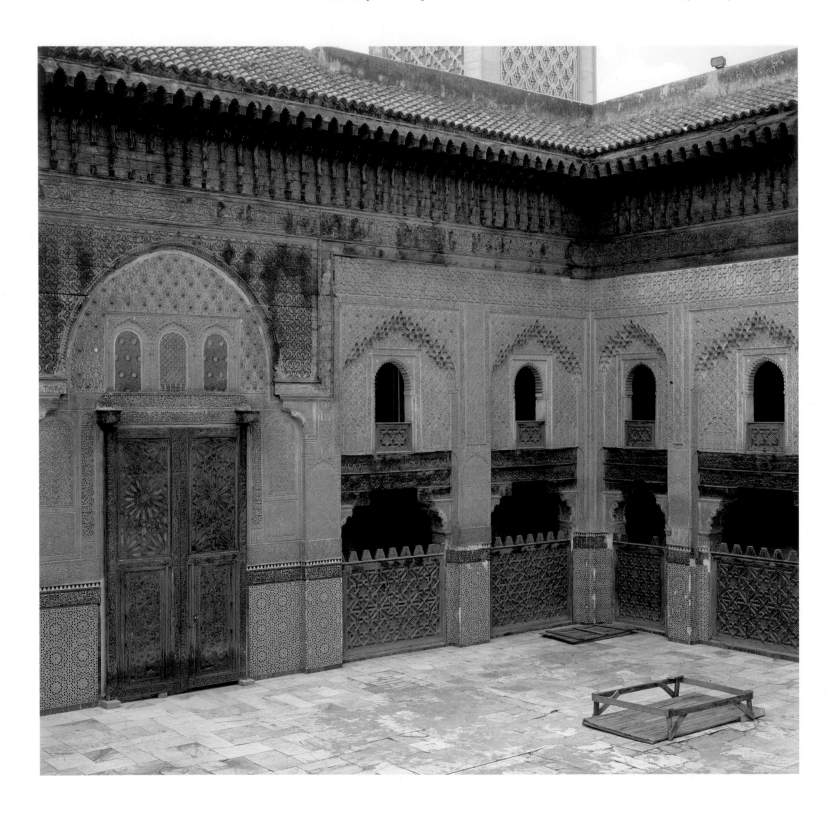

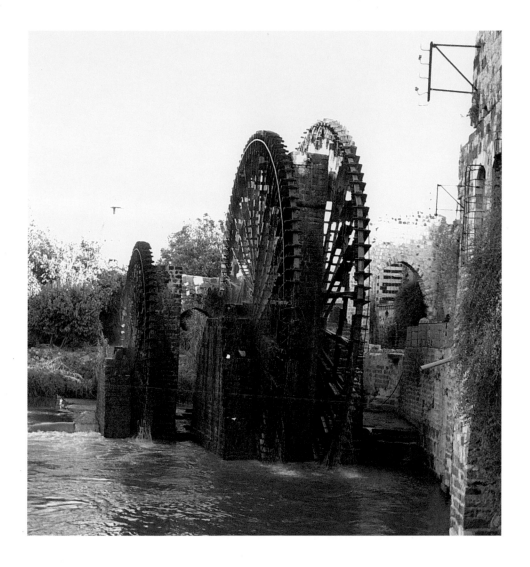

Noria of Hama

Atabeg, Ayyubid, Mamluk and Ottoman,
AH 6th–10th/AD 12th–16th centuries
Hama, Syria

Sülaymaniye waterway map

Ottoman, AH second half of the 12th/
AD 18th century
Museum of Turkish and Islamic Arts
Istanbul, Turkey

Bowl

Depictions of ships first appeared at
the time of the *Reconquista*.

Nasrid, AH *late 8th century–834/*
AD *late 14th century–1430*
Museum of Islamic Art, State Museums
Berlin, Germany

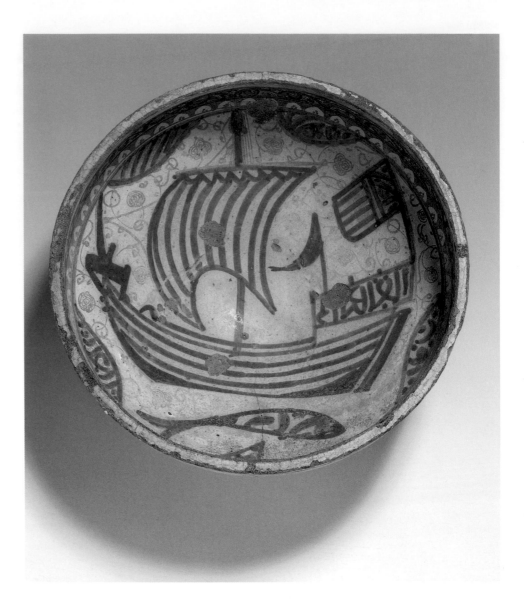

Bowl

Nasrid, second quarter of the AH *9th/*
AD *15th century*
Victoria and Albert Museum
London, United Kingdom

explorers. Naval dockyards also witnessed great levels of activity and the
creation of new designs in shipbuilding. Arab geographers also developed the
science of cartography, preparing maps of the known world such as the one
created by al-Idrisi in the 6th/12th century for King Roger III of Sicily.

The Ottomans: Rulers for Six Hundred Years

Verena Daiber and İnci Kuyulu Ersoy

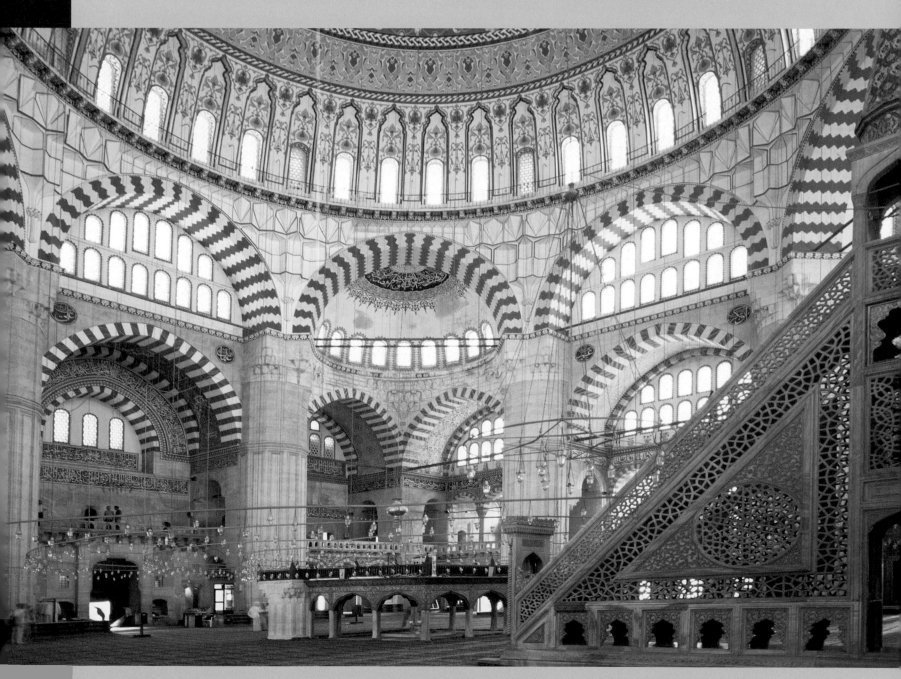

Selimiye Mosque (interior)

Ottoman, AH 982/AD 1574
Edirne, Turkey

Yeşil (Green) Mosque
Minaret (detail).

Ottoman, AH 780–795/AD 1378–1392
Iznik, Turkey

Fleeing the Mongols in Central Asia the Qayı tribe, a branch of the Oghuz Turks, ended their journey in Söğüt and Domaniç a region in today's Marmara. The area became an emirate named after its founder Osman ('Uthman) Ghazi Bey (AH 679–724/AD 1281–1324), and prevailed continuously for 622 years – that is from its foundation in 699/1299 until 1340/1922.

Being in continuous contestation with the Byzantine Empire and the other Turkic neighbour-emirates, the Ottomans began to expand their frontiers during the reign of Orhan Bey (724–63/1324–62). Following its capture in 726/1326, Bursa became the new capital. Already a commercial centre before the birth of the Ottoman Empire, Bursa was the root from which Ottoman art and architecture grew. Mosques, *khan*s (inns, hostels), *madrasa*s (schools), *hammam*s (bathhouses) and *turbe*s (mausoleums) were built in a new style that melded with the vernacular, and this synthesis became distinguishable especially on façades, based on the materials used. Immediately after Bursa, Iznik was taken by the Ottomans in 731/1331. Iznik became an important centre for tile production whose fame spread worldwide.

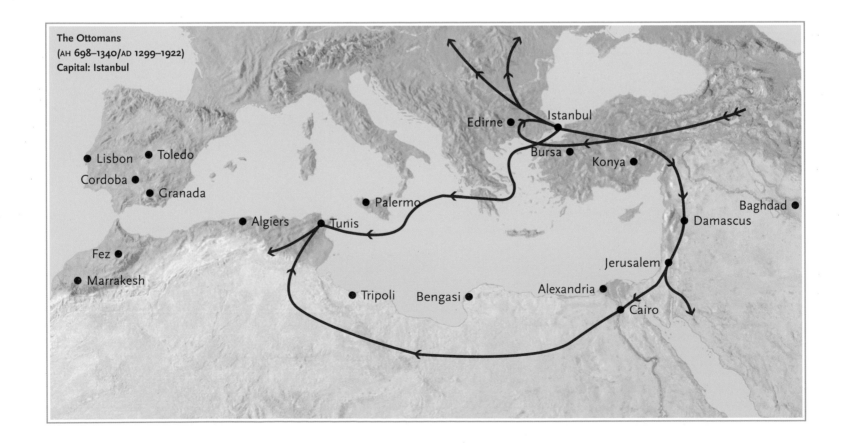

The Ottomans
(AH 698–1340/AD 1299–1922)
Capital: Istanbul

Edirne • Istanbul
Bursa • Konya •
Lisbon • • Toledo
Cordoba • • Granada
Palermo •
Algiers • Tunis
Baghdad •
Damascus
Fez •
Jerusalem
Marrakesh •
Alexandria •
• Tripoli Bengasi •
Cairo

Meanwhile the Ottomans crossed the Dardanelles to Thrace where they expanded their frontiers. Edirne was taken during the reign of Murad I (763–91/1362–89) in 763/1362, and soon after it became the new capital of the emirate (769/1368). It is here that the first indications of the architectural excellence the Ottomans would reach in their Classical period were seen.

The first sign of the Ottomans reaching into the heart of Europe was also evident in the conquest of Bulgaria, Macedonia and Serbia. These efforts continued during the reign of Bayazid I (known as Yıldırım, 'the Lightening Shaft', r. 791–804/1389–1402). Finally the Ottomans' initial attempt at capturing Constantinople also occurred in this era.

The Interregnum period caused by the defeat and capture of Bayazid I by Timur and his forces in 804/1402, was a period of uncertainty due to in-fighting between Bayazid's sons. This was brought to an end by Çelebi Mehmed (Mehmed I, r. 815–23/1413–21) after he established his dominance over his brothers. Mehmed I is credited with reforming the emirate which had started to disintegrate during the Interregnum. During his son, Murad II's rules (823–47/1421–44; 849–54/1446–51), these efforts continued, and the emirates that had regained their independence after the Battle of Ankara (804/1402), came back under Ottoman rule. Another important event of the period was the defeat of the new Crusades, which were launched in order to expel Turks from the Balkans, with decisive battles fought in Varna (847/1444) and in Kosovo (851/1448).

During the reign of Mehmed II (854–85/1451–81), the borders of the Ottoman Empire were further extended to the Euphrates in the east and the Danube River in the west. Mehmed II was known as *Fatih* 'the Conqueror'

Talismanic shirt
Decorated with Qur'anic verses, prayers, magic formulas and numerological charms.

Ottoman, AH *end 8th–beginning 9th/* AD *end 14th–beginning of the 15th centuries*
Museum of Turkish and Islamic Arts
Istanbul, Turkey

Yeşil (Green) Türbe
Tiled cenotaph of Sultan Mehmed I
(r. AH 816–23/AD 1413–21).

Ottoman, 822/1419–20
Bursa, Turkey

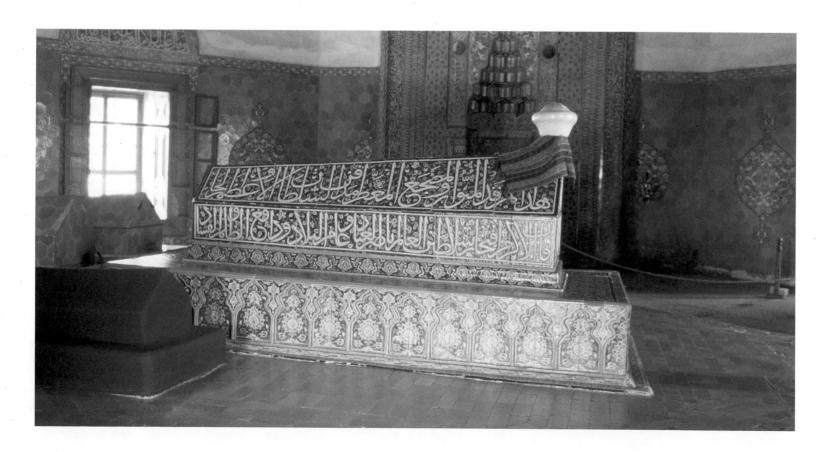

Topkapı Palace

The palace was founded on an area of the Istanbul peninsula which commands the Golden Horn on one side, and the Bosphorus Strait and the Sea of Marmara, on the other.

Ottoman, begun in the AH 9th/AD 15th century, final additions in the 13th/19th century
Istanbul, Turkey

Kilitbahir Fortress

Built by Sultan Mehmed II to enforce his rule over the Dardanelles.

Ottoman, AH 866/AD 1463
Kilitbahir in Eceabat, Çanakkale, Turkey

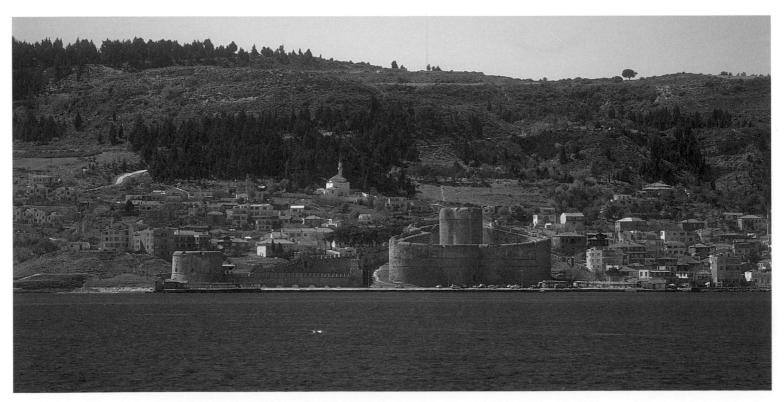

following his conquest of Constantinople aged 21 in 856/1453, an event that also marked the end of the Eastern Roman Empire, better known as the Byzantine Empire.

Mehmed II invited the Italian painter, Gentile Bellini, to paint his portrait in the European style, seen today as an indication of Mehmed's open-minded view of the world. Mehmed 'the Conqueror', known as a genius on the battlefield, was also a wise leader with a liberal approach to politics, science and art. Shaped by this new vision, Istanbul became the capital of Turkish-Islamic civilisation and also a cultural mosaic embellished by both Western and Eastern cultures through the preservation of examples from the Byzantine world.

The Fatih Complex, commissioned by Mehmed II, was the first monumental complex to be built by any sultan. Topkapı Palace, also built under the auspices of Mehmed II as the governmental centre, soon became the imperial residence and the palace school for the education of future administrators. Topkapı Palace today is the result of the continuous additions and enrichments that took place from the mid-6th/13th up until the end of the 13th/19th century. All high-ranking officials of the Ottoman court contributed to the immense output of public works which gave the capital, Istanbul, and the other towns of the empire, a recognisable Ottoman style.

Special attention was paid to strengthening the naval forces, that were seen as key to establishing solid power not only at sea but also in some of the islands in the Eastern Mediterranean, and which had been taken from the Genoese and the Venetians. Crimea was also conquered as a result of efforts to make the Black Sea a secure part of the empire. Meanwhile new campaigns were carried out both in Anatolia and Europe. Although the

Topkapı Palace
Gate of Felicity.

Ottoman, begun in the AH 9th/15th century, final additions in the 13th/19th century
Istanbul, Turkey

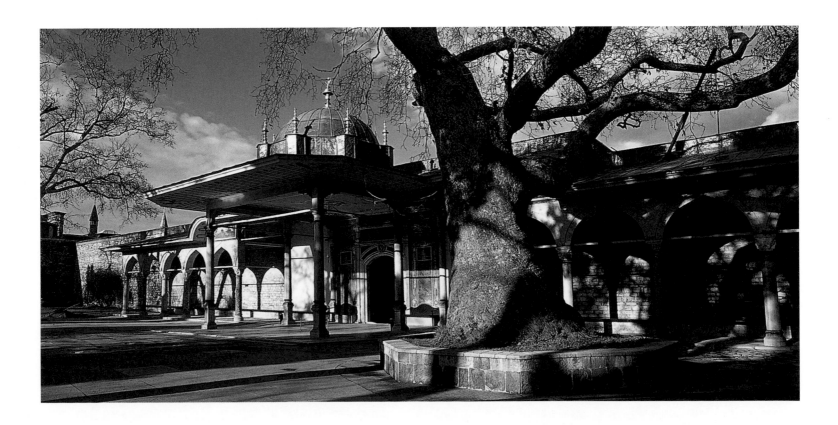

FACING PAGE
Sülaymaniye Complex
Built by the famous architect, Sinan.

Ottoman, AH 957–64/AD 1550–7
Istanbul, Turkey

Topkapı Palace
Pavilion of the Holy Mantle and Holy
Relics.

*Ottoman, begun AH 9th/15th century, final
additions 13th/19th century*
Istanbul, Turkey

campaigns slowed down during the reign of Bayazid II (r. 895–917/1481–1512; son of Mehmed II), some fortresses on the northern shores of the Black Sea such as Ismaïl, Akkerman and Kilia were taken. An important example of Ottoman tolerance was the acceptance of Jewish refugees, forced to leave Spain in 897/1492, and allowed to settle in Ottoman lands.

Sultan Selim I (known as *Yavuz*, 'the Grim', r. 917–26/1512–20) took over by force from his father and proceeded to expand the borders in the east and south by defeating the Mamluks in a battle at Marj Dabiq (near Aleppo) in 921/1516. He put an end to Mamluk power and took over the former Mamluk territories of Egypt, Bilad al-Sham and the Holy Cities in the Hijaz. Istanbul became the centre of the Islamic World, with Selim I claiming the title of caliph and moving the Holy Relics to Istanbul. The Ottomans became a global power during the reign of Selim I, who was also the pioneer of the Sunni world, which stood opposed to the Shi'ite Safawids in the East. The conflict

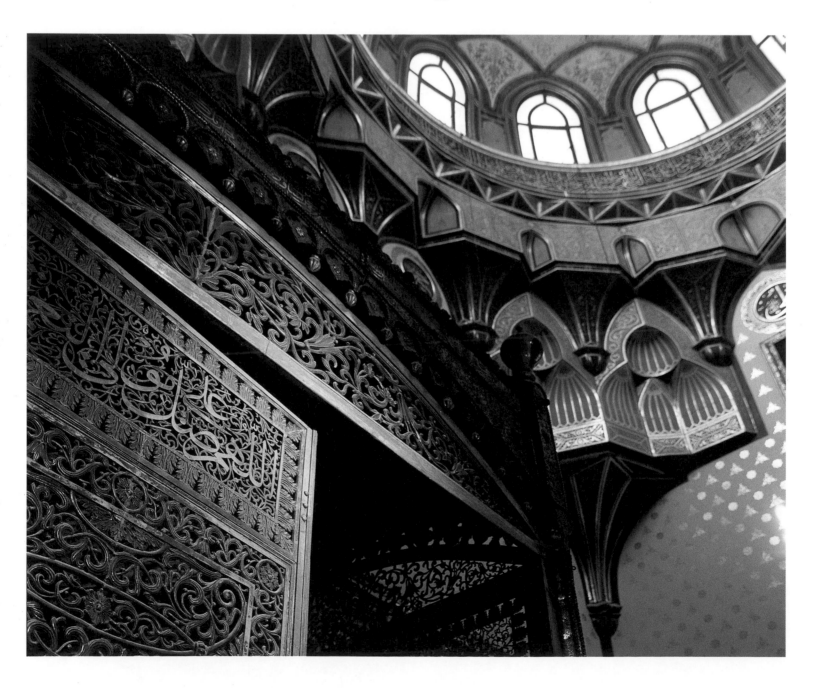

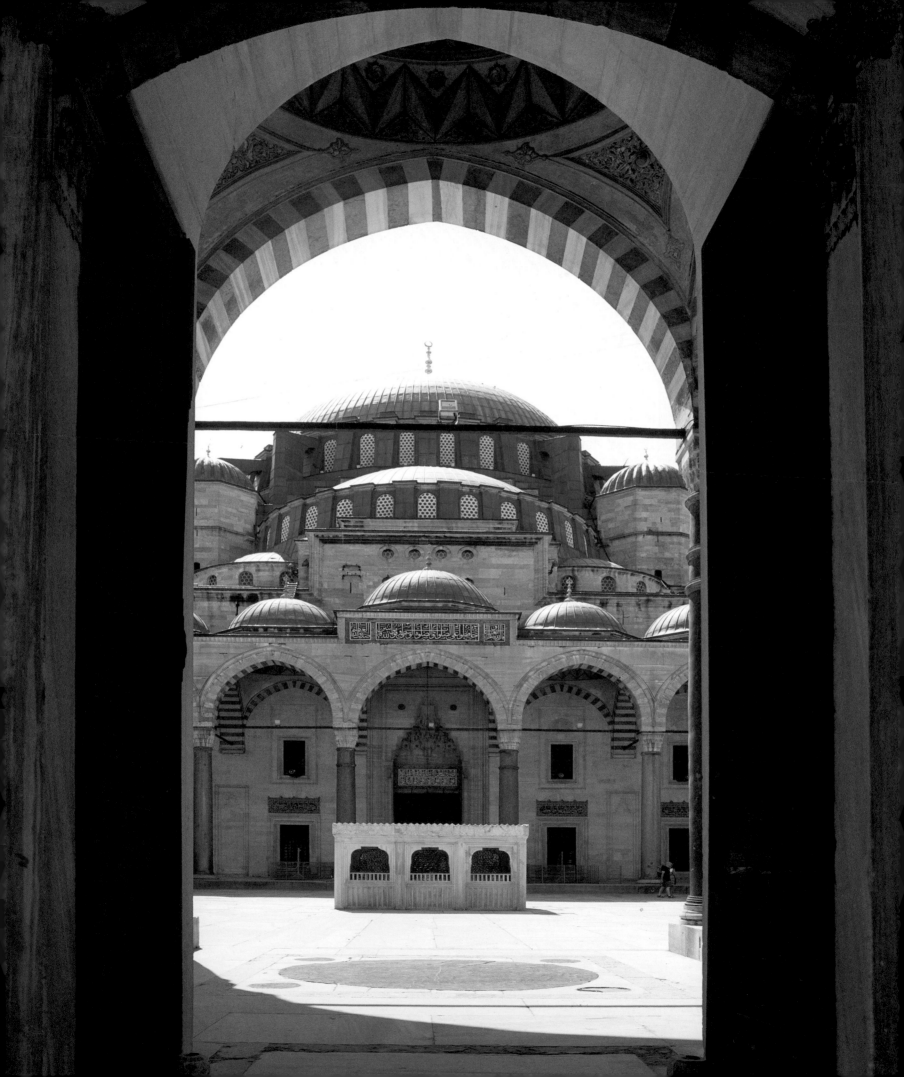

Vizier and soldiers
Illustrated manuscript

Around AH 998/AD 1590
Austrian National Library
Vienna, Austria

between the two states continued during the rule of Sülayman I (known as *Qanuni*, 'the Lawgiver' or, in the West, 'the Magnificent'; r. 926–73/1520–66). Military campaigns in the West brought Belgrade (927/1521) and Budapest (932/1526) under Ottoman rule, but the first siege of Vienna in 935/1529 failed. Almost all the islands in the Aegean were taken, while Ottoman power in the Mediterranean was sealed with the capture of some other islands on the shores of Italy and Spain. Long-lasting Ottoman-French relations began when French King François I asked Sülayman the Magnificent for help in taking King Charles V of the Habsburg Empire, captive. In 942/1536 a Capitulation trade agreement was signed between the two empires to activate relations between Europe and the Ottoman Empire. Similar agreements were renewed many times in the following years and centuries.

Istanbul, seat of the government, was also the centre for Ottoman art. Artistic output was controlled by the palace and then distributed throughout

the empire. Architects, designers, artisans and calligraphers were all brought together in the palace workshops where they produced work according to the desire of the royal family and their entourage. The designs (*naqsh*) were collected in pattern books and applied to many different media, thereby assuring the uniformity of designs. Iznik tiles or Uşak carpets were produced outside the palace ateliers but always in accordance with the motifs set by the palace; they were sold on both the domestic and export markets.

In this period the Ottoman capital took on a new character whose signature was in the style of the head architect of the palace, Sinan. Among the monuments built by him, the Sülaymaniye Mosque built on a hill overlooking Istanbul is a synthesis of Sinan's genius on the one hand, and Sülayman the Magnificent's power on the other. The mosque stands as the most monumental example of the large complexes undertaken by Sinan that began with the Fatih Complex.

The expansion of the empire continued during the reign of Selim II (son of Sülayman the Magnificent; r. 973–81/1566–74). The Ottoman Empire's borders stretched over a greater area than ever before during the reign of Murad III (r. 981–1003/1574–95), encompassing Europe, Asia and Africa, whereby the Black Sea, the Aegean Sea and a major part of the Mediterranean became an enormous Ottoman lake.

Having lost its position as the capital to Istanbul, Edirne retained its importance as the headquarters for military campaigns to the heart of Europe. It was crowned with another Sinan masterpiece: the Selimiye Mosque that was commissioned by Selim II, representing the final phase of Ottoman classical architecture with its central plan.

In the provinces, new features appeared in Ottoman architecture and decoration, merging into the local repertoire and emerging as a new innovative style. Cairo, once the splendid capital of the Ayyubids and

Uşak carpet from Bergama
Turkish carpets were exported in large numbers to European markets.

Ottoman, AH 10th/AD 16th century
Museum of Turkish and Islamic Arts
Istanbul, Turkey

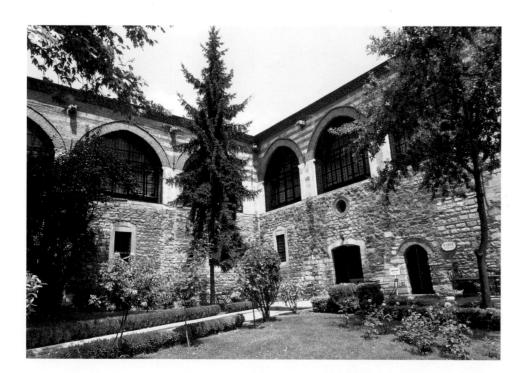

İbrahim Pasha Palace
View of the courtyard.

Ottoman, possibly built AH *late 9th–10th/*
AD *15th–early 16th centuries*
Istanbul, Turkey

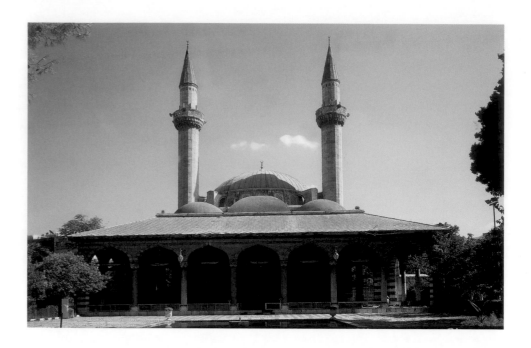

Al-Takiyya al-Sülaymaniyya
The Takiyya functioned as an inn
which served free food to pilgrims.

Ottoman, AH 973/AD 1566
Damascus, Syria

Darwishiyya Mosque

Ottoman, AH 979–81/AD 1571/2–1574
Damascus, Syria

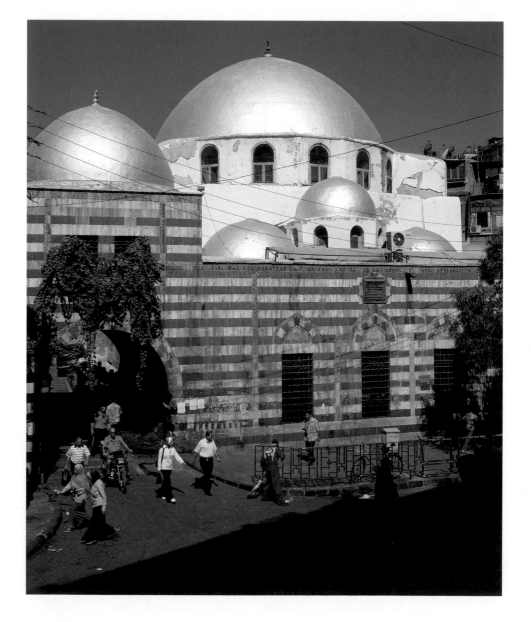

Mamluks, was now reduced in rank to a provincial city with less monumental building activity than before. Now the domed mausoleums largely disappeared and a large number of religious buildings and especially *sabil-kuttab* (water fountains with schools) emerged. The Mosque of Sülayman Pasha was commissioned by the Governor of Egypt, Sülayman Pasha al-Khadim (935/1528). It stands as a self-documenting example of the inspirational architecture of Istanbul, modelled as it was on the mosque of the Takiyya al-Sülaymaniyya in Damascus, which had been built under the auspices of Sülayman the Magnificent.

Takiyya al-Sülaymaniyya was completed in 973/1566 and stands as an architectural symbol of Sülayman's power, similar to the display of Ottoman supremacy evident in the commissioning of the Mosque of Sülayman Pasha, completed in 934/1528. The Takiyya al-Sülaymaniyya stood within an enclosure and comprised a mosque, a *madrasa* and an *imaret* or soup-kitchen. The complex was situated on the shores of the Barada River and served as both a meeting place and hostelry for pilgrims who travelled from

Album of famous calligrapher Ahmed Karahisari

Ottoman, AH 10th/AD 16th century
Museum of Turkish and Islamic Arts
Istanbul, Turkey

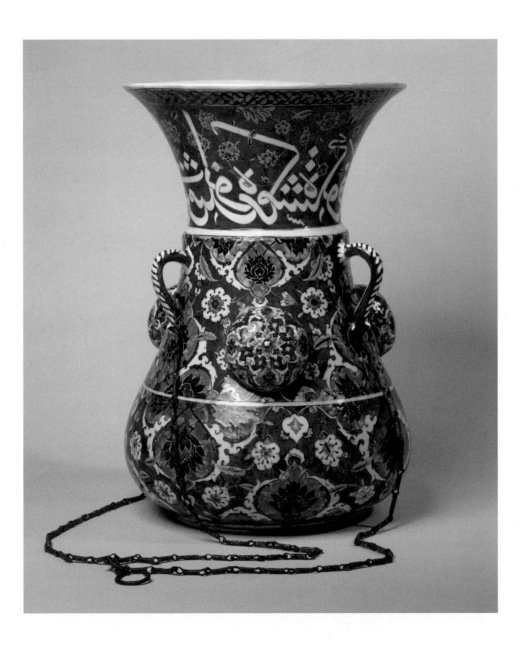

Mosque lamp

Ottoman, c. AH 963/AD 1557
Victoria and Albert Museum
London, United Kingdom

FACING PAGE
Tent

Ottoman, AH 11th/AD 17th century
Army Museum
Stockholm, Sweden

Selimiye Mosque
Considered to be the masterpiece
of the architect, Sinan.

Ottoman, AH 982/AD 1574
Edirne, Turkey

all over the Islamic lands. The complex was designed by Sinan, who sent his plans to Damascus where local architects and workmen accomplished the project according to his design. A landmark of Ottoman power – the new mosque type – was now established: typically preceded by a portico, the mosque was covered by rows of domes and equipped with pencil-shaped minarets.

In Damascus the large-scale production of Iznik-style tiles began. These were used in the décor for structures such as the Darwishiyya Mosque. They show the common decorative repertoire of the Ottoman court, but keep their local imprint both in colouring and detailing.

In the course of the 10th/16th century a large number of *caravanserais*, all featuring Ottoman elements in layout and decorative style, were built in the provincial capitals of Damascus, Aleppo and Tripoli. They marked not only the new ruling power but also the economic prosperity at the beginning of Ottoman rule, a prosperity that was encouraged by the commercial caravans, coming from all over the Islamic lands, and passing through the major cities on their way to the Hijaz.

In the 11th/17th century the political, military and fiscal power of the Ottoman Empire began to unravel, leading to weaknesses that were further compounded by internal conflicts and continuous wars, above all the Ottoman defeat at the second siege of Vienna in 1094/1683. In order to throw the

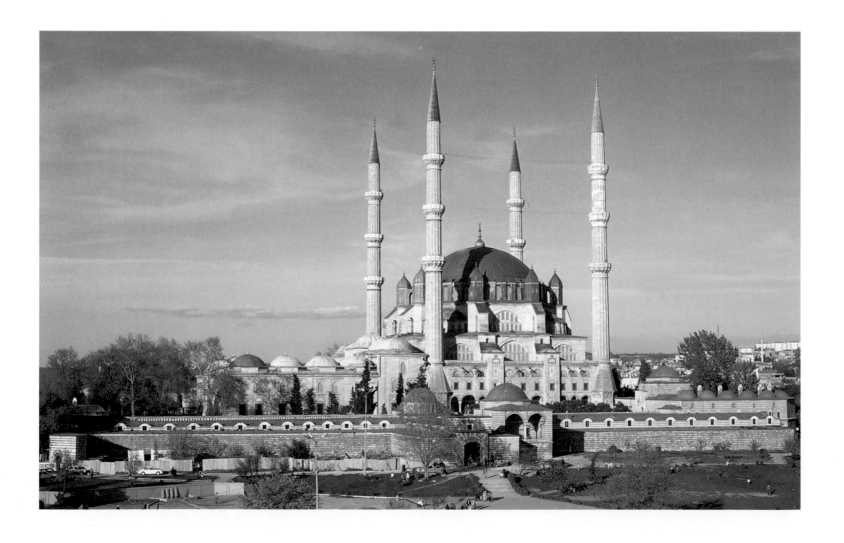

Throne of Sultan Ahmed I

Ottoman, AH *1011–26/*AD *1603–17*
Topkapı Palace Museum
Istanbul, Turkey

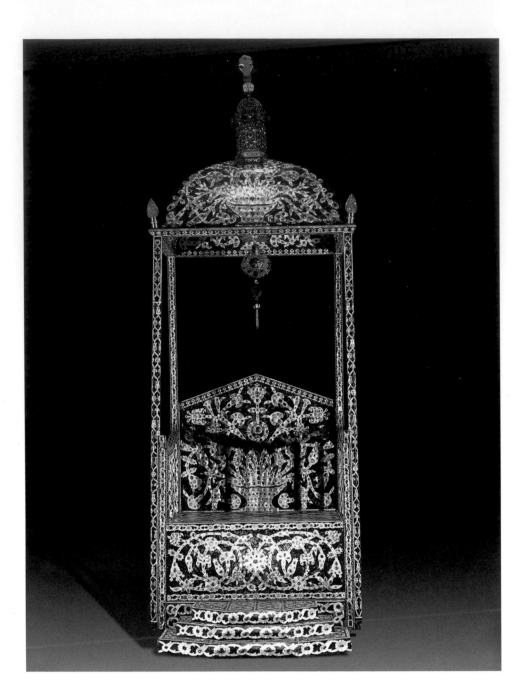

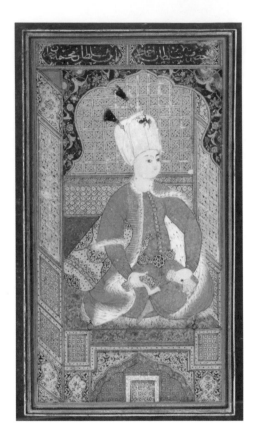

Portrait of Sultan Ahmed I

Ottoman, AH *first half of the 11th/*
AD *first half of the 17th century*
Royal Museum, National Museums Scotland
Edinburgh, United Kingdom

Ottomans out of Europe, a European–Christian Union was formed that was initiated by the Pope and, as a result, the Ottomans had a multi-enemy fight on their hands. The Treaty of Karlowitz (Karlofça) was signed and the Ottomans experienced their first loss of territory in Europe. From time to time from then on there were some short-lived victories but the loss of Ottoman territory in Europe continued.

Despite the decline of Ottoman politics, the so-called Tulip period during the reign of Ahmed III (1114–42/1703–30), signalled a new way of life with prevailing Western influence finding its way into the Ottoman heartland. It is possible to see the naturalistic depictions of the period as the most important novelty to be introduced into Ottoman art by the West. The Fruit Room of Ahmed III in the Topkapı Palace, and also the fountain bearing his name (1141/1729), are both testimony to the Westernisation of Ottoman art during

the Tulip period. After the Tulip period, Ottoman architecture takes on Rococo features mixed with Baroque. Nuruosmaniye Mosque (1158–69/1746–56) is the most important building in the Baroque style in Istanbul. Some other mosques, such as Ayazma (1173/1760) and Laleli (1176/1763) in Istanbul; and Aydın Cihanoğlu (1169/1756), Gülsehir Karavezir (1192/1779), Yozgat Çapanoğlu (1208/1794) and Hızır Bey (1206/1791–2) in Soma, Anatolia, represent Western-influenced architecture of the Baroque genre.

In the provinces, the European style came to be influential but not earlier than the first half of the 13th/19th century. Before that, a mix of local and Ottoman features created a typically charming style seen particularly in private residences, which still give the old cities of Aleppo and Damascus their unique character. The most splendid of these houses is the Qasr al-Azm in Damascus. It was constructed in 1163/1749 as the residence of the Damascene Governor, As'ad Pasha al-Azm and his family. The house is built in the local style with two courtyards, the inner facades of which are decorated with coloured stone-paste décor that was very fashionable in the 12th/18th century.

In order to hark back to the former magnificent days of the empire reformist steps were taken. In the late 12th/18th and early 13th/19th centuries

Fruit Room of Ahmed III in the *harem* of the palace

Ottoman, AH 1117/AD 1705
Topkapı Palace
Istanbul, Turkey

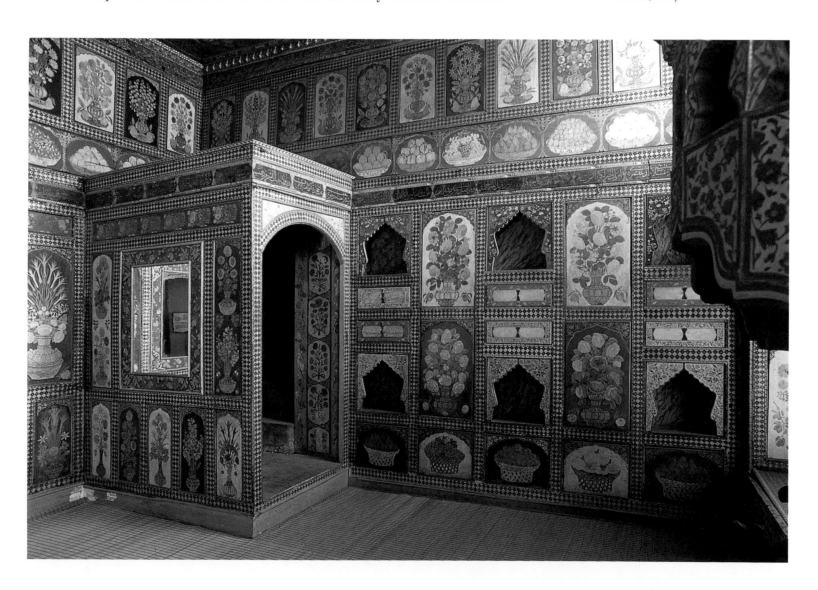

sympathetic sultans such as Selim III (r. 1203–21/1789–1807) and Mahmud II
(r. 1222–24/1808–39) initiated a reform programme known as the Tanzimat
Ferman (1254/1839). The reformist movements, the result of close relations
with Europe, found their expression in art and architecture, causing the
disintegration of traditional forms. Changes in the state administration and in
society itself brought about new building types, such as train stations, post
offices, banks, theatres, museums, business centres, as well as barracks,
ministries and schools, which were planned, built and decorated in the
Western style. During this period, in addition to the Baroque and Rococo
styles, the influences of the Empire and Neo-Classical styles are seen. These
styles were sometimes employed in an eclectic style. Mosques such as
Nusretiye (1241/1826), Dolmabahçe (1270/1854), Ortaköy (1271/1855) and
Aksaray Pertevniyal Valide Sultan (1287/1871), in Istanbul, are well-known
examples that embody the general characteristics of the period. Başçavuşoğlu
(1215/1801) in Yozgat, İlyas Ağa (1226/1812) in Söke, Çiftehanlar (1281/1865)
in Kırkağa and Hacı Ziya Bey (1312/1895) in Söke can be counted among
examples in the same style in Anatolia.

Newly built palaces such as Dolmabahçe (1270/1854), into which the royal
family moved abandoning the Topkapı, Yıldız and Beylerbeyi palaces, are just
a few examples of the mentality of the eclectic style as it was used in Istanbul.
Besides the domestic architecture of the period, improvements in commercial
life impacted on material culture and on the infrastructure, for example in
the establishment of permanent embassies, while Europe's fascination with
the East softened the cliché of the Ottoman lifestyle and encouraged an
awareness of intellectual life beyond the confines of the declining empire.

The Tanzimat period (1254–1325/1839–1908) brought tighter and firmer
administration, which in turn brought closer together the capital and the
provinces. European influence spread as a result, producing a dynamic that

Fountain and *sabil* of Ahmed III

Ottoman, AH 1141/AD 1729
Istanbul, Turkey

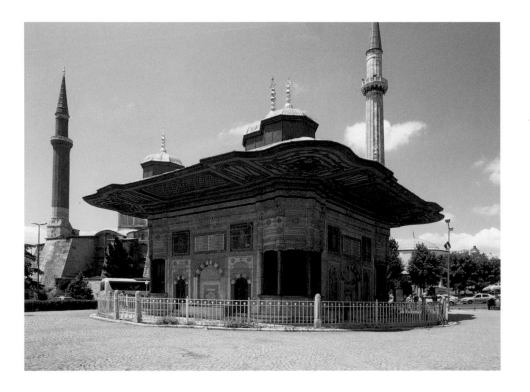

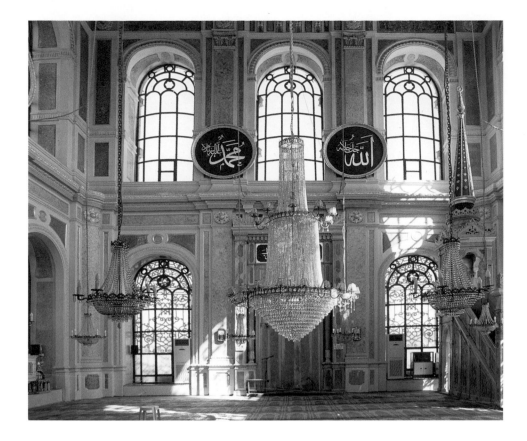

Ortaköy Mosque
Interior view.

Ottoman, AH 1270/AD 1853
Istanbul, Turkey

Cover for an astronomical instrument
Decorated in the taste of the period.

Ottoman, AH 1151/AD 1738
Museum of Turkish and Islamic Arts
Istanbul, Turkey

can be seen not only in the architecture but also in the urban planning. The décor in aristocratic houses was now in the splendid Ottoman-Baroque style and comprised gilded marble in fantastic forms. In the late 13th/19th century, technical achievements of the industrial age saw steamboats crossing the Bosphorus, and even aeroplanes served as motifs on wall paintings in the representative rooms of larger houses. Similarly the city centre of Damascus, one of the main provincial cities, was shifted beyond the medieval city walls and a completely new city centre with main streets, a square with a city hall, cafés, a cinema and hotels in the European style was created around Marja Square.

Sultan Abdülhamid ('Abd al-Hamid II, r. 1292–1326/1876–1909) renovated the traditional bazaar area made up from small alleyways, and built in its place a huge main retail artery inspired by the shopping galleries of Milan, Brussels and Paris. But in Cairo, only the Mosque of Muhammad Ali Pasha (r. 1220–65/1805–48) reached the dimensions and splendour of the mosques in the capital, Istanbul, with its rich, Baroque-style gilded-marble interior. This is no wonder, since Egypt gained a sort of independence from Istanbul under the rule of Muhammad Ali Pasha, who had managed not only to establish an economic foundation by introducing modern industries based on European technology and expertise, but also succeeded in securing Egypt's predominant standing in the region by reforming the military forces.

Despite the large construction projects undertaken by the last Ottoman sultans, the independence of Egypt was a sure sign of the empire's decline. The conflict between the reformists and the scholastic religious thinkers led to the absolute sovereignty of the sultan. As a result, Sultan 'Abd al-Hamid II

Mosque of Muhammad Ali Pasha

Ottoman, AH 1265/AD 1848
Cairo, Egypt

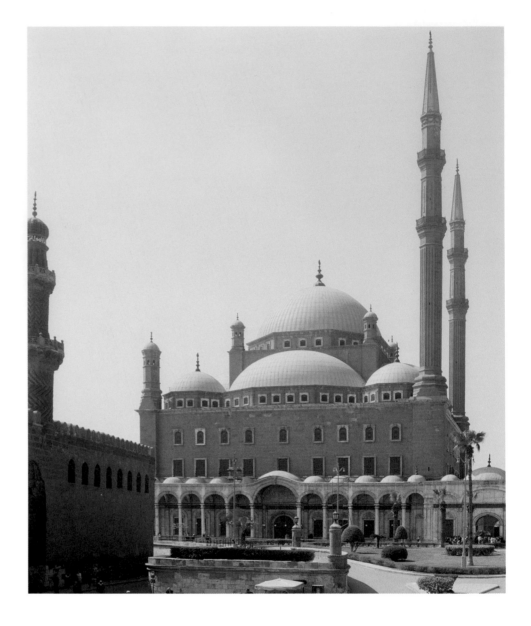

had to declare a constitutional monarchy twice (1292–4/1876–8 and 1325-1340/1908–1922). The terrible situation in which the empire found itself already, worsened during the reign of Mehmed Reshad (1326-1336/1909–18) and, with the elimination of the sultanate when the last sultan, Mehmed VI Vahdeddin (Wahid al-Din, 1336-1340/1918–22) was on the throne, the end to a 622-year-long history of the Ottoman Empire finally came, and a young Republic of Turkey was raised from its ashes.

Reflections of Paradise:
Floral Decoration in Islamic Art

A collaboration

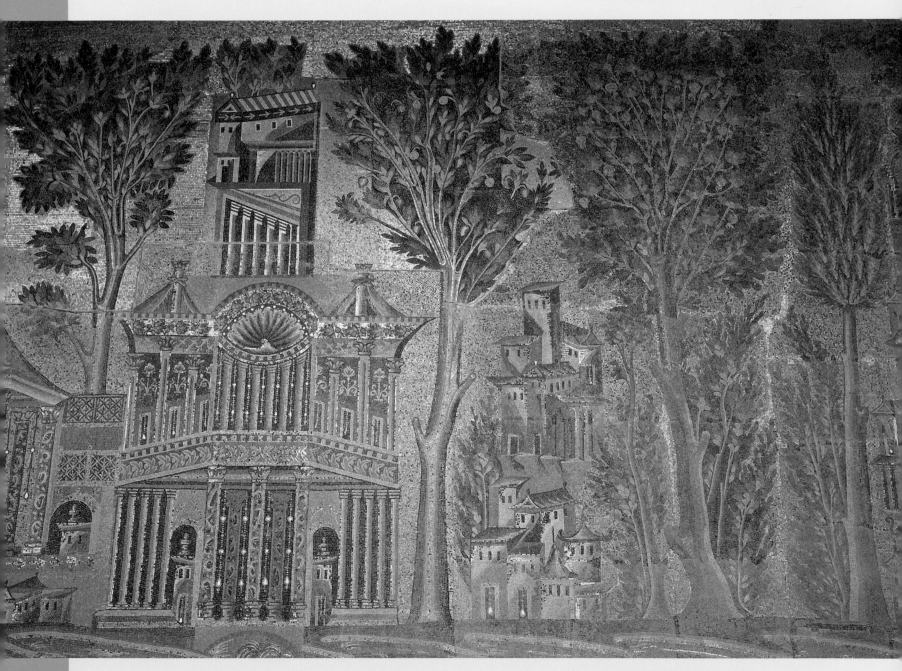

Umayyad Mosque
Mosaic (detail).

Umayyad, AH 87–96/AD 706–715
Damascus, Syria

Wooden panel (detail)

Abbasid, AH 3rd century/AD 9th century
Museum of Islamic Art
Cairo, Egypt

Decorative panel

Fatimid, AH 6th/AD 12th century
Museum of Islamic Art, State Museums
Berlin, Germany

Throughout the history of Islamic civilisation the concept of the garden holds particular significance. This is due in part to the arid landscapes where traditionally most Muslims lived and where the soothing green of the occasional oasis or garden complex was precariously maintained by precisely controlled water management; a luxury affordable only to the elite. Those that were privileged enough to enjoy the respite of a lush and shady garden would have enjoyed not only its physical pleasures, but at the same time would be reminded of the vivid Qur'anic evocations of the Islamic paradise, *al-Janna*.

The central importance to Muslims of *al-Janna* as well as their love of earthly gardens is echoed in the predilection for floral and vegetal decoration within the context of Islamic art, be it in mosaics and other architectural forms of decoration, or in the decorative arts.

Literal representations of the garden of paradise are rare. One outstanding example is the astonishing mosaic cycle within the AH 2nd-/AD 8th-century

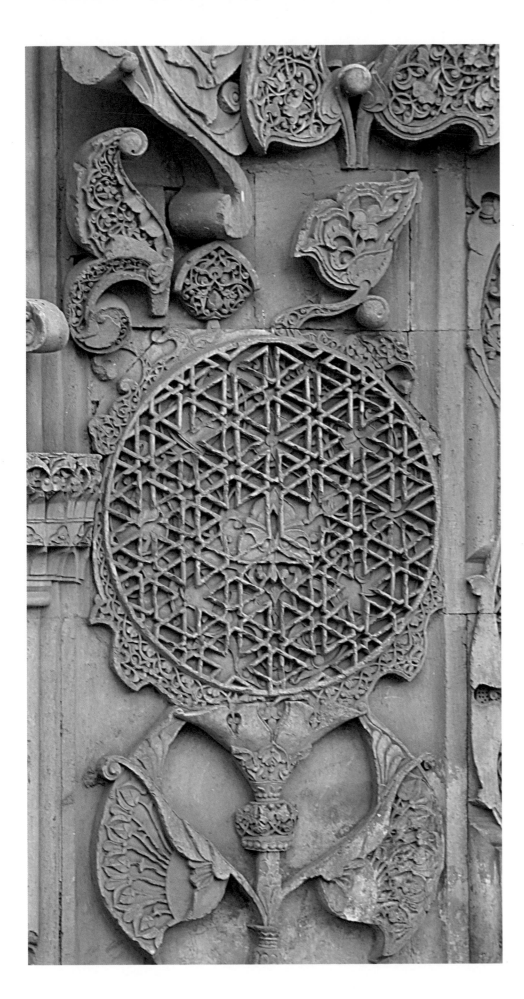

Great Mosque and Hospital of Divriği
Decoration of the North Portal also
called the 'Baroque Portal' (detail).

Menjüjekid Emirate, AH 626/AD 1228–9
Divriği, Sivas, Turkey

Fragment of a wall decoration

Rustamids of Sedrata, AH 296–467/
AD 909–1074
National Museum of Antiquities
and Islamic Arts
Algiers, Algeria

FACING PAGE
Embroidery

Ottoman, AH 11th/AD 17th century
The Burrell Collection, Glasgow Museums
Glasgow, United Kingdom

**Fruit Room of Ahmed III in the
harem of the palace**

Ottoman, AH 1117/AD 1705
Topkapı Palace
Istanbul, Turkey

Umayyad Mosque in Damascus. A statement by one of the mosaicists survives to confirm its symbolic significance: 'In the mosaics we represented what we found in the Qur'an with regard to trees and palaces of paradise. And when a worker had executed a tree in a particularly fine manner, the Caliph 'Umar would give him 30 *dirhams* as a reward.' Another interesting reference to the garden of paradise occurs many centuries later on the ceiling of Ahmed III's Fruit Room in the *harem* in the Topkapi Palace, Istanbul.

Artistically, another way of evoking paradise was the depiction of arched gateways filled with flowers. Some commentators have interpreted these as artistic references to contemporary garden pavilions, while others likened them to archways through which believers glimpsed the elusive and otherworldly garden. Stylistically, such depictions hark back to pre-Islamic, Hellenistic-period renditions of the Font of Life.

Trees laden with fruit provided another popular motif intended to echo notions of the eternal tree-of-life. A special place was held by the date palm, which according to one tradition, was created from the clay left over after God's creation of Adam. Other pious stories recount that the Prophet Muhammad associated the palm tree with paradise.

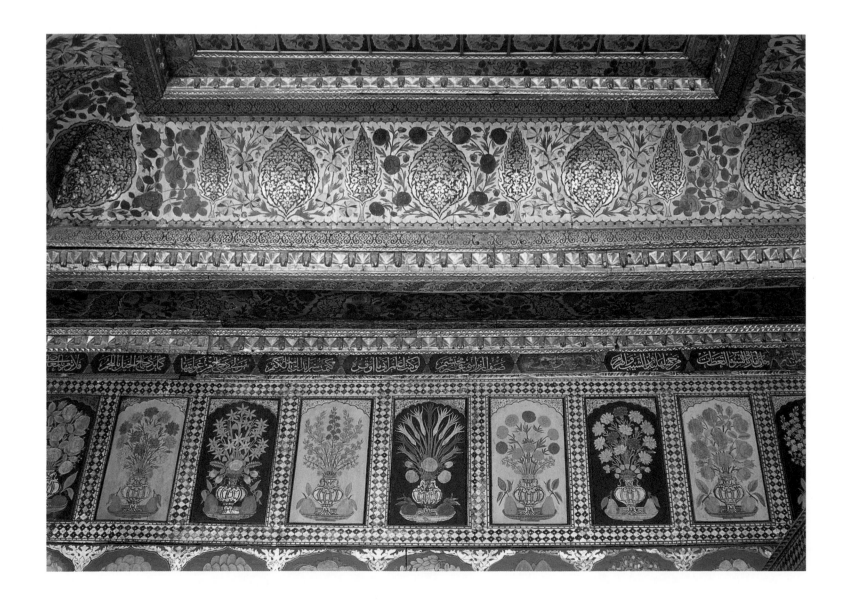

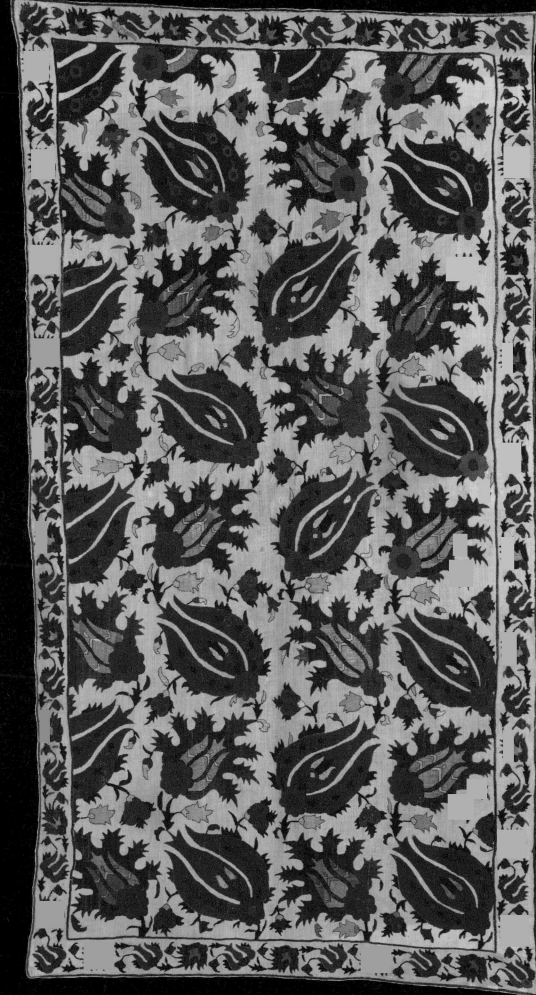

Individual flowers and plants, carefully cultivated in Muslim lands, also frequently occur in artistic form. Many were chosen not only for their horticultural qualities, but also for their religious or poetic symbolism. A particular favourite was the rose, which according to popular Islamic tradition, was created from a drop of the Prophet's sweat, lost during his miraculous nocturnal journey to paradise. The rose also symbolises the unity of Allah, its petals the Muslim *ummah* or community.

Another popular flower, particularly in Ottoman Turkey, was the tulip. The Ottomans cultivated it with great passion and over a thousand varieties were known. Tulip bulbs were keenly traded and reached Europe as early as the 10th/16th century. Here it triggered a new age of cultivation, particularly in Holland. The beauty of the tulip was also celebrated in religious poetry where it was likened to the martyr for the faith and the mystical, self-denying lover.

Not all the flowers and plants that can be observed in Islamic art have their origins within the Muslim world. Thus, the grape-laden vine represents a survival from Hellenistic times, while the lotus – an Eastern symbol of spiritual purity – was introduced into the Islamic repertoire by the Mongols in the 7th/13th century. When flowers are not depicted in naturalistic form, they often occur in fantastic arrangements intended to enhance or indeed obscure

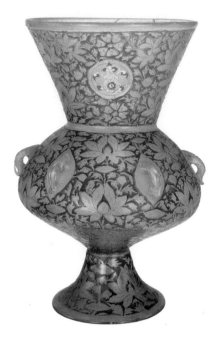

Mosque lamp

Mamluk, AH 750–61/AD 1350–60
The British Museum
London, United Kingdom

Dish with floral decoration

Ottoman, AH 10th–11th/AD 16th–17th centuries
National Museum of Oriental Art
Rome, Italy

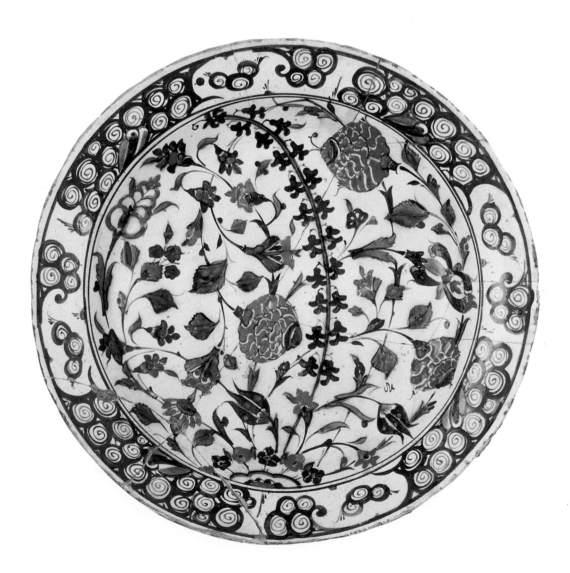

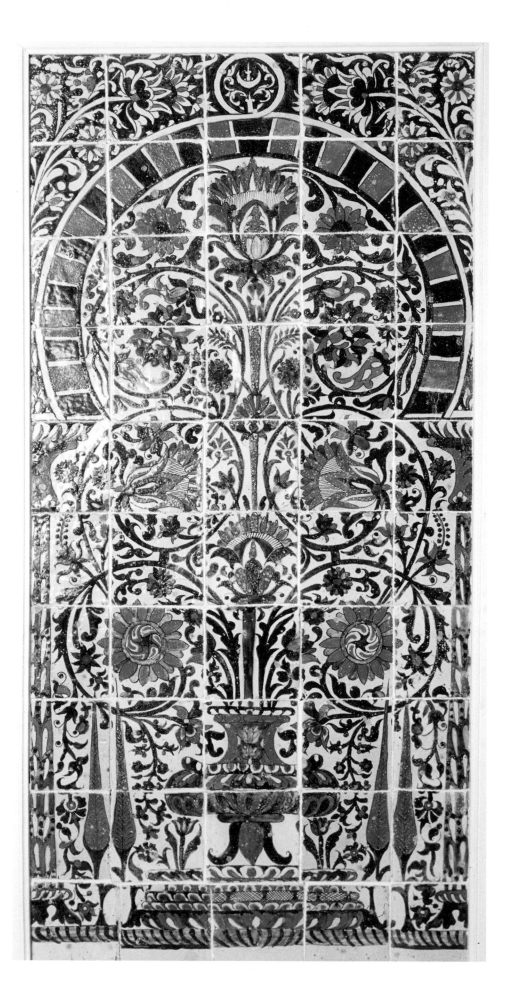

Tile panel

Husaynid, AH 12th–13th/AD 18th–19th centuries
Museum of Mediterranean and
Near Eastern Antiquities
Stockholm, Sweden

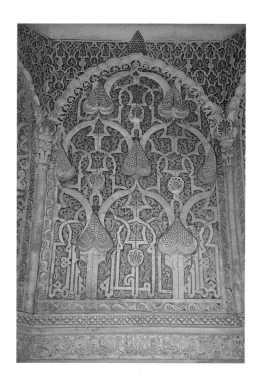

Ibn Yusuf Madrasa
Plaster decoration covering the
interior walls (detail).

Sa'did, AH 972/AD 1565
Marrakesh, Morocco

Carved limestone block

Umayyad, first half of the 8th century
Museum of Jordanian Heritage,
Yarmouk University,
Irbid, Jordan

the surface of a building or an artefact. Primarily decorative, such floral schemes nevertheless offered spiritual minds the opportunity to contemplate the infinite complexity of the universe with the unity of its creator, Allah, as its source.

The arabesque is undoubtedly the most popular and characteristic alternative to Islamic flower compositions. Formed from a combination of stalks, scrolls, leaves and palmettes that grow out of each other and develop in an endless symmetrical arrangement, the arabesque in its infinite variety became popular in the 5th/11th century. Its adaptability and versatility lends itself naturally to the decoration of artefacts and architectural structures alike, while inviting contemplation of the unfathomable interconnections and interdependencies of Allah's universe.

Western Influences in Ottoman Lands

Mehmet Kahyaoğlu and Paola Torre

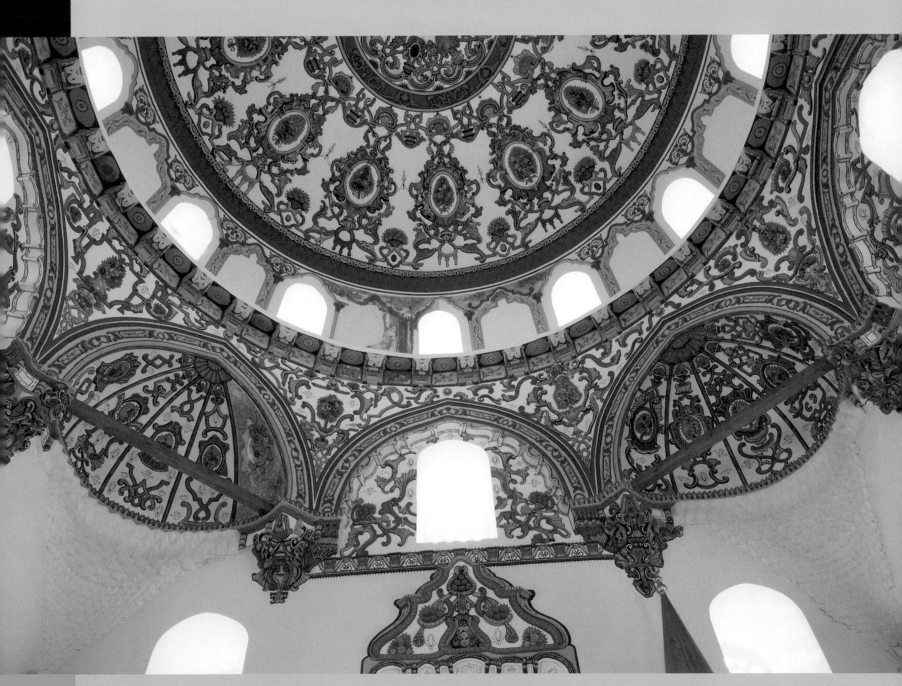

Cihanoğlu Mosque

Ottoman, AH 1170/AD 1756
Aydın, Turkey

Western Influences in Ottoman Lands

Dolmabahçe Palace
Ceremonial Hall.

Ottoman, AH 1259–73/AD 1843–56
Istanbul, Turkey

Nuruosmaniye Mosque
Example of the Baroque influence on
Ottoman architecture.

Ottoman, AH 1169/AD 1756
Istanbul, Turkey

The epoch in Ottoman art that started with the so-called Tulip period
(AH 1131–43/AD 1718–30) and lasted up until the last decades of the 13th/19th
century is determined by a strong Western influence on artistic styles, which
was due to the intense commercial, political and cultural relationships that
existed between the Ottoman Empire and the West. Following the failure of
the Second Siege of Vienna in 1094/1683, the political balance between the
Ottomans and the West gradually started to change in favour of the latter.
Although this brought tidier economical and diplomatic relations, it also
opened the way for new artistic tastes. Eventually in the 12th/18th century,
Ottoman art was 'conquered' by Baroque and Rococo features, followed in
the 13th/19th century by the Neo-Classical, Empire and Orientalist styles.
Throughout this period the grandiose religious architectural style of the
Classical Ottoman era was replaced by more modest edifices. Attention was
more focused on their decorative embellishment, with distinctive Baroque
and Rococo architectural decoration comprising a profusion of curved,
undulating motifs.

An obvious element of the new style was the naturalistic approach to
decoration that was seen mainly in the floral decoration. This was a type of
decoration where the rich world of flowers became elements of inspiration in
themselves. In architecture, the decorative repertoire made for a play of

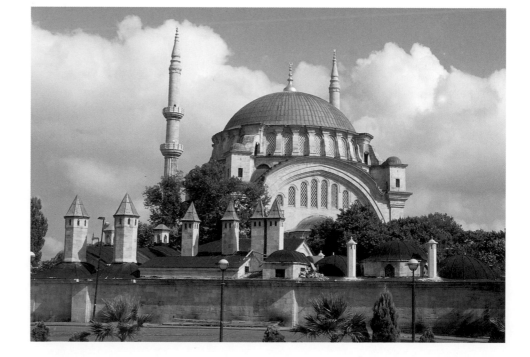

contrasts between the horizontal and vertical lines and the play of light and shade. All of this produced quite original results. Traditional Ottoman art was now infused with a decorative vocabulary that included the introduction of acanthus leaves and 'C' and 'S' curves.

Nuruosmaniye Mosque in Istanbul (completed in 1169/1756) was the strongest sign of the new cultural era, with its polygonal courtyard without a fountain, polygonal *mihrab* that projected from the main body of the mosque, as well as the sinuous nature of its decorative elements.

The new taste was conveyed to the provinces in Anatolia through powerful land-owners such as the Cihanoğlu and Karaosmanoslu families. Cihanoğlu Mosque in Aydın (1169/1756) is a striking example of its age in the plasticity and illusionist effects of its decoration. Another mosque commissioned by the same family in Cincin village (Aydın) is worth a mention, especially its *mihrab* which bears close resemblance to the Altar of San Lorenzo by Guarini in Turin (1090/1679).

Landscape wall paintings became popular both in civic architecture and even in some mosques, for instance those in Hızır Bey Mosque in Soma

Hızır Bey Mosque

Ottoman, AH 1206/AD 1791–2
Soma, Turkey

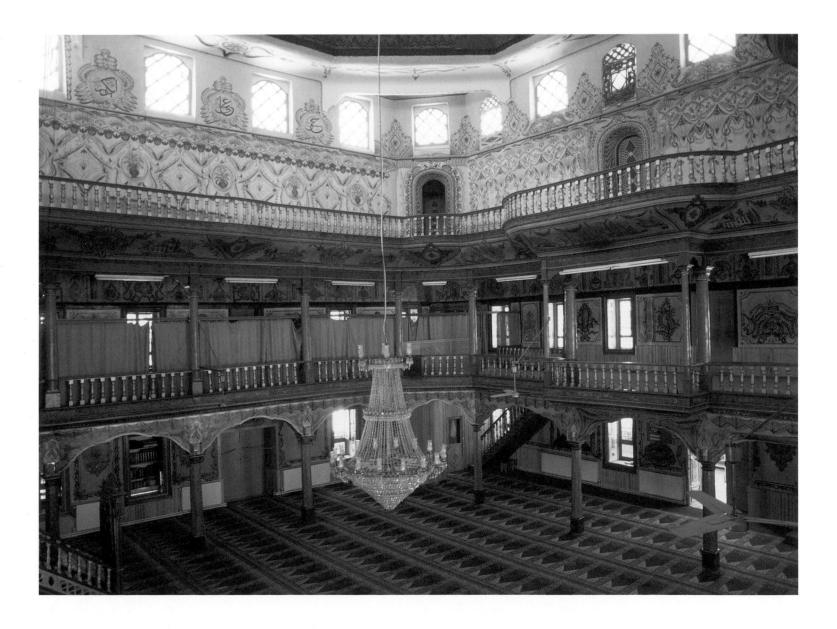

Mosque of Muhammad Ali Pasha
Ablutions fountain in the courtyard.

Ottoman, AH 1264/AD 1848
Cairo, Egypt

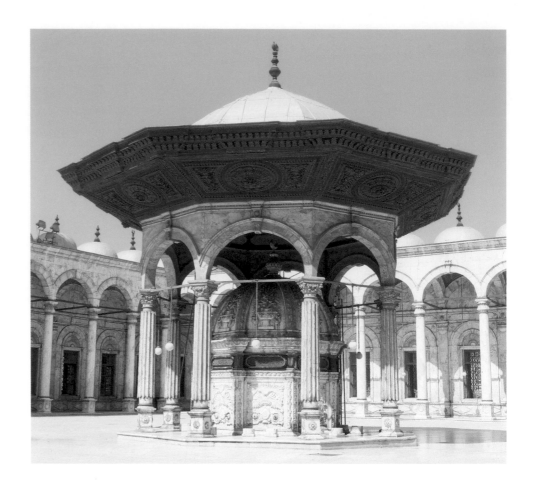

Beylerbeyi Palace
The façades include arches and
windows in the Greek and Roman
styles, while the interior spaces are
heavily decorated with traditional
Ottoman and Eastern motifs.

Ottoman, AH 1281/AD 1865
Istanbul, Turkey

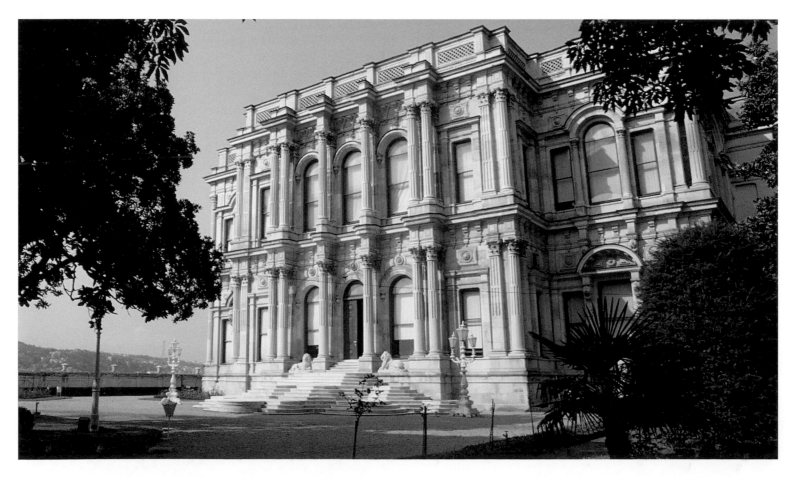

(1206/1791–2). Furthermore, the murals in this building can be regarded as an example of the transition from traditional illuminations to Western-style painting. Some mosques from earlier periods gained a new look by way of renovations carried out in the 'new taste' in the 13th/19th century; some beautiful examples of this are seen at Kemeraltı and Hisar mosques in İzmir.

The new Western style found its reflection in different ways throughout the vast territory of the Ottoman Empire, such as in the Mosque of Muhammad Ali Pasha in Cairo (1264/1848). In the countries of the Maghreb that were under Ottoman rule but with a broad autonomy, the artistic influences were both from first-hand European contact and through exposure to fine products that were produced in Istanbul.

One popular motif at the time was the European-style vase containing a bouquet of flowers surrounded by leaves or entwined branches. This motif can be seen on a variety of different products such as woven goods, carpets

BELOW
Textile

Ottoman, AH 13th/AD 19th centuries
National Museum of Oriental Art
Rome, Italy

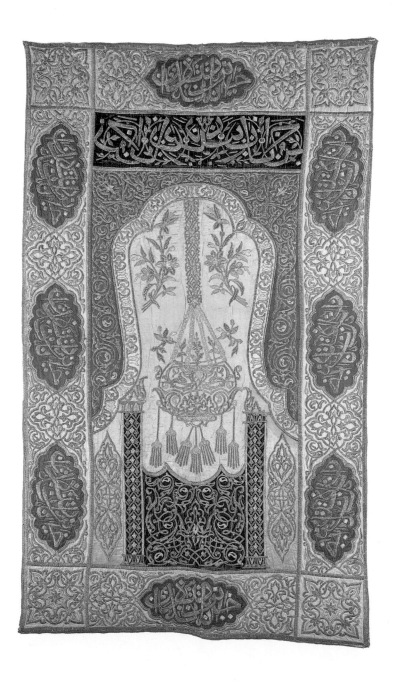

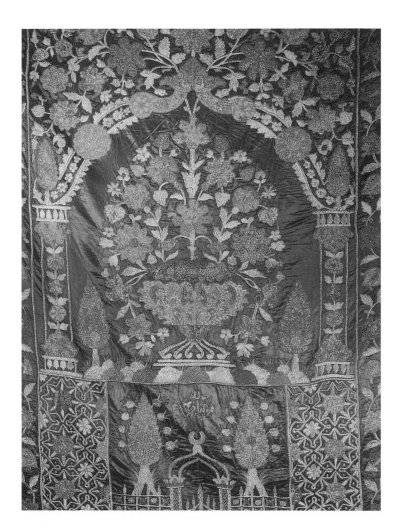

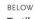

LEFT
Textile
Decorated with a *mihrab*.

Ottoman, AH 12th to 13th/AD 18th to 19th centuries
National Museum of Oriental Art
Rome, Italy

Triptych with *Hilye-i-Sherif*
(Noble Description)
Belief in the protective power of
such triptychs made them objects
of veneration.

Ottoman, AH 12th/AD 18th century
National Museum of Oriental Art
Rome, Italy

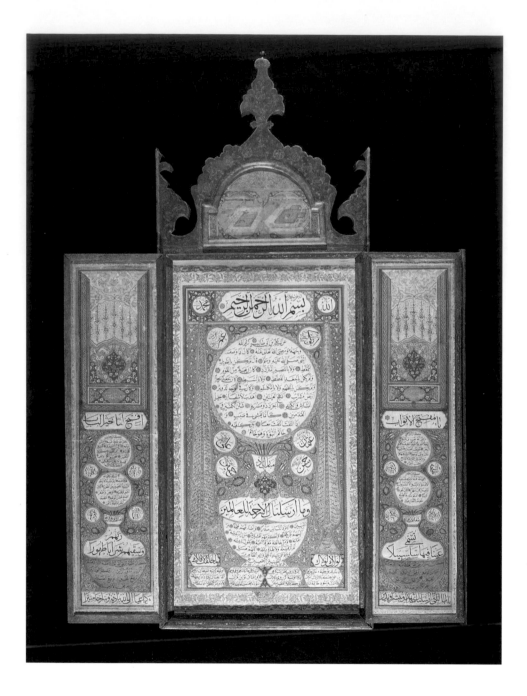

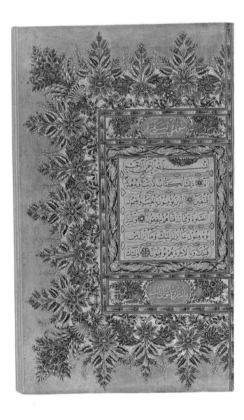

Qur'an

Ottoman, AH 1259/AD 1843
Museum of Turkish and Islamic Arts
Istanbul, Turkey

and on objects used in the religious context and everyday objects. Two fine
examples of the new tendency towards flower pieces are seen in the
embroidered fabrics illustrated here: one a sumptuous vase of flowers, and
the other a *mihrab* with naturalistic floral decoration.

A triptych also illustrates how Western influences penetrated on a large
scale into Ottoman art. When its wings are closed the triptych can be easily
attributed to any European ambient due to its typical Western-style floral
decoration but, once open, a typical example of Ottoman religious art with
extensive use of epigraphic elements is seen.

Ottoman art of the period shows great capacity to reformulate and integrate
foreign cultural and artistic elements and in so doing achieves very original
results.

Glossary

Amir: A military commander, prince or senior official.

Al-Andalus: The name of the Iberian Peninsula (Spain and Portugal) under Muslim rule, which lasted from AH 92 to 897 (AD 711–1492).

Al-Aqsa: An adjective meaning 'the furthest', it refers to the Aqsa Mosque in Jerusalem, revered by Muslims as the first *qibla* (direction of prayer) and the principle holy site where the Prophet's ascent to Heaven (see also, *al-Israa' wa al-Mi'raj*) took place.

Arabesque: Decorative designs of intertwined leaves and geometric shapes developed during the Islamic era.

Astrolabe: An instrument to measure the distances between the earth and stars.

Atabeg: Commander-in-Chief of the armies. The term is Turkish, *ata* meaning father and *beg* meaning leader. Atabegs were employed to teach princes the arts of military leadership.

Bani/Banu: Sons of, used to refer to people of a certain clan. In the singular, it is Ibn/Bin.

Baroque: A 17th-century European artistic movement distinguished by extravagance, dynamism and high emotion. The Western influence on Islamic art appears during the Ottoman period when Baroque forms are incorporated into the Islamic repertoire.

Bilad al-Sham: A region often translated as 'the Levant' or 'Greater Syria' which includes present-day Syria, Jordan, Lebanon and Palestine.

Bimaristan: A hospital or infirmary that was also furnished with a medical library and functioned as a scientific educational centre. Medical treatment was offered charitably on a gratis basis where herbal remedies, music, and relaxation were used to treat the sick.

Caliph (or *Calife*): From Arabic *Khalifa*, meaning the supreme head of the Muslim community in the line of the prophet's successors.

Caravanserai (see also *khan*): Hostel along the main trade and pilgrimage routes where travellers (pilgrims and merchants) were accommodated and where merchandise could be safely stored.

Copts: Mainly Egyptian Christians; followers of one of the oldest forms of Christianity with communities extending from East Africa to Ethiopia. They have their own language, Coptic, and their own calendar.

Faranja/Ifranj: The Arabic term for the Franks used by the Arabs to refer to the Crusaders.

Gothic: A style of architecture that lasted from the 12th to the 16th centuries in Northern Europe and Spain. It is characterised by an elongation of the figure and soaring architectural lines (verticalism). Examples of Gothic architecture were transported to the Muslim world by the Crusaders.

Hijra (literally 'migration'): referring to the exodus of the Prophet from Mecca to Medina in AD 622.

Hijri: Reference to the Muslim calendar, which takes the year of the Prophet's *hijra* as the starting point. The Muslim calendar follows a lunar year of 354 days.

Ibn/Bin: Son of, used often in names. To indicate a clan, the plural form of *Bani/Banu* is used.

Imam: One who presides over Islamic prayers, a guide, chief, spiritual model or cleric; always known for his purity and wisdom and sometimes also a political leader.

Ifriqia: The pre-modern Islamic name of the region roughly comprising today's Tunisia.

Al-Israa' wa al-Mi'raj: The miraculous nocturnal journey of the Prophet Muhammad from Mecca to the Aqsa Mosque in Jerusalem; it was from here that he ascended to heaven, met with many apostles who had preceded him, and spoke with God.

Iwan: A vaulted hall that is walled on three sides. It is a typical feature of Islamic architecture whereby the *iwan* would usually look out onto a courtyard with a fountain.

Jahiliyya: A period of ignorance, referring to the paganism of the Arabian Peninsula before the advent of Islam.

Jihad: Striving towards moral and religious perfection, either through education or donations of money of wealth, the motivation for which may lead to fighting 'on the path to God' against dissidents or pagans.

Ka'ba (literally 'cube'): a small temple in Mecca that was converted to become the centre of Islam, and was originally thought to have been constructed by the prophet, Abraham, and his son Ismaíl.

Kasbah: Fortress, citadel. A citadel and residence of the local leader, usually equated with the city centre. The term *kasbah* is used most commonly in western parts of the Islamic lands: Tunisia, Algeria, and Morocco.

Khan (see also *caravanserai*): Hostel along the main trade and pilgrimage routes where travellers (pilgrims and merchants) were accommodated and where merchandise could be safely stored.

Khanqah: A monastery or hostel dedicated to the use of Muslims who follow a mystical, or *Sufi*, lifestyle.

Khutba: The weekly sermon of the Friday payer.

Kufic: Named after Kufa in Iraq. It is one of the earliest forms of Arabic calligraphy, distinguished by its angular style.

Lustre ware: A type of glazed pottery produced by a sophisticated firing technique using metallic oxides in order to achieve a luxurious metallic sheen. It was invented in the early Islamic period in Mesopotamia and flourished throughout the Islamic lands.

Madrasa: Islamic school of religious sciences (e.g. theology, law, Qur'an) and lodgings for scholars.

Mahdi: Religious leader, literally meaning the 'guided one'.

Malik: A title signifying prince or king.

Mihrab: Arched niche in a mosque or prayer hall, most often concave but sometimes flat, indicating the direction of Mecca for prayer. It is usually the most decorated part of a mosque or prayer hall.

Minbar: A raised pulpit for delivering the sermon during the Friday prayer.

Mulk: A noun meaning kingdom or sovereignty. It is often applied in calligraphic ornamentation to decorate luxurious courtly items.

Muqarnas: Stalactite- or honeycomb-like architectural ornamentation. It is a characteristic feature of Islamic architecture, appearing on many surfaces, including domes and recessed doorways.

Naskhi: One of the more widespread of Arabic calligraphic styles, comprising an easily flowing cursive. Its literal meaning is related to 'copying' and manuscript production.

Qal'at: Citadel, fortress, with visible features of defensive architecture, such as high impregnable walls, towers, arrow-loops and glacis.

Qasr: Palace, castle, from Latin *castrum*, a monumental residence.

Qibla: Direction of the *Ka'ba*, towards which believers pray.

Qubba (literally 'dome'): by extension a monument or chamber built over the grave of a saint which is usually marked by a dome, hence, a mausoleum.

Qur'an: From the root qr', 'to read' and referring to the sacred text of the Islamic Revelation transmitted by the Archangel Gabriel to the Prophet Muhammad in Arabic.

Reconquista: Reconquest of the Iberian Peninsula (Spain and Portugal) by the Christians from the Muslims, which caused mass exodus and put an end to eight centuries of Arab rule.

Ribat: Fortified enclosure for religious warriors (North Africa); a hospice for pilgrims (Mamluk Egypt, Palestine and Syria).

Rococo: An 18th-century European artistic style that followed the Baroque, distinguished by exaggerated embellishment intricate designs. Examples of the Rococo style appear in some Ottoman architecture.

Sabil: A charitable building designed to provide drinking water; a public fountain.

Sharif (or *sherif*): Descendant of the Prophet Muhammad, literally meaning 'honourable'. Families that trace their ancestry to the prophet are known as *Ashraf* or *Shurafa* and often hold prestigious religious and political positions.

Shi'a: Correctly, 'Shi'at 'Ali', meaning the 'Party of 'Ali', and referring to the Muslims who chose 'Ali as their leader following the Prophet's death and who subsequently rejected the legitimacy of the caliphs following 'Ali's assassination in 50/661.

Sultan: A title meaning sovereign and usually indicating a supreme political leader whose authority does not threaten the nominal superiority of the ruling caliph.

Sunna (literally 'traditions'): Refers to the traditions of the Prophet which were used by legal advisers and theologians to provide the necessary support for the foundation of Islamic Law as written in the Qur'an.

Sunni (sing; plural Sunna): The followers of the Sunna, or the Sunnis, came to signify the orthodox majority of the Muslim community.

Suq: Market, the hub of the Muslim city, the centre of urban life.

Ta'ifa: Factions or groups. The term usually refers to the disintegration of Muslim Spain into several smaller kingdoms during the 5th/11th century.

Vizier: An honorific title given to senior administrators; a minister.

Waqf: A non-taxable endowment of land or property whereby the revenue earned is used for the upkeep of pious Islamic foundations.

Zellij: Small enamelled tiles.

Further Reading

Akşin, S. (Yay. Yön.), *Türkiye Tarihi*, 1–4, 3, Istanbul, 1990–3.

Amine, A., Boutaleb, B., Brignon, J., Martinet, G., Terasse, M., *Histoire du Maroc*, Paris, 1990.

Arabica, L., Talbi, M., *Un nouveau fragment de l'histoire de l'Occident musulman (62–196/682–812) l'épopée d'al-Kahina*, RT. 19, 1971.

Arık, R., *Batılılaşma Dönemi Anadolu Tasvir Sanatı*, Istanbul, 1988.

Arseven, E. C., *Les arts décoratifs turc*, Istanbul, 1952.

The Arts of Islam, Hayward Gallery exhibition catalogue, 1976.

Atil, E., *Turkish Art of the Ottoman Period*, Washington, 1973.

Atıl, E., *Renaissance of Islam: Art of the Mamluks*, Washington DC, 1981.

Baer, E., *The Human Figure in Islamic Art: Inheritances and Islamic Transformations*, Costa Mesa, 2004.

Behrens-Abouseif, D., "Sabil", *Encyclopaedia of Islam*, Vol VIII, Leiden (n.d.).

Behrens-Abouseif, D., *Islamic Architecture in Cairo: An Introduction*, Cairo, 1996.

Bosworth, C. E., *Encyclopaedia of Islam*, 2nd edition, 1979 (various articles).

Bosworth, C. E., *The New Islamic Dynasties*, New York, 1996.

Bowersock, G. W., Brown, P. and Grabar, O., *Late Antiquity*, Cambridge, Mass. and London, 1999.

Brown, P., *Power and Persuasion in Late Antiquity: Towards a Christian Empire*, Madison, 1992.

Burlot J., *la civilisation islamique*, Paris, 1995.

Cahen, C., *Orient et Occident au Temps des Croisades*, Paris, 1983.

Clevenot D., *Une esthètique du voile, essai sur l'art arabo-islamiqu*e, Paris, 1994.

Delpont, E., *L'Orient de Saladin: L'art des Ayyoubide*, Paris, 2001.

Enciclopedia dell'arte medievale, diretta da A. M. Romanini, Rome, 1991–2002.

Ettinghausen, R. and Grabar, O., *The Art and Architecture of Islam, 650–1250*, New York and Harmondsworth, 1987; paperback, New Haven and London, 1992.

Fasi, Muhammad ibn Ahmad, "Shifa' al-Gharam bi-Akhbar al-Balad al-Haram", edited by Ferdinand Wuestenfeld, in vol. 2 of *Die Chroniken der Stadt Mekka*, Leipzig, 1857; reprinted, 1981.

Francesco G., Gioia G., Clelia S. C., Lucien G., Pierre G., *Le maghreb medieval*, Aix-en-Provence, 1991.

Gautier, E. F., *l'islamisation de l'Afrique du Nord. Les siècles obscurs du Maghreb*, Paris, 1927.

Gautier, E. F., *Le passé de l'Afrique du Nord. Les siècles obscurs*, Paris, 1937.

Grabar, O., *The Formation of Islamic Art*, New Haven and London, 1973; reprinted 1988.

Hillenbrand, C., *The Crusades – Islamic perspectives*, Edinburgh, 1999.

Hillenbrand, R., *Islamic Architecture: Form, Function and Meaning*, Edinburgh, 1994.

Hitti, P. K., *History of the Arabs*, 10th edition, New York, 1970.

Hodgson, M. G. S., "The Venture of Islam", in *The Classical Age of Islam*, Vol. 1, Chicago, 1974.

Hourani, A., *A History of the Arab Peoples*, Cambridge, Mass, 1991.

Ibn 'Abd al-Hakam, *Conquête de l'Afrique du Nord et de l'Espagne*, Vol. II, Algeria, 1947.

Ibn Khaldun: (732–808/1331–1406), *Histoire des Berbères et des dynasties musulmanes de l'Afrique Septentrionale*, 4 vols, official edition Algeria 1867; 7 vols, Cairo 1984.

Idris, H. R., *L'Occident musulman (Ifriqiya et al-Andalus) à l'avènement des Abbasides, d'après le chroniqueur Ziride al-Raqiq*, REI, 39, 2, 1971.

Islamic Art: The David Collection, Copenhagen, 1990.

Jones, A. H. M., *The Later Roman Empire 284–602: A Social and Administrative Survey*, 3 vols, Oxford, 1964; reprinted 2 vols, Baltimore, 1986.

Kennedy, H., *The Prophet and the Age of the Caliphates: The Islamic Near East from the 6th to the 11th Century*, 2nd edition, London and New York, 2004.

Krautheimer, R., *The Christian Capitals: Topography and Politics*, Berkeley, 1983.

Lane-Poole, S., (original in English 1893) *Tabaqat Salatin al-Islam*, Baghdad, 1968.

Lehrmann, J., *Earthly Paradise: Garden and Courtyard in Islam*, London, 1980.

Levi-Provençal, E., *Histoire de l'Espagne musulmane*, 3 vols, Paris, Leyde, Brill, 1950–3.

Levi-Provençal, E., *Un nouveau récit de la conquête de l'Afrique du Nord par les Arabes*, 1954.

Long, D., *The Hajj Today: A Survey of the Contemporary Pilgrimage to Mekka*, New York, 1979.

Marcais,G., *L'architecture musulmane d'occident*, Paris, 1954.

Marçais G., *L'art musulman*, Paris, 1962.

Le Maroc Andalou, MWNF/Édisud-Eddif, Aix en Provence-Casablanca, 2000.

Mernissi, F:, *Sultanes oubliées, Femmes chefs d'Etat en Islam*, Paris, 1990.

Museum with no Frontiers, *The Umayyads: The Rise of Islamic Art* (Islamic Art in the Mediterranean, Jordan), Vienna, 2000.

Museum with no Frontiers, *Mamluk Art: The Splendour and Magic of the Sultans* (Islamic Art in the Mediterranean, Egypt), Vienna, 2001.

Museum with no Frontiers, *Early Ottoman Art: The Legacy of the Emirates*, (Islamic Art in the Mediterranean, Turkey), Vienna, 2002.

Museum with no Frontiers, *Siculo Norman Art: Islamic Culture in Medieval Sicily*, (Islamic Art in the Mediterranean, Italy), Vienna, 2004; *L'arte siculo normanna. La cultura islamica nella Sicilia medievale*, Palermo-Vienna, 2004.

Museum of Turkish and Islamic Art, Istanbul, 2002.

Nasr, S. H., *Sacred Art in Persian Culture*, Leiden, 1971.

Peters, F. E., *The Hajj: The Muslim Pilgrimage to Mecca and the Holy Places*, Princeton, 1994.

Qalqashandi, A., *Subh al-A'sha fi Sina'at al-'Insha*, Cairo, al-Matb'a al-Amiriya, part 3, 1913.

Rogers, J. M., "Innovation and Continuity in Islamic Urbanism" in I. Sarageldin and S. el-Sadek (eds.), *The Arab City: its Character and Islamic Cultural Heritage*, Medina, 1982.

Saïd S. A., *Ma'a Mu'jam al Usar al Hakima*, Cairo, 1972.

Saladin, H., "Manuel d'art musulman", *L'architecture*, Paris, 1907.

Salameh, K., *The Qur'an Manuscripts in the Haram al-Sharif Islamic Museum*, London, 2001.

Scerrato, U., *Arte islamica in Italia*, in F. Gabrielli, U. Scerrato, *Gli Arabi in Italia*, Milan, 1979.

Schimmel, A., *Calligraphy and Islamic Culture*, New York, 1984.

Stanley, T., *Palace and Mosque: Islamic Art from the Middle East*, London, 2004.

Taylor, R., *Ottoman Embroidery*, London, 1993.

Üçok, B., "Islam Devletlerinde Kadın Hükümdarlar", introduction by Ibrahim Daququi, "An Nisa al Hakimat fi Tarikh" Matbaat al-Saadoun, Bagdad, 1973.

Viguera Molins, M. J. (co-ord.), *Historia de España fundada por Menéndez Pidal*, Vol. VIII, Madrid, 2000.

Wolfram, H., *The Roman Empire and its Germanic Peoples*, Berkeley, 1997.

Zakkar, S., *Hittin: Masirat al-Tahrir min Dimashq ila al-Quds [Hittin: the Route to Liberation from Damascus to Jerusalem]*, Damascus, 1984.

Index

Note: Page references in *italics* indicate illustrations; those in **bold** type indicate end of chapter biographies. The prefix Al- is ignored in the alphabetical order.

Abbadids 129, 140
Abbasid art:
 figurative 54
 glass *68*, *220*
 music 222
 painting 65
 sculpture *63*
 stucco decoration *66*
 see also architecture; calligraphy; ceramics; textiles; wood carving
Abbasids 60–78
 and Byzantine Empire 63, 65, 66, 70, 78
 capitals 65–6, 67, 68, 74, 77–8
 and city planning 72–7
 and Fatimids 67, 72–4
 legacy 74–8
 and medicine 222
 overthrow by Mongols 67
 overthrow of Umayyads 50, 60–2
 and Seljuqs 67, 179
 in Syria and Egypt 68–70, 218
 and Umayyads of al-Andalus 84
 and water supply *162*
'Abd al-Malik (Sa'did) 137–8, 140
'Abd al-Malik ibn Marwan 40–2, **50**, 52
'Abd al-Mu'min, Caliph 104, 132, 155, **160**
'Abd al-Rahman al-Dakhil I 70, 84, **86**
'Abd al-Rahman III, Caliph 77, 84, **86**
'Abd al-Rahman ibn Rustam 70, 150, **160**
'Abd al-Wadids (Ziyanids) 155, *157*, 158
'Abda (Fatimid princess) 112
'Abdallah ('Ubaydallah) al-Mahdi 74, 106, 151
Abdülhamid (Abd al-Hamid II) 243–4
ablutions, ritual *86*, *164*, *256*
Abu 'l-'Abbas al-Saffah, Caliph 62
Abu Abdallah al-Shi'i 74, 106
Abu Bakr, Caliph 34, 36, 38
Abu Dulaf (Baghdad), mosque 78
Abu al-Fida 186
Abu al-Hasan, Sultan 135, **140**
Abu Inan 140
Abu al-'Izz Ismail al-Jazari 186
Abu al-Qasim *218*
Abu Qasim al-Zahrawi (surgeon) 223
Abu Qurra 150
Achir (Berber town) 152, 160
Acre, battle of (690/1291) 178, 194, 218
Aghlabid art *70*, *72*
Aghlabids 70, 71, 78
 city planning 76
 conquest of Sicily 71, 98, 104
 and Fatimids 72, 98, 106
 and Franks 72
 reservoirs *161*
Aghmat Aïlane, mosque 81
Ahmad al-Wattasi 122
Ahmad ibn Tulun 70, 76, **78**
Ahmad al-Mansur 138, **140**
Ahmed I, Sultan *240*
Ahmed III, Sultan 240
 see also Topkapı Palace
'A'isha (wife of Prophet Muhammad) 121, 124–5
 'A'isha al-Hurra 122, 126
Ajlun Castle *178*, 207

Alarcos, battle of (591/1195) 132
Alaric the Goth 25, 30
'Alawid art *140*, *141*, *164*
'Alawids 128, 138–40
albarello (pharmaceutical jar) *169*
Alentejo, Alandroal Castle 172
Aleppo:
 Atabeg control 179–80
 Citadel *178*, *181*, 189
 city walls 188
 Madrasat al-Firdaws *185*
Alexandria 208
Alfonso VI of Castile 129
algebra 67, 146, 148, 220
Algiers *see* al-Jaza'ir (Algiers)
'Ali Abu al-Hasan, Sultan 126
'Ali ibn Abi Talib, Caliph 36, 38, 62, 71, 86, *106*, *109*, 124–5
'Ali ibn Yusuf 131
almanacs, geographic 186
Almohad art *153*, *158*, *221*
 see also architecture; ceramics
Almohads 128, 131–4, 140, 155, 160
Almoravid art *58*, *146*, *155*
 see also architecture; wood carving
Almoravids 128, 153–5
 and Almohads 131–2
 and al-Andalus 86, 130–1, 140
 and women 122
Al-Alya, foundation 77
Al-Amir bi-Ahkam Allah, Caliph 113
Amman, Citadel *45*, 47
Amr ibn al-'As 160
Anatolian Seljuqs *see* Seljuqs of Rum
Al-Anbar (Abbasid capital) 63
Al-Andalus:
 and Almohads 132, 155
 and Almoravids 86, 130–1, 140
 and science 223
 Umayyad rule 70, 77, 80–6, 128, 130
Al-Andalus, art:
 architecture *79*
 ceramics *83*
 figurative *52*, 54
 ivory carving *52*, *82*, *84*
 metalwork *83*
 stonework *24*, *86*
 see also architecture; ceramics; metalwork
Ankara, battle of (804/1402) 229
Al-Aqsa Mosque (Jerusalem) *41*, 42, 50, 185
arabesque 19, *109*, *218*, 252
Arabic 42, 50
Arabs, and Abbasid dynasty 62
arcade motif *47*, 47
Arcadius, Eastern Emperor 25, 30
architecture:
 Abbasid *60*, *64*, 65–6, *67*, *71*, 77–9, *80*
 Aghlabid *59*, *74*, *122*
 'Alawid *138*, *139*
 Almohad *132*, *133*, *133*, 140, *146*, *167*, *173*
 Almoravid *130*, 131, *131*, *149*, *156*
 Al-Andalus *79*, *82*, *84*
 Atabeg *182*, *186*
 Ayyubid *178*, *180*, *182*, *184*, *185*, 188, *203*, *210*
 Byzantine *22*, *28*, *42*, 44
 Fatimid *102*, *105*, 106–9, *107*, *108*, *109*, *142*
 and figurative decoration 52–8, 146
 Frankish 179, *182*, *183*, *189*, 192
 Hammadid *153*, *154*
 horseshoe arches 174, 216

Hudid 129, *129*
Mamluk *178*, *180*, *182*, *192*, *193*, 194, *207*, *209*, 210, *211*, *212*, *214*, 216, *216*, 218
Marinid *134*, *157*, *224*
Mudéjar *167*, 168–70, *168*, *169*, *170*, *171*
Nasrid *127*, *135*
Norman 100, *103*
Ottoman *126*, *159*, *227*, 228–9, *230–3*, 235–7, *235*, *236*, 240–3, *243*, *244*, *254–6*
pre-Umayyad *34*
Sa'did *136*, *137*
Umayyad *39–41*, 42–4, *46*, 47–8, *47*, *80*, *173*
Western influences 241–3, 254–8
Zangid 178
Zirid *105*, *107*, *122*, 150, *151*
 see also brick
Arianism 26
Aristotle 86, 120
armour, Mamluk *204*, *205*
Artuqids 190
Asad ibn al-Furat 98, **104**
Al-'Askar, foundation 76
astrolabes *85*, 116, *130*, 186, *187*, 221
astrology 111
astronomy 111, 129, 220–1, 223, *243*
Atabeg art *188*, *189*
Atabegs 179–80, 186, 188–90
automatons 223
Averroes (Ibn Rushd) 86, **86**
Awraba tribes 81, 86
Aydın, Cihanoğlu Mosque 255
Ayla, city gate *34*
Ayyubid art:
 coinage 126
 figurative art 56–8
 jewellery *124*
 painting *180*, *190*
 pilgrimage proxy scroll *199*
 stone carving *177*
 see also architecture; ceramics; metalwork
Ayyubids 180–94
 army 122, 125, 183
 and *madrasas* 186, 188
 as patrons of the arts 188–90
 and science 185, 186, *187*
 and women 122, 125–6
Al-Aziz, Caliph *118*

Badis (Zirid prince) 122
Baghdad
 (Abbasid capital) 65, 67, 74, 77–8
 Bayt al-Hikma 66, 220
 Madinat al-Salam *64*, 65
 in miniature painting *62*
 Mongol conquest 67, 204
Baldwin of Boulogne 176
Banu 'Ali 68
Banu Hashim 60
Barbarian conquests 22, 25–6
Baroque, influence of 241, 242–3, 254, *254*
Barquq, al-Zahir, Sultan 207, **218**
Barsbay, al-Ashraf, Sultan 208
basins, stone *86*
baths, public *102*, 164
Bayazid, Amir *94*
Bayazid I (Yıldırım 'the Lightning Shaft') 229

Bayazid II 96, 232
Baybars al-Bunduqdari, al-Zahir, Sultan194, *194*, 207, **218**
Béjaia (Hammadid capital) 152, 153
 Bab al-Bunud *154*
bell towers 170, 218
Berbers 81, 86, 121
 in al-Andalus 82–4, 129, 155
 in Central Maghreb 81, 130, 150–1
 Kutama 72, 155
 see also Almoravids; Zirids
Bethlehem, Solomon's Pools *162*
beys and *beyliks* (provinces) 158
bimaristans (hospitals) 78, 186, *186*, 188, 216, 221–2
Al-Biruni (astronomer) 221
Biskra (Algeria), Sidi 'Uqba Mosque 81, *81*, 86, 150, *151*, 160
Boabdil (Abu Abdallah) 122, 126
books and manuscripts:
 Almohad *133*, *221*
 Mamluk *186*, *205*, *206*, *215*, *218*, *219*
 Ottoman *31*, *33*, *35*, *57*, *234*, *258*
 see also calligraphy; Qur'an
bottles *178*, *183*, *198*, *208*, *213*
brass *130*, *166*, 190
 Ayyubid *185*, *187*, *189*, *191*
 Mamluk *165*, *193*, *208–10*, *212*, *215*
 Umayyads of al-Andalus *85*
brazier, bronze *47*, *50*
brick architecture 168–9
bronze *47*, *50*, *93*, *135*, *152*, *194*
Bursa (Ottoman capital) 228
 cenotaph of Sultan Mehmet I *229*
Buyids, and Abbasids 67
Byzantine Empire 25–7
 and Abbasids 63, 65, 66, 70, 78
 and Christianity 26, 28
 economic crisis 28–30
 and Ottomans 228, 231
 Reconquest of the West 27–30
 and rise of Islam 34–5
 and Sicily 98
 see also architecture; mosaics

Cairo 66, 211–18
 Aqmar Mosque 109, *142*
 Al-Azhar Mosque *108*, 109
 Bab al-Futuh *107*, 108
 Baybars Mosque 218
 Citadel of Salah al-Din *203*
 city walls 188
 Eastern Palace (*al-Sharqi*) 108
 Ibn Tulun Mosque *71*, 78
 Muhammad Ali Pasha Mosque 243, *244*, *256*, 257
 and Ottomans 235–7
 Al-Qahira 76, 107–8
 Qalawun Madrasa 216, 218
 Sülayman Pasha Mosque 237
 Sultan Hasan Madrasa and Mosque *209*, *212*
 Sultan al-Mansur complex *192*, 194, *214*
 Sultan al-Nasir Muhammad ibn Qalawun Mosque *193*
 Sultan Qaytbay Madrasa and Mosque *211*, 218
 Sultan Qaytbay Sabil and Kuttab *216*
 Western Palace 108, 113
 see also Mamluk art; Mamluks
caliphate:
 hereditary 36, 39–40, 50

Rightly Guided Caliphs 34–6, 38
and Shi'ites 62
Umayyads of al-Andalus 84
and women 121
calligraphy 88–96
Abbasid *89*
Aghlabid *70*
Fatimid *109*
kufic script *72*, *76*, 88, *88*, 109, 113
Maghrebi script *90*, 91
Mamluk *87*, 91–2, *91*, *92*, *93*, *121*, *218*
muhaqqaq script 91
naskhi script 91, *92*, 218
Ottoman 92–6, *94–6*, *237*
and Qur'an *70*, *87*, 88, *89*, *90*, 91, *91*, *94*, 96, *109*, *123*
thuluth script 91, *91*, *92*, 218
by women *121*
Camel, Battle of the (36/658) 125
candlesticks *192*, *210*, *215*
*caravanserai*s 183, 185, 215, 238
carpets 19, 189, 217, 235, *235*
Carthage *23*, 25, 26, 27
Cefalà Diana (Sicily), Arab baths *102*
Cefalù (Sicily), cathedral 102
ceilings *103*, *110*, 174
Central Maghreb 150–60
and Almohads 132, 134
and Almoravids 140
and Berbers 81, 130, 150–1
and Kharijites 70
and Ottoman Turks 137
ceramics:
Abbasid *65*, *68*, *69*, *77*, *78*, *223*
Aghlabid *70*, *72*, *125*
'Alawid *140*, *141*
Almohad *132*, *164*
Atabeg *188*
Ayyubid *55*, *125*, *181*, *189*
Fatimid *54*, 116, *116*
Hammadid *152*
lustre-work *78*, 116, 169, *189*
Mamluk *198*, *217*
Mudéjar *51*, *168*, 169–70, *169*, *174*
Nasrid *226*
Ottoman *32*, *195*, *197*, *200*, *237*, *250*
Seljuq *189*
Umayyads of al-Andalus *83*, *84*
Zirid *152*
see also tiles
Charlemagne *62*, 66, 71–2
Chateau de Saone (Saladin's castle) 183
chess 111
Christianity:
Byzantine monuments 28
consolidation 26
Mudéjar art 168–74
and patronage of art 191–3
in Roman Empire 22–4, 30
churches, Mudéjar 170
clothing:
female *120*
male 114–15, 200
talismanic shirt *229*
coinage:
Aghlabid *70*
Almoravid *155*
Ayyubid *126*
Fatimid 116, *118*
Sa'did *136*
Umayyad 42, *42*, 50, 52–3, *80*
columns, capitals *47*, *49*, *63*, *148*, *154*
Companions of the Prophet 34–6
Constantine I, Emperor 22, **30**, *188*
Constantinople:
Ottoman attacks on 229, 231
status 22, 24–5, 30
Umayyad siege (99/717) 47
Constantinople, Council (381) 24, 26
copper:
Mamluk *92*, *192*
Marinid *134*, 135
Mudéjar 171–2, *172*
Ottoman *158*, *202*
Córdoba:
Great Mosque *79*, 84

Al-Zahira Palace 77, *86*
Crac des Chevaliers *175*, *177*
Crusader art, marble balustrade *191*
Crusaders 118, 176–9, 180, 186, 189
and Ayyubids 122, 125
fortifications 183
and Mamluks 178, 183, 193–4, 204, 218
as patrons of art 191–3
and Salah al-Din 182–3
culture, Islamic 19, 86
cupolas *135*, *149*, *168*

Damascus
and Abbasids 68
Atabeg control 179–80
Bimaristan Nur al-Din *186*, 194, 216
Citadel *188*
city walls 188
Darwishiyya Mosque *236*, 238
and European style 243
Great Mosque *28*, *41*, 43, 50, 182, 188, 194, 246–8
and learning 186
Madrasa al-Jaqmaqiyya *147*
Madrasa al-Zahiriyya *207*
and Mamluks 215
Qasr al-Azm 241
Takiyya al-Sülaymaniyya Mosque *236*, 237–8
and tile production 238
as Umayyad capital 36, 39, 46, 68, 86
Dayfah Khatun *185*
decoration:
figurative 46–7, *51*, 52–8, 96, 115, 146
geometric *141*, 142–8, *143*, *144*, *145*
Mudéjar 169
naturalistic *28*, 240–1, *243*, 246–53, 254–8
non-figurative 43
stucco 66
Dhu 'l-Nunids 129
Dias, Pedro 174
diplomacy *see* gift
Divriği, Sivas province (Turkey), Great Mosque and Hospital *247*
Diyar Bakr Citadel (Turkey) *188*
Dome of the Rock (Jerusalem) 42–3, 50, *192*
Church of the Holy Sepulchre *183*
exterior *39*
interior *24*, *40*, *190*
mosaics 43
pilgrimage to 185
plan *38*
Donatism 26

Edict of Milan (313) 22, 30
Edict of Thessalonica (380) 22, 30
Edirne (Ottoman capital) 229
as calligraphic centre 92
Eski Mosque *94*
Selimiye Mosque *227*, 235, *238*
Egypt:
and Abbasids 68–70, 78, 218
and Ayyubids 182
and Fatimids 56, 67, 107–18, 151
and Mamluks 204–18
and Ottomans 232
'Eid al-Adha 200, 202
'Eid al-Fitr 213–14
embroidery *76*, 113–15, *249*, 257, *258*
endowments (*waqf*) 163, 186, 214
engineering 186
hydraulic 98, 140, 223–4
Europe:
and consumption of Islamic art 19, 179, *235*
and Ottoman conquests 229, 231, 234, 238–46
Évora (Portugal) *173*

Al-Farabi 67
Fatima al-Hadinah *122*
Fatimid art:
coinage 116, *118*
geometric decoration 144

jewellery *112*, 113
metalwork 116
painting 56, 102
stonework 19, *53*
textiles 113–15, *113*
see also architecture; ceramics; ivories; wood carving
Fatimids 106–18
and Abbasids 67, 72–4
and Aghlabids 72, 98, 106
city planning 76
court life 110–15
defeat by Salah al-Din 118, 180–2, 186
as patrons of the arts 109–11, 113
in Sicily 98, 109
and women 111–13, 122
Fez (Idrisid capital) 71, 77, 84, 130, 151
'Alawid control 140
Andalusian Mosque 110
'Attarine *madrasa* 134, *134*
Buinaniya *madrasa* 135, *143*, *224*
Marinid capture 134
Nejjarine Funduq *164*
Qarawiyin Mosque 131, 138
and Sa'dids 137
Fez al-Jadid 77, 134
fountains 163–4, *164*, 217, *242*
spouts *53*, *83*, *153*
Franks *see* Crusaders
Frederick II 100
Al-Fudayn (Jordan), and Umayyad art 47
Fustat (Egypt) 66, 115–16

Galla Placidia Mausoleum, mosaic *25*
gardens 100, 111, 114, 164
and paradise 246–8
geography 186, *186*, *219*, 224–6
geomancy *185*, 186
geometry:
and architecture 168
and decoration *141*, 142–8
George of Antioch 102
Al-Ghuri, Ashraf Qansuh, Sultan 210–11
gifts, diplomatic 189–90, 214
glass 68, 115–16, 166, 189, *189*, 217
bottles *208*, *220*
enamelled *92*, *178*, *213*, *214*, *216*, *217*
mosaic 43, *207*
Godfrey of Bouillon 178
Grabar, Oleg 45–6
Granada 129
Alhambra 126, *127*, 135–6, *135*, 164
and Marinids 134
and Nasrids 135–7, *135*, 140

Hafiz Osman 96
Hafsids 122, 134, 155, *158*
hajj (pilgrimage) 183–5, 196–202
clothing 200, 202
milestone *199*
proxy scroll *199*
rituals 200–2
Al-Hakim bi Amrillah 111–12, 122
Hama (Syria), *noria* 162, *163*, *225*
Hamdullah, Sheikh 92–6
Hammad ibn Buluggin I **160**
Hammadid art *152*, *153*, *154*, *155*
Hammadids 152–3
hammams (public baths) *102*, 164, 228
hand-warmer *55*
Haram al-Sharif *33*, *184*, 185, *197*
Harem, Ottoman *126*, 241, 248, *248*
Harun al-Rashid 65, 70–1, **78**
and Charlemagne *62*, 66, 71–2
and music 222
Hasan ibn 'Ali 36, 71
Hasan al-Kalbi 98, **104**
Hashimids *see* Abbasids
Al-Hashimiya 63, 78
Hebron, Sanctuary of Abraham *191*
Hijra (migration) 33
Hilye-i Sherif 96, *258*
Hisham ibn 'Abd al-Malik **50**
Hittin, battle of (583/1187) 182
Honorius, Western Emperor 25, 30
Horseman of Raqqa *181*

horsemanship 111, *205*, 214
houses:
Byzantine 28
Mudéjar 170
Ottoman 241, 243
Hudids 129, *129*
Al-Humayma (Jordan) 48, *48*, *61*
hunting 45–6, 54, 111, 113, 214
Al-Hurra, Sayyida 122
Husayn, Imam 106
Husaynid art *251*

Ibaditism 160
Ibn al-Aghlab, Ibrahim 71, **78**
Ibn Hani (poet) 111
Ibn Jubayr 104, 183–4
Ibn Khaldun 121
Ibn al-Khatib 135, **140**
Ibn Muqla 91
Ibn Sina 67
Ibn Tulun, Ahmad 70, 76, **78**
Ibn Tumart 132, **140**, 155, 160
Ibn al-Zarqalluh 223
Ibrahim II 72
Ibrahim ibn al-Aghlab 71, **78**
iconoclasm *26*, 50
iconography, royal 45, 53–8
Idris ibn 'Abdallah (Idris I) 70–1, 77, 84, **86**, 151
Idris II 77
Al-Idrisi 226
Idrisids 71, 77, 84, 130
Ifriqiya:
and Abbasids 70–4, 78
and Almohads 155
and Berbers 150–1, 152
and Fatimids 106–18
Kharijite states 150–1
and Normans 132
and Ottoman Turks 137
and Umayyads 80–1
Ikhshidids 70
'Imad al-Din Zangi 180
imamate, and women 121
incense burners *55*, *191*, *193*, *194*, *212*
Iran 35, 47, 122
Iraq,
and Abbasids 50, 62, 65, 77–8
irrigation 43, 45, 50, 84, 98
Ishaq ibn Ibrahim al-Mawsili (composer) 222
Islam:
early history 32–6
and role of women 120–1
Islamic art:
and abstraction 50
and culture 19, 52
European consumption 19, 179, 235
Graeco-Roman influences 19, 46–8, 53, 250
Sassanian influences 46, 48, 53
Western influences 194, 240–3, 254–8
see also calligraphy
Isma'il, Mulay 138, *139*, 140, **140**
Istanbul (Ottoman capital) 231–2:
Aksaray Pertevniyal Valide Sultan Mosque 242
as artistic centre 234–5
Ayazma Mosque 241
Beylerbeyi Palace *256*
and calligraphy 92
Dolmabahçe Mosque 242
Dolmabahçe Palace 242, *254*
Fatih Complex 231, 235
fountain and sabil of Ahmad III *242*
Hagia Sophia 22
Ibrahim Pasha Palace *235*
Laleli Mosque 241
Nuruosmaniye Mosque 241, *254*, *255*
Nusretiye Mosque 242
Ortaköy Mosque 242, *243*
Sülaymaniye Complex *233*, 235
see also Topkapı Palace
ivories:
Fatimid *55*, *104*, *110*, *111*, 116, *118*
Mamluk *92*, *121*, *211*

Norman *104*
Umayyad 48, *48, 52*, 54
Umayyads of al-Andalus *82*
Iznik:
 and tile production 228, 235, 238
 Yeşil (Green)Mosque *228*
 'Izz al-Din Aybak 206

Al-Janna (paradise) 246–8
Jaqmaq, Sultan *206*, 208
Jawhar al-Siqilli (Fatimid general) 76, 107
Al-Jaza'ir (Algiers) 152, 158, 160
 Dar 'Aziza Bint al-Bay *159*
 Great Mosque 131, 155, *156*
 Jami' al-Jadid 158–60
Jerusalem:
 Anastasis church 42
 Al-Aqsa Mosque *41*, 42, 50, 185, 192
 Ascension church 42
 Haram al-Sharif *33*, *184*, 185, *197*
 and Mamluks 215
 Monastery of Mar Ya'qub 191
 mosaic representation *21*
 pilgrimage to 200, 202
 status 24
 see also Dome of the Rock
Jerusalem, Crusader Kingdom 176–8, 182
jewellery *112*, 113, *124*, *153*
jihad (holy war) 178
Jordan *see* Al-Fudayn; Al-Humayma;
 Madaba; Al-Qastal; Umm al-Rasas
Judaism, in late Roman Empire 27
Julian the Apostate 22, **30**
Justinian, Emperor 22, 27

Ka'ba (Mecca) 33, *195*, 196–8, 200
 key *196*
 kiswa (cover) *198*, 213
Kairouan:
 and calligraphy 88–91
 foundation 80, 160
 Great Mosque 72, *73*, 78, *80*
Kalbids, in Sicily 98, 104
Karahisari, Ahmed *96*, *237*
Karak Castle *180*, 184
Karlowitz (Karlofça), Treaty (1094/1683)
 240
Kastron Mefaa (Umm al-Rasas), floor
 mosaic *26*
Khalil, al-Ashraf 194
Khan al-'Arus *184*
khans *184*, 185, 215, 228
Kharijite movement 36, 70, 150–1, 155
Khirbat al-Mafjar 44, 45, 48, 50
 mosaics *42*, 46
Al-Khwarizmi 67, 146, **148**, 220
Kilitbatir Fortress *230*
Al-Kindi 66–7
knowledge, transmission 186–7
Köckert, Julius *62*
kohl container *121*
Kosovo, battle of (851/1448) 229
Kufa (Iraq), Great Mosque 62
Kusayla (Berber chief) 81, **86**

Al-Ladi (poet) 111
lamps:
 mosque *92*, *216*, *217*, *237*, *250*
 secular *47*
Las Navas de Tolosa, battle of (612/1212)
 133
Lisbon, Mouraria Mosque 171
Louis IX of France 122, 125
Lu'lu', Badr al-Din 190
lunch box *208*

Madaba (Jordan), mosaics *26*, *27*
Madinat al-Zahra 77, *84*, 86
madrasas 186–7, 188, 216, 223, 228
Maghreb:
 and al-Andalus 128–30, 136
 and Byzantine Empire 28
 and Marinids 134, 136, 140
 and Ottomans 158, 257
 Spanish incursions 158
 see also Almohads; Almoravids;

Central Maghreb; Fatimids; Idrisids;
 Zirids
Mahdiya 76, 106
 Great Mosque *105*, *107*, 109
Mahmud II, Sultan 242
Maimonides (Moshe ibn Maimun) 86, *86*
Ma'in, mosaic panel *26*
Maione of Bari 102
Majlis al-Lahu 46
Malaga (*ta'ifa* kingdom) 129
Al-Malik al-Salih, Sultan 122, 125
Malikism 155
Mamluk art:
 ceramics *198*, 217
 figurative 58
 geometric decoration 144, *144*, *147*, *148*
 glass *178*, *208*, *213*, 217
 stone carving *194*
 see also architecture; books and
 manuscripts; calligraphy; ivories;
 metalwork; wood carving
Mamluks 204–18
 army 204–5
 Bahri 206–7
 Burji 207–8, 218
 and Crusaders 178, 183, 193–4, 204,
 218
 hierarchy 211–13
 and Ottoman Turks 211, 232
 as patrons of the arts 91, 216–18
 see also Cairo
Al-Ma'mun, Caliph 62, 66, 68, 148, 220
Al-Mansur, Abd Allah Abu Ja'afar,
 Caliph 63–5, 70, *78*, 104
Al-Mansur ibn Abi Amir 77
Manuel I of Portugal 174, **174**
Manzikert, battle of (463/1071) 179
maps *225*, 226
Maredolce (Sicily), Castello della Favara
 102
Marinid art *90*, *134*, *135*, *143*, 144
 see also architecture
Marinids 77, 128, 134, 136, 140, 155
Marrakesh:
 'Alawid capture 140
 Almohad capture 132, 155
 as Almoravid capital 86, 153
 Badi Palace 138, *146*, *148*
 foundation 130, 140
 Ibn Yusuf *madrasa* *137*, 138, *251*
 Koubba *130*, 131
 Kutubiya Mosque *130*, *132*, 140, *146*
Marwan ibn al-Hakam 40
mathematics 67, 129, 146; *see also*
 algebra; geometry
Mausoleum of Galla Placidia, mosaic *25*
mausoleums, Fatimid 109–10
Mecca:
 depiction *33*
 and origins of Islam 32–3
 topographical view *196*
 see also hajj; Ka'ba
medallion, Almohad/Hafsid *158*
medicine 186, 220, 221–2
 instruments 116, 222
 prescriptions *215*, *222*
 treatises 67, *133*, *218*, *221*
Medina:
 depiction *33*
 Mosque of Prophet Muhammad *32*, 33,
 42, 50
 and origins of Islam 32–3
Mehmed I (Çelebi Mehmed) 229
Mehmed II (the Conqueror, al-Fatih) 92,
 229–31, *230*
Mehmed Resad 244
Mehmed VI Vahdeddin (Wahid al-Din)
 244
Meknès 140
 Bab Mansur *138*, 140
 Mulay Isma'il Mausoleum *139*
Merida, Citadel *82*
Mértola (Portugal), mosque *167*, *173*
metalwork 164–6, *166*, 188–90, *190*
 Al-Andalus *83*, 84
 Atabeg *189*

Ayyubid *189*, *191*, *194*
Fatimid 116
Mamluk *92*, *165*, *192*, *193*, *196*, *204*,
 205, 208–10, *212*, *215*, 217–18, *250*
 see also brass; bronze; copper
mihrabs:
 Abbasid 73, *78*
 Aghlabid *122*
 Fatimid *107*, *112*, 113
 Mamluk *212*
 Ottoman 255, *257*
 Umayyad *73*, *78*
 Ziyanid 158
minarets 109
 Abbasid spiral 66, *67*, *78*
 Hammadis 152, *153*
 Mamluk 216–18
 Mudéjar *133*, *146*
 Ottoman 228, 238
minbar (pulpit) 33, 81
 Aghlabid 72, *78*
 Almoravid *130*, *146*, 155, *156*
 Fatimid *108*, 110
 Mamluk *213*
 Umayyads of al-Andalus *108*
Mongol invasion 67, 186, 204, 207, 218,
 250
Morocco:
 and 'Alawids 128, 138–40
 and Almohads 131–2, 155
 Almoravid rule 122, 128, 130–2, 140
 and al-Andalus 84, 86, 134
 and Marinids 134–5
 and Sa'dids 137–8
 water supply 163
 see also Fez; Marrakesh
mosaics:
 Byzantine *21*, *25*, *27*, *28*, *29*
 glass 43, *207*
 non-figurative 43
 Norman *97*, *100–1*
 Umayyad *26*, *27*, *28*, *29*, *42*, *43*, *45*,
 46, *245*, 246–8
mosques:
 Abbasid 66, *67*, *78*
 basilical 158–60
 Fatimid 109–10
 hypostyle 42–3
 Ottoman 228, 236–8
 Umayyad *28*, *32*, *33*, *41*, 42, 43, 50,
 81, *81*, *245*
 Umayyads of al-Andalus 79, 84
Mu'awiya ibn Abi Sufyan 36, 38–40, **50**,
 80, *86*
Mudéjar art 168–74
 processional cross 171–2, *172*
 see also architecture; ceramics
Muhallabids 71
Muhammad (Prophet):
 biography *31*
 and figurative art 57, 58
 footprints *32*, *35*
 genealogy *49*
 and origins of Islam 32–3, 198
 successors 34–6
 sword 36
Muhammad V, Sultan *127*, 135, 140
Muhammad Ali Pasha 243
Muhammad ibn Yusuf ibn Nasr 135, **140**
Al-Mu'izz li-Din Allah, Caliph *107*, 111
muqarnas 144–6
 Almohad *132*
 Mamluk *147*, *148*, 217
 Marinid 135
 Norman 99
Al-Muqtadi, Caliph 122
Al-Muqtadir 129
Al-Muqtafi, Caliph 72
Murad I 229
Murad II 229
Murad III 235
Musa ibn Nosayr 81–2, *86*
Mushatta Palace (Jordan) *46*, *47*, 47–8,
 56
music 54, 56, 111, 222, *223*
Al-Musta'in, Caliph 72

Al-Mustasim, Caliph 125
Al-Mu'tadhid, Caliph 74
Al-Mutamid of Seville 129, **140**
Al-Mu'tasim, Caliph 65–6, *68*, 70, **78**
Al-Mutawakkil, Caliph 66, 68
Al-Mutawakkil, Muhammad (Sa'did) 137
Al-Muwaqqar palace *47*, *49*, 50

Najm al-Din Ayyub 206
Al-Nasir (Hammadid ruler) 153
Al-Nasir Muhammad 194
Nasrid art 19, 144, *145*, *226*
Nasrids 122, 128, 135–7, *135*, 140
navigation 224–6
Nedroma (Algeria), Great Mosque 131,
 155
Nicea, Council (325) 26
Nilometer 78, *162*, *162*
noria *162*, *163*, 223–4, *225*
Norman art *99*, *100*, *103*, *110*;
 see also architecture; mosaics
Normans:
 in Ifriqiya 132
 in Sicily 99–100
North Africa:
 and Donatism 26
 and Fatimids 106–18, 151
 Umayyad conquest 80
 see also Carthage; Ifriqiya; Maghreb
Nur al-Din Mahmud bin Zangi 180,
 182, 183, 186, 188

oliphants *100*, *104*
Orhan Bey 228
Osman ('Uthman) Ghazi Bey 228
Ottoman art:
 European influences 241–3, 254–7
 figurative 58
 paintings *196*, 255–7
 printing block *202*
 Siyar-i Nebi *31*
 tile panels *32*, *195*, *200*
 tiles 228, *229*, 238
 tomb covers *94*, *201*
 tray *158*
 see also books and manuscripts;
 calligraphy; ceramics; stonework;
 textiles
Ottomans 228–44
 decline of Empire 243–4
 in Europe 229, 231, 234, 238–40
 extent of Empire 229–32, 235
 and Mamluks 211, 232
 in North Africa 137, 158
 reforms 241–3
 Tulip period 240–1, 250, 254

paganism 22–4, *30*, 32
painting:
 floor paintings *27*, 48, *49*
 frescoes *37*, *44*, 46, *49*, *52*, *190*, *223*
 gouache on paper *180*
 miniatures *62*
 murals *119*, 255–7, *255*
 wooden panels *65*, *103*, *110*
palaces:
 Norman 100–2
 Umayyad 44–5
Palermo (Aghlabid capital) 98
 Cappella Palatina 102, *103*, *110*
 Cuba 102, *103*, 152
 Piccola Cuba *103*
 qanat 98, 99
 Royal Palace *97*, 100, *100*, *101*
 Uscibene 102
 Zisa *99*, 102
paradise:
 and arcade motif 47
 and gardens 246–8
Pedro I 'the Cruel' of Castile 170, **174**
pen box *209*
pilgrim bottles *178*, *183*, *198*
pilgrimage:
 Christian 184
 Muslim *see hajj*
plasterwork, carved 151, *151*, *247*

poetry, Fatimid 110–11
polo *208*
Portugal:
 and Almohads 132, *167*
 and Almoravids 131
 and Morocco 137
 and Mudéjar art 170–4
 prayer books, illuminated *33*, *35*
 privateering 140, 158–60
 processional cross, Mudéjar 171–2, *172*

Al-Qahira *see* Cairo
Qalaat al-Jabal 76
Al-Qal'at Bani Hammad 152–3, *153*, 160
Qal'at Salah al-Din *181*
Qal'at Shmemis *182*
Qalawun, al-Mansur *192*, 194, *203*, 207, 216, **218**
 qanat (canals) *98*, 99, 162, 164, 224
Qasr al-Hayr al-Gharbi *27*, 44, 45, 48, *49*, 50
Qasr al-Hayr al-Sharqi 44, 50
Qasr al-Mushatta *see* Mushatta Palace
Al-Qastal (Jordan) *29*, *43*, *45*, 46, 50
Al-Qata'i' 76, 78
Qaysi tribes 40, 60
Qaytbay, Sultan *92*, 208, **218**
qibla (direction of prayer) 33, *197*, 198, 202
Qur'an:
 Blue Qur'an *109*
 and calligraphy *70*, *87*, 88, *89*, *90*, 91, *91*, *94*, 96, *121*, *123*
 decoration *206*, *258*
 and figurative art 52
 and geometric decoration *144*
 and importance of water 162
 and 'Uthman *35*, 36
Qur'an box *93*
Quraysh tribe 38, 60, 198
Qusayr 'Amra *37*, *44*, 45–6, 47, *52*, *223*
Qutuz, Sayf al-Din 206–7

Rabat:
 Chellah Necropolis 134, 140
 Hassan Mosque 140
Al-Rafiqa *see* al-Raqqa
Al-Raqqa (al-Rafiqa) *64*, 65, 66, 70, 78
 ceramics 188, *189*
 column capital *63*
 goblet *68*
Raqqada 76, 78, 106
Ravenna, mosaics *25*, *29*
Al-Razi (Rhazes) 67, 221
reservoirs, Aghlabid *161*
Ribat al-Fath 133
Rio Salado, battle of (741/1340) 135
Robert Guiscard 99, **104**
rock crystal, carved 19, 115, *117*
Roger de Hauteville 99–100, **104**
Roger II of Sicily 100, 102, **104**
Roger III of Sicily 226
Roman Empire:
 and Barbarian conquests 22, 25–6
 and Christianity 22–4, 30
 dual capitals 24–5
 Eastern *see* Byzantine Empire
Rome, sack (410) 25, 30
roses 250
Ruqayya, Sayyida, shrine *109*, *112*, 113
Rusafa palace (Syria) 50, 70
Rustamid art *150*, 151, *151*, *247*
Rustamids 150–1

sabil 163–4, 217, 237, *242*
Sabra al-Mansuriya 76, 78
Sa'did art *136*, 138, *148*, *251*
Sa'dids 128, 137–8, 140
Safawids 232
Al-Saffah, Abu 'l-'Abbas 62–3
Saladin's Castle (Chateau de Saone) 183
Salah al-Din Ayyub (Saladin) 76, 86, *184*
 army 183
 and the arts 188
 conquest of Fatimids 118, 180–2, 186
 and Crusaders 182–3

and *madrasas* 186
Samarra (Abbasid capital) 65–6, 68, 74, 78
 geometric decoration 142
 Great Mosque 66, *67*, 78
 stucco decoration *66*
Al-Sanhajiya, Sayyida 122
Sassanian Empire 34, 35, 38, 46
science 220–6
 and Abbasids 66–7
 and Ayyubids *185*, 186, *187*
 and Fatimids 111, 116
 and Umayyads of al-Andalus *85*
 see also astrolabes
sculpture *see* stonework and sculpture
Sebastian I of Portugal 137–8
Sedrata 151, *151*
Selim I 'the Grim', Sultan 232
Selim II, Sultan 235
Selim III, Sultan 242
Seljuqs of Rum (Anatolian Seljuqs)
 and Abbasids 67, 179
 ceramics *189*
 figurative art *56*, 58, *179*
 and *madrasas* 186
Seville (*ta'ifa* kingdom) 129, 140
 Citadel 170
 Giralda Tower *133*, 140, *146*, 152
 Palace of Pedro I 170
Shajar al-Durr 122, 125–6, 206
Sharwa al-Hakkari, tombstone *177*
Shawbak Castle *182*, 184
Shayzar Castle 192
Shi'ites 36, 106, 109, 125, 151, 155
 and Abbasids 62–3
 see also Buyids; Fatimids
shipbuilding 226
Sicily 98–104
 Aghlabid conquest 71, 98, 104
 and Byzantine Empire 98
 and Fatimid architecture 109
 Norman conquest 99–100
Siffin, battle of (37/657) 36
sikaya (fountains) 163–4, *164*
silks:
 Fatimid 114–15
 Nasrid 19, *145*
 Ottoman *94*, *120*, *201*
 Umayyads of al-Andalus 84
Sinan (architect) *232*, 235, 238, *238*
Sitt al-Mulk 112–13, 122
Sitt al-Nisa 122
Siyar-i Nebi (Biography of the Prophet) *31*
Soma (Turkey), Hızır Bey Mosque 255–7, *255*
Sousse (Tunisia) 80
 ribat *59*, *74*
Spain:
 and Maghreb 128–30, 136, 158
 and Mudéjar art 168–70
 Reconquista 130, 134, 135, 186, *226*
 Vandal conquest (439) 25
 see also al-Andalus; *ta'ifa* kingdoms
sprinkler, Mamluk *214*
stonework and sculpture:
 Abbasid *63*
 Fatimid *53*
 Hammadid *153*, *154*, *155*
 Mamluk *194*
 Ottoman *160*, *247*
 Seljuqs of Rum *56*, *179*
 Umayyad *47*, 48, 53, *53*, *56*, *81*, *199*, *252*
 Umayyads of al-Andalus 24, *86*
 stucco decoration *66*
Sülayman Pasha al-Khadim 237
Sülayman I 'the Magnificent' 234–5, 237
Sunni Islam 179, 186, 232
suqs 185, 215
swords *177*, *205*
Syria:
 and Abbasids 68–70
 and Ayyubids 182–3, 188–90
 and Crusades 176–9, 183
 and Fatimids 67
 and learning 186–7

and Mamluks 207
 Monastery of Musa al-Habashi 191
 and Umayyads 38–40, 44–6, 62
 see also Aleppo; Crac des Chevaliers; Damascus

Tahert (Kharijite state) 70, 150, 160
ta'ifa kingdoms, Spain 86, 128–9, 135–6
Tanzimat Ferman (Ottoman reform movement) 242–3
Tariq ibn Ziyad 82, **86**
Tavira Vase *58*
Templar Knights *177*, 192
tent, Ottoman *239*
Teruel (Spain), cathedral of Santa Maria *169*, 170
Tétouan, Lebbadi Palace 141
textiles:
 Abbasid *75*, *76*, *78*
 dar al-tiraz 102, 113–15
 Fatimid 113–15, *113*, *114*, *115*
 Mamluk 217
 Nasrid 19, *145*
 Norman 102
 Ottoman *94*, *143*, *198*, *201*, *229*, *239*, *249*, *257*
 see also carpets; embroidery; silks
Al-Tha'alibi 43
Theodora, Empress *29*
Theodosius the Great 25, **30**
Three Kings, Battle of (986/1578) 137–8
throne, Ottoman *240*
tiles:
 Ottoman *228*, *229*, 238
 tile panels *32*, *141*, *143*, *148*, *174*, *195*, *200*, *251*
Timur 207, 229
tiraz (embroidered band) 102, 113–15
Tlemcen:
 and Abd al-Walids 158
 Great Mosque 131, *131*, *149*, 155, *156*
 Al-Mahala al-Mansura *157*
 Sidi al-Halloui Mausoleum 158
 Sidi Bel-Hasan Mosque *157*, 158
 Sidi Boumediene Mausoleum 158
Toledo (*ta'ifa* kingdom) 129, *130*
tomb cover, Ottoman *94*
Topkapı Palace (Istanbul) *230*, 231
 Fruit Room 240, *241*, 248, *248*
 Gate of Felicity *231*
 Harem 126
 Pavilion of the Holy Mantle and the Holy Relics *35*, *36*, *232*
toy, Abbasid *76*
trade:
 and Crusades 179, 182, 183–5
 and Mamluks 208, 211, 214–15
 and Ottomans 238
 and Sa'dids 138
trays *158*, *208*
trees, depiction 248
triptych *258*, *258*
Tughrul Beg, Sultan 67
tulips 250
Tulunid art *68*
Tulunids 70, 144
Tumartism 155
Tunis, Zaytuna (Great) Mosque 72, 81;
 see also Carthage
Turan Shah 206
turbes (mausoleums) 228
Yeşil Türbe (Green) *229*
Türkan Khatun 122

'Ubaydallah *see* 'Abdallah al-Mahdi
Umar ibn al-Khattab, Caliph 34–5, 36, 38
Umayyad art:
 bronzes *50*
 figurative 53–4
 floor painting 27
 frescoes *37*, *44*, 46, *49*, *52*, *223*
 geometric decoration 142–4
 ivories 48, *48*, 54
 murals *119*
 non-figurative 43, 52–3
 see also architecture; coinage;

Dome of the Rock; mosaics; mosques; stonework
Umayyad dynasty 38–60
 Abbasid overthrow 50, 60–2
 court life 44–7, 53–4
 Damascus as capital 36, 39, 46, 68, 86
 extent of Empire 44, 62, 80
 genealogy *49*
 and water supply 164
 see also al-Andalus
Umm al-Rasas, floor mosaic *26*
'Umra 200, 202
universities, Muslim 86, 109
'Uqba ibn Nafi' Qays Qurayshi 80–1, **86**, 150, *151*, **160**
Urban II, Pope 100, 176
Usama ibn Mundiqh (writer) 192
'Uthman ibn 'Affan, Caliph 35–6, 86

Vandals 25, 26, 27
Varna, battle of (847/1444) 229
Vascos (al-Andalus), remains 82
vase motif 257–8, *257*
Vienna, sieges 234, 238, 254

Al-Walid ibn 'Abd al-Malik 42–4, **50**
water 161, 162–6, 214, 223–4, 246
 baths *102*, 164
 canals *98*, 99, 162, 164
 drinking vessels 164–6, *166*, *178*, *183*
 reservoirs *160*
 and ritual ablutions 86, 164, *256*
 sikaya (fountains) 163–4, *164*
 see also sabil
Al-Wathiq, Caliph 68
Wattasid *90*
Wattasids 136–7
weights *80*, 118
William I of Sicily 102, **104**
William II of Sicily 102, 104, **104**
women:
 as calligraphers *121*
 clothing *120*
 in Fatimid era 111–13, 122
 and power 120–6
wood carving:
 Abbasid *65*, *76*, *246*
 Aghlabid 72
 Almoravid *130*, 155, *156*
 Ayyubid 188
 Fatimid *108*, *111*, *112*, 113, 116, *246*
 Mamluk *213*
 Umayyads of al-Andalus *108*
 Zirid 150
wooden toys *76*

Yakut al-Mustasimi (calligrapher) 91
Ya'qub al-Mansur 132, **140**
Yazid ibn Mu'awiya 39, 50
Yazid II ibn 'Abd al-Malik **50**
Yemeni tribes 40, 50, 60
Yusuf I, Nasrid Sultan 135, 136, 140, **140**
Yusuf Buluggin I, Amir 110
Yusuf ibn 'Abd al-Rahman al-Fihri 86
Yusuf ibn Tashufin I 122, 130, **140**

Al-Zahira Palace 77, *86*
Zangid art *189*
Zangids, and *madrasas* 186
Zaragoza, Aljafería Palace 129, *129*
Zaynab bint Ahmad Maqdisiyya *121*
Zaynab al-Nafzawiya 122
zellij (tile panels) *32*, *141*, *143*, *148*, *164*, *195*
ziggurats 78
Zirid art 150, *152*
 see also architecture
Zirids 100, 108, 129, 151, 152
Ziryad (composer) 222
Ziyadat Allah I 104
Ziyadat Allah III 72, *72*
Ziyanids ('Abd al-Wadids) 155, *157*, 158

Index compiled by Meg Davies (Fellow of the Society of Indexers)

About the Authors

Mohamed ABBAS M. SELIM (Cairo, Egypt) is the General Director of the Museum of Islamic Art and the Museum of Egyptian Textiles (in preparation), Cairo. He graduated from the Faculty of Archaeology, Cairo University in 1974 and holds a Master's degree from the same faculty (1995). Co-author of the first catalogue of the Abegg Foundation (on textiles) and of the catalogue *Treasures of Islamic Art from Cairo Museums* published by the American University in Cairo, he has also contributed many articles to specialised periodicals and journals in Arabic and English.

Muhammad AL-ASAD (Amman, Jordan) is an architect and architectural historian, and Director of the Centre for the Study of the Built Environment in Amman. He studied architecture at the University of Illinois at Urbana-Champaign and the history of architecture at Harvard University. He held post-doctoral research positions at Harvard University and the Institute for Advanced Study, Princeton. He taught at the University of Jordan, Princeton University and the Massachusetts Institute of Technology, among others. He has published on the architecture of the Islamic world in books and academic and professional journals.

Şule AKSOY (Istanbul, Turkey) is an art historian and Vice Director of the Museum of Turkish and Islamic Arts in Istanbul. She graduated from the Department of History and Art History of the Faculty of Letters, Istanbul University in 1970. She has been working at the Museum of Turkish and Islamic Arts in Istanbul since 1967, first as an expert then as the Head of the Manuscripts Department, until 2003, when she became Vice Director. She has participated in numerous projects and exhibitions organised by the museum and is the author of various publications.

Noorah AL-GAILANI (Glasgow, United Kingdom) is Curator for Islamic Civilisations at Glasgow Museums, Scotland, UK. She has a degree in interior design from Baghdad University, a degree in museum studies from the Institute of Archaeology, University College London, and has been working in the heritage sector since 1989.

Nazmi AL-JUBEH (Jerusalem) is an archaeologist and historian and Co-Director of RIWAQ, Centre for Architectural Conservation in Ramallah, Palestine. He studied at Birzeit University in Palestine and at Tübingen University in Germany. He taught at Birzeit University and at al-Quds University. He was Director of the Islamic Museum, al-Haram al-Sharif, Jerusalem, and directed various cultural heritage projects in Palestine, including surveys of archaeological and architectural sites. He was a major contributor to *Pilgrimage, Sciences and Sufism: Islamic Art in the West Bank and Gaza* (Vienna: MWNF, 2004) and other publications.

Ulrike AL-KHAMIS (Edinburgh, United Kingdom) is Principal Curator for the Middle East and South Asia at the National Museums Scotland, Edinburgh. Based there since 1999, she began her academic career in Germany before obtaining a BA (1st class Hons) in Islamic art and archaeology at the School of Oriental and African Studies in London in 1987. In 1994 she completed her PhD thesis at the University of Edinburgh. From 1994 to 1999 she was Curator of Muslim Art and Culture for Glasgow Museums and, in 1997, helped to create the first ever Scottish Festival of Muslim Art and Culture, SALAAM.

Gaspar ARANDA (Madrid, Spain) has a degree in art history and a *Mastère* degree in museum studies and is a member of the research team at the Antonio Fernández-Puertas Chair of Muslim Art at the University of Granada. He has worked with the Department of Medieval Antiquities at the National Archaeological Museum in Madrid and some of his work on Nasrid art has been published.

Aïcha BENABED (Tunis, Tunisia) is head of research at the Tunisian National Heritage Institute and the archaeologist in charge of a number of ancient sites in Tunisia. She has overseen several international exhibitions of Tunisian heritage, and has had numerous books and articles on Antiquity published, in particular on mosaics, domestic architecture, funerary architecture and Christian architecture.

Farida BENOUIS (Algiers, Algeria) has a degree in history from the University of Algiers and taught history and geography at the Descartes school in Algiers. She has had a number of textbooks published and is currently the General Secretary of the Association for the Preservation and Protection of the Architectural Heritage of Algeria.

Jamila BINOUS (Tunis, Tunisia) is a planner with degrees in history and geography from the Universities of Tunis and Tours. She was first a researcher and then Director of the Association for the Preservation of the Tunis Medina. She has taken part in many international congresses and has written a number of articles and books on the monuments of the Tunis Medina.

Ghazi BISHEH (Amman, Jordan) was Director General of the Jordanian Department of Antiquities 1988–91 and 1995–9. He studied archaeology at the University of Jordan, and history of Islamic art and architecture at the University of Michigan, Ann Arbor, from where he holds his PhD. He was affiliated with the Jordanian Department of Antiquities for most of the period between 1980 and 1999. He was also an associate professor of archaeology at Yarmouk University during the early 1990s. Author of numerous publications, he has carried out excavation work in Jordan and elsewhere. He is the Deputy Director of the International Council of Museums for the Arab countries.

Gonzalo M. BORRÁS GUALIS (Zaragoza, Spain) is Professor of Art History at the University of Zaragoza and Director of the Institute of Islamic and Near-Eastern Studies at the Aljafería, Zaragoza. His principal area of research is Mudéjar art and he has co-ordinated research programmes for UNESCO and MWNF in this field.

Sheila CANBY (London, United Kingdom) is an art historian and curator in charge of Islamic art and antiquities at The British Museum. She received her MA and PhD from Harvard University. After working at several American museums, she joined The British Museum in 1991. She has organised exhibitions of Islamic art and has written and edited a variety of books while at The British Museum. In 2005–6 she taught at the School of Oriental and African Studies, University of London.

Mounira CHAPOUTOT-REMADI (Tunis, Tunisia) is a university teacher and professor, Doctor of Philosophy, specialist in medieval history in the Near East during the Mamluk period, lecturer at the University of Tunis, and Director of the *Revue des Cahiers de Tunisie*. She has published several studies on the Near East during the Mamluk period and on the Maghreb in the later centuries of the Middle Ages.

Verena DAIBER (Berlin, Germany/Damascus, Syria) is a PhD candidate in Islamic art and archaeology (Bamberg University). Based at the German Archaeological Institute (DAI) in Damascus since 2002, she is working on her PhD thesis on the building history of Ottoman Damascus. She studied archaeology and Arabic literature in Berlin, obtaining her MA with a thesis on medieval ceramics from Aleppo. Among her publications are a study on medieval ceramics from Baalbek and two volumes on the Raqqa excavations. An experienced translator (German–Arabic) she organised the editorial co-ordination of the translation of DAI and MWNF publications into Arabic.

Naima ELKHATIB-BOUJIBAR (Casablanca, Morocco) is an archaeologist, art historian and member of international scientific institutions. She has studied at the Sorbonne, the École du Louvre and the Institute of Ethnography at Neuchatel. She has held a number of positions of responsibility in the Moroccan cultural heritage sector, taught at the National Institute of Archaeological Sciences and Heritage (INSAP) and directed an archaeological dig. She has participated in various conferences, organised exhibitions and published articles and a monograph on archaeological and artistic heritage.

Claus-Peter HAASE (Berlin, Germany) is Director of the Museum of Islamic Art at the State Museums Berlin. He has published on early Islamic art and culture, Timurid architecture of

Central Asia, Ottoman classical art, and calligraphy, and is preparing an Arabic, Persian and Ottoman manuscript catalogue. He is honorary professor at the Free University of Berlin, and Director of Excavations in the early Islamic site Madinat al-Far/Hisn Maslama in Syria.

Mehmet KAHYAOĞLU (Brussels, Belgium) received his BA and MA from the Art History department at Ege University, Faculty of Letters (Izmir, Turkey). He has lectured on art history, iconography and mythology in the Fine Arts Faculty of Dokuz Eylül University, Izmir. He is currently studying for his PhD at Ege University focusing on the harbour towns of Western Anatolia during the 12th and 13th centuries.

Jens KRÖGER (Berlin, Germany) graduated in Art History and Ancient Near Eastern Archaeology at the Free University of Berlin. He is curator at the Museum of Islamic Art at the State Museums in Berlin and has participated in numerous exhibitions and published on the subject of pre-Islamic and Islamic art.

İnci KUYULU ERSOY (Izmir, Turkey) graduated in Art History and received both her MA and her PhD from Ankara University, Faculty of Letters. She works as a professor and is the head of both the Western and Contemporary Arts Branch of the Art History Department and the History of Turkish Art Department, Institute of Turkish World Studies, Ege University, Turkey. She has published various research and works on Turkish-Islamic art and architecture.

Kamal LAKHDAR (Rabat, Morocco) is a linguist and sociologist and has undertaken independent historical studies focused on the history of the Almohad dynasty and the city of Rabat. A diplomatic adviser with links to several ministers, he has also developed his talents as a journalist and painter. He co-authored the MWNF publication *Andalusian Morocco*.

Santiago MACIAS (Mertola, Portugal) holds a doctorate in history from the Lumière-Lyon 2 University, and is a researcher for the Mertola Archaeological Camp and editor of the journal *Arqueologia Medieval*. He was the scientific co-ordinator of the exhibitions 'Islamic Portugal' (Lisbon, 1998) and 'Portugal-Morocco' (Tangiers, 1999), and he co-authored *O legado islâmico em Portugal* with Cláudio Torres.

Mohamed MEZZINE (Fez, Morocco) is a historian and Doctor of Philosophy, Prix du Maroc for Human and Social Sciences, head of research at the training and research centre 'The Arab-Muslim Town' and member of the National Centre of Excellence for National Heritage. He has written a number of books and articles on the history of Morocco.

Abdal-Razzaq MOAZ (Damascus, Syria) is a historian of Islamic architecture. He studied history at Damascus University, Syria, and obtained his PhD in the history of Islamic art and archaeology at Aix-en-Provence, France. He has taught at universities in Syria, France and the USA, including Harvard University. He was Director General of Antiquities and Museums in Syria and is currently Deputy Minister of Culture. He is the author of numerous publications on Islamic history, art and architecture in Arabic, French and English.

Mohammad NAJJAR (Amman, Jordan) is a field archaeologist and researcher and is the Chairperson of the Friends of Archaeology of Jordan. He studied archaeology in Moscow 1972–8, and finished his PhD studies in art history and archaeology in 1981 at the Institute of Archaeology of the Academy of Science in Moscow. Between 1982 and 1988 he was curator at Jordan Archaeological Museum in Amman. Currently he is the Head of Archaeological Excavations and Surveys in the Department of Antiquities of Jordan. He has published on the archaeology of Jordan in books and academic and professional journals.

Boussad OUADI, (Algiers, Algeria) is a trained sociologist, an editor and a bookseller, and has contributed to a number of works on the literature, art and history of Algeria, mainly relating to the rock art of the Algerian Sahara and Berber cultural expression in the Maghreb.

Pier Paolo RACIOPPI (Rome, Italy) obtained a doctorate in history and the conservation of art and architecture at the University of Rome 3. He worked on the *Dizionario Biografico degli Italiani* (Enciclopedia Treccani) and is a specialist in antiquarian arts and sciences of the eighteenth century. He edited the Italian edition of the Museum With No Frontiers collection *Islamic Art in the Mediterranean*. He teaches Renaissance Art at the Institute for the International Education of Students at LUISS, Rome.

Mónica RIUS (Barcelona, Spain) teaches Arabic Studies at the University of Barcelona. She has a PhD in Arabic Language from the University of Barcelona (1999) with a thesis on the orientation of mosques in the Muslim West during the Middle Ages, *La Alquibla en al-Andalus y al-Magrib al-Aqsà*. She has worked on a number of exhibition catalogues for the Institut du Monde Arabe and the Fundación el legado Andalusí and is regularly published in international scientific journals and by leading publishers. She is the secretary of the SEEA (Spanish Society of Arabic Studies) and the SCHCT (Catalan Society of Scientific and Technical History).

Khader SALAMEH (Jerusalem) has been the Director of the Islamic Museum and Al-Aqsa Library in Jerusalem for more than two decades. He was previously employed in the Hebrew University Library and worked as a librarian in Saudi Arabia and as a teacher in Libya. He is a PhD candidate in Ottoman History. He received a Certificate of Librarianship in 1986 from the Hebrew University. He obtained his BA degree from Beirut University in 1980. He catalogued the Manuscripts Collections of al-Haram al-Sharif, which was published in six parts in several countries. His publications include many articles on different subjects.

Eva SCHUBERT (Rome, Italy; Brussels, Belgium) is the initiator and founder of Museum With No Frontiers (MWNF) and currently its chair and chief executive. After studying acting and stage direction in Vienna, where she was born in 1957, she started her career as an organiser of international cultural events. A series of bilateral projects in various fields of the arts and culture led to her true passion: the design and management of multilateral cultural projects with a strong political component.

Ettore SESSA, (Palermo, Italy) graduated in architecture from the University of Palermo in 1981, where he now teaches the history of architecture and the history of gardens and landscape. He has been a researcher in the history of architecture at the School of Architecture at Palermo since 1985, becoming Associate Professor in 2003. He has published just over one hundred essays and some books on Sicilian architecture (Mediaeval, Late Baroque, Neo-classical, eclecticism, modernism, 1920s and 1930s) and has jointly co-ordinated several exhibitions.

Emily SHOVELTON (London, United Kingdom) is a freelance Islamic art historian. In recent years she has worked on a number of projects at The British Museum. She is currently completing her PhD on Indo-Islamic painting at the School of Oriental and African Studies, University of London.

Zena TAKIEDDINE (Damascus, Syria) is a researcher in Arab history and Islamic art. She received her BA in history from the American University of Beirut, her MA in art and archaeology from the School of Oriental and African Studies in London, and a diploma in antiques connoisseurship from Sotheby's, London. Her fields of interest include the development of the Arabic script, early Islamic art and architecture, Arab miniature painting, cross-cultural interaction between Islamic and Western civilisation, and post-colonial methodology in the study of history and identity.

Paola TORRE (Rome, Italy) is Head of the Department of Islamic Art & Archaeology and the Education Service at the Giuseppe Tucci National Museum of Oriental Art in Rome. A graduate in Islamic art and architecture, she has taught at the Istituto Universitario Orientale (now the Università degli Studi l'Orientale) in Naples for many years and has had several of her works published, including *Maioliche a lustro ispano-moresche* (1987), *Le Mille e una Notte. Ceramiche persiane, turche e ispano-moresche* (1990) and *Un Oriente di Seta e d'oro. I corredi di una famiglia di Aleppo* (2004).

Barry WOOD (Istanbul, Turkey) is an art historian. He studied the history of art and architecture at The Johns Hopkins University and Harvard University, where he specialised in Islamic art. He has taught Islamic art history at Eastern Mediterranean University (Famagusta), the School of Oriental and African Studies (London) and the Courtauld Institute of Art (London). He is also an experienced museum curator, having worked at the Harvard University Art Museums, the Walters Art Museum (Baltimore), and the Victoria and Albert Museum (London). He has published on topics ranging from Persian painting to the history of exhibitions.

About Museum With No Frontiers (MWNF)

MWNF manages a diverse programme of activities that are based around the development of new exhibition formats, using both physical and virtual exhibition venues, which complement and integrate with each other. The aim is to create a platform that will allow partners from different countries to join the MWNF network on an equal and neutral basis independent of political and economic differences. Presenting history, art and culture from the local perspective of each country is thus the distinguishing *leitmotif* of the MWNF programme.

MWNF, an international non-profit-making organisation, was founded in 1994 on the initiative of Eva Schubert in Vienna (Austria). The organisation operated from Madrid (Spain) from 1998 to 2002 and moved its headquarters to Brussels (Belgium) in 2002.

In parallel with the Virtual Museum programme, MWNF develops a network of Exhibition Trails that are designed to transform regions or countries into authentic open-air exhibition venues where the exhibits are presented and appreciated *in situ*, within their natural environment and cultural context.

The following catalogues are designed to complement the MWNF Exhibition Trails: *Islamic Art in the Mediterranean*

Turkey (Western Anatolia and Thrace)
EARLY OTTOMAN ART: The Legacy of the Emirates

Portugal
IN THE LANDS OF THE ENCHANTED MOORISH MAIDEN: Islamic Art in Portugal

Morocco
ANDALUSIAN MOROCCO: A Discovery in Living Art

Tunisia
IFRIQIYA: Thirteen Centuries of Art and Architecture in Tunisia

Spain (Madrid-Aragon-Castilla La Mancha-Castilla y León-Extremadura, Andalucía)
MUDEJAR ART: Islamic Aesthetics in Christian Art

Jordan
THE UMAYYADS: The Rise of Islamic Art

Egypt
MAMLUK ART: The Splendour and Magic of the Sultans

Palestinian Authority (West Bank and Gaza)
PILGRIMAGE, SCIENCES AND SUFISM: Islamic Art in the West Bank and Gaza

Italy (Sicily)
SICULO-NORMAN ART: Islamic Culture in Medieval Sicily

In preparation:

Algeria
TRACES OF ISLAM IN ALGERIA: The Art and Architecture of Light

Syria
THE AYYUBID ERA: The Art and Architecture of Medieval Syria

For more information about these publications and how to order copies please visit **www.museumwnf-books.net**